THE THIRD HAND

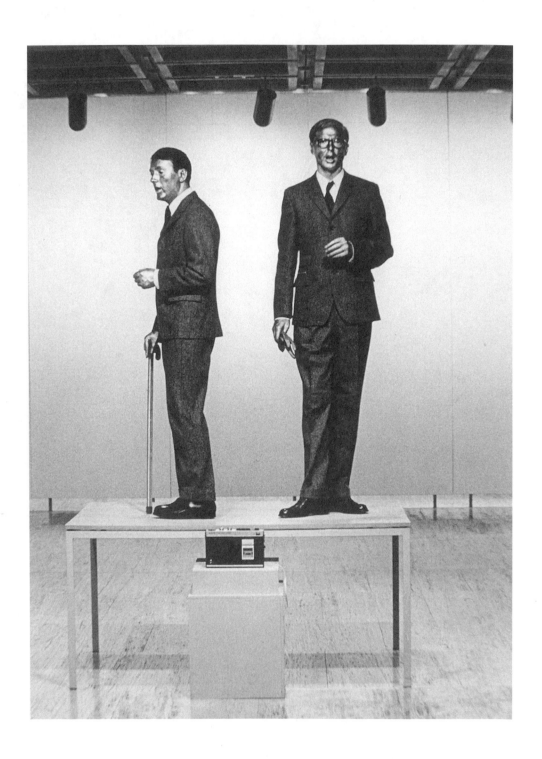

University of Minnesota Press / Minneapolis London

THE THIRD HAND

collaboration in art from conceptualism to postmodernism

Charles Green

Frontispiece: Gilbert & George, *The Singing Sculpture* (1973). Art Gallery of New South Wales, Sydney. Living sculptures singing. Photograph courtesy John Kaldor archive, Sydney.

The University of Minnesota Press gratefully acknowledges permission to reprint the following articles by Charles Green. Earlier versions of portions of chapter 1 were published as "Art by Long-Distance: Joseph Kosuth and the Assistance of Others," *Visual Arts and Culture* 1, no. 2 (1999): 178–95, and "Joseph Kosuth and Archives," in *Joseph Kosuth* (Wellington, New Zealand: Adam Gallery, Victoria University Wellington). Earlier versions of portions of chapter 2 appeared as "Ian Burn and Artistic Collaboration," *Art Monthly Australia*, no. 116 (December 1998): 7–10, and "Ideas and Actions: Conceptual Art. Performance, Process, and Documentation," *Art/Text*, no. 69 (May–July 2000). An earlier version of chapter 6 was originally published as "Disappearance and Photography in Post-Object Art: Christo and Jeanne-Claude," *Afterimage* 27, no. 3 (November/December 1999): 13–15. Earlier versions of portions of chapters 7 and 9 appeared as "Doppelgangers and the Third Force: The Artistic Collaborations of Gilbert & George and Marina Abramović/Ulay," in *Art Journal* 59, no. 2 (summer 2000).

Published by the University of Minnesota Press
111 Third Avenue South, Suite 290
Minneapolis, MN 55401-2520
http://www.upress.umn.edu

Library of Congress Cataloging-in-Publication Data
Green, Charles.
 The third hand: collaboration in art from conceptualism to
postmodernism / Charles Green.
 p. cm.
 ISBN 0-8166-3712-1 (acid-free paper)—ISBN 0-8166-3713-X
(pbk. : acid-free paper)
 1. Artistic collaboration—Case studies. 2. Artist couples—Case
studies. 3. Conceptual art. 4. Modernism (Art). 5. Postmodernism. I.
Title.
 N6490.6.G74 2001
 700′.9′04—dc21

 00-010820

Printed in the United States of America on acid-free paper

The University of Minnesota is an equal-opportunity educator and employer.

12 11 10 09 08 07 06 05 04 03 02 01 10 9 8 7 6 5 4 3 2 1

Contents

Acknowledgments

Marina Abramović, Helen Mayer Harrison and Newton Harrison, Christo and Jeanne-Claude, and Anne and Patrick Poirier are extraordinary people, and their boundless energy, generosity, and passionate commitment to art are profoundly inspiring. Joseph Kosuth, Alex Melamid, Mel Ramsden, Avril Burn, Gilbert & George, and many others have all been extremely helpful. Other sources remained unavailable because of busy schedules or their absolute reluctance to be interviewed; this has been a lesson in how reluctantly history is written. I developed the manuscript in 1995, during a six-month Australia Council residency in Paris. In 1997, I was fortunate to be able to use the superb holdings at the Center for the Humanities of the New York Public Library and then to spend three months at Sanskriti Kendra, a cultural foundation outside New Delhi, India. My text has been carefully and critically read by many people. I must acknowledge Roger Benjamin, for his rigor, scholarly integrity, and the example of his own elegant writing, and my colleagues at the University of Melbourne, Jeanette Hoorn and Chris McAuliffe. The School of Fine Arts, Classics and Archaeology, and Cinema Studies at the University of Melbourne provided me with a scholarship and several travel grants enabling research in the United States and Europe while I wrote the early drafts of this book. Later, the College of Fine Arts at the University of New South Wales awarded me further travel grants, as did the Australian Academy for the Humanities in Canberra. Stephen Bann, Nikos Papastergiadis, David Joselit, John Farmer, Jeremy Gilbert-Rolfe, and Kathy O'Dell have all given me rigorous and welcome advice about revisions. Most of all, for her tireless, patient editing and unstinting support, I acknowledge my wife, Lyndell Brown, with whom I was also working on many exhibitions in our other life as collaborating artists during the preparation of this book.

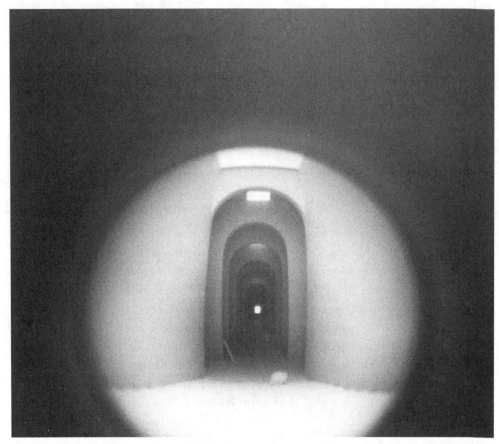

Anne and Patrick Poirier, *Ouranopolis* (detail) (1995). View through peephole. Wood, acrylic paint, Plexiglas, steel, 72 inches × 172 inches; work suspended from ceiling. Courtesy Thaddeus Ropac Gallery, Paris.

Introduction:
Collaboration as Symptom

Nothing, I think, is more interesting, more poignant, and more difficult to seize than the intersection of the self and history.—Linda Nochlin, describing the first "Women and Art" seminars at Vassar in 1969

Collaboration as Symptom

Artists appear in their art, voluntarily placing themselves center stage in self-portraits but also at the margins of all their other works, constructing themselves through brush marks, in signature style, by individual preferences, and through repeated motifs—in short, from the intersection of subjectivity with medium. As a basic tenet of connoisseurship, this seems obvious, but there are degrees of self-conscious intention that complicate this process, especially during the latter half of the twentieth century, for many artists have thought carefully about the way they code themselves into their art, manipulating the way they appear. This is not to suggest that artists are narcissistic, or that they are necessarily even interested in the politics of identity; rather, artists have always conceded and exploited the inevitability of implicit self-representation. Artists are thieves in the attic: They far from innocently try out different, sometimes almost forgotten identities in the chaotically organized attic of history, rummaging in dusty, dark rooms where variations of authorial identity are stored away from view. This runs counter to the conventional idea of the lonely artist passively waiting for inspiration's light bulb to be turned on. Such a clichéd figure is deeply embedded in media representations of artists, in market valuations based on authenticity and originality, and in so much public discourse that it is generally perceived as "normal." If

this is normal, then the deliberate, careful construction of authorial alternatives described in my book must be aberrant. Artistic collaboration is a special and obvious case of the manipulation of the figure of the artist, for at the very least collaboration involves a deliberately chosen alteration of artistic identity from individual to composite subjectivity. One expects new understandings of artistic authorship to appear in artistic collaborations, understandings that may or may not be consistent with the artists' solo productions before they take up collaborative projects.

I propose that collaboration was a crucial element in the transition from modernist to postmodern art and that a trajectory consisting of a series of artistic collaborations emerges clearly from late 1960s conceptualism onward. The proliferation of teamwork in post-1960s art challenged not only the terms by which artistic identity was conventionally conceived but also the "frame"—the discursive boundary between the "inside" and the "outside" of a work of art. I would argue that artistic collaboration in the late 1960s and during the 1970s occupies a special position: Redefinitions of art and of artistic collaboration intersected at this time.

Just what, though, were the stakes in these different methods of collaboration? Who benefited, who got marginalized, who was eventually obliterated from the historical record? If, as I think, these teams re-created themselves as embodiments of textual mimicry, then we need to pay close attention to both artistic text and context. I will answer these questions through a very selective history of artistic collaborations after 1968—specifically, those collaborations that involved unorthodox models of authorship—in a series of case studies. I focus on artistic collaborations in international art that came to notice in the 1970s, locating them within the evolution of conceptualism: conceptual art, Earth art, systems art, land art, body art, and many other stylistic labels. Because of this narrow focus, however, I have not written about many teams whom I admire greatly, including Group Material and Komar and Melamid.

Each of the three parts of this book looks at a different type of collaboration, for three overlapping modes of artistic teamwork developed from the mid-1960s onward. First, between 1966 and 1975, the future members of Art & Language constructed highly bureaucratic identities. Second, at the end of the 1960s, Boyle Family, the Poiriers, and the Harrisons separately developed close-knit collaborations based on marriage or lifetime, family partnerships. Finally, artist couples developed a third authorial identity effacing the individual artists themselves: From the start of the 1970s onward, Christo and Jeanne-Claude developed a transitional author figure that varied from traditional patriarchy, to a corporation, to a trademark; from 1969, Gilbert & George identified their artistic collaboration with their art; between 1976 and 1988, Marina Abramović and Ulay consciously developed their "third hand." These categories overlap to a considerable extent. The Poiriers, for instance, did evolve a third hand—their "architect/archaeologist." They did not literally identify themselves with their art.

Aims, Methods, Objections, and Exclusions

A study of artistic collaborations is a telescope onto a larger study: that of a shift to a new understanding of artistic identity that emerged from modernist notions of artistic work—both radical and conservative—and progressed toward alternative and quite extreme authorial models, a long way from the simple paradigm of the single lone artistic originator and creator. The process problematizes straightforward suppositions about both artistic identity and the origin of postmodern art.

During the 1960s and 1970s, artists were testing the limits of art. It has been argued that they were involved in testing the limits of other domains as well, among them the studio and artistic work. The movement away from the lone artist was a journey similar to that from the studio. It was less shockingly literal, certainly, than Tony Smith's famous New Jersey Turnpike drive—during which he asked himself why one would continue to make art in the studio—but it was equally radical. Looking closely at works by artistic collaborations, I discovered that artists found collaborations and other, modified types of authorship necessary to answer pressing questions facing contemporary art. What were they asking, and how did they go about framing these questions? This book hinges on a period that might be broadly called the 1970s, extending from the late 1960s into the first years of the 1980s. During that time, there was a significant sea change in both critical discourse and art, coinciding with the generally accepted but quite dramatic ascendancy of postmodern art and theory. Looking back, we see that the reinventions of artistic identity in the late 1960s and 1970s have largely been described through the narrative terms of the next decade's victors—in this case, through the terms of postmodern critiques of representation. But are these terms sufficient to draw out the common threads underlying artists' modifications of artistic authorship? Certainly, theories of postmodern art based on allegorical identifications, simulation, and appropriation are increasingly inadequate tools for evaluating art beyond the horizon of art canonized during the 1980s. It may be that the sheer institutional success of postmodern style, tempered by its reaction against a highly conservative form of neo-expressive postmodernity, blinkered art-critical discourse to certain types of difference. Many alternative trajectories emerge from a rereading of the 1970s, problematizing the conceptions of artistic identity that underlay the postmodern canon with its hall of mirrors. Artists in the 1990s inevitably began to widen these boundaries. Even allowing for the (illusory) arbitrariness of decade divisions, we are left with the impression of a greater discontinuity between the 1970s and the 1980s than we might expect and surprising signs of continuity between the artists I write about in this book and art in the later 1990s. There is another reason why it is important to revisit these collaborations: the suddenly compelling relevance of alternative 1970s art practices to 1990s conceptualist agendas.

In part I, I look at collaborations in early conceptual art, particularly the collaborations of Joseph Kosuth, Ian Burn, and Mel Ramsden. Joseph Kosuth called his

reaction against self-expressive identity a reaction against "painting," even though, to a surprising degree, he managed to construct a certifiable, well-policed signature style from the bare bones of typography. In his case, though, the clearly enunciated delegation of manufacture was crucial to the integrity of his work from the *Second Investigation* onward. Burn and Ramsden "framed" their reaction against self-expressive, individual artistic identity through the hierarchical metaphors and teamwork methods of bureaucracy, in jointly written, quasi-philosophical discourses surrounding (and contained within) the works. They thought that a zone between art and art theory could be created by a collective art of text-based critical propositions.

In part II, I look at collaborations based on a long-term, lifetime commitment and thus at couples and family units. In the years around 1970, Boyle Family, Anne and Patrick Poirier, and Helen Mayer Harrison and Newton Harrison reformulated artistic work as "fieldwork" to be undertaken through the agency of a collaborative structure identified with the family or the couple and articulated through determinedly anonymous styles in projects that would last for decades. Their anthropological archivism stands at the cusp of modernism and postmodernism, for they sought modes of production that might be genuinely decentered. However, because these artists were not part of an assault on Clement Greenberg's modernism, they have to a large extent become historically invisible, since a debate in which they had little stake—the ideological critique of late modernism—has remained so paradigmatic. Their emphasis on the stakes involved in memory representation, however, was quite systematic, even if it did not affect their misleading legibility within more canonical debates as a mere footnote. The result was that their understanding that the crisis of visuality was also a prolongation of the memory crisis remained invisible to most critics. The proof of this is that alternative critical agendas, such as that of then-important critic Jack Burnham, have more or less disappeared from recent revisionist texts. However, these artists extend the conceptualist dogma that a work of art is about ideas that must be encoded in language. Their works contest the antivisual disposition attributed to 1970s conceptualisms.

In part III, I look at artistic collaborations where artists identified their collaboration as their art. I propose that the intersection of collaboration with a discourse of silence and inaccessibility shows us that representation is neither a transparent window onto authorial subjectivity nor sufficient to index the self. My method is to map Michael Fried's terms of absorption and theatricality onto Gilbert & George's and Marina Abramović and Ulay's collaborations. This clarifies why these artists' actions ignored the viewer: Silence and unknowability, in combination with the complexities of double authorship, denied the expected economies of representation (specifically, the binary terms through which we habitually describe gender, pain, and experience). The works are complicated by this series of doublings, so much so that an understanding of the limits of identity as an index of the self becomes apparent. First, the artistic collaboration between Christo and Jeanne-Claude represents an incomplete transition from individual to corporate identity. Second, Gilbert & George represent

a far more complex, troubling example of collaborative self-effacement. In their work the artists appear as three-dimensional sculptural objects of a particular type: as cult apparitions of a higher reality nominally governed by aesthetic appearance. Third, I'll isolate Marina Abramović and Ulay's conception of artistic language's primal ground, which they saw as voidness experienced, already in translation, as a body memory of rapture. The final chapter of part III defines the third identity that resulted from these collaborations, arguing that the artists' doppelgängers were strategic but almost terminal means of shedding traditional signs of unwanted artistic personality—the conventional artistic identities increasingly under question during the 1970s.

The lonely individual artist is a historically specific figure. There are many studies of medieval authorship—of its frequent communality and anonymity—and of Renaissance workshops, with their complex, hierarchical divisions of labor and graded scales that individually defined an assistant according to his position in an atelier. Research into the nature of authorship—and not simply of attribution—in Renaissance and Baroque painting also renders our picture of great figures, specifically Rembrandt and Peter Paul Rubens, much more complex as we begin to understand the collective nature of the Dutch and Flemish studio enterprise.[1] Thomas Crow's studies of French neoclassical painting make Jacques-Louis David's grand reputation seem to be the product of many hands and even of many signature styles.[2] This research obviously inflects my study of artistic collaboration, for I take special account of collaborations that are not simply mergers of two "hands" into one and look instead at collaborations that manipulate the concept of signature style itself. Equally, not all artistic collaborations are interested in authorship; many collaborations construct works as if there is just one artist and no collective work. I have found, however, that few collaborative works failed to encode their dispersed authorship in specialist divisions of labor or in increases in the possible expenditure of labor. Almost all invented strategies in which knowledge of collaborative authorship was implicitly assumed in order to convince the audience. But of what?

Since the great changes in art during the 1960s, artistic identity has not been a straightforward given. It has been selected in good and bad faith, out of duplicity, or from acts of speaking for someone else. The categories of artistic collaboration and constructed, manipulated—as opposed to "natural" or individual—authorial identities overlap but are not the same. There are other forms of modified artistic identity that I could have logically written about—hoaxes and pseudonyms, for example—and though these fictional identities appear in certain of the collaborations I describe, they are not central to this book, though concealment and disappearance are.

Many short-term collaborations preserve each individual's authorial signature style, even though the participating artists might all contribute to each area of a work; a good example is Andy Warhol's collaboration with Jean-Michel Basquiat. But such short-term collaborations that preserve authorial style rarely occupy much more than an incidental position within an artist's oeuvre. In another type of collaboration, also ignored in this book, dedicated and highly skilled craftsmen or technicians, who must

be considered more than assistants, collaborate over a long period of time with an artist who nevertheless is given sole credit. Ian Hamilton Finlay and Frank Stella are cases in point, for each artist worked with master craftsmen in order to realize works that would have been otherwise impossible. Different types of collaboration emerged in Europe and North America during the early to middle 1990s: first, the collaborative category of twins and siblings (the Starn Twins, the Wilson Sisters, and Jake and Dinos Chapman, among many other twins who work together); second, the long-term collective with a relatively large and fluid membership (for example, Group Irwin, Dumb Type, and Tim Rollins and K.O.S.; this type of collaboration is similar in structure to Art & Language of the 1970s); third, complicated authorial fictions in which individual artists pose as collaborative groups (including Scottish artist Peter Hill's Museum of Contemporary Ideas, Dutch collective Seymour Likely, and Los Angeles artist David Wilson, who is director of the Museum of Jurassic Technology). Several artist teams came to prominence before the period I describe, including major figures whose production continued well into the 1990s (Ed and Nancy Reddin Kienholz, and Claes Oldenburg and Coosje Van Bruggen), but I do no more than allude to these artists; nor do I discuss the ongoing and complex production of post-1975 Art & Language, about which much has been written. I ignore the many collaborations that surfaced in the 1980s, including Jones and Ginzel, TODT, Clegg & Guttman, McDermott & McGough, or Gran Fury, and the reader is directed to the important waves of collaborations by Russian artists during the 1980s and 1990s (for example, Medical Hermeneutics).[3]

Two important objections might be made to the way I treat my limited number of case studies. First, this project might be misinterpreted as arguing that something inherent in all texts—textuality—is also literally embodied in collaborations and that collaborations are therefore in some way a privileged form. After all, the few critics who have written about artistic collaboration have asserted that behind an unexpectedly large number of authors are unseen collaborators, usually female partners. This is more or less the position taken by the book edited by Whitney Chadwick and Isabelle de Courtivron, but their overpersonalization simplifies the more complex issue of intention and identity.[4] Unlike such writing, my book does not rely at all upon the excavation of previously unexposed joint works, though it is clear in two of the teams I discuss—Boyle Family and Christo and Jeanne-Claude—that the patriarchal name was for a long time credited with the work of a partnership. The teams in this book were chosen for another reason, and definitely not to assert the centrality of collaboration within the corpus of early postmodern art. Nor are the artists interesting simply because they worked collaboratively. Collaboration has not in itself been a radical act since early modernism, when Russian constructivists or the French surrealists, for vastly different reasons and in different media, used artistic collaboration to escape the constricting consequences of existing individual production methods.

A second criticism is more difficult for me to answer: that these artistic teams are isolated figures, that my choice of artists is idiosyncratic and unrepresentative, and

that within the wider field of post-1968 art their relevance is limited. Certainly, the artists in this book are unusual, and their works, in part because of their collaborative production, have been difficult to categorize. The central focus of my discussion, though, is not the enumeration of strange artists' working processes or a critique of their marginality. It is, rather, the need to unravel the enigma of alternatively constituted "authors" and their link to the crisis of artistic representation, which is also a crisis in artistic intention. Conceptual art is an appropriate starting point because conceptualist collaborations were not simply the result of a fusion of voices but were implicit and highly intentional products of a textual version of the "expanded field."

The literature on artistic collaboration in post-1960s art is at first sight surprisingly scant, but it indicates that the second objection, at least, is unfounded, as does the exploding corpus of literature on Marina Abramović. There are a couple of exhibition catalogs and a few feature articles on collaboration in journals, including most notably an *Art Journal* issue on collaborations between artists and writers, and a separate body of literature on each of the artists about whom I write.[5] In 1984, Cynthia McCabe curated *Artistic Collaboration in the Twentieth Century* for the Hirshorn Museum (Washington, D.C.). Although the exhibition catalog is an interesting sourcebook, it seeks to prove its premise—that "artistic collaboration has been a vital component of avant-garde development"—by demonstrating the ubiquity rather than the significance of collaboration.[6] The catalog for curators Susan Sollins's and Nina Castelli Sundell's exhibition *Team Spirit* focuses on post-1970s collaborations, and it includes Irit Rogoff's comprehensive and eloquent essay "Production Lines," which identifies structuralist theories of authorship as central to the work of understanding artistic collaboration.[7] First, Rogoff identifies a positivist strain in art criticism through which collaboration can be viewed as an "expansion" of the field of art, thus demonstrating the ineffable inventiveness of the human spirit. Modernist artists worked in revolutionary collaborations and subversive collectives, but these projects were invariably recuperated in the literature by the cult of individual genius. As she observes, "[T]his concept of collaboration is extremely limited. It assumes a coming together of talents and skills which cross-fertilize one another through simple processes, neither challenged by issues of difference nor by issues of resistance."[8] Second, she suggests that collaborations be seen as highly significant practices within both modernism and postmodernism, because the practice of subjugating the individual signature is a paradigmatic interrogation of artistic production.

Accounts of literary collaborations in relation to theories of authorship are both more intriguing and more rewarding. In *Multiple Authorship and the Myth of Solitary Genius*, Jack Stillinger presents an account of editorial interventions in English literature from William Wordsworth onward, focusing on Wordsworth, John Keats, Samuel Coleridge, and T. S. Eliot (in the latter case, analyzing Ezra Pound's modifications to *The Waste Land*).[9] Stillinger rehearses Roland Barthes's essay "Death of the Author." But he literally assumes that this essay legitimizes his thesis that collaborative practices will be found behind many famous authors, an approach that has severe

shortcomings, to say the least: It remains oblivious to the unorthodox surplus "author" constituted by collaborative authorship; instead of one solitary genius, he substitutes two. A more useful distinction—between constructed artistic identity as strategy and as a universal textual property—is usefully expounded in Michael Wood's study *The Magician's Doubts: Nabokov and the Risks of Fiction*.[10] Wood describes a writer's "signature" as the characteristic signs and tropes by which readers recognize the identity of writers. This signature, he argues, is the writer's visible subjectivity, but "style," on the other hand, is the more complex deployment of tropes, metaphors, structures, and devices within which signature is contained. Even if we acknowledge Barthes's, Michel Foucault's, and Jacques Derrida's revelations about reading, this does not, of course, mean that authors are dead or destined to disappear. Instead, authors may often be conspiratorial when they are absent, for their signatures may be as carefully constructed as their styles. Leo Bersani and Ulysse Dutoit develop a related insight of great subtlety in their study of Michelangelo da Caravaggio's "enigmatic signifiers," that is, his portrayal of enigmatic desire and of "the 'concealment' of an unmappable extensibility of being."[11]

In many of the collaborative works discussed in this book, the signs of personality and subjectivity were deliberately and thoroughly suppressed. It can certainly be argued that the relativizations of stable authorial identity by postmodern, structural, and poststructural theorists, especially Barthes and Foucault, inevitably lead to the conclusion that all authors are culturally or socially constructed from other texts. One might naively then conclude that these constructions are "fictional"; to do so, however, would be to conflate a theory of cultural reception with a strategy of artistic production and to confuse an ethic for artists with an analysis of art. But collaborations did construct themselves as texts, elaborating self-consciously chosen, modified authorial identities.

Collaborations and modifications of authorship existed in modernist art and were often linked with the marginal—with the alternative modernist stream that includes surrealism's collectively produced "exquisite corpses" and dada actions. A circle of authors connected with the journal *October*—particularly Rosalind Krauss, Benjamin H. D. Buchloh, Yve-Alain Bois, and Hal Foster—has gradually revised our understanding of that modernism and post-1960s art alike, drawing a new picture of twentieth-century art, a picture in which the enigmatic Marcel Duchamp quietly sits at the epicenter.[12] In relation to the decades that preoccupy me here, a younger generation of scholars, including Jessica Prinz and Caroline Jones, has since begun to patiently analyze and periodize the 1960s and 1970s.[13] Charles Harrison has argued, to some effect, that Foster's and Krauss's books represent a new homogenizing voice of centralizing logic, even though they include a far wider methodology and canon than the formalist narrative. Harrison himself, through his own writing and his work as part of the artistic team Art & Language, has a considerable investment in the periodization of art history after 1960. He has also eloquently described the complications of authorship and artistic identity in modernist art, and there is also considerable force

in Harrison's regionalist arguments.[14] Postcolonial theorists have also discussed the mechanisms of power and translation, particularly the ability of subjects to reconstruct identity when they move across cultural and national borders.[15] For the theoretical underpinnings of concepts of mimicry developed in my later chapters, the writings of Gayatri Chakravorty Spivak, Homi K. Bhabha, and Geeta Kapur suggest that the deconstructive analysis of postmodernism and, implicitly, modernism reinscribed the conceptual boundaries of the West onto the colonized periphery.[16] Further, Edward Said observes in *Culture and Imperialism* that postcolonial authorship often moved away from a stable idea of the original author.[17]

Art and Identity

In the course of this book, I will invert the terms of previous accounts in order to see the 1970s from a different perspective. For example, during the later 1960s, claims were made that contemporary art—and especially the emerging conceptualisms— would "alter" its audience. These claims centered on the perceptual changes induced by viewer participation in phenomenological inquiries as they were supposedly incarnated in conceptualist artworks. Harald Szeemann's early exhibition *Live in Your Head: When Attitudes Become Form* (Kunsthalle [Bern] and then at the Institute of Contemporary Art [London] in 1969) captured this aspiration.[18] Charles Harrison republished his catalog essay in *Studio International,* writing:

> Art changes human consciousness. The less an art work can be seen to be dependant,
> in its reference, on specific and identifiable facts and appearances in the world at one
> time, the more potent it becomes as a force for effecting such a change.[19]

I contend in this book the reverse: that the demands of contemporary art changed the artist. Artists examined the shape and limits of the self, redefining artistic labor through collaborations. To paraphrase Linda Nochlin's eloquent words at the start of this introduction, we must begin to look closely at how artists responded to the intersection of the self and history.

PART I
COLLABORATION AS ADMINISTRATION

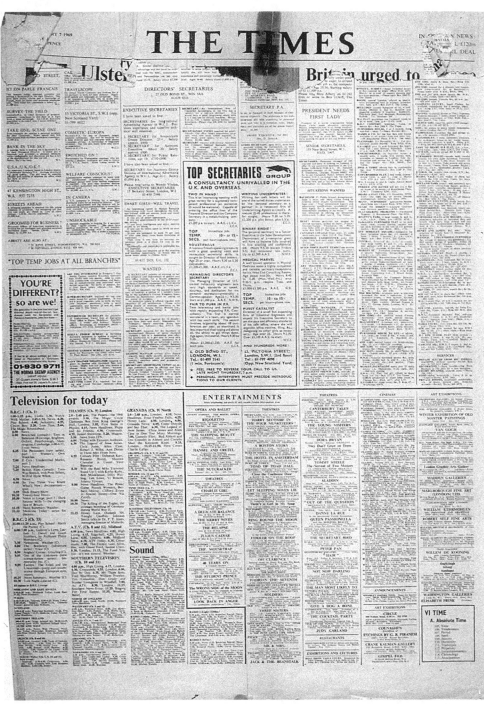

Joseph Kosuth, *VI Time (Art as Idea as Idea)* (1969), from the *Second Investigation*. Paid notice in newspaper, *Times* (London), 7 January 1969.

1. Art by Long Distance:
Joseph Kosuth

Art as Archive

This chapter contextualizes Joseph Kosuth's early work, and in particular that made around 1970, in relation to one type of artistic collaboration—the delegation of manufacture—because this delegation was crucial to the often-debated integrity of his early work and necessary to his defeat of painting.[1] It intersected with his decision from the late 1960s to produce art almost exclusively using writing and text or using other artists' works. Kosuth's productions were linked by his ambition to evolve a different and distanced type of artistic identity, one removed from the modernist imperative that the personal "handwriting" of an artist was intimately connected with art. There was a twist: Though Kosuth and other first-generation conceptual artists wanted to mimic the cultural authority of hegemonic discourse (remember, these artists all lined up against the Vietnam War, and most had links or sympathies with the Left) in order to critique and lay bare its operation, and though they understood (or at least had access to such concepts, which were current in the early 1970s through anthropological discourse well before the appearance of French poststructural theory) that language itself contained and perpetuated power structures, this mimicry almost immediately became pastiche and then, in a Rake's Progress of good intentions, the incarnation of authority and managerial efficiency.

Joseph Kosuth assembled, excavated, and organized information. From the mid-1970s onward, he often located his installations in real archives and assembled collections of text into books that resembled systematic samplings from archives. In addition, he increasingly saw his art, and art in general, as possessing many of the social properties of archives. Since Kosuth's works were always, after the late 1960s, collections

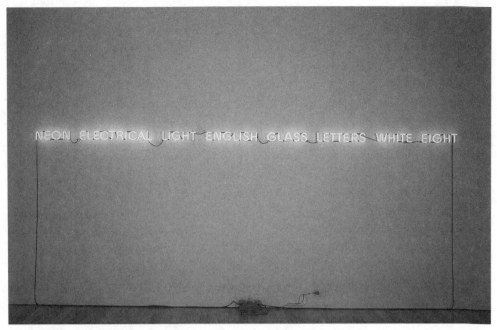

Joseph Kosuth, *One and Eight: A Description* (1965). Neon. Private collection, Paris.

and arrangements of text or "found" works of art, they in turn require a consideration of the ways in which information is stored and displayed and a reflection upon the connection between art and archives. Here, the focus will be on the appearance— little-noted, it has to be said—of Kosuth's *Second Investigation* at fifteen locations around the world in 1969, and here, as throughout this book, I want to pay attention to the *form* that conceptualist art took.

What is the connection, then, between archives and language, especially visual language? Many artists and critics assume that there is a connection, that archives have a grammar, and that archives have the status of statements. These assumptions, very typical of the 1970s, must be critically examined. An archive is a collection of records—preserved documents and objects. It is also their physical repository. Some of the items in these storehouses of representations are instances of language—written documents for example—and others, such as paintings or photographs, are not, at least, according to the restrictive criteria of analytic philosophers and aestheticians. For though photographs, paintings, and other types of representation are certainly organized according to rules, these are not necessarily the rules of language. Instead, they may be organized according to the rules of other sign systems and may even be quite pragmatically deposited in an archive according to size, shape, or the date of deposit. Only some items found in an archive may be instances of speech or writing, utterances in a real language system. All representations, nevertheless, are composed according to sign systems—they have semiotic lives.

Archives are undoubtedly a form of statement, at least in the terms that Foucault

recognizes, because archives incorporate interwoven depositions of differences that are historical, denotative, and connotative and that are composed according to codes, in the following four ways.[2] In an archive, patterns of meaning can be definitely articulated at the level of the archive itself, a form of recording through the deposit of items. Reading and viewing material deposited in an archive can embody a memorial function. Inside an archive, items are organized according to principles of repetition, transformation, and retrieval. Finally, an archive is linked to the historical situation and processes that brought it into being. It exists diachronically as well, for it is linked to and its integrity is dependent upon the historical consequences of its foundation. An archive can, therefore, be seen as constituting a statement. The implication of looking at works of art as archives is that they are therefore seen as textual, as composed of records and memories that can be read.[3]

Having noted the idea of an archive and emphasized the importance of reading, it is necessary to think about an archive's form in art as well.[4] The *form* of archive-oriented art was connected to a more general reformulation of artistic work as "fieldwork" undertaken outside the studio, outside the conventional locus of artistic identity, as a sort of pseudoanthropological work. The late 1960s and early 1970s saw artists—both members of the New York conceptual art movement and artists associated with wider definitions of conceptualism—reassess the properties of archives as anthropological, rather than as sources of surrealist wonder, at least in part because there had been a loss of confidence in the properties of aesthetic experience and even in vision as a means of gaining knowledge, as a way of successfully transforming and ordering information, let alone imagining that visual art had a clear, socially redeeming capacity.

Written language at least seemed less problematic. Kosuth's early art (and that of many other conceptual artists of the period but specifically Ian Burn and Mel Ramsden, whose contemporaneous work is the subject of chapter 2) represents an overwhelming disillusionment with the visual (and with the power and integrity of non-language-based signification) in favor of written and spoken language, and obviously therefore in favor of the expression of ideas.[5] An unexpected relationship evolved between this crisis—which we might also see as a late phase of the memory crisis of modernity that Richard Terdiman has described—along with the shift toward the word, away from the image, and the decisions of many artists, both in New York and elsewhere, to work with systems and texts. In other words, the forms, curatorial attributes, and conservation methods of archives and classification systems were the means through which culture was identified with information and systems.[6] Finally, words and text readily lent themselves as the *forms* of interdiscursive conversation, for there were many examples from literature, philosophy, and anthropology for artists to draw upon.

Curator Harald Szeemann was particularly attuned to this artistic tendency, and he wrote in the catalog essay for his landmark 1969 exhibition, *Live in Your Head: When Attitudes Become Form,* that

Joseph Kosuth, *Titled (Art as Idea as Idea)* (1967). Photographic enlargement on board. Reproduced as page of the exhibition *January 5–31, 1969* (1969).

Diese Konzeptuelle Kunst benützt sehr gerne bereits bestehende systeme (Telefonetz, Post, Presse, Kartographie), um "Werke" zu Schaffen, die schliesslich zu neuer Systemen führen, die jeden Kommentar über den Ausgangspunkt meiden.

[This conceptual art happily uses already existing systems (the telephone network, mail, the press, maps) to create new "works" that ultimately lead to new systems that avoid any commentary on their point of origin.][7]

Conceptual art with its archival methods was not without critics who saw it as a style—a conceptual style. In 1972, writing in *Artforum,* Max Kozloff criticized the "ritualization of the unusual," "data overloads," and the hermetic obscurity of conceptual and systems-based art.[8] The lack of a frame—an unambiguous demarcation between the "inside" and "outside" an artwork—implied a solution that produced its own problems. This agoraphobic freedom obviously preoccupied many artists.

During the late 1960s and early 1970s, Kosuth, like his then-colleagues and collaborators within New York Art & Language, Ian Burn and Mel Ramsden, saw art in terms of arguments and propositions about art. Kosuth, like Burn, simultaneously took authorial and critical positions, writing polemical essays as well as making art in the form of written essays. Like many other 1970s artists, Kosuth dealt with theoretical issues as art, not as written theory. In the famous 1969 *Arts Magazine* interview for which he was secretly both interviewer (under the pseudonym A. H. Rose) and interviewee, Kosuth said:

> Q (KOSUTH): Why do you think the—as you put it "Art of our time"—cannot be painting and sculpture?
> KOSUTH: Being an artist now means to question the nature of art.[9]

Kosuth saw artistic texts as part of a permeable artistic "frame" and as elements of the syntax of an emerging post-studio art. Conceptual art appeared in exhibitions as excerpts from archives rather than as visual events.

In 1969, Joseph Kosuth coordinated the "exhibition" of part of his *Second Investigation* at art centers around the world. Kosuth contacted several international galleries, asking them to place his *Second Investigation* as paid advertisements in newspapers. *Joseph Kosuth: Fifteen Locations 1969/70 (Art as Idea as Idea 1966–70)* (1969–70) was "exhibited" at the Pasadena Art Museum, later at the Leo Castelli Gallery (New York), and almost simultaneously at several other places, including a version in Seth Siegelaub's book, *January 5–31, 1969* (1969) and at Pinacotheca, in Melbourne, during November 1969.[10] Each gallery was obviously chosen as being one of the network of adventurous venues showing conceptual art. Kosuth wrote:

> My current work, which consists of categories from the thesaurus, deals with the multiple aspects of an idea of something ... The new work is not connected with a precious object—it's accessible to as many people as are interested, it's non-decorative—having nothing to do with architecture; it can be brought into the

Joseph Kosuth, *VI Time (Art as Idea as Idea)* (1968), from the *Second Investigation*. Mock-up of paid notices in newspapers. Reproduced as page of the exhibition *January 5–31, 1969* (1969).

house or museum, but wasn't made with either in mind; it can be dealt with by being torn out of its publication and inserted into a notebook or stapled to the wall—or not torn out at all—but any such decision is unrelated to the art. My role as an artist ends with the work's publication.[11]

In fact, his role had ended even earlier, at the point of commissioning collaborating galleries—in Australia, for example, Bruce Pollard at Pinacotheca—to place the statements as advertisements in national newspapers, including the *Age,* the *Sun,* and *Newsday.* His "assistants" had mediated for him, had willingly negotiated payment from their own funds (in Pollard's case at least), and had distanced him from the process of production.[12] Seth Siegelaub, in particular, had evolved a role that was recognized as being far in excess of that of curator, for he was orchestrating and choosing other artists' works into a series of publications/exhibitions that were effectively his own artist's books.

Kosuth's work was one of many made using circulated instructions and postal services as media, and Siegelaub was not the only "curator" crossing over into the role of artist. Critic Lucy Lippard conceived *Groups* (1969) as a "project" that she sent to about thirty artists in October 1969, receiving twenty-two responses. She exhibited

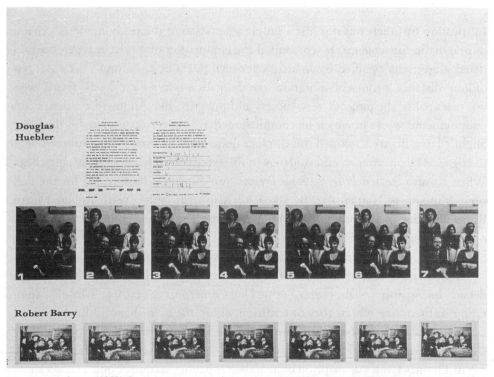

Lucy Lippard, *Groups* (1969). Pages in art magazine, from project sent to thirty artists. The twenty-two responses were exhibited at the School of Visual Arts Gallery (New York), 3–20 November 1969, and as *Groups, Studio International* 179, no. 920 (March 1970): 93–99.

the results at the School of Visual Arts Gallery (New York) on 3–20 November 1969, and in the pages of the March 1970 *Studio International*.[13] Her basic instruction to the artists was "A. Photograph a group of five or more people in the same place, and approximately the same positions in relation to each other, once a day for one week." The participants, her "cross-section" of the artistic community, included Lawrence Wiener, Jon Borofsky, the N.E. Thing Company, and Douglas Huebler. Lippard asserted that "[t]he photographs and texts here are not considered Art, except in the sense that they were executed by artists," which seems somewhat disingenuous, since she and the editors positioned them in the features section of an important art magazine.[14] Photographic documentation and printed text, in effect, were surrogates for art, gaining status in an intermediate zone by virtue of a quality shared with Kosuth's advertisements: In the context of a semi-ephemeral publication, text and photographs were, in Lippard's words, "undifferentiated, or low-energy, images."[15]

One of the central points about the new, post-studio art was its fabrication by others. Scott Burton, in the catalog for *Live in Your Head*, wrote:

> Carl Andre has used the term "post-studio artist" to describe himself and others who do not actually make their own art but have it fabricated. The phrase is equally applicable to artists like Serra and LeWitt, who make their own pieces though not always in their studios, as well as to Kosuth and Weiner, who may use typewriters and telephones, but eliminate the production of objects entirely.[16]

Fabrication by others was not just a simple adaptation of the ready-made as a matter of pragmatic convenience. It represented the elimination of a certain type of overinflated subjectivity signified by an artist's personal touch or signature. This was a type of long-distance artistic collaboration—or delegation—in which the assistants' work was essential to the project's very success and integrity, like Alighiero e Boetti's contemporaneous works in which he commissioned assistants to complete his drawings. Slightly later, Boetti developed this distance quite literally, employing a subcontractor to engage Afghani women embroiderers in the execution of his designs as tapestries.[17] When Kosuth created *Fifteen People Present their Favourite Book* (1968) for the fictitious Museum of Normal Art, he asked Ad Reinhardt, Sol LeWitt, Robert Morris, Robert Smithson, and others to participate, considering their collected responses as one of his own works. Seth Siegelaub's role as coordinator and publisher of artists' books also blurred the line between artist, publisher, and curator.

Whether this type of artistic work constitutes artistic collaboration is a matter of debate. In "Against Collaboration," critic Dan Cameron, for example, wrote: "Exploitation is, then, one subcategory or tradition within the quasi-historical mode of collaboration, and the one best eliminated from the discussion [of collaboration] early."[18] Cameron's view is incorrect, for this tradition of delegation is far from simple. According to Thomas Crow's description of neoclassical painter Jacques-Louis David's studio at the end of the eighteenth century, David designed his paintings and completed their initial blocking-in; his students executed key figures without correction, their

Joseph Kosuth, *Fifteen People Present Their Favourite Book* (detail) (1968). Museum of Normal Art, Lannis Gallery, New York. Ad Reinhardt's contribution is shown here.

disjunct signature styles constituting the famous painter's finish.[19] This process is more complex than simply using assistants. Like David, Kosuth and Boetti chose not to completely execute their works themselves. They sought the cooperation of others to enable their authorship to be camouflaged so that the immateriality of the work would be stressed. This type of collaboration was different from the conventional use of assistants. It was also different from the standard atelier system of previous centuries, in which many students assisted with an artist's production, often contributing specialist skills, but this work was ultimately corrected by the master's hand. Kosuth's or Boetti's preservation of an economic transaction between artist and subcontracted employee or newspaper, involving payment for labor or page space, was central, and the role of assistant was not itself revalued upward in order to create another artist. Manufacture at long distance according to instructions was a means of eliminating the individual artistic hand, rather than a result of technical requirements, convenience, or simple indifference to the handmade: Kosuth referred to his processes as "breaking out of the first frame" constituted by painting and sculpture and thus as rejecting out of hand Clement Greenberg's demands that art respect its media-specific boundaries.[20]

Breaking out of the frame implied more than a distancing from painting, which was Kosuth's and other artists' cipher for conventional artistic identity and production. In the early *Arts Magazine* interview (conducted by himself under the pseudonym of A. A. Rose), he commented:

The largest change has been in the realm of presentation—going from the mounted photostats to the purchase of spaces in newspapers and periodicals (with one work sometimes taking up as many as five or six spaces in that many publications)—depending on how many divisions exist in the category. This way the immateriality of the work is stressed and any possible connections to painting are severed.[21]

The work's immateriality was stressed and its connection with painting was diminished precisely through its placement in newspapers as advertisements. Newspapers are ephemeral and are thrown away by their readers; the advertisements were almost certainly unnoticed by most readers. An artist had succeeded in producing a work that was not art. Even so, it is important to remember not only that Kosuth preserved his identity as an exhibiting artist (the galleries exhibited the typed sheets, along with a list of other locations) but also that he experimented with the further dispersal of this identity, crediting various works to fictitious "foundations" and publishing statements in the form of interviews conducted under a pseudonym. In the 1972 *Documenta 5* catalog, under "positions held," Kosuth listed directorships of "The Museum of Normal Art" (in 1967), "Art Process Corporation" (in 1968), and "The Foundation for Non-Sensorial Activity" (in 1969).

The Melbourne *Truth* refused to accept Pollard's advertisement, asserting that there was something improper or even revolutionary about the simple words (perhaps they were code). The artist was aware that the possibilities of dialogue were complex and ambiguous, but the advertised works were distinguished by their emphatic contextual resonance—a quality Jessica Prinz has carefully and eloquently noted—perhaps even more than the artist expected.[22] At its different ephemeral appearances (rather than locations), the *Second Investigation* seems to have accommodated itself rather well to its incarnation as *Fifteen Locations* by a "framing" that was less specific, more idealized, more open-ended—as well as much more humorous—than the contemporaneous works of his other Art & Language peers, who often adapted the prevailing conceptual aesthetic with a consciousness of distance and geography. Kosuth single-mindedly but uncharacteristically allowed, whether he acknowledged it or not, an accommodation to circumstance: to framing contingencies such as the placement of tautologies next to titillating scandal. This accommodation and mutability would surface more clearly from the 1980s on in his archival installations, which took social and cultural debates as their historical materials rather than simply as content. Kosuth understood, unlike many younger, more overtly socially committed artists, that "content" could not be so simply and readily available.[23]

Fifteen Locations was a reaction against the unexpected recuperation of Kosuth's preceding dictionary works, which could be confused with panel paintings. He had decided to make collecting and aesthetically "appreciating" his works even more difficult.[24] The strategy worked: Other than the *Truth*'s self-censorship, there was virtually no Australian public or critical response to Kosuth's work at all. If interest in the conventional artistic author often stands in the way of viewing the work of art (except

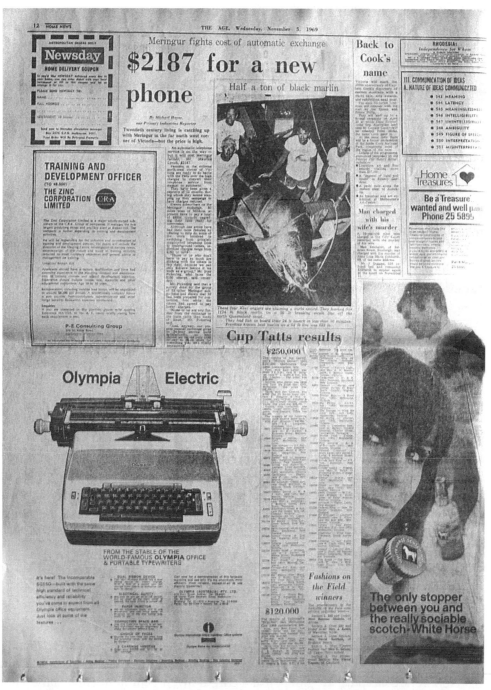

Joseph Kosuth, *III. Communication of Ideas* (1969), from the *Second Investigation*. Paid notice in newspaper, the *Age* (Melbourne), 5 November 1969 (page with headline "$2187 for a new phone"). From the exhibition project *Joseph Kosuth: Fifteen Locations 1969/70 (Art as Idea as Idea 1966–70)* (1969–70).

within the celebratory individualist terms appropriate for the smooth functioning of the market), then the artist's anonymity did result in his effective, intentional disappearance. Orthographic verification and connoisseurship were impossible and inappropriate for works placed in newspapers.

The contingency of *Fifteen Locations* stands in contrast to the immanent immediacy of the earlier dictionary definitions' existence as idea demonstrations. Except for their persistent, unwanted, but undeniably elegant aesthetic quality, the definitions are visually consumed in a mental instant. Their too all-at-once immanence links Kosuth's early definitions to minimal art. The withdrawal from real objects also presented him with a problem: Although each abstract proposition was transcendentally clear, it was also completely divorced from its political and social contexts. The propositions could not be easily given contexts—genealogical, intellectual, or social—without reverting to painterly complications. Victor Burgin encountered the same problem, and he moved during the same period from a hyperabstract moratorium on art objects to similarly psychoanalytic and sociological themes. The way out of tautology was to embed propositions and even artistic genealogies in social, nonartistic contexts.

The organization of genealogies was a real and pressing issue for artists, as Kosuth's late-1960s essays, Smithson's encyclopedic projects, and Art & Language's filing cabinets and art journals all attest.[25] It remains critically important to critics, curators, and artists involved with conceptual art, as the continuing debate prompted by Benjamin H. D. Buchloh's 1989 *L'art conceptuel* catalog essay attests.[26] Buchloh had isolated the trope of bureaucracy in an important, narrowly focused, but highly complex essay on early conceptual art, in which he accused the conceptual artists associated with the Art & Language circle, and particularly Kosuth, of a limited, sterile understanding of Duchamp and a restrictive, doctrinaire misapplication of Ludwig Wittgenstein to art. The essay attracted the furious, published ire of Kosuth and Siegelaub. The organization and status of genealogies already loomed large, and not just as a matter of pride and prestige: Increasingly, contemporary art was becoming more the memory of remarkable actions carried out by artists and less the sum of their autonomous works. Genealogies, therefore, became something more than an imprecise affinity evoked by poetic choice, for in an important way they were part of the works themselves. Thus, conceptual artists, not least Kosuth, claimed their essays occupied a zone between art and art criticism as "primary texts" that were intentionally and categorically distinct from the work of art critics and art historians. Paradoxically, Kosuth was publicly suspicious of the late 1960s and early 1970s vogue for concrete poetry, which he saw as a type of formalism, and he was also suspicious of poetic pretensions to saying the unsayable, though his later installations play with precisely this conceit to great and elegant effect. Further, Kosuth, like other members of the original New York conceptual art group, had a critical investment in intentionality. This desire to police the audience now seems both distant and odd, but those artists were determined to avoid "misinterpretation." Douglas Huebler was quoted as follows:

"What I say is part of the art work. I don't look to critics to say things about my work. I tell them what it's about."[27] Seth Siegelaub emphasized that his own role as the group's publisher was to facilitate the circulation of the artists' works "without the risk of spurious identities becoming attached to them."[28] There was no space in his mind for aleatoric improvisation, as there is for the musician interpreting a John Cage score.

There are theoretical models that consider how a shifting conception of genealogy and a rejection of previous artistic languages might be represented, but they all involve, to some extent, the abdication of authorial intention as the exclusive determinant of reading. They are, for example, frequently represented through the metaphors of archaeology and archives, whose appearance was automatically and uncritically taken to stand for history and which was equally automatically taken to be organized according to particular modes of fragmentation and narrative during the 1980s and 1990s.[29] Walter Benjamin used the closely related metaphor of ruins to explain allegory, drawing an analogy between the relationship of allegory to thought, and of ruins to the realm of things.[30] Kosuth's texts and, even more, his installations could perhaps be interpreted in this way; to do so, though, would link his work to particular literary and critical modes of postmodernism embodied in the art criticism of Buchloh, Owens, Krauss, Foster, and other members of the group of writers centered around the magazine *October*. This would be substantially incorrect. Confronted with a disbelief in self-expressive artistic systems, equipped with a determinedly ethnographic perspective, but determined to conserve his authorial authority, it was inevitable that Kosuth would attempt, beginning in the early 1970s, to alter quietly but completely the focus of his work, approaching the art-historical archive in a particularly historicist way, disorganizing as much as demystifying the archive of historical and modernist styles. The drive toward reorganization and historicization was already clear in Kosuth's important essays, also of 1969: the three installments of "Art after Philosophy," in the second of which Kosuth mapped out a genealogy for conceptual art.[31] Interestingly enough, given his distaste for poetry, he was willingly bracketed by curators such as Germano Celant with the *arte povera* artists, whom he counted as close friends.[32] This contradictory trajectory proceeded through his career to the 1995 exhibition at Yvon Lambert (Paris), where he constructed Alexander Calder–like mobiles from phrases from Gertrude Stein, Piet Mondrian, and Walter Benjamin.

His decision to work with written language, with texts, and with other artists' or authors' works as a "curator"—as opposed to his associates' more exclusive reliance on language as medium—was unusual and canny, even when contextualized within 1970s art generally. In *Fifteen Locations* he had uncannily blurred the division between the real and the imaginary—the artist said that "the idea was to put back into the world its own description"—but the work was not organized allegorically, nor, even more obviously, was this or any other of his works aligned with traditional notions of the heroic artist and his hermetic workplace.[33] The early works lived in the viewer's mind, but they were limited by their inability to offer a mental experience that could be intellectually sustained beyond the simple apprehension of a textual punch line.

Joseph Kosuth, *III. Communication of Ideas* (1969), from the *Second Investigation*. Paid notice in newspaper, *Newsday* (Melbourne), 5 November 1969 (page with headlines "Nixon's 'Soft Sell' Attacked" and "Hotel Welcomes Girl in Undies"). From the exhibition project *Joseph Kosuth: Fifteen Locations 1969/70 (Art as Idea as Idea 1966-70)* (1969–70).

A return to painterly metaphor or conventional spectatorship was impossible. The answer to this problem, again, was to offer the experience of reading, and so the *Second Investigation* appeared in a text-dominated medium—newspapers—and his subsequent works were almost exclusively text based. His later arrangements of other artists' works were archives organized like writing, conforming exactly to Foucault's definitions of an archival statement described earlier. Kosuth's works represented a nonallegorical organization of metaphor that was permeable: In his 1974 essay, "(Notes) On an 'Anthropologized' Art," he quoted another author, Mary Douglas, without full citation details, to the effect that systems "allow meaning to leak from one context to another along the formal similarities that they show."[34]

"(Notes) On an 'Anthropologized' Art" was written during a transition in Kosuth's thought, at a time when he was turning, under the impact of teachers such as Stanley Diamond, to the "soft sciences" and in particular to new methods within anthropology for a methodology of art practice. He had studied anthropology and visited the Trobriand Islands and then Australia in an early 1970s journey in which he recapitulated as a tourist the travels of earlier anthropologists. In Central Australia, near Alice Springs, a friend who spoke several Aboriginal languages took him out of town to meet traditional Aborigines living at one of the several missions in the far-flung area. Kosuth remembered nothing of his journey to Australia except the "profound" journey to Alice Springs, although he made contact with minimalist artist Robert Hunter (a friend of Carl Andre).[35] Kosuth's new ethnographic and anthropological enthusiasm was of course shared by many other 1960s artists—Robert Smithson in particular—as is attested by a quick perusal of books from the period such as Lucy Lippard's *Six Years* and Jack Burnham's *Great Western Salt Works*.[36] His open enthusiasm for these disciplines and the connections he made between anthropology and conceptual art must be contrasted with the closed systems of his earliest works.

Fifteen Locations represented, I think, a transitional moment in Kosuth's work. No matter how hard writers such as Gabriele Guercio have tried to represent this transition as orderly and consistent, there is a vast gulf between *One and Three Mirrors* (1965) and Kosuth's installations of the 1980s, and that gulf is only just bridged—and even then only with great difficulty and diffidence—by the ghostly, ephemeral public apparitions represented by the *Second Investigation*.[37] Kosuth frequently acknowledged the limitations of his early, antivisual model of conceptual art, and his frustration with those limits can be linked to the inability of the early works to contain internal relationships beyond the most elemental kind (division within a traditional triptych format, for example) without sliding back into a sort of "painting." The contextual "frame" of the *Second Investigation* in its public incarnation defeated painting, as did the architectural, dimensional contingency of Kosuth's later text-based installations and montages of other artists' works, as in the Brooklyn Museum installation *The Play of the Unmentionable* (1990).

From the late 1970s on, under the mnemonic influence of Sigmund Freud, whose working methods he clearly saw as archaeological, Kosuth began using mosaics of text,

producing visual metaphors for interdiscursive connectivity and allowing unscripted, unplanned juxtapositions and contingent relationships to emerge between text and its architectural ground. Kosuth also self-curated his own archive, both through the republication of his own writing and later through the production of particularly beautiful artist's books, for example *Joseph Kosuth: (Eine Grammatische Bemerkung) (A Grammatical Remark)* (1993) and *Two Oxford Reading Rooms* (1994).[38] The process, though, was not confined to such post-1975 works. The *Second Investigation*'s permeable "frames" and the artist's use of assistants to eliminate his hand had been more-literal examples of discursive connection or delegation—artistic collaboration of a particular type—in which the evidence of subcontracting was preserved rather than camouflaged.

To "break the frame" of art, Kosuth, like Burn and Ramsden, had to break the "frames" of both artistic work and artistic identity. The permeable "frame" and the delegation of work to others admitted the repressed and uncanny and therefore allowed a quality that Kosuth had affected to despise: poetry. Although Kosuth claimed to reject the element of poetry, and though his sternest critics, like Donald Kuspit, asserted that his work was devoid of precisely that quality, this should not divert the viewer from appreciating the triple function of text in his later work as icon, allegory, and decoration. All the elements in the complicated visual fields constituted by Kosuth's later text-covered walls and artist's books were quotations from well-known, canonical sources, just as the fields of dry dictionary definitions in the *Second Investigation* were undisguised appropriations from *Roget's Thesaurus*. He never sought

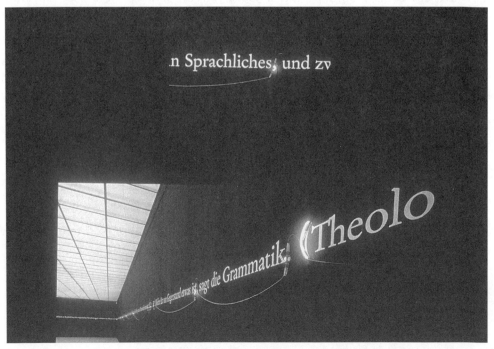

Joseph Kosuth, *A Grammatical Remark* (1993). Mixed media. Installation view, Württembergischer Kunstverein, Stuttgart.

permission for his appropriations, arguing that though the precise words had been written by someone else, their appearance was as a frame around "his" gap and that the intellectual and physical spaces between the quoted texts were his.[39]

In a well-known essay for *L'art conceptuel*, later published in *October*, that included what Kosuth saw as a sustained attack on his reputation, Benjamin Buchloh described conceptual art as a set of strategic positions formulated around the artistic exploration of language, noting that there was an eventual intersection of the exploration of language with the presentation of a sociopolitical critique.[40] He located the latter in the works of Hans Haacke and, less convincingly, Marcel Broodthaers. According to Buchloh, Kosuth's had only partly understood Duchamp, resulting in a misguided view of art as a linguistic proposition, focused on the same problems as certain philosophical books, juxtaposing formal reduction with a limited structuralist model of perception. Buchloh identified a second type of conceptual art in Dan Graham's and Robert Smithson's essayistic, discursive, multidisciplinary presentations: In these works, essays were presented as the work of art and reflected on paradigm changes in the social sciences.[41] Kosuth and the remaining members of Art & Language, although deeply hostile to each other, all resented the charge that their work was detached from any representation of contemporary social experience. Ian Burn, for example, insisted that the backdrop to his work on the *Information* (1970) exhibition at the Museum of Modern Art (New York) was a long summer of race riots broadcast continually on television in New York. Kosuth rejected the characterization of conceptual art in binary terms—social versus aesthetic—clearly preferring to focus on conceptual art's redefinition of artistic work and identity:

> Je m'efforce de ne jamais oublier que l'art est essentiellement un jeu de significations, et qu'en notre qualité d'artistes, nous devons encore et toujours poser des questions, chercher, et jouer. Pour cette raison je continue à réaliser des oeuvres de types très divers.
>
> [I try hard never to forget that art is essentially a game of signification, and that in our capacity as artists, we always endeavor to ask questions, to search, and to play. For that reason, I continue to make very different types of work.][42]

One can feel some sympathy for Kosuth's frustration at the critical attacks he received, for he had never seen the subject matter of art as being the same thing as its content, even though he had wished to police admission to the historical record pretty much from the start of the movement, distinguishing early on between conceptual art and conceptual style. His excessive rhetorical dislike of certain art critics and his feud with the 1980s members of Art & Language masked several points of agreement, most obviously on the interdiscursive affectiveness of text in the visual field and on a belief in the special status of "primary" texts as art, even when recast from literary or poetic sources. In the 1975 essay "The Artist as Anthropologist" and his later writings such as "No Exit," Kosuth spoke directly of "the artist as an anthropologist," and he seems to

have imagined that this identification had been established and was therefore evident in his later works.[43] His fierce overdetermination of artistic intention and polemic war with former colleagues and hostile critics such as Buchloh virtually ensured that he would be taken literally, triggering savage critiques of his work not only by Buchloh but also by Charles Harrison and other members of Art & Language, who questioned his prominent place in early conceptual art.

For many critics, Kosuth's anthropological contextualization (and in his 1980s installations, the quasi-allegorical dramatization of psychological and linguistic processes through textual juxtaposition with architectural choreography) appeared to be a simple-minded denial—even active repression—of the uncanniness of the works or texts that he appropriated, despite his protestations to the contrary.[44] In other words, his early works were determinedly antiretinal, privileging intellectual abstraction and the manipulation of concepts, refusing vision in favor of pure thought as an instrument of knowledge, and his later works appeared at first sight to continue this trajectory. But I think not. Kosuth's architectural installations, such as *The Fiftieth Anniversary of Sigmund Freud's Death* (Sigmund Freud Museum, Vienna) (1989), were, like *Fifteen Locations*, quite crucially incompletely contained by their "real" architectural edges (unlike Smithson's nonsites), which should have policed the borders between one domain (art) and another (notart). This quality had surfaced before: In the Melbourne appearances of *Second Investigation*, one text appeared beside a photograph of the then-premier of Victoria, Sir Henry Bolte, in proximity to an article about how this politician had been rendered voiceless. The coincidental juxtapositions of headlines—such as "Nixon's Silent Ones Speak," "Back to Cook's Name," and "Hotel Welcomes Girl in Undies"—with Kosuth's enigmatic texts gave the news a special, uncanny significance.

Kosuth's often-expressed interest in Freud was complicated. Freud is relevant to any consideration of jokes or archives, for he explains how meanings are lost and found. That is a continual preoccupation of everyone working with archives. The permeable, ephemeral newspaper "frames" of the *Second Investigation* and the uncannily blurred borders between text, decoration, and architecture in his later installations perhaps inadvertently escaped the antiretinal iconoclasm of the early works through two strategies: first, the interdiscursivity emphasized by Kosuth (which is, as John Welchman explains, intimately connected with theories of translation); second, the reformation of the author in his literary appropriations as well as in his use of others (which has been my chief focus here) to make his art. Text alternated as figure and ground, but it also worked as discourse in itself, for the denotative aspect of text in art is irresistible and almost irrepressible even when canceled out, as in *The Fiftieth Anniversary of Sigmund Freud's Death*. As Welchman observes, Kosuth was thus able to manipulate the text as if it were a speech act.[45] Chains of text—sentences, whole pages—and their implicit but definite discursive histories, whose recollection involves memory, were now the syntax through which propositions would appear to be articulated. This was all dependent on something ill-defined: memory.

Joseph Kosuth, *Zero & Not [The Fiftieth Anniversary of Sigmund Freud's Death]* (1989). Silkscreen on paper applied as wallpaper with colored tape. Installation view, Sigmund Freud Museum (Vienna).

The omnipresence of nonallegorical classification systems—of archival systems—in Kosuth's works is significant, for sorting systems (even systems involving cancellation) are connected with attempts to organize and interpret memory. As Terdiman observes, memory is "the most general form of determination," the place through which the past projects itself into the involuntary present.[46] As historian Mary Carruthers observes:

> Without the sorting structure, there is no invention, no inventory, no experience and therefore no knowledge—there is only a useless heap, what is sometimes called *silva*, the pathless "forest" of chaotic material. Memory without conscious design is like an uncatalogued library, a contradiction in terms. For memory is most like a library of texts, made accessible and useful through various consciously-applied heuristic schemes.[47]

Carruthers's observations can easily and usefully be extended by analogy to conceptual art, for they begin to explain Kosuth's drive to reorganize art through the grammar of philosophical systems, and then, having moved toward a model of the artist as archivist, his predilection for two particular models of the archive: a library and a list. And lists are at the heart of models of memory based on archival registration. This is the subject of later chapters; meanwhile, though, it is worth reemphasizing that at least in the opinion of Kosuth and his friends, the believability of other modes of recollection and principally that of allegory, whether in the long-discarded didactic schemes of Victorian painting or the more recent histrionic heroism of abstract

expressionism, had been wrecked. Kosuth's writings and mosaics of quotes reiterate this. The codes were simply no longer believable, and the question of what was believable, as Kosuth put it, was central to his and other artists' work. Believability was not possible within traditional artistic identities, especially those that generated the "authenticity" of an individual, personalized style. Kosuth identified this mock authenticity with painting, and Kosuth's dislike of painting has to be understood as a dislike of the conventional artistic "I."

I am not suggesting that Kosuth was seriously interested in collective authorship. His interest in artistic collaboration per se was very limited (his assistants were not credited as coauthors), and his delegation of work (with its accompanying distancing from individual subjectivity) was a subsidiary if important element within the late 1960s and early 1970s phase of his production. This was definitely not the case for his colleagues Ian Burn and Mel Ramsden, who invested enormous energy in their collaborations (and whose work is the subject of chapter 2). Kosuth's critical investment in intentionality aligns him with more traditional notions of artistic identity at the same time that the tensions within his work demanded, at a key moment in time, that he disperse authorial responsibility if he was to be able to really genealogically claim art-historical descent as Duchamp's heir. Nevertheless, his initially central role within the fractious Art & Language collective remained a determining experience within his oeuvre, central to his public accounts of conceptual art. This most difficult commodity—believability—would also be central, through the later 1970s, to the most extreme and eccentric modes of collaboration.

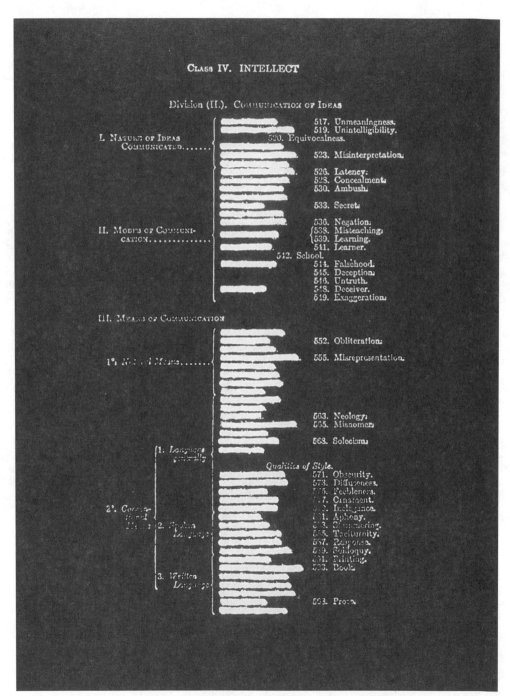

Ian Burn and Mel Ramsden, *Six Negatives* (detail) (1968–69). "Class IV, Intellect," page from artists' book. Lithograph, fourteen pages.

2. Conceptual Bureaucracy:
Ian Burn, Mel Ramsden, and Art & Language

The Great Modernist Machine Grinds to a Halt

During the late 1960s and early 1970s, a key group of conceptual artists worked within artistic collaborations that were the result of much more than a generational rejection of the conventional: The corporate nature of these collaborations was a definite response to specific artistic problems that had preoccupied the artists—Ian Burn, Mel Ramsden, Joseph Kosuth, and others—in their individual careers. Artistic collaboration seemed to be a solution to urgent problems connected with the intersection of artistic language and artistic identity. The artists' collaborative works must be discussed alongside their individual productions—and bureaucracy must not be seen as an epithet—for both were part of a considerable impatience with conventional artistic identities and enterprises. This chapter focuses on conceptualist Ian Burn, an important member of New York Art & Language, taking his early works and then his collaborations between 1966 and 1971 as a case study.

Impatience also had a context: From the late 1960s into the early 1970s, many artists worked with a widely noted sense of two related cultural crises. The first was the enormous crisis of confidence in modernism and its institutions in the late 1960s. Italian critic Germano Celant, a crucial figure in European art of the 1960s and 1970s, looked back in 1985 and noted that

> [t]he creative events of 1967–68 thus marked a historical watershed: the dogma of neutrality was rooted out, since there is no way of separating the object from the creative act, from the awareness of and participation in its reasons and technical input. Art is no longer a virginal nature.[1]

Celant theorized that after the failure of the 1968 student riots, exasperation with

unrealizable utopias made the 1970s schizophrenic. Artists with radical sympathies—many marched against the Vietnam War—naturally but uncritically identified the practice of art with an often inconsistent alternative culture, an identification based on a shared sense of being "outside the system." Many artists, confronted by the choice between a conception of the artist as a pseudobohemian professional aspiring to a one-way flight to New York and Marlborough Galleries and an image of the artist as a social critic and committed conscience, felt a profound if confused desire to move outside conventional forms of art into a different relationship with their audience. The few, however, who were actually prepared to move outside "the system" into the counterculture disappeared into the alternative milieus of inner-city community activism or rural hippie-commune politics, leaving little trace of their existence. The schizophrenia noted by Celant ensured that cultural criticism would be imaged as crisis, or else that it would simply disappear.

The second crisis, felt particularly keenly by many conceptual artists from 1970 through the mid-1970s, was a crisis of confidence in the transformative capacity of new art itself. According to Bruce Pollard, a pioneering gallery director and early champion of international conceptual art in Australia, "There are some periods that are absolutely crucial. The time around 1970–71 was crucial—a real moment of crisis—because of the disintegration. The great modernist machine had ground to a halt. Anything could have happened."[2] Pollard, like many other observers, also commented on an additional feeling noticed almost simultaneously at both center and the periphery: a sense of the exaggerated speed with which art's previous certainties seemed to unravel, a complicated process culminating in a type of artistic stalemate within conceptual art during the early 1970s.

The melodramatic character of the period—in North America, at exhibitions such as 555,087 (1969) in Seattle; in Europe, at events including *Sonsbeek '71* (1971) in Sonsbeek, Netherlands; in Australia, at *Sculpturescape* (1973), in Mildura—was definitely international, partly generational, and even frequently comic. These were important meeting places and showcases for conceptual art, for installations and for performances. By the early 1970s, a hostile generational gulf had opened. At the small-town edge of the Australian desert during *Sculpturescape*, groups of art students and younger artists, resplendent in embroidered shirts or peasant skirts, openly derided the heavy-metal enclave of older, welded-steel sculpture, labeling it "Karo Korner" in sarcastic allusion to a recent visitor, the then-celebrated doyen of formalism, British sculptor Anthony Caro. The same situation existed in Europe: West German critic Bazon Brock remembered that among the European young, there was to be "no cultural rubbish that had to be sent to museum dumping grounds. The museum itself was to become a department store, transit depot for groceries and articles of everyday use."[3] Adventurous young artists, in centers around the world, from New York to Vancouver to São Paulo, had moved far beyond late-modernist formalism by the start of the 1970s. Conceptual art was no longer the sole domain of its canonical, celebrated pioneers. It already competed for attention with a variety of other movements,

including left and Maoist groups calling for politicized, collective art that would not take the form of painting. Even though many of its "first" practitioners objected to the heterogeneous forms grouped then and later under the umbrella of "Conceptual art," the general term "conceptualism" usefully signifies a wide variety of styles and types of art, each of which rejected traditional definitions of the art object in favor of inquiries into the nature of art, artistic identity, and artistic work. Many conceptualisms and many independent variants of conceptual art were current by 1970.

The cultural moment was international, but the international and hybrid character of conceptual art has been insufficiently analyzed or acknowledged. The same is true for the historicization of avant-garde art generally, even though from the mid-1990s on, the conceptual movement began to be reassessed in exhibitions such as *Reconsidering the Object of Art, 1965–75* (1995, Museum of Contemporary Art, Los Angeles) and then, more thoroughly, in *Global Conceptualism: Points of Origin, 1950s–1980s* (1999, Queens Museum of Art, New York).[4] Curators Ann Goldstein and Anne Rorimer, for example, traced an extensive, year-by-year chronology of truly international events in locations as diverse as New York, Vancouver, Melbourne, and São Paulo for their revisionist Los Angeles exhibition.[5] Artists travel relatively frequently and easily now, if they so choose, but it is important to appreciate how new was the mobile, easily transported character of the first wave of conceptual art during the 1960s and early 1970s and its rapid global circulation, often by mail or in roving artists' and curators' suitcases. In retrospect, historians have come to understand that conceptual art was always an unstable category spanning a range of extremely diverse work, but they have been relatively slow to comprehend the sheer quality, quantity, and diversity of conceptual art produced outside New York without once again simply reinscribing the myth of originary creation elsewhere. Redressing this imbalance is one of the aims of this book—an aim, of course, shared by many critics—but a few writers at the time did chronicle the very different work made outside the standard conceptual/minimalist canon, including that created far away from New York.[6] Lucy Lippard's *Six Years* included not only Robert Morris, Eva Hesse, and Carl Andre (a catholic list in itself) but also politically committed, ritual-based, antiform, and performance art from California, Canada, Australia, and elsewhere.[7]

Phantom Discourse: Bill Indman, the Ghost Conceptualist

Art and Australia is Australia's oldest surviving art magazine. Reincarnated in 1963 as a resuscitation of the earlier, much-respected publication *Art in Australia*, the journal's editorial content has always faithfully reflected both its advertisers—commercial galleries exhibiting paintings—and its largely conservative readership, which is surprisingly substantial (the magazine is bought by virtually every public and school library in the country). At times, though, its editors wander onto the rougher side of the artistic street. At the end of the September 1970 issue, for example, the magazine published a dense article on difficult art: expatriate Ian Burn's "Conceptual Art as Art." According

to Burn, "It is the nature of this art that it replaces the customary visual art constructs with arguments about art, and this article will follow this pattern."[8] It did: The piece was an extended argument for the historical redundancy of painting, arguing that late-modernist painting was inevitably succeeded by its nemesis, minimalist art, which was in turn to be supplanted by conceptual art. "Conceptual Art as Art" was illustrated by austere black-and-white photographs of works that were almost exclusively composed of arrangements of text. Burn included examples of his own conceptual productions, including one of his collaborations with artist Mel Ramsden, *Text #3 from "Proceedings"* (1970). He sympathetically if pedantically described the production of a group of artists who were about to become the nucleus of the international art collective, Art & Language.

At the beginning of the same issue, the editors published a perplexing letter to the editor in which a certain Bill Indman launched a vitriolic attack on Patrick McCaughey, a well-known local critic and formalist spokesman who in the 1990s would become director of the Wadsworth Athenaeum. Responding to an article by McCaughey on a local formalist painter, Sydney Ball, Indman berated the young critic for his wholesale and in Indman's view sycophantic appropriation of Clement Greenberg's late-modernist formalism: "I consider the article to be mimicry. It presents a distorted view of what has been important to the art of the sixties and is, I believe, a covert attempt to hoodwink the public."[9] According to Indman, McCaughey had merely repeated U.S. critic Michael Fried's claims for post-painterly abstractionist Kenneth Noland, altering almost nothing except the artist's name. Indman mocked McCaughey's claims that painting "circles to the edge of the canvas" and that it constituted an artistic language of "radical self-criticism," a term that Indman felt certainly applied to Frank Stella's early work (presumably the black-striped paintings of 1958) but certainly did not apply to the derivative work of a second-generation eclectic like Ball.

McCaughey's critical position must be described: He understood cultural quality as an almost wholly First World affair whose homes were in great centers such as New York. Advanced art issued from these key centers—from the metropolis constituted by a network of museums, magazines, publishing houses, commercial galleries, and the other points of cultural accreditation and valuation. The relationship between the main center of Western culture, New York, and elsewhere was limited and fairly straightforward: The periphery occasionally provided "raw materials" (including works by regional artists) for theorization and evaluation. Many regional artists of the later 1960s hoped to be "picked up" in the way that Clement Greenberg had promoted the previously obscure Canadian painter Jack Bush. McCaughey saw himself, and he was seen by many Australian artists, as a gatekeeper, arbitrating reputations and mediating between Melbourne or Sydney and New York. Indman's letter seemed a confusing aberration to McCaughey, who was used to both reactionary populist antagonism and to the more sophisticated humanist distress at New York School abstraction. What was crucial and clearly perplexing to McCaughey in Indman's letter was the latter's assumption that international modernism was sick. Indman's argument was unusual:

Proceedings

The initial contention is that propositional ARGUMENTS or the "linguistic
form" of "as art" assertions have priority over material constituents (or
the "content") of those assertions. A central tenet of this and the pre-
vious Proceedings is to plan and specify procedures outside of material
application (cf. Proceedings: February, March, 1970).

To comprehend the move toward propositional arguments, it is useful to con-
sider the notion of stratification: the following notes trace some evident
examples of propositional "strata" which have contributed toward the move
from material constituents to propositional arguments of "as art".

Consider the following distinction:
(1) assertions in the material mode,
(2) assertions in the formal mode.
The contention is that (1) is factual and (2) is linguistic in format; that
within the art-province, assertions in the material mode are misleading
since these assertions, as arguments, are always functionally directed from
within the formal (ie. the linguistic) mode. As arguments, material con-
structs lack intrinsic "proof". As arguments for "as art" they are contin-
gent and a priori regulated from within the linguistic mode. A similar
and problematic distinction can perhaps be added: that between the basic
function of "as art" assertions and this assertion's contents or embell-
ishments. Function is posited as determined by (2), and it is here that
function is regulated as a "syntactical sentence". It is held that (1) is
irrelevant as a domain of significant arguments, and that (1) is parasitic
upon the more radical operations of (2).

If the customary propositional format, "object of art", is replaced by
"..... of art", then we may consider the "of art" to be a predicate or
second context and the "....." to be a subject. It follows, by the "de-
clarative" method, that anything can be declared the subject of an "as
art" predicate. Indeed, if anything is syntactically correct providing
it is placed within this customary linguistic collocation, and since we
seem stuck with this collocation, then we are compelled to accept the syn-
tax "..... of art" and therefore to construe our province of significant
assertions within the ".....".

Nominating the following "family" of terms assists in the planning of ar-
guments and may help to clarify the issue of stratification: these terms
are ... "what" "where" "when" and "why".

The specification of alternate sets of conditions will depend upon speci-
fication along the right level; hence the importance of language-strata.
Essentially this "right" level cannot be attained by asking any "what"
questions since these appear to be restricted to a material stratum. As
far as any revision of the syntactical position of the "....." is concerned,
the "what" is an inept manoeuver, and the same could be said of the "where"
and the "when". There are perceptible differences, of course, but it is
difficult to see any of these initiating major functional change. Such as-
sertions restrict innovative moves to spatio-temporal manoeuvers. With
some operative differences, all these remain within the material mode, which,
as we have postulated, cannot initiate functional change. The material
mode presupposes the support of formal conditions and only offers tactics
internal to the ".....". It offers no exit from the ".....".

Certain possibilities are advanced by shifting to the "why". This may
force one to move beyond the "....." constriction (and this at least is
setting off in the right direction). Such analysis will precede any new
planning or any specifying of alternate conditions. "What" constructs
have entailed a specific type of syntactical functioning for the ".....
of art". "Why" constructs may entail a type of theory, language or model
constructs and these are problematic, that is, at least as to the extent
of their completeness (cf. Proceedings: March, 1970). One may have to pro-
vide specifications and then specifications for those specifications, and
so on! At any rate nothing prevents the instituting of "alternate condi-
tions" through certain of the "why" constructs.

These notes establish the possibility of stratification interpretation as
central for the move toward propositional arguments as "as art". It is not
so much "where", "when" or "what" one says with the language, but "the
language" one uses to say it.

Ian Burn and Mel Ramsden, *Text #3 from "Proceedings"* (1970). Typed text, pages from Ian Burn,
"Conceptual Art as Art" (1970).

He was accusing McCaughey of not being sufficiently up-to-the-minute, especially when he mocked McCaughey's dislike of the more recent art of minimalism. In conclusion, Indman noted McCaughey's claim that the role of criticism had become "only slightly less important than the paintings themselves."[10] Why, Indman wondered, did not these critics just become artists? This question was to be taken up and inverted in Indman's own strange, hybrid career.

Patrick McCaughey's response to Indman's letter is a demonstration of why it is inadvisable for a working critic to reply to opprobrium, for his rejoinder is an index of confusion in response to assault from an unexpected quarter: from a reader who was clearly aware of the latest art news and arguments. Indman had outflanked McCaughey's cosmopolitan authority as the critic in command of the latest discourse from Manhattan. McCaughey replied from a direct presumption of formalist painting's aesthetic dominance, asserting therefore that "the interest, distinctiveness and quality of Syd Ball's painting lies in its acceptance of many of the disciplines of American post-painterly abstraction."[11] Arguing for the audience's recognition of his own expertise in this judgment, he asserted that "the so-called 'formalist' critique of these disciplines is the most penetrating and the most convincing available." McCaughey's analysis was bemused but clear: "If Mr Indman doesn't think that Michael Fried's long introductory essay to *Three American Painters* (Harvard University Press, 1965) is one of the central critical statements of the sixties, then we simply disagree on our priorities."[12] In his conclusion, he addressed the difficult questions raised by Indman regarding minimalist art, an art that claimed to have displaced formalist painting as the most advanced style. Implying that minimalism was a novelty, he reiterated his U.S. mentors' disapproval, asserting: "Likewise, I remain unmoved by the claims of Minimal Art."[13]

The most telling aspect of this exchange was the unexpected but, as shall be seen, recurring association of fiction, collaboration, and conceptual art. "Bill Indman" was, in fact, Ian Burn's friend and collaborator Mel Ramsden. He had written the letter under a pseudonym that was both an ironic play on the vernacular "It's so in, man!" (echoing the shrill phrase "get it!" peppered through the letter), and a near anagram of "Blind Man," which had been the title of the short-lived magazine published by Marcel Duchamp, Henri-Pierre Roché, and Beatrice Wood as part of a polemical campaign in 1917 for Duchamp/R. Mutt's *Fountain* (1917).[14] Burn and Ramsden planned Indman's timing carefully so that the letter would be mailed from New York to Burn's mother in the provincial Australian town of Geelong, mailed again to avoid suspicion, and published in the same magazine as Burn's article. Everything they did, as their friend Nigel Lendon recalled, was carefully premeditated and plotted, like waging war with a planned battle campaign.[15]

Two themes emerge: First, these artists were fascinated with conspiracy and were more than willing to hide behind hoaxes and pseudonyms. This fascination was shared by other conceptual artists, who also planned and premeditated their artistic work and their public interventions like chess games or battles. Second, they identified so

strongly with Duchamp, as is obvious from the near anagram "Bill Indman," that it is possible to say that they saw themselves, sitting at their typewriters in New York, as the French chess grand master's heirs. Conceptual art was the logical next step after Duchamp's hermetic, highly coded ready-mades. They set a trap for the provincial critic because his Greenbergian art criticism, Lendon recalled, relied unreflectively on its authoritative position as provincial gatekeeper. Burn and Ramsden set themselves to disrupt such relationships.

McCaughey's disagreement with Indman reflects an acute and widespread anxiety about self-definition in a regional culture. The avant-garde terms through which Indman asserted his awareness of the American formalist colonization of Australian art were themselves borrowed from the colonizer. Even as he attacked that hegemony, Indman reinforced it under another vanguard guise, excoriating McCaughey's formalist desire to see missing "consecrated forms"—implicitly, Western art's great canon of museum masterpieces—in contemporary art. Indman replaced one genealogical notion of artistic self-validation—comparison with masterpieces from the history of art and placement in the stream of a great tradition—with another: the disruptive avant-gardism of "serious," concept-driven new art, New York Conceptual art. Indman's praise was cryptic, but it was implicitly directed toward the enigmatic, virtually invisible work explained and illustrated in Ian Burn's accompanying article.[16]

But this was more than a regional matter. For all the apparent discontinuity and immateriality of their works, conceptual artists in general, and these artists in particular, were major players in a global movement, for that is what conceptual art effectively was. They were also clearly ambivalent and more than a little deceptive about the idea of an end of art. This ambivalent dualism (or, more literally, duplicity) was evident in Bill Indman's letter, which subtly asserted his alternative claim to centrality and to the possession of the modernist emperor's clothes. Within conceptual art and its emerging discourse, however, the signs of a different type of author/artist could be discerned "behind" the apparently meaningful walls of words and assemblages of Xeroxes—signs that appeared unexpectedly because conceptual artists needed to see the survival of art as a category.

Why? Obviously, the mainstream avant-gardisms of both McCaughey and Indman assumed they were able to arbitrate cultural importance. Both approaches were determinedly Darwinian, for they posited a crucial site or laboratory from which innovations spread. There are many other models of cultural innovation and transaction. The most intensely regional art may even deliberately conceal its difference from almost identical work made in the major metropolitan center. This is far from the evolutionary history of modernist and also postmodernist narratives, even those covertly constructed by sophisticated historians and theorists. Postcolonial perspectives such as those of Gayatri Chakravorty Spivak or Geeta Kapur, which were to become crucially important to art-critical discourse outside New York from the early 1990s on, suggested that the avant-garde mainstream was a culturally conditioned construction and that "border histories" of exchange, transaction, and difference were

at least as meaningful as and often more accurate than metanarratives of art and modernization, even at the "center." When translated to Australian, Indian, South American, Eastern European, and other "peripheral" contexts, as Geeta Kapur observed, modernist and postmodern avant-gardes were not necessarily driven by the same crises that drove contemporary culture in general, and conceptualism in particular, in Europe and America during the late 1960s and early 1970s.[17] Nor were those differences the result of failures of understanding or nerve. This was the second, more subtle reason for the artists' continuing investment in art: their insight that art was contingent—on location, on the identity of the author, and on the type of identity of the artist, whether collaborative or individual. It was by no means bounded by the horizon of representationally fixed signifiers. Although Ramsden/Indman would not necessarily have sympathized with this perspective, it was embodied in his and Burn's works.

The debate between Indman and McCaughey ended there in 1970, although many artists continued to make similar observations about the modernist machine's failure. The failure was traced exhaustively each month in many art journals, principally in the pages of *Artforum* and *Studio International* but also in new and often short-lived small art journals. Art criticism had an important instrumental role and, inverting this equation somewhat, art itself was an instrument for art critical awareness. This had two implications.

First, Ramsden/Indman, Burn, and their colleagues saw art in terms of arguments and propositions. As Burn said, "It is the nature of this art that it replaces the customary visual object constructs with arguments about 'art.'" To do this, it was necessary to denigrate the primacy of the visual (and to question its special link with knowledge) and in particular to critique the central role that painting had occupied in modernist discourse. Burn cited U.S. minimalist Don Judd's comment that painting was no longer able to claim a special privilege. It now had to be interesting as art. Burn therefore continued: "To confuse the appearance of painting with art is to mistake the identity of a class of things with art itself (which of course has no appearance)."[18]

Second, Ramsden/Indman and Burn, like Joseph Kosuth, were among the first artists to simultaneously take authorial and critical positions, generating both their own critical discourse and hybrid artistic identities. By carefully reading through Burn's cautious, pedantic prose, it is possible to identify the logic that led to the adoption of alternative forms of authorship. Burn insisted that artists must not abandon the critical role to critics, asserting that artworks could and should incorporate many levels of discourse and that the role specializations attendant upon participation in the "art industry" should not squeeze the artist out of potentially articulating his or her ideas in language:

> The critical role sustaining the function of Formalist art depends on the Formalist presenting the "experience" and the critics presenting the "ideas". Such artists appear

to have abandoned responsibility for their ideas in order to allow the critic to analyse (or interpret) the experiences provided by the art.[19]

Burn's dematerializing logic implied much more than the war over artistic turf enacted in Indman's letter and McCaughey's response. Both strands of this logic suggested that Burn (among many other artists and critics) was demanding not the mere succession of one style by another but something more complicated than regional pluralism. The proliferation of conceptual art incorporating regionalisms and subcultures (for remember, the term "Conceptual art" was being used in its wider sense) could be traced in such contemporaneous books as Lucy Lippard's *Six Years* and in the multiplicity of hybrid conceptual and postconceptual forms illustrated in art magazines of the period.[20] It was clear that many artists, especially those associated with U.S. minimalist art, were prepared to blur the divisions between different modes of artistic work and between criticism and practice. However, the demands this placed on art and on audiences were to produce a self-imposed crisis among conceptual artists.

Reflective Discourse: Ian Burn and Mel Ramsden

Conceptual art had been historicized by a phantom who had also been present at conceptual art's appearance. Here, we focus on the figures behind the phantom and on their early New York collaborations. Ian Burn's and Mel Ramsden's joint works acknowledge the contingency of both making and viewing by a "framing" that is more specific and less idealized than that of many of their New York peers, including Joseph Kosuth, for they developed the conceptual art aesthetic of administration with particular postcolonial malice. Stylistic distortion is usually attributed to the diffusion of influence and its resulting distortion over time and distance. The modifying impact of collaborative authorship on conceptualism has been largely ignored even though, as I show throughout this book, it is possible to see that distortion and morphological mimicry are intimately associated with artists' awareness of contingency and context. Conceptual art's apparently neutral, matter-of-fact texts, installations, and mirrors may, in fact, not always tell the truth.

Almost all evidence shows that the young conceptualists—and especially Ian Burn (who lived in London from 1964 to 1967 and then in New York between 1967 and 1977) and Mel Ramsden—were extremely well informed. They were aware of the international contexts framing their productions and those of others. In New York, Burn exhibited in *Conceptual Art and Conceptual Aspects* (1970, New York Cultural Center, cocurating with and advising Donald Karshan), and was included in Kynaston McShine's exhibition *Information* (1970, Museum of Modern Art, [New York]).[21] He worked collaboratively (Burn, Ramsden, and Roger Cutforth founded the Society for Theoretical Art and Analyses) and then collectively, as part of a much larger team, becoming one of the key New York members of the Art & Language group. Burn himself repeatedly returned to a particular framing context—value—and how it was

produced. This can be seen both in his art and in his equally important parallel vocation of art criticism. His collaborations with the center—in partnerships with artists and curators and in his own critical representations of contemporary art—were distinctly ambivalent. He argued in 1975 that truly radical art practice amounted to the dissolution of art, artists, and authorship, concluding, "What can you expect to challenge in the real world with 'color', 'edge', 'process', systems, modules, etc., as your arguments? Can you be more than a manipulated puppet if these are your 'professional' arguments?"[22] Like many other artists, Burn came to see the cultural periphery—whether Los Angeles, Australia, or Canada—rhetorically, as a distorting mirror of the center, New York.

Burn's works, like those of several other conceptual artists, explicitly and implicitly suggested that the presence of an autonomous subject had been abandoned in favor of a more heterogeneous conception of the author and a more diffuse notion of truth in which fact and fiction were interwoven. Even in his earlier, individually produced, minimalist paintings such as *Blue Reflex* (1966–67), the viewer became the subject quite literally, because the work's audience saw itself reflected in an aqueous, glossy blue surface. Burn's continual interest in exploring the edges of conventional models of authorship and spectatorship was typical of his later Art & Language work.

Burn's early collaborations, before his involvement with Art & Language, fell into two types: The first was his work with Mel Ramsden, in which the two artists eliminated the signs of their separate identities, subsuming their individual "hands" within a hybrid identity that was corporate, impersonal, and bureaucratic. Second, and more unusual, they co-opted other "authors," preserving the other authors' identities as a crucial aspect of the work. Such pieces—for example *Six Negatives* (1968–69)—represented a sort of unwilling dialogue.[23] Their collaborative practice was an example of Burn's stated aim to "participate in a dialogue," and in "Conceptual Art as Art," Burn alluded to several other collaborations among his colleagues, for example Terry Atkinson's and Michael Baldwin's conceptual maps. British-born Ramsden met Burn in 1963 in Australia, at Melbourne's National Gallery Art School, and according to Ramsden's 1992 recollections, they were very close friends, seeing each other every day in New York: "I collaborated on much of it [Burn's early work] and that which I did not collaborate on I talked about or knew about or was influenced by."[24] *Soft-Tape* (1966) was their first joint work.

Soft-Tape communicated its "content" in a deliberately inadequate fashion, reflecting the artists' simultaneous overcompensation for their peripheral status and their knowing reinscription of marginality. It was the work referred to in Burn's 1970 essay "Conceptual Art as Art" as "an exhibition consisting solely of information relayed through a hardly audible tape-recording."[25] In an interview with Hazel de Berg recorded the same year, he noted:

> During the time in London ... I worked quite closely with Mel Ramsden, in fact on one project we worked mutually on a work which was meant for Australia but it was

Ian Burn and Mel Ramsden, *Six Negatives* (1968–69). Installation view of work, taken in the artists' New York studio during 1969.

rejected. It was a self taped recording which was dealing with information on a level of bare audibility. That project never was accepted by the gallery we proposed it to. That was, I think, in 1966.[26]

Burn's and Ramsden's instructions detailed the installation of a tape recorder in an empty room. The machine was to continuously play and replay a text spoken in a low whisper; the tape would be either indecipherable or barely audible. *Soft-Tape* was "about" translation—the representation of recoding from a different context. As Ramsden noted, *Soft-Tape* incorporated a figure-ground relationship more typical of painting: The evanescent environment of faint sounds and environmental noise was the ground upon which the figures of viewers positioned themselves.[27] The viewer became a transitory figure and the work's subject, in both senses of the word "subject." Burn and Ramsden separately cited Allan Kaprow—the early exponent of Happenings—who had described the same relationship in an article titled "Impurity" that appeared in a 1963 issue of *Art News*.[28] *Soft-Tape* shared its contextualization of the subject with another collaborative project, Terry Atkinson's and Michael Baldwin's 1966 *Air Conditioning Show*, which was an exhibition where there was, according to Michael Baldwin, "nothing to see, nothing to do."[29] Translation was a key concept in conceptual art during this period, but *Soft-Tape* and *The Air Conditioning Show* all demonstrate that translation fails to deliver. They are all mordant, brooding works, playing on the viewer's inevitable frustration at the works' inability to inform or enlighten.

Ian Burn and Mel Ramsden, *Six Negatives* (1968–69). Artists' book. Lithograph, fourteen pages.

Given this, Burn's and Ramsden's repeated comments on the importance of communication and dialogue take on a more complicated complexion. *Soft-Tape* was first of all a discussion, and the sound track included the following sentence: "It occurred to us that it was no longer enough to have an object hanging on the wall; some way should also be found to make the ideas explicit."[30] A mountain of notes exceeding the taped text itself therefore accompanied the tape. *Soft-Tape* was sent to its planned exhibition as notes and instructions: "[W]e thought that to transport something 12,000 miles simply deprived it of 'context'—reified it in a misapprehension of its history—or historicity."[31] The association of context with deceptiveness is significant, for Ramsden and Baldwin later insisted that the implications of geographic location were less important than the logic of dematerialization. The same logic had been paramount in Bill Indman's letter. Burn retrospectively insisted that *Soft-Tape* was about a spatial "problem of translation," which was also true of his *Xerox Books* (1968) and *Mirror Pieces* (1967–68).[32] It is also possible that Baldwin and Ramsden were correct in resisting Burn's apparent postcolonial revisionism but mistaken in their straightforward avant-garde logic of dematerialization.

The artists' extensive notes confirm this reading: distance and translation were encoded in the work, but distance was not simply geographic. Instead, distance was encoded through the nature of *Soft-Tape*'s collaborative author: a hybrid construction constituted like a fiction from the mingled subjectivities of two separate artists working collaboratively. This is confirmed by a closer reading of *Soft-Tape*'s accompanying text, which insists on the importance of considering dimensions rather than distance. In this extended discussion on perception and consciousness, the artists assert that "[w]hat is particularly interesting to us is the way elements in this world group themselves according to their dimension."[33] Citing the early-twentieth-century mystic P. D. Ouspensky, G. I. Gurdjieff's leading disciple, on the link between space and consciousness, the two artists reinforced the connections among understanding, enlightenment, and transformation and its frustration. Gurdjieff had emphasized the necessity of group work in the attainment of personal mystical illumination. Burn and Ramsden apparently had little or no interest in mysticism. By 1997, Ramsden was unable to recall whether or why Ouspensky's name had appeared, but he admitted: "I think I was reading this stuff because Mondrian had read it."[34] As for the eclecticism and countercultural weirdness of the source, according to Ramsden, "[I]t's very important to remember that this was before the sleekness of cultural theory."[35]

Soft-Tape was created in an intellectual climate that included Buckminster Fuller, Marshall McLuhan, the Gothic structuralism of Jorge Luis Borges's short stories, and J. G. Ballard's science fiction. Robert Smithson's baroque, autodidactic scientism and encyclopedic imaging of entropy and exhaustion were, according to Ramsden, another important element in the creative milieu behind their collaborative project. The two artists were well aware of Smithson's essays in *Artforum* magazine through the 1960s, and in particular "Entropy and the New Monuments," which appeared in the June 1966 issue of *Artforum*.[36]

Ian Burn and Mel Ramsden, *Soft-Tape* (1966). Tape recorder and photostat, reconstructed for the Eighth Biennale of Sydney (1990).

I will return to the two artists' construction of author and language. For the moment, however, it is important to contextualize *Soft-Tape* within Burn's solo productions and to note that he inscribed the terms of distance and difference in both collaborative and solo works in two ways: as the avant-garde discourse of phenomenologically oriented conceptual art and, later, as a self-conscious, articulate postcolonialism. The problems of provincialism were linked in his mind to alternative authorial models, and his 1973 essay "Provincialism" is an instructive backdrop to the conceptual work, demonstrating as well his consciousness of his expatriate status in the New York art world.[37] In that essay, Burn teased out the idea that context is ideological and then asserted: "It is especially important, if obvious, not to assume that one's activity is neutral on ideological grounds. Accepted norms of behaviour may appear neutral simply because they are the accepted standards."[38] He expanded on this, outlining the ideological implications of cultural hegemony and the problems of a provincial artistic practice:

> What is the missing element in this situation? It is some sense of interplay between divergent contexts and concepts. But it's not merely being open to alternatives that is important, it is the strength of the interplay that counts and which in turn strengthens and develops the divergent contexts. Rejuvenation or the genesis of new ideas depends largely on what amounts to cultural cross-fertilization.[39]

This answer amounted both to a nascent critical regionalism and a recipe for his collaborations with Mel Ramsden.

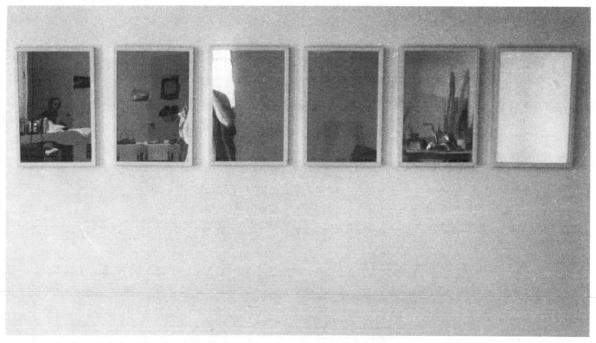

Ian Burn, *1–6 Glass/Mirror Piece* (1967). Glass, mirror, frame, in six units, each 16.5 inches × 12 inches.

Soft-Tape reproduced the shape and sound of misapprehension in a hermetic absence of shape, and such negation and elision of actual form had particular significance. Next, in his *1–6 Glass/Mirror Piece* (1967) and *Mirror Piece* (1967)—mirrors framed behind sheets of glass—Burn literalized the gaze of the metropolitan center like a deliberately overcalculated visual pun. In other *Mirror Pieces,* words appeared on the glass surfaces, constructing an additional layer of poetics, and these words both described the artwork and anticipated the response. Spelling out the conditions and outcomes of viewing was a constant in all Burn's works. The *Mirror Pieces,* like *Soft-Tape,* were planned and executed according to bureaucratic instructions, which Burn photocopied and then mailed to galleries. Extensive notes again accompanied these works, but now Burn intended that the accompanying notes, detailing how structure is derived from perception, be exhibited with the works. He mailed instructions, diagrams, and an essay to Australia in 1968 from New York, but *Two Glass/Mirror Piece* (1968) and *Four Glass/Mirror Piece* (1968) were exhibited without the notes. In his text, "Notes for Mirror Reflexes," he reinforced their status as the part of the work free from contingency:

> All diagrams are made after the work; they are literally invented, the fiction following a fact: the invention of methods-of-viewing as art. Diagrams serve to project away from factual/physical work into a context with multiple dimensions (aspects): it is not important even that the diagrams be correct, accurate or necessary, but only that they are conceivable.[40]

The notes and diagrams were, according to Burn, absolutely crucial. But they provided a discursive complication similar to that offered by collaboration, and Burn was clearly seeking to complicate Conceptual art. He was working as a picture-framer at the time, which explains his ready access to inexpensive supplies of mirrors, glass, and frames but not his sensitivity to the issues raised by the notes accompanying the *Mirror Pieces*—nor his active desire for obscurity and misrecognition, a desire far removed from the reductive quest for absolute communicative transparency putatively ascribed to Conceptual art. Burn's ingenuous 1970 explanation was that

> I initially started working again with materials such as glass and mirrors, because these seemed to offer to me the least amount of visibility, that I could make structures or in some way I could structure perception through using almost invisible materials. It was at this stage I first started making the mirror pieces which were exhibited in The Field, in 1968.[41]

Glass—a virtually invisible material that seemed to offer the least obstacle to the transmission and representation of information—was in Burn's eyes the most "transparent" substance that he could work with without attracting attention to his own interference with the image. Mirrors suggested the psychological and metaphoric elimination of traditional depth (the viewer looks at herself, not into the depicted space of the work of art), but the literal superimposition of the artist's words or the

discursive superimposition of diagrams and texts reestablished the space between author and reader. The opposite—the complete obliteration and disguise of the image—was represented by his colleague and collaborator Mel Ramsden's contemporaneous *Secret Painting* (1967–68), within which Burn discerned his friend's desire to "undermine the art's visual status."[42] The work was a diptych: the first part a blank, black monochrome painting; the second a photocopied text that read: "The content of this painting is invisible; the exact character and dimension of the content are to be kept permanently secret, known only to the artist." Ramsden's work represented an exercise of power in the form of the artist's ability to grant or refuse vision, whereas Burn was clearly interested in the difference between seeing and reading. Whereas "looking" was a relatively passive action, "seeing" signified finding and extracting sense and meaning, and "reading" represented unconstrained interpretation. In "Looking at Seeing and Reading," Burn's 1993 essay for his exhibition of the same name, there is an extended explanation of the understanding of mirrors that he had developed two decades before in "The Role of Language."[43] Noticing that he, like most people, saw the reflections in a mirror more readily than he saw the mirror's surface, Burn extended this meditation:

> To "see" (produce, project) the mirror surface demands concentrated effort, which may be assisted by focusing on imperfections, dust, smears, haze, steam (that is, by the mirror's inability or failure to be a perfect mirror). The extent to which we are able to see the mirror surface irrespective of these incidental factors depends on a self-consciousness of the possibilities of seeing: on being able to look at ourselves seeing, and on being able to interpret our not-seeing of the surface. The instability of perception is encoded within that critical faculty, indexed to the (density of) social and historical constructs underlying how we see, and to the discursive factors which produce our seeing and organize value.[44]

This long passage is quoted in full because it summarizes Burn's understanding of the critical possibilities of mimicry and reflection. Mirrors were the perfect conceptual art medium, for what they present is apparently neither a representation nor a picture of an Other. From a cosmopolitan modernist viewpoint, the great European and American art centers were places of light while the periphery was a site of darkness—the much-diminished reflection of the centers. Latin American art critic Nelly Richard, whom Burn acknowledged as an influence on his later critical development, suggested in a particularly acid essay that the dual metaphor of an original and its copy was an apt description of the center's colonization of cultures at the periphery, such as in Chile. Accordingly, the gaze of New York (and the gaze of both Indman and McCaughey) comprehended only what was generated by its own reflection. The periphery was the copy—the reflection—and its artists were involved in a mimetic reproduction of language that was subordinate in power and originality to that of the original, the center.[45] Burn's work, from the *Mirror Pieces* onward, materialized this gaze like a deliberately overinscribed, overcalculated visual pun.

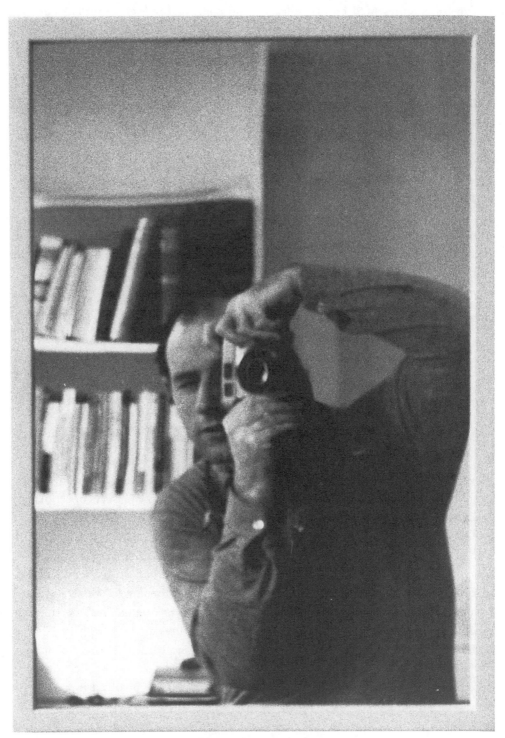

Ian Burn photographing a *Mirror Piece* in his New York studio, 1968.

The myopic dematerialization of the regional referent was also the subject of Burn's *Xerox Books* of 1968. In the late 1960s, midtown New York saw the appearance of many small printing bureaus, most of which offered xerographic printing on the newest machines, even though the relatively high cost per sheet prohibited the careless proliferation of copies that has since become normal. The new fetish of the Xerox led to Hilton Kramer's observation that "Xeroxphilia" was raging out of control. A New York artists' book, *July 1969* (titled by its date), contained Burn's *Xerox Piece* (1969).[46] According to the explanatory text, Burn copied and recopied a blank sheet of white paper on a Xerox 720 machine, and the hundredth copy faced this text, demonstrating a "pure" idea's movement toward entropy. Whether an idea is discerned or whether something—the original blank sheet—simply becomes more and more distorted is unanswered: As the copy becomes more distant from the original, new impurities appear. When the final copy is polluted by interference, the work becomes complete. There is considerable social and philosophical irony in this humble, paper-covered book, for its pages are barely marked, by a minimal language that only communicates accidental traces.

Four of the *Xerox Books* were exhibited in Melbourne at Pinacotheca during 1969, in a three-person exhibition that also included works by Mel Ramsden and Roger Cutforth. The box that arrived at Pinacotheca with their works inside also contained leaflets and literature from the New York-based collective the Art Workers' Coalition. The *Xerox Books* were displayed in an empty room on a table with chairs around the table, but Burn described how one critic insisted on reading the exhibition's table and chairs as part of the artwork.[47] Gallery director Pollard's reaction, though absolutely positive, was also colored by the sense of emptiness and absence that intrigued his Pinacotheca conceptualists and is a fair index of a sympathetic first encounter with conceptual art:

> When I first saw them [the *Xerox Books*] in the box I wondered why bother with an art gallery. When they were installed, the fact that they were in an art gallery intensified my reactions to them. . . . I would say that none of you are actually free from objects, but I would agree that the objects are merely clues to ideas. Ideas, however, may be the wrong word. An idea implies a concept with boundaries. Your work seems to sensitize me to non-physical factors like time, space, relationships.[48]

As Pollard's comments indicate, even though the initial phase of conceptual art represented by *Soft-Tape*, the *Mirror Pieces,* and the *Xerox Books* was supposed to represent a discussion about translation and distance (and even though Burn and Ramsden were relatively oblivious to other implications), their provincial audience was well aware of the poetic, nonpropositional, and unintended contingencies inevitable in conceptual art's approach to language.

So we arrive at a contradiction: Conceptual artists maintained their massive investment in intentionality, but increasingly they also exploited the connection between information and fictionalization. Ramsden noted that Burn regarded the diagrams "as

Xerox Piece.

A blank sheet of clean white paper was
copied in a Xerox 720 machine. This copy
was then used to make a second copy, the
second to make a third, the third to make
a fourth, and so on. Each copy as it
came out of the machine was re-used to
make the next: this was continued for one
hundred times, producing a work of one
hundred sheets. The machine was used
under normal conditions and was not
interfered with in any way.
The original work exists as the idea in
specification and/or the one hundred
sheets. No single sheet can comprise
the work. The sheet facing this is
a copy of the one hundredth sheet.

(2)

Ian Burn, *Xerox Piece* (1969). Pages in *July 1969,* artist's book (New York: Art Press, 1969).

Ian Burn, *Xerox Book #1* (1968). Artist's book. Collection Art Gallery of Western Australia, Perth.

fictionalizing or conceptualizing," not clarifying the meaning of the materials.[49] On the one hand they were approximations and reflections, testifying to the artists' skepticism about even their own works of art, as if conceptual artists were surprised that their works were actually exhibited even as, at the same time, they carefully stockpiled notes and photographs for future art historians, intensely and competitively aware of their dates and significance (Ramsden observed that "none of these works really had to be made").[50] On the other hand, the diagrams were supposed to be a guide to the works. A guide to what? The delegation of artistic work (the same process used by Kosuth to make *Fifteen Locations*) meant the artists' hands were in theory not necessary, for assistants were easily capable—if they followed instructions—of executing the final work. Burn's photocopied diagrams for his *Mirror Pieces,* however, were left out of the exhibition for which they were intended. *Soft-Tape* was not fabricated for another twenty-four years. The *Mirror Pieces* were doubly overwhelmed by context: They were invisible, and they were overshadowed by their own notes. Slippages and "mistakes" often appeared when an image was required; the tension between word and image persisted.

The word "fiction" is found several times in conceptual artists' statements. The fictionalization of art represented most obviously an emancipation from studio handiwork. About this time, Allan Kaprow wrote about the "unreal" artist, a concept that should supplement the now-overconventional image of the "death of the author."[51] The "artist" as such, Kaprow noted, was no longer a real entity, having eliminated most of the traditional characteristics of artistic authorship, including signature style, a studio-garret workplace, sole manufacture, and, most important, individual authorship.

This all led toward both an art of "imagineering"—a word invented by U.S. critic Richard Kostelanetz—and, in Benjamin Buchloh's pejorative but memorable phrase, to an "aesthetic of administration".[52] But what was the link between bureaucracy and fiction? The answer is that Burn and Ramsden wanted to turn the cultural authority of metropolitan discourse against itself through mimicry, and in particular through the construction of an impersonal, apparently neutral authorial voice that mimicked and then, because of the perfection of this mimicry, ingenuously attained the authority of cultural administration. Burn and Ramsden had reduced their work—their participation in the business of representation—to a few key decisions. "Work" was the operative word, as we shall see in the remainder of this chapter, for Burn and Ramsden would not quite designate their works as "art," preferring instead an intermediate imaginative zone of reflexive critique connoted by "work."

Written Discourse: The Society for Theoretical Art and Analyses

From 1969 onward, Burn saw himself as an artist who worked within multiple, overlapping collaborations. The first was the 1969 three-person (Ian Burn, Mel Ramsden,

and Roger Cutforth) Society for Theoretical Art and Analyses, which was his initiative. He continued working with Ramsden after Cutforth severed all connections with the two in February 1970.[53] Before we describe the society's works, however, I need to briefly map the collaboration into which the society was eventually subsumed to note the direction in which Burn's and Ramsden's work was headed. From 1969 Burn also worked with the Art & Language Press, which published the journal *Art-Language*. In the spring of 1970, he cocurated *Conceptual Art and Conceptual Aspects* at the New York Cultural Center. In 1971, he became a member of the Art & Language collective.

Art & Language was both a group of artists and an enterprise. According to Michael Baldwin, it was an entity that subsumed its members within a new artistic identity defined by activity. In other words, underneath Baldwin's often hermetic prose, Art & Language defined itself in fluid, contingent terms rather than as a collective with identifiable members working at a particular place and time. Art & Language had been formed in Coventry, England, in 1968 by Michael Baldwin, David Bainbridge, Terry Atkinson, and Harold Hurrell. Charles Harrison and Mel Ramsden joined in 1970; between 1968 and 1982, according to Art & Language, up to fifty people were associated with the group. Michael Baldwin said:

> We did not work as a group. This is complex and hard to describe. There was never a moment when you could deduce the cardinality of Art & Language from its ordinality. We sought, or perhaps I ought to blur the edges so that it would not be possible or necessary to decide who or what constituted the "membership" of Art & Language, not to be the authors of our work so much as agents in a practice that produced it.[54]

Ramsden felt that at this point the group best resembled a pragmatically organized editorial collective:

> We work with each other and sometimes with other people. This has the potential of being a place of production that does not exclude some sort of (perhaps negligible) social life....Writing and producing journals is quite often a collaborative activity. Making an exhibition and making an art object are also social activities. There was never much of a structure or scheme in Art & Language apart from the attempts, usually ludicrous, to formalize incomes.[55]

According to Harrison, who was associated with the group from its start as critic and theorist, collaborations between artists in Art & Language were based on trust and on agreement about first principles.[56] Relationships were not quite this simple: Cutforth, for example, became a dissident voice within the community of conceptual artists and had left the collaboration with Burn and Ramsden, the Society for Theoretical Art and Analyses, by February 1970. In 1971, he described a division of roles within Art & Language: Harrison, he said, had assumed the task of manager; disagreements were subsumed within a specific type of collaborative artistic identity, that

of the corporation.[57] A corporate identity did not necessarily entail refusing the privileges accruing from original authorship, for collectives, like individual artists, could and did insist on the ownership of ideas. There was, therefore, considerable competition among conceptual artists as to who was "first" at each stage of the dematerialization of the art object. Cutforth lamented the attempts of Art & Language (but not, intriguingly enough, Kosuth's attempts) to introduce later parts into earlier works and to backdate some pieces in order to establish historical primacy.[58] New York Art & Language itself fragmented after 1975, precisely because of disagreements about the underlying ideological principles of collaboration. Harrison insisted: "The very formation of Art & Language in 1968 could be seen as symptomatic of dissent from prevailing stereotypes of artistic personality and of the individual artistic career."[59] True to the character of the period, Art & Language wanted alternative models of being an artist, not simply alternative models of making art. At the conclusion of his 1970 article "Conceptual Art as Art," Burn criticized the latter approach as a mannerist impoverishment of conceptual art.

However, other conceptualist teams, including the Spanish group Equipo Crónica, were recognizing at exactly the same time that the roles of artist and activist were in conflict on every imaginable level. Thus, for example, in their allegorical painting *The Visit* (1969), Equipo Crónica painted the crypts of the Prado swallowing Pablo Picasso's famous antifascist, antiwar painting *Guernica* (1937); Picasso's painting is depicted as simultaneously emasculated, fragmented, and frozen in its attempt to struggle free of its canvas support. Art & Language sincerely believed, presumably, in a social dimension for art-as-argument, and its arguments were plausible, but the prose in 1970s issues of *Art-Language* was often more rhetorical than analytical. Its essays/artworks acknowledged the underlying obscurity of language but, nevertheless, somewhat inconsistently insisted on the ability of artistic language to present meaningful philosophical propositions. Terry Smith, who worked with Burn and Ramsden after his arrival in New York in 1972, saw the task of text-based art in less circuitous terms: He thought that it was imperative to "objectify" the conditions that made the production of meaningful art impossible.[60] A new phase of conceptual art developed in the mid-1970s as several artists, Burn included, gave up art altogether, while others directed their efforts more toward the description of cultural systems and less toward the conditions of "dimensional" possibility, with all its connotations of higher-order perception and enlightenment.

We have seen that Burn, in common with other members of the Art & Language group, was interested in meaning and context. This interest had blind spots, among which was the assumption, challenged even by his own works, that writing and typed text had no significance in themselves. In 1970, Burn insisted that "[t]he use of words itself is of no significance. What is important is the art information carried by the words. The presentation of art writing 'as art' does not mean that the form of the words is aesthetically significant."[61] The same year, he repeated to Hazel de Berg the claim that his works' texts were neither art nor criticism:

The use of text is simply to get over in the most direct way possible what we are talk-ing about, the problems that we're actually concerned with. There seems no need to build an intermediary object to convey what we are thinking, in fact that seems totally out of the question.... The actual text we work on is not being asserted as art at all, it is simply text.[62]

Burn was attempting in a somewhat overinsistent way to distinguish between a text-based zone between art and philosophy and Duchamp's ready-made. He was insisting on the transparency of typed words, which were taken to be identical with spoken lan-guage. This identification was dubious, relying on an acceptance of the distinction between visual art and information, on a lack of difference between writing and think-ing, and on an overanxious, artificial division between seeing and reading. Attempt-ing to police the borders between poetry and information and between seeing and reading, Burn insisted that conceptual texts were "not to be considered literature or aesthetics or criticism or any of the standard categories that one gets in the support or surrounds of the art environment."[63] He shared this belief in a text-driven, reader-free zone between art and art criticism with his then-colleague Kosuth. Even though the following answer is putatively that of Kosuth's friend, Douglas Huebler, the words were in fact written by Kosuth:

Q: How does the work enter "the mind" as you have put it?
HUEBLER: Through a system of documentation which includes the use of maps, drawings and descriptive language. The documents are not intended to be necessarily interesting, that is, they are not art.[64]

According to Kosuth/Huebler, text was simply the medium for the expression of thought. Early in the text work titled *Dialogue* (1969), Burn agreed: "1. Language and the product are separate and independent."[65] *Dialogue*'s final paragraph reads:

1. Language suggests, through the idea and viewer, a kind of dialogue or "conversation."

2. This creates an actual area of the work.

3. Participating in a dialogue gives the viewer a new significance; rather than listen-ing, he becomes involved in reproducing and inventing part of that dialogue.[66]

The presence of text in or as the artwork was supposed to disrupt art's auratic, spec-tacular "presence." Burn's logic was that words would never be totally diverted from their production of meaning into images, even though text's double role as icon and signifier had obsessed earlier artists such as proto–pop art painter Stuart Davis. According to conceptual artists, the presence of text or writing punctured the purely visual self-sufficiency of art.

Burn insisted on this "neutrality," aware that it was highly debatable. Accord-ing to him, conceptual art "expands the art ideas beyond the limits of visual object-making and in doing so repudiates all formal aesthetic considerations." Just as this

repudiation should properly have been called a proposition about art, so the form of this art was almost exclusively that of proposition. Burn illustrated his sweeping, global claims for language with a definition of what a proposition in visual art might be: his and Ramsden's bureaucratically titled *Text #3 from "Proceedings"* (1970), which had concluded, "These notes establish the possibility of stratification interpretation as central for the move towards propositional arguments as 'as art.'"[67]

Burn's and Ramsden's understanding of interpretation was semiotic—terms only had meanings in relation to one another—and they critiqued formalism from this semiotic perspective: "Our contention is that the reasons (whys) for the predication of art-work may be radically distinct from the properties of membership."[68] Artists' texts were an attempt to identify art with work through a valorization of the possibility of artwork as a "proposition-function." In another collaborative work—an artists' book titled *The Grammarian* (1970)—Burn and Ramsden enlarged on their homespun, obstinate semiotics. The book was a slim volume of photocopies containing the typed texts of twelve propositions about art. Its low-budget presentation was also extremely elegant: on the cover, the title in a minimal serif type; inside, the propositions in a simple sans serif type; on the last page, the artists' names and the date, but no other publishing details. In this work, Burn and Ramsden acknowledged their indebtedness to minimalist art but emphasized in the eighth proposition a particularly unminimalist sentiment: "The separation of an art-work's function from its structure has so far been a central tenet of Conceptual art."[69]

Burn and Ramsden's early text works presupposed, then, the identification of dialogue-as-function (both between artists, in collaborations, and between artist and audience) with statements self-consciously proposing themselves—or, more accurately, advertising themselves—as lucid and logical. *The Grammarian* was an extended argument for these new propositional and conversational premises.[70] According to Burn and Ramsden, the book reflected on the possibility of changes in the status of artworks and spectatorship. *The Grammarian* concluded:

> To inquire into the premisses of "why an art-work is an art-work" one's methodology must first be made straight. This paper has initiated one type of inquiry in that, in continuing to use the term "art-work," we may have to provide a theoretical account of the rules for its use. It has reflected upon certain problematic features in the art-work's operation—viz. in maintaining that this present text counts as an art-work.[71]

For all its impersonality, this text demonstrates an awkward internal complexity and awareness of its own contradictions that can be opposed to the relative sleekness of Kosuth's *Investigations*. Burn and Ramsden, like Kosuth, produced syllogisms and tested premises, but compared with Kosuth's texts, their investigations were extremely circuitous. Whereas Kosuth was interested in the epistemological status of his works, Burn and Ramsden were interested in discursive placement. The quality of the philosophy behind the collaborative texts reflected to a large extent an eclectic hybridity

(1)　　　　It is too often blandly supposed that art-work will go on developing through changing the material or denoted subjects of its propositions while resting on a mandatory and functionally 'given' framework. This entails that the formal aspects of the propositional function persist, while the properties of the propositional subject become more and more diverse. The argument here advanced is that the meta-structure of this proposition, its operation or its modality, is able to be transformed or, more simply, that specific propositions can be replaced by formative rules which lay down modes of operation.

The contention is that the formative premisses through which an art-work can occur are of greater consequence than the effect of such premisses (e.g., art-work may not need to be a denoted physicality and may be a study of the premisses governing this denotation). It is certain that the kind of methodology which needs to be instigated in order to examine such a contention will entail shifting the general functional area of art-work into talking *about* the formation of premisses rather than just operating *upon* such premisses; — in other words, examining *the language* without projecting physicalities *through* the language.

If the above entails an inquiry into the nature of our art-work, it also entails some re-thinking about the function of conceptual inquiry with respect to art-work in general vis a vis the manner in which this art-work may be stated to be art-work.

Ian Burn and Mel Ramsden, *The Grammarian* (1970). Page from artists' book. Proposition #1.

The conditions governing non-propositional constructs may turn out to be the bid for membership (i.e., synonymity). Our contention is that the reasons (why's) for the predication of art-work may be radically distinct from the properties of membership (what's); — that while members are structurals in the material mode, art-work may be stated in the propositional mode. Furthermore, questioning why this proposition functions as it does is not the same as questioning what can constitute an art-work, in other words *what* can constitute an art-work and *why* this art-work is an art-work are questions of radically distinct intent.

Without trying to put forward quick or comprehensive retorts, we do hold it tenable that there is a distinct incompatibility between the evincing of art-work which is alike in function and the evincing of those which may be said to *be* functionals. Conventional art-work has been more concerned with the ramifications of morphological likeness than in determining the kind of relationship these constructs may have with the predicate art-work simply because of the persistent constriction of these constructs to first order physicalities. Such constructs *cannot* be a factor within the proposition.

To re-state: there's a break between the application and the stating of art-work which corresponds to the break between non-propositional and propositional constructs. The stating of art-work demands an account of the whole proposition, i.e., 'this is an X', without merely zeroing in on the components of that proposition, i.e., 'X'. This is by way of maintaining that art-work is an art-work due to its collocation within that proposition — and Conceptual art may fall within the sphere of indicating such collocations.

To inquire into the premisses of 'why an art-work is an art-work' one's methodology must first be made straight. This paper has initiated one type of inquiry in that, in continuing to use the term 'art-work', we may have to provide a theoretical account of the rules for its use. It has reflected upon certain problematic features in the art-work's operation — viz. in maintaining that this present text counts as an art-work.

IAN BURN–MEL RAMSDEN. 1970.

Ian Burn and Mel Ramsden, *The Grammarian* (1970). Page from artists' book. Proposition #12. ("one's methodology must first be made straight").

that drew upon the logical insights and terminology of professional semantics and analytic language theory, as did Joseph Kosuth's works of the same period. Burn, Ramsden, and Art & Language were undertaking a kind of structuralist dismantling of subject positions within art, and thus their analyses were often accompanied by the forms of symbolic logic or by notations that mimicked its structures. Sometimes this use was ironic, but at other times it was a pastiche that concealed a real lack of philosophic rigor. As Pinacotheca director Pollard recalled: "On another occasion, I sat down and spent a whole day with Mel and Ian's texts, and analyzed them with the logic that I had studied at university. They didn't make sense. When I told this to Mel he laughed and said that you weren't meant to read them so closely; you were meant to skim-read the texts."[72] Many observers were aware of this shortcoming. For example, during the discussions and seminars that doubled as artworks in themselves, organized by Art & Language and coinciding with the Museum of Modern Art's *Modern Masters* exhibition tour of Australian state galleries in 1975, guests consistently and pointedly described the shortcomings of art as discursive propositions. Art & Language members themselves understood that they had fetishized extremely bureaucratic methods in their reaction against self-expressive individual artistic identities, and they acknowledged that this had resulted in a corporate professionalism at odds with their ideals of freewheeling, discursive intervention. When Baldwin, Harrison, and Ramsden reassessed the period in 1997 for Art & Language's occasionally published official journal, *Art-Language*, they wrote:

> There was the lurking difficulty of Concept Art's potential to be an executive and administrative form. I mean the opportunity for it (somehow) to consolidate an historically ratified ultra-professional superiority over other forms of art which had been written off as hopelessly craft-based nostalgia. Here was the possibility of redefining the artist as cultural manipulator. . . . In 1975, one thing was for sure: the apparently second-order text work had long lost its ability to be aggressive and rude in its insistence on first-order status.[73]

There were, however, exceptions to this propositional paradigm within conceptual art long before this, including the 1969 index-based works by Burn's and Ramsden's collaborator, Roger Cutforth.[74] Cutforth, of course, violently disagreed with Burn's and Ramsden's claims for language's neutrality, asserting in 1971 that "[i]t just strikes me that language is not neutral, and that certain types of language support certain types of thinking."[75] His dislike of their "restricted idea of art" hinged on understanding the relative—as opposed to the absolute—status of art as both "fiction" and "reality":

> The whole issue seemed to me to come down to choosing between "art" (a fiction constructed from and referring to certain historic guidelines—this formulation, it might be pointed out, is in most cases arbitrary, being based on personal choice and preference—although they pertain to a quasi-determinism: i.e. that because of this, there was this, etc.) or experience (non-fictional references dealing with our

experience of the world). I disagree with them that "art" is so restricted an idea in application.... I no longer see the issue therefore as the dichotomy of "art" or "experience," but as the dichotomy of "art"/non-"art"—which is implicit in all art-work.[76]

Cutforth had come to see that Burn and Ramsden, and later the Art & Language collective, had overemphasized "the efficacy of language in being able to deal with certain problems and the possible solutions." He no longer shared either their simple-minded confidence in the explanatory power of language or their belief that they could intentionally separate the intertwined strands of fiction and nonfiction in an artwork. Burn's and Ramsden's annotations and emphatic assertions try to ward off something inevitable: the unconstrained interpretation that undermines their belief in the transparency of language and the congruence of signs with their signified referents. Burn later wrote: "The strategy, I think, was to create awareness of the 'talking-about' part by forcing awareness of its inaccessibility."[77]

Why, then, were Burn and Ramsden, like Kosuth, such great self-publishers? The reason was both unusual and perverse: These artists were all using writing as a foil, just as Burn, in his individually created works, had used glass as a barrier because of its contradictory double nature— its invisibility and opacity. The precursors for this transparent opacity are unlikely, but they are hinted at elsewhere: Raymond Roussel's novels, Georges Bataille's surrealism, and Robert Smithson's diaristic meditations.[78] Burn and Ramsden, like Smithson and Kosuth, particularly thought of themselves as influenced by phenomenology and particularly by Wittgenstein's understanding of the fluidity of language usage and the arbitrariness of fixed disciplinary boundaries.[79] Just as Smithson had been empowered by Wittgenstein's blurring of critical and poetic discourse, so Smithson's insight that truth was always contaminated by poetry was echoed in Burn's work. Smithson's sentence "Look at any word long enough and you will see it open up into a series of faults into a terrain of particles each containing its own void" aptly describes Burn's *Xerox Books*.[80] The perfect ordinariness of text enabled the artists to talk about art and assertions about art. In order for such words not to disappear into the void of real-life conversation, Burn and Ramsden positioned the figure of the artist in their works in such a way that the question of authorial status itself was foregrounded: They disavowed art and reinforced their disavowal by rejecting conventional authorship and publicly replacing it with the hybrid figure of bureaucratic collaboration. At the same time, though, they depended on art as a particular type of public discourse that keeps the work from disappearing. As Kaprow had indicated, "others must be made aware of the artist's disavowal of authorship if its meaning is not to be lost. It is just this which has been the dramatic lesson of the 'inactivity' of Marcel Duchamp."[81] Burn was aware of the significance of this choice:

We neither of us are producing individual work; the work we are producing is mutual and is totally a consideration of art problems using text. This way of working, in which text only is used, is a very radical attitude, it involves an attitude very very

different from what has gone on before, in fact I'd go so far as to say that, though what might be considered the art in each case is different... The bigger difference is probably in the artist, [as] if the artist has needed to change.[82]

He was aware that collaboration implied not just the production of joint work but a different model of artistic identity. This different model had an almost militaristic character, as one Art & Language cofounder, the English artist Michael Baldwin, emphasized in his summation of Burn's and Ramsden's early work:

> Collaboration ... was not a kind of working-togetherism. It was a matter of destroying the silence of beholding with talk and with puzzles, and a forcing any and every piece of artistic 'work' out of its need for incorrigibility and into the form of an essay.[83]

Antivisual, second-order art was linked to experiments with collaboration. The common feature of each was the displacement of stable, autonomous subjects and authors Charles Harrison wrote: "A conventional concept of the individual artist as author serves to determine the expectations of viewers as readers."[84] The displacement of a stable spectatorship based on the artist's ideological but comforting patronage of the viewer was accompanied by a surprisingly melodramatic language of ruin and terror, as well as by "ultra-professional superiority," as Baldwin remembered: "I also thought that a sort of terror, a suppressive action, had to be mounted against the fetishes or talismans of Modernist power."[85] Harrison also repeatedly used a vocabulary of war to describe Art & Language's project, referring retrospectively to conceptual tropes of terror, insurgency, and violence in late 1960s Art & Language work: "In the face of the regulative effects of the beholder's discourse, Art & Language's attempt to carry artistic practice into the territory of language was a form of insurgency."[86] Writing about his work with Burn, Ramsden emphasized that the early Art & Language experience was an "epistemological inquisition," noting their collaborative preference for "community" over "authenticity."[87] Ramsden implicitly opposed fiction and community against the entropic stability represented by authenticity and a solo artistic career, referring approvingly to Burn's handmade conceptual art as the opposite of the slick conceptualism of their one-time colleague Kosuth.[88] The quasi anonymity granted by collaboration was crucial to the artists' guerrilla polemic as well to their "ultra-professional superiority."

The Society for Theoretical Art and Analyses had articulated the collapse of conventionalized identities in art. Understanding the nature of this collapse is crucial. Establishing its connection with artistic collaboration has been the aim of this chapter. Although the conceptual artists' landscape was one of images of failure and ruin, the substitution of written language for images in art coincided not only with the initial emergence of what would become postmodern notions of textuality but also with nuanced articulations of alternative authorial identities, coded into art that preferred to be designated as "work." Just as Smithson's encyclopedic inclusiveness had

transformed the field of images into a field of textuality, so Burn's and Ramsden's collaborative texts both productively and inadvertently conflated reading with seeing. Burn and Ramsden, like Smithson, looked to Wittgenstein to help them imagine and script a series of conceptualizations able to describe an active gaze that would resemble neither finding nor reading. Their early works oscillate, as the preceding pages show, between rhetorical myopia and a rich, literary conception of the artist as a site of communal play and instability. Their works had contradictory trajectories: on the one hand an orientation toward the unconstrained textuality of Borges and Smithson; on the other, toward a neo-avant-garde conceptual intentionality. Burn's evolving conception of "seeing" was shaped by complicated hybrid authorial constructions that involved artistic collaboration and the adoption of corporate, conspiratorial, militaristic artistic identities. Conceptual art should be examined far more suspiciously than it has been: Paying attention to its deconstructive intention ignores its deliberate mystification and ignores the dissociations deliberately provoked by artistic collaboration and bureaucratically modeled impersonality. Over time, conceptual artists (not least Kosuth and Burn) shifted both theoretical ground and identities to accommodate this. Conceptual art—as it developed from Burn's solo works, through his work with Ramsden, and then into his participation within Art & Language—was reluctantly predicated on the disintegration of authorial stability, and this presaged more extreme experiments with artistic identity in the remainder of the 1970s.

PART II
COLLABORATION, ANONYMITY, AND PARTNERSHIP

3. Memory, Ruins, and Archives: Boyle Family

Collecting the World: The Intersection of Memory and Self

The first two chapters of this book traced a double narrative in conceptual art: The first was a narrative of a crisis—a loss of confidence that art, especially art that did not employ words or propositions, could be a means of understanding, transforming, and interpreting the world. The corollary was successive attempts to privilege the word in visual art through identifications of art with provisionally presented, systematically organized information. The second narrative was of the unexpected but direct relationship that evolved between this crisis and a parallel development: the decisions of some artists to work collaboratively.

This chapter and chapters 4 and 5 explore the next phase of art—that which develops from the innovations of conceptualist and minimalist art. They isolate subsequent systems-oriented attempts around 1970 by three artist teams in Europe and North America to excavate and memorialize something apparently lost: shared memory in visual form. These chapters contend that since memory plays such a crucial determining role in the construction of power and the social adjudication of responsibility and since memory had been so problematized in the process of modernity (and almost entirely negated in the tropes of late-modernist art), then two domains of activity that both exemplify and demand continual processes of negotiation—archaeology and the family unit—would be called on to stabilize and systematize the representation of memory's link to self within the context of a crisis of representation. This was the three teams' gamble with art history, but did they succeed, or did they simply add an auratic veneer to conceptualist method? The intersection of memory and self—both terms of enormous concern to artists at the end of the 1960s—was almost inevitably going to occur in and through artistic teams. The link between an

expanded field of art (especially as it relied on processing information into image and text) and expanded ideas of artistic identity becomes evident from the 1970s on in the tension between word and image. Earlier conceptualist works—and obviously that of the New York conceptual art of chapters 1 and 2—were "about" ideas and were largely phrased in words because images, let alone aesthetic organization, were redundant. The works in chapters 3, 4, and 5, though, presume the power of images. They organize images into systems and yet strain against reducing these same images to their significations. In other words, they struggle against the allegorical readings that they seem to encourage and argue against reading images and words simply through ideological constructions. This is the real subject of these chapters.

Boyle Family, Anne and Patrick Poirier, and Helen Mayer Harrison and Newton Harrison faced the particular problem posed by a difficult 1960s artistic legacy: the combination of a loss of confidence in the visual and a desire to evolve a nonmaterial and nonmaterialistic art that would make complex sense, describing or representing memory rather than an idea. This posed a problem: What would be the reference points for both word- and image-based art that wished to do more than state the tautologically obvious or reify old identifications and artistic formulas?

The three teams separately constructed iconic and textual memorials from nonvisual systems, each based on separate theories of memory but also on a shared belief that it was possible to recover and reinstate the affective power of images. Their collaborations were of a particular type: Marriage and working partnership coincided; the collaboration was expanded when or if a couple's children wished to join the team.[1] Another type of long-term collaboration—that between an artist and a devoted group of assistants—could conceivably be considered in the same company, but such collaborations should be differentiated from the type of teams discussed here, for in these collaborations the artist usually retains sole credit as author.

The three teams worked with similar methodologies, creating architectural, archaeological, and ethnographic descriptions of the loss of what could be loosely termed shared cultural memory, which was clearly taken by the artists as a key condition for the maintenance, re-creation, and renovation of social organization.[2] Such methods in themselves were not atypical of the period. On the one hand, the artists' early ideas reflected particularly strong countercultural influences that were themselves conducive to collective or group creation: Boyle Family was deeply involved in the late 1960s London counterculture and in the psychedelic rock music scene; the Poiriers were decisively influenced by the example of rock musicians and their own Hippie Trail travels; the Harrisons were profoundly affected by the late 1960s peace movement, California consciousness-raising groups, and, in particular, the meditation-oriented Esalen Institute and contact with the Esalen psychotherapist Fritz Perls.[3] On the other hand, the teams' works variously bore signs of the influence of previous dematerializations of art, specifically early Happenings, French *nouveau réalisme* (particularly Yves Klein's actions), minimalist art, and conceptualist art. To appreciate the context of their works, it is also helpful to remember the *arte povera* variant of the

latter two movements: Guilio Paolini and Jannis Kounellis, for instance, both emphasized a quasi-filmic experience of installation in which the setting itself—the ground—was foregrounded, as opposed to the U.S. minimalist and conceptualist invocation of the aesthetic frame. Rather than transcribing propositions, *arte povera* artists staged the work of natural processes—decay, gravity, ruin—as a play of artifice directed by a choreographer/scenographer, as opposed to the creation of systems-based installations through dialectical or conceptual processes. Installations combining two- and three-dimensional forms and found, "poor" objects in constructed, often messy, but dramatically lit environments had become a major European phenomenon by the beginning of the 1970s, even though they were difficult to collect and display.

The decision of the Poiriers, Boyles, and Harrisons to work exclusively within their chosen long-term collaboration, as opposed to the short- to medium-term, project-based collaborations of other artists, was unusual, even when contextualized within the general atmosphere of pluralism and collectivism in 1970s art. They were linked by something else as well: Their work represented a reaction against the perceived predatory encroachment of nation-states and against the late-capitalist consumer and corporate culture that had become so problematic to artists involved with the counterculture and alternative political radicalism during the 1960s. However, these artists, unlike their peers, saw themselves as conservators and conservationists, and they ennobled obscurity to the level of a conservatizing strategy even though they saw themselves as radical artists, an apparent contradiction that was shared far more widely than just among these collaborations.

This obscurity requires definition: It often, for example, both induces and is characterized by amnesia and uncertainty. In the adoption of the tropes of ethnographic and archaeological research methodology, these artists fetishized a dysfunction associated with deficient information retrieval (obscurity), consciously deploying it as an aesthetic rather than a heuristic warning signal. Such an aesthetic—it can be seen and analyzed as style—marks these artists as belonging to, and perhaps as bounded by, a 1970s sensibility and taste that remains to be properly mapped but that was also accompanied by archaeological reconstructions within art history at the time, as feminist art historians such as Linda Nochlin and artists including Judy Chicago excavated art history for women antecedents. The artist collaborations attempted in different ways to memorialize and sublimate the limitations of an anthropological aesthetic, without ever abandoning an essentially poetic conception of artistic language as obscure but also without, they hoped, constructing a "soft" model of memory out of nostalgia. Like other artists, they reformulated artistic work as fieldwork to be undertaken outside the studio and therefore outside the conventional locus of artistic identity.

All three artist teams produced works that visually resembled the aftermath of a violent, mystical, and Manichaean war between light and darkness. Ruins, catastrophe, and melodramatic contrasts of light and dark recur across many of their most important works: an aesthetics of warlike conflict. They also problematized the idea

of the natural, so that it was clear that "nature," in its binary pair with "culture," was not necessarily "natural."[4] The difference between the two was frequently blurred. The Harrisons' "nature" was not a sublime, eternal bedrock underneath "culture," nor was it an irrational force. In their ecological blueprints, nature was shepherded, constructed, and reinvented. The Poiriers' classical "culture" was more like "nature," for they deliberately emphasized the irrational and abject aspect of classicism, presenting it in the process of independent, evolutionary growth or entropic withdrawal. Wrenched out of context and encased in resin in the Boyles' *World Series* casts, urban detritus looked as timeless and geological as natural strata. The division between nature and culture in all three oeuvres was unpredictable, uncertain, and unclear.

The artists also moved outside the narrow discourse of art itself, ranging at various times across other disciplines as *bricoleurs,* consultants, futurologists, and mediators in ambitious amateurisms recalling Karl Popper's model of inadvertent scientific discovery.[5] As amateur archaeologists, geologists, ecologists, or epigraphers, they slipped past mainstream art-critical attention and were allocated a marginal place in history, peripheral to principal accounts of the post-1960s avant-garde.[6] Indeed, their works did resist easy incorporation into critical discourse and even seemed inconsistent or backward looking. This may have been because the artists' oeuvres were highly fragmented and hermetic or because of their eclectic artistic vocabularies: For example, neoclassical syntax—the artistic language used by the Poiriers—was difficult for many critics to see as anything other than neoconservativism. They also incorporated poetry and text into their works, and as a result their poetic prose ran the risk of dominating reception.

As it turns out, all the artists found it difficult to attract sophisticated commentary despite their considerable reputation among critics and curators. To compound this, the Harrisons and Boyle Family, in particular, skewed their critical reception by consistently refusing to talk about their work in terms of its aesthetic or stylistic dimensions or its place in contemporary art discourse. Instead, rather like politically committed activists, they insisted on discussing the politics or the poetics, at the expense of their visuality, of their installations. Their desire to shape critical discourse on their own work, and the specific problems faced by critics in writing about such erudite, overexpert figures, has clearly edged historians and critics toward a similar encyclopedic but extra-artistic erudition.[7] The need to be expert, in other words, hijacked analysis of the artists' works.

This leads to ambiguity in the question of their place in the narrative of art since 1968. There is little discussion about their position in the history of the dematerialization of artistic language during the 1970s, within which their works constitute something of a counternarrative in the transition between mid-1960s conceptualisms and early-1980s postmodernism. Their work remains a relatively unknown quantity, in part because of the critical and curatorial concern with marketable individual subjectivity, a concern that over time has militated against the inclusion and collection of unorthodox or aberrant modes of art making.

The Poiriers, Boyle Family, and the Harrisons memorialized a quasi-anthropo-logical aesthetic, adopting the same methodology: They were organized like a highly competent research community, which meant combining collaborative, cooperative teamwork with such standard techniques of historiography as indexes, catalogs, archae-ological detail, and archival searches.[8] They were, in effect, conservators of memory. Their works, in theory at least, preserved or, more important, re-created and repre-sented information and were intended, therefore, not to be beheld but instead to be read, like archives of books.

The reverse was just as true in practice. The appearance of a proliferation of useful-looking, impressively assembled information was probably more important than actual veracity or utility, for few people ever bothered to read all the information on display in works like the Harrisons or in Art & Language's endless file-card systems. According to Mark Boyle, Japanese farmers found his rice-field simulacra deeply moving. But the same curiosity value also resulted in the Boyles' artistic marginaliza-tion and some critics' judgment that they were flawed, academic conceptualists—latter-day Meissonniers, according to a *Burlington Magazine* reviewer—whose pro-jects strayed from ethnographic research to auratic self-fashioning.[9]

Cataloging, urban archaeology, and archival documentation made fictionalized constructions of "reality" more plausible. The three collaborations had appropriated and hybridized the conceptual aesthetic of administration, but they then displayed their works according to a contrary aesthetic: making use of the tropes of cinema and scenography, as had *arte povera* artists. The Harrisons' and the Poiriers' large installa-tions, for example, were enormous, iconic, impossible to absorb at a glance, and fre-quently dramatically lit.

Like one or two members of the *arte povera* group, in particular Alighiero e Boetti, the three collaborations also worked with elaborate, overdetermined systems—dis-placements of those seen in minimalist and conceptualist art. Many U.S. installation artists of the early 1970s did the same; certain critics even thought artists were devel-oping new forms of celebratory social ritual. Jack Burnham, for example, wrote widely read articles for magazines such as *Artforum* about the new "systems aesthetic," within which he located Newton Harrison's first works. His description of a "systems" work-ing method is worth quoting at length:

> The systems approach goes beyond a concern with staged environments and hap-
> penings; it deals in a revolutionary fashion with the larger problems of boundary
> concepts. In systems perspectives there are no contrived confines such as the theater
> proscenium or picture frame. Conceptual focus rather than material limits define the
> system. Thus, any situation, either in or outside the context of art, may be designed
> and judged as a system.[10]

Burnham not only defined a heuristic possibility—that formal decisions might be discovered from process—but also hinted at the likelihood that formal structures (grids, syntactical consistency, and input/output equations) might be superimposed

upon the disorder of such approaches, rather like compositional and framing devices laid across "poor" materials. The very lack of a framing proscenium also hints at a solution that produced its own problems. Burnham's "conceptual focus" could amount to the reappearance of self-consciously generated style governed by nothing more than its own new tropes. His "system aesthetics" may have been a call for the reenchantment of art through ritual and ecological consciousness, but it also fetishized anthropology so that sentimentality posed as anthropological method.

Elsewhere in the same article, though, Burnham implied that the figure of the artist could be manipulated as part of the work of art by being included as a researcher within the organization of a team. He suggested that the presentation of systematic structures of information and assessment had become intertwined with artistic identity. These elements were deeply coded into the making of the art itself; they were inextricably part of the new art. By contrast, a painting may be produced unconventionally, as the result of a politically committed collaboration, and yet still preserve an old-fashioned structure that renders radical intentions opaque. The Harrisons' statistical tables and commissioned environmental consultancies, the Poiriers' vitrines, and the Boyles' geological dioramas all began to resemble directed research presentations. They can be compared with Robert Smithson's textual version of Earth art, though his work has been extensively reassessed since the 1970s and theirs has not.

Burnham's statement repays careful analysis, for it assumes common ground among what seem to a later generation to be apparently unrelated works. This assumption was shared by other writers and curators, including Harald Szeemann, for example, in his exhibitions *Live in Your Head: When Attitudes Become Form* (1969) and *Documenta 5* (1972). Burnham provides a reference point from which to begin an investigation of the expanded concept of authorship after conceptual art. The collaborating artists in chapters 4 and 5 assembled, excavated, and organized information. They were constructing visual archives, and they owed this language principally to minimalism and conceptual art. In addition, they also separately saw their art—and art in general—as possessing many of the properties of archives described earlier in the discussion of Joseph Kosuth in chapter 1.

But what was the organization of these archives? Boyle Family's, the Poiriers', and the Harrisons' archives-as-art stand at the cusp of modernism and postmodernism, yet their archives offer a conception of memory different from that favored by postmodern artists during the 1980s, for whom the model of memory was an allegory of ruin. In particular, these teams stressed iconicity at the expense of indexical form, whereas later postmodern critics stressed the opposition between symbolic and allegorical workings. The opposition was made most overtly by Craig Owens and Benjamin Buchloh, citing Walter Benjamin as their authority, but in practice, as Hal Foster has pointed out, the modes of symbol and allegory are never so distinct.[11] Finally—and this, too, is contrary to the usual expectation of postmodern art's genealogy—the artist teams' conception of memory as a product of reading was specifically ethical

because their works and artists' statements imply that reading is a moral activity based on the displacement of individual subjectivity.

Boyle Family

Boyle Family was the successor to a series of collectives founded by Scottish artists Mark Boyle and Joan Hills during the 1960s. Mark Boyle's Sensual Laboratory had created light shows and environments for London concerts by psychedelic rock bands at alternative venues, including the UFO Club. At UFO, Boyle worked closely with The Soft Machine, Jimi Hendrix, The Cream, and dancer Graziella Martinez. But even in the late 1960s, the Sensual Laboratory was more than a cooperative vehicle for multimedia performances behind rock bands; it was also a way of avoiding conventional self-expression. According to a 1969 article, the Sensual Laboratory was by now "a registered company . . . not only a kind of stepping-up of activity by expansion into group research [but] an organization for keeping track of the activity."[12] Boyle and Hills worked as scientifically and methodically as possible, rather like a research team of urban archaeologists.

They began a long-term, encyclopedic project, *Journey to the Surface of the Earth*, in 1969. Utilizing pseudoscientific research methods, including core samples from each site and the construction of what they called "earthprobes," they generated an almost megalomaniac project—one that they insisted would take the rest of their lives to complete. Their blindfolded friends threw 1,000 pins at a map of the world, determining sites where the artists were to make scrupulously accurate casts of the earth's surface. As their two children, Sebastian and Georgia, grew up, they joined their parents to coproduce these works.

For Boyle Family, far-off locations—at the fringes of Europe and North America but also far beyond—were perfect laboratories where they made the long series of fiberglass resin casts within the overall *Journey to the Surface of the Earth* or *World Series*. For example, six darts struck the Australian continent: two in Queensland, three in the Northern Territory, and one in South Australia. On location in the Central Australian desert, they made *Journey to the Surface of the Earth: Australia. Study of Anthills, Tanami Desert* (1979) and *Journey to the Surface of the Earth: Australia. Study of a Dried-Up Watercourse, Tanami Desert, Central Australia* (1979) with colors derived from earth pigments, embedding fragments of red desert earth and plants.

Boyle Family's casts were a strange, trompe l'oeil blend of absolutely accurate description and fiction, as if the surface of the Earth had been peeled away. Their bas-relief moldings resembled real samples of terrain, down to the most minute details of texture and color. The casts were exhibited according to precise lighting specifications in order to heighten the illusion that they were select patches of earth, crumbling masonry, and crushed rubbish magically transplanted to the art gallery, flipped to a vertical axis, and carefully cross-lit with highly staged, dramatic, Caravaggesque

lighting that accentuated otherwise insignificant shadows and dramatized minute variations of texture. The Boyles also gradually cultivated a mystique around the casting methods, coloration, and fiberglass materials they used to make their simulacra.

Their semisecret methods, though, were less important as a "framing" device than the collaborative process itself. This was always on the audience's mind, diverting attention away from the casts' craft qualities and strong visual likeness to experimental ceramics of the same period. As sculptural objects alone, the *World Series* casts were undercoded, but Boyle Family's grand narratives—distant locations, random choice of site, and cooperative manufacture—added an exotic aura to a conceptually simple but highly skilled, time-intensive casting process. Without the extra conceptual dimensions—without an elaborate explanatory and authorial frame around the trompe l'oeil simulacra—the degradation of the materials would have been emphasized, and the casts would then have resembled Jean Dubuffet's 1950s earth-encrusted paintings, the *Terres Radieuses*. Instead, the *World Series* can be compared both to Robert Smithson's "nonsites" and to process artworks made according to elaborate rules, such as Daniel Spoerri's *An Anecdoted Topography of Chance (Re-Anecdoted Version)* (1966). Like Spoerri's title, the Boyles' names were misleading puns—in the Boyles' case with a sporting or gambling reference. The final casts even more closely resembled Yves Klein's *Planetary Reliefs* (1961). Both the *World Series* and the *Planetary Reliefs* were complicated by the artists' elaborate, semisecret production methods.

In terms of direct influence, however, it seems more than likely that the Boyles were aware of other English land artists working at the same time or even slightly earlier, including Hamish Fulton and Richard Long, who both established considerable international reputations with their photographic documentations of walks in isolated, lonely places around the world. Long had also produced simple, transient assemblages from pebbles and other natural, found materials, arranging them in galleries or leaving them as lines in the landscape. He was arguably better known in Europe than in Britain during the early 1970s, as his curriculum vitae shows, but he made two miniaturized simulacra of pieces of ground during the 1960s that bore more than a passing resemblance to the works that the Boyles embarked upon shortly afterward: *An Irish Harbor* (1966) and *A Square of Ground* (1966). Long painted these plaster casts realistically so that he was presenting replicas—like the Boyles' *World Series,* though in this case made-to-scale miniatures—of selected landscapes. He had also isolated, marked, and cut out real strata from a patch of turf at Bristol, which became *Turf Circle* (1966). Long's peripatetic aesthetic and his "realist" simulations—traveling to isolated places around the globe, presenting reconstitutions of his nomadic experiences within an art gallery's white walls—predate the Boyles' casts by several years.

Without their intricately constructed family identity, the scientific rationale, and their elimination of a fixed studio, Boyle Family's accomplished mimesis would have seemed overemphasized to the point of fetishization, problematizing their recovery of technical mastery within the contemporary art museum. Even so, this virtuoso manufacture remained in a crucial sense theatrical but not dramatic, for the carefully

melodramatic stage lighting that always accompanied their exhibitions was a simulation of drama, and this melodrama was crucial to the distinction between art and window display, as formalist critics such as Michael Fried were reiterating at the time. The distinction between theater and drama, with the associated problem of the difference between bathos and profundity, would remain a difficult juggling act for the Boyles. The very handmade conventionality of the artistic form that they chose to work in—sculptural bas-relief assemblage—produced its own problems. But collaborative manufacture, the nomadic studio, and random choices were crucial tools that dissociated Boyle Family from pure craft, so that the predominant reaction to their work would be wonder at the constructed illusion rather than awe at the artists' skills.

The effect was similar to that achieved by natural history dioramas on the one hand and to the illusions created by nineteenth-century phantasmagoric displays on the other.[13] As if to confirm this, the Boyles strongly felt that their works were uncanny and should have the presence of something issuing suddenly from long-buried but deeply familiar memories.[14] They therefore referred to the pantheistic "power of the earth," and their casts resembled the exact re-creations of geological strata and terrain types found in a different type of museum, a museum of natural history rather than of art. They felt no affinity, on the other hand, with the idea of a collaboratively constructed doppelgänger directing their work, nor with the conception that a "third hand" constituted their collaboration, unlike many other artists who experimented with such identities. The democratic, communal, artistic "family" was their overriding model, displacing all other collaborative types and intentions.

In his early Happenings, Mark Boyle had experimented with the uncanny and unexpected, blurring the division between art and life through carefully stage-managed theater. In a well-known early work, *Street* (1964), he led an invited audience from a narrow back alley into a darkened space, seated them, and drew the curtains open, revealing a busy London street beyond the shopwindow. In the same way, the *World Series* casts were genuinely confusing, for they had the uncanny impact of transporting the real world outside an art gallery into its transforming white cube.

After 1971, Mark Boyle stopped producing light shows for rock music concerts. He reduced the Sensual Laboratory's membership until it only comprised his immediate family. The Boyles' work from then on was produced under the umbrella title of Boyle Family, and this sublimation of the individual artist into a collaborative team was central to Mark Boyle's explanations of their work, for he became Boyle Family's usual spokesman. Nevertheless, Mark Boyle, along with the essayists who wrote about Boyle Family's work, persisted—in much the same way as did Christo's commentators—in emphasizing his proprietorial ownership of the *World Series* through the use of "I" or "he" rather than "we" or "they." Boyle explained this inconsistency, and this apparent patriarchal usurpation of the family's joint work, quite pragmatically:

> At first we only used my name because we hardly ever sold anything and there was
> no way we could afford to be so self-indulgent as to argue with an art world that

wanted to believe in a single (preferably male) obsessed artist. Since then, we have exhibited under a variety of names: Mark Boyle and Joan Hills, the Institute of Contemporary Archaeology, Sensual Laboratory, Sense Laboratory Ltd., "a notional gallery," and Boyle Family.[15]

The problematics of exhibiting collaboratively produced works, and the ease with which their assemblages could be attributed solely to Mark Boyle in order to solve those difficulties, was Boyle Family's reason for their slow "coming-out" as a team. In contrast, other collaborations, such as Gilbert & George and Abramović and Ulay, necessarily identified their collaboration with their art, as we will see in later chapters. Boyle Family evaded direct confrontation with curatorial expectations that the male gender has a privileged link with creativity because Boyle Family and their art are not identical, and a male name—Mark Boyle's—is legible within a conventional artistic economy predicated on self-expression. This evasion (and that of other collaborations) is comprehensible, for well-known artists often retain something of the younger artist's usual sense of raw-skinned, well-hidden vulnerability (sometimes even paranoia) into midcareer, and many critics (even feminist critics) and curators remain obstinately convinced that any male artist who voluntarily subsumes his name will in fact continue to take control behind the scenes or will collaborate in works that demonstrate how power is always unbalanced.[16]

Boyle Family's deeply felt, passionately expressed rhetoric of familial democratic decision—removing the personal and subjective as much as possible from the making of art—was therefore both consistent and inconsistent with their artistic product, which was relatively traditional and recognizably "artistic," even though accompanied by the authority of a paternal name and even though created in an unconventional way. Despite their rhetoric to the contrary, the Boyles were not antiart. They were, however, antiartist and quite pragmatic. This apparent contradiction itself could be traced back to the pluralism, collectivism, and idealism of the 1960s psychedelic milieu, within which they had been important participants. They insisted that their collaboration was like a communal countercultural family democracy in that they each had an equal vote and equal say regarding all decisions. Every member of the family had a veto, and the role of leader alternated. Until the 1980s, the leader and spokesman was usually Mark Boyle, but from then on, according to them, the role was frequently adopted by their son, Sebastian. Joan Hills usually took on the job of organizer. The children invariably arrived at a project site early to do the advance work of preparing transport, materials, and accommodation. The family members had each evolved individual skills and accepted specialist roles during a project. Mark Boyle observed:

And it's in this context . . . that I would like to assert there is only one reason that we bill ourselves as Boyle Family. It is the fact. We work together from the initial concept, through every stage of making each piece, through to

hanging the exhibitions and talking to the public. It's not a cosy coopera-
tive. It's not even a partnership. It's four individuals each of whom has a veto.
So that if any one person doesn't want to work on a certain piece, we don't
do it. As Sebastian says "*Boyle Family* is not a democracy. It's four feuding
dictators."[17]

The family structure permitted each member to retain highly disparate identities
behind the unified front that they presented to the world. They never aspired to psy-
chic union, as did Marina Abramović and Ulay. They even, like both the Harrisons
and the Poiriers, spent long periods working individually rather than in each other's
company, though always on the collaborative works.

Family membership was the guarantee of a certain protective psychological bar-
rier, giving each member considerable safety and creative security inside its bound-
aries. The perimeters of this castle had to be patrolled, so Mark Boyle habitually
played the discursive role of patriarchal defender: He charmed, misled, and diverted
interviewers, even brusquely evading unwelcome interlocutors. Boyle wrote:

> I believe that throughout most of history and in most other cultures at the present
> time artists work together quite naturally in family groups. I have no conceivable
> problem about artists working together as individuals. If it's right for you, it's great
> for you. I would just like to state that the idea that art can only be produced by
> obsessed individuals is a neurotic aberration of our times.[18]

The first sentence is important: Different Boyle Family members emphasized the
traditional nature of family-based artistic collaborations and the diffuse but regulated
ownership of motifs within older societies, observing that in tribal communities, mar-
riage often meant the emigration of a son or daughter and the subsequent loss of visual
motifs when a child took his or her share of the family's designs to a new home. Boyle
Family worked like a pre–Industrial Revolution cottage industry, and yet the stakes
for this model of collaboration were changing from the early 1970s on, due both to
shifts in the status of women in postindustrial societies and to the successful recuper-
ation of sexual and social critique into the commercial and institutional art worlds.
These historic changes produced a new, more opportunistic cultural space, in which
aberrant or unusual artistic identities could, if they chose (and, more important, if
they were able to forge links with newer discursive networks, art magazines, and
curators) bring their artistic identity into closer congruence with their production
methods. Whereas for some artists, collective identity was crucial from the start,
Boyle Family, Christo and Jeanne-Claude, and many other long-term artistic part-
nerships adjusted to these shifts by "coming out" as collaborations. Even in newly
revealed collaborations, however, the motifs of manipulated identity had already been
inscribed deeply on the work: Boyle Family had always presented itself as a collec-
tive enterprise even though its works were accessioned into museum collections as
Mark Boyle's.

Boyle Family also continually emphasized the element of distance and their own actual lack of availability, for they disappeared to distant sites to make their casts, and their handiwork was as anonymous as possible. They considered themselves voluntarily isolated, and Mark Boyle wrote: "As you probably realize Boyle Family is antithetic to networking. As far as networking is concerned we belong in the holes. We exist in the black holes of the art world."[19] Boyle Family cultivated the role of outsiders, tolerated but not fully accepted by the conventional, highly socialized, close-knit British art community, which was economically based, as Boyle and Hills observed, upon the celebration of individual style instead of cooperation.[20] Their double movement outside traditional artistic identity, away from a fixed studio and toward an economy of nomadic, shared labor, forced a shift in the locus of meaning so that their casts, like Robert Smithson's almost contemporary *Non-Sites* (1968), could not be successfully "read" in conventional formal terms, except in the most superficial way, as the product of a fixed author.

Where any identifiable, signature-style set of marks or visual tropes appeared in the *World Series* casts, it was as other people's debris and rubbish selected randomly, through the most impersonal human intervention possible. Mark Boyle had asserted from the start of the project: "As far as I can be sure, there is nothing of me in there."[21] The works themselves were constructed according to apparently inflexible preordained criteria and methods, like a recipe. Boyle Family therefore constructed tableaux that both mimicked the impersonal appearance of *objets trouvés* and took their place in a tradition of European *vanitas* still-life painting, in which obvious brush marks were minimized in favor of the most exact, anonymous mimesis possible. Signatures disappeared except as discarded signs of the crude, exploitative relation of civilization with nature.

This relationship has been often associated with European colonization from the Age of Exploration onward, and J. L. Locher located Boyle Family's work as a double-edged, critical embodiment of the Enlightenment tradition, referring to Bernard Smith's important book, *European Vision and the South Pacific*.[22] According to Locher, Smith analyzed the shifts toward romanticism in science and art during the late Enlightenment, tracing the changes through the art produced during Captain James Cook's voyages in the South Pacific. Cook's artist, William Hodges, was on board the *Endeavour*, to faithfully record what he saw; this was the opposite—in Locher's gloss of Smith—of previous artistic research methods, which had been based on classical copy traditions of idealized stylization. Locher compared Boyle Family to Cook's artist.

The Boyles themselves firmly rejected Locher's interpretation and were so sensitive to the tag "romantic artist" that they had a disclaimer inserted beside Locher's essay. Mark Boyle and Joan Hills insisted, instead, on their work's antiart genealogy within 1960s counterculture, firmly rejecting any analogy with Cook's and Joseph Banks's topographical artists. According to the Boyles, the absolute importance of sensation and phenomenal facts was at odds with all new or old systems of metaphorical,

and particularly romantic, identification. Their unexpectedly strong antiromanticism was linked to their refusal to ascribe, or allow, either fixed or fluid systems of metaphorical identification. Their descriptive precision was, they felt, a refusal of romantic allegory. As we shall see, this was an unexpected refusal of some consequence: It was an antiallegorical refusal shared in various ways with other artists in this book. Even so, no matter how hard the Boyles protested, theirs was not a complete refusal of symbols. It was a refusal of a particular type of symbolic organization: of allegory. They certainly would therefore have disagreed on empirical and ethical grounds with Walter Benjamin's allegorical dictum that "any person, any object, any relationship can mean absolutely anything else."[23] How, then, was Boyle Family's sensual memory to be represented?

There had been more than a little truth in Locher's observations. The eclipse of neoclassicism did lead, eventually, to John Ruskin's theories of landscape. The Boyles were as antipathetic as a Ruskinian to the excesses of modernist self-expression. A similar antipathy—with the same paradoxical, neo-Ruskinian flavor—could also be seen in the very different, contemporaneous collaborations of Gilbert & George. The Boyles' scientism—their fascination with random processes, their active disinterest in originality, and their fetish of precise craft—paralleled Cook's artists' conception of "scientific" detachment.[24] The scientific detachment that the Boyles assumed they were incorporating into their works was a mimicry—an idealized stylization—of scientific method based on precise measurement. Exact measurement could, it was hoped, eliminate Ruskin's artistic conservatism but preserve his veneration for nature. However, the two went hand in hand, as the *Burlington Magazine* reviewer had noted on the occasion of their 1986 retrospective at London's Hayward Gallery.[25] Godfrey saw their verisimilitude as an extreme realism, which he likened to French *pompier* Jean-Louis-Ernest Meissonnier's exact mimicry of visual appearances. The Boyles would have seen Meissonnier's supposed defect as their virtue, for they exaggerated and emphasized the quality of exact mimicry by lighting and staging. They wanted to summon up an almost cinematic presence, but the trajectory of such mimicry was toward the work's transformation into a museum curiosity, for the Boyles' casts perfectly mimicked their referents, like waxworks. The Boyles shared this uncanny neutrality with the Harrisons and the Poiriers, for all three blurred the difference between reality and a simulation.

The Boyles emphasized their desire to make an exact replica of reality—something so exact that it would perfectly re-create the sensation of standing in a place:

> ... trying to make the best visual description our senses and our minds can achieve of a random sample of the reality that surrounds us. *Boyle Family* are not social or anti-social, radical or anti-radical, political or apolitical. We feel ourselves to be remote from all these considerations.[26]

Mark Boyle and Joan Hills spoke forcefully of the need to "hold" a sensation, an experience, or a moment in the mind in a state of perfect concentration that transcended

the dualities of this quotation. Their work represented an extreme expenditure of labor to create a perfect description: a map that was so accurate that it was by necessity the same size as the territory it charted, like Jorge Luis Borges's infamous hero who painstakingly rewrote *Don Quixote*.[27] At the forefront of the Boyles' intentions was the aim of stimulating or creating memory through precise description—or more precisely, the illusion of precise description. The work was a mnemonic for its referent, and anything more metaphorical than this strayed dangerously close, in their eyes, to a romantic statement.

Their concern with the link between presence and fact and the importance of descriptions did have a recent and unexpected precedent in minimalism, and especially in the hyperpedantic art criticism of Donald Judd. According to Burnham:

> Pioneered between 1962 and 1965 in the writings of Donald Judd, [this mode of description] resembles what a computer programmer would call an entity's "list structure," or all the enumerated properties needed to physically rebuild an object.... A web of sensorial descriptions is spun around the central images of a plot. The point is not to internalize scrutiny in the Freudian sense, but to infer the essence of a situation through detailed examination of surface effects.[28]

Like Burnham's minimalist artist, the Boyles were attempting to infer the essence of a situation by describing surfaces. They certainly did not see their works as dumb objects resisting analysis or sensation, but they did wish to resist interpretation. Burnham's description fits the Boyles, for they wished to re-create the essence of a situation through a minutely detailed examination and elaboration of surface. The aim was fidelity, and yet this fidelity was so elusive and required such complicated and laborious expenditures of labor that its unattainability was masked by the Boyle's spectacular theatricalization of their research findings.

Less obvious, but just as important, the series extended interminably and was infinitely descriptive. As the artists journeyed around the world, the series stretched into an apparently endless proliferation of formally almost indistinguishable samples of terrain. This endlessness, along with the collaborative working method of a democratic family and a nomadic studio practice, was central to the integrity and the uncanniness of the *World Series*. In *Machine in the Studio: Constructing the Postwar American Artist*, Caroline Jones eloquently traces the imagery of U.S. artists at work through the artists' own self-presentations of themselves at work.[29] Jones describes the studio as a site invested with a crucial, authenticating presence—as the place where solitary work is authenticated as the product of an artist. In other words, an artist works in a studio, and the product of this work is the result of intense, bohemian anguish and solitude, as well as the artist's own craft skills. Freedom from the constricting boundaries of such authenticity may superficially be thwarted by the market forces of conventional art, which require that decisions be solely made by an individual artist. Boyle Family represents a transitional moment toward post-studio art. They did not believe in a unitary artistic identity and clearly went to great lengths to

disperse authorial activity. Equally, they moved well beyond the conventional confines of a studio. However, the products of their activity were neither embedded in, nor presented through, a radical synthesis of image and text, whether visual, verbal, real-time, or social. The *World Series* casts were, for all their appearance as evidence of an elaborate post-studio process, the specific site wherein the art would be experienced, much as for any traditional painting or sculpture. In the end, the unusual identity of the artist was integral to the *World Series* casts. Patriarchy (incarnated as Mark Boyle) even sometimes claimed the works quite unproblematically, with wife, son, and daughter subsumed under Mark Boyle's name in museum catalogs for a long time in order to smooth the circulation of the family's art. Boyle Family challenged the limits of the term "artist" but not, I think, the category of art itself.

A shifting conception of history is frequently expressed through the metaphor of ruins, which, as we noted in the discussion of Kosuth, stand in for history and are read allegorically. When American critics Douglas Crimp and Craig Owens wrote about the *Pictures* artists (Sherrie Levine, Jack Goldstein, Richard Prince, and Cindy Sherman), they described a particular operation of allegory in postmodern art by which allegorical mapping produced the ruination or collapse of signification. Hal Foster then observed that the opposition between "allegorical" postmodernism and "symbolic" modernism was polemical rather than actual.[30] The Boyles, Poiriers, and Harrisons shared a common interest in ruins, archaeology, and historical memory, and it would be extremely tempting to insist—despite their fierce resistance to the term—on seeing their works as allegories. They are not, and the artistic trajectory to which these artists belong became almost invisible because it was not legible within the process of defining the postmodern against the modern, an activity that during the 1980s preoccupied a generation of now-authoritative postmodern theorists.

If the *World Series* is not allegorical, it must rely on metonymy. It was inevitable that theorists would identify the motif of ruins with the disorganization and destruction of historical and modernist styles and with a disbelief in these styles' significations and narratives, but in the Boyles' works these narratives had been replaced by an archaeological system that, though comprehensible in organization, was not a system for deciphering the world. Making sense of vast quantities of phenomenological sensations and information meant something else: It meant critically representing memory, and this meant the representation of memory's disappearance through metonymy. Boyle Family understood this point clearly, as their rejection of Locher's romanticism and metaphoric determinism showed. Their works stimulate and simulate an involuntary memory chain of quasi recognition through an auratic presence that uncannily blurs the division between the real and the imaginary but that is neither overdetermined by allegory nor aligned with traditional notions of the heroic artist and his hermetic workplace. *Journey to the Surface of the Earth* was an activity that was logically and stylistically interminable. Understanding the relation between horizontal extension, metonymy, undecidability, and the collaborative systems by which these were framed will be the subject of chapters 4 and 5.

Anne and Patrick Poirier, *Ouranopolis* (detail) (1995). Installation view. Wood, acrylic paint, Plexiglas, steel; 72 inches × 172 inches; work suspended from ceiling. Courtesy Thaddeus Ropac Gallery, Paris.

4. Memory Storage:
Anne and Patrick Poirier

Ruins: The Classical Past as Style, Burden, and Retrievable Archive

From 1966 onward, Anne and Patrick Poirier assembled an invented version of antiquity from a combination of fictitious and accurately reconstructed archaeological documents, models, and sculptural fragments. Just as the couple occasionally masqueraded as twins, in severe black clothes, they presented a blend of alternate futures, invented pasts, and a thinly disguised trompe l'oeil present, combining found objects, synthesized fragments, and fictive documentary commentaries. The Poiriers' miniaturism was gradually refined and modified through acquaintance with ancient and medieval memory retrieval systems into the invention of an overarching world, organized by architectural rules and expanding according to resemblances to the human body and the physiology of the mind. They extracted fragments from their imaginary world, arranging them in curiosity cabinets and extremely elegant models of monuments, incorporating earlier works and, in their role as archaeologists, themselves as a collaborating research team. Anne Poirier explained that collaboration "came naturally, because Patrick and I had not worked a great deal separately."[1]

In the late 1960s the Poiriers were profoundly affected by two formative experiences: They traveled in Cambodia, visiting the great temple complex of Angkor, and they lived in Rome between 1967 and 1971. At both places they were immensely impressed by the sight of vast, crumbling ruins and, even more, were emotionally struck by a corollary: the fragility of civilizations.[2] Their work was evidence, as was Alighiero e Boetti's, of the intersection of many European artists' 1970s travels to distant locations (I will return to this in later chapters) and a shift away from conceptual art's tautological rigor toward anecdote, figuration, and, it seemed, the nostalgic pursuit of a vanished past. The use of classical motifs in European conceptualism and

minimalism often presupposed a scholarly acquaintance with literary culture, with the cult of memorials—and therefore with the cult of memory. Christian Boltanski, Jannis Kounellis, and Guilio Paolini separately linked the metaphors of history and death, and their literariness was not at all isolated. They used the motif of history in code to suggest the experience of death and then the motif of death to speculate on what the experience of memory might still be. Boltanski's *The Sixty-two Members of the Mickey Mouse Club in 1955* (1972) is a tableau comprising rephotographed portraits of members of the Mickey Mouse Club, published in the club's French fan magazine in 1955. The children present themselves in their best clothes with their favorite toys. Viewed decades later, the photographs seem a memorial to the death of childhood and to the death of a certain 1950s idea of childhood innocence constructed by consumer icons and cults. Boltanski's formal decisions were largely dictated by his source material—its quantity, its grainy monochrome—and the work was limited by the finite number of club members rather than by a compositional decision about dimension. In the same way, Jannis Kounellis's shelves or containers, upon which he arranged slabs of wood and iron that were punctuated by the "eternal flames" of acetylene torches and their gas canisters, were a metaphor for history: Objects accumulate on shelves over time just as events accumulate in memory.

During the early 1970s, the Poiriers constructed an enormous scale model of an ancient ruined city, *Ostia Antica* (1972); there had been an antique Roman town of a similar name. The Poiriers' model ruin extends along a trajectory slightly different from that of Boltanski or Kounellis: It is a partial remnant or index of the vast, infinite, and horizontal expanse of cultural memories. Later in the decade, they built models of a second ruined city that they named *Domus Aurea*. This series of vast models includes *Domus Aurea, Ausée* (1976), *The Burning of the Great Library* (1976), and *Domus Aurea, Construction 4* (1977), which was shown at *Documenta 6* (1977). The Poiriers' miniature ruins are built from terra-cotta or charcoal and carbon, and are accompanied by paper casts taken from classical sculptural and architectural fragments and by collections of pseudoarchaeological sketchbooks. From the late 1970s onward, with the *Villa Adriana* series, which includes the early *Villa Adriana, Equilibre instable* (1977) and *Villa Adriana, Hommage à Piranèse* (1980–81), they evolved a second type of representation of ruin, in which small fragments were enlarged to gigantic proportions, as in *Jupiter and the Giants, Encélade* (1983). The series includes several sculptures of monumental proportions, such as *The Great Black Column of Suchéres* (1984–85). Some were commissioned as public sculptures (for example, *Jupiter and the Giants, Encélade* for the Jardin du Musée Picasso [Antibes] and *The Great Black Column of Suchéres* for the Clermont-Ferrand Autoroute, near Saint-Etienne), assuming the theatrical quality of large-scale environmental spectacles.[3] These often seemed to threaten to topple over and injure the unwary viewer, like Richard Serra's contemporaneous arrangements of steel and lead. Explorations of the premodern genre of utopian architecture, they are similar in imaginary status to the projects for ideal cities of such eighteenth-century French architects as Étienne-Louis Boullée and

Claude-Nicolas Ledoux. Many of the Poiriers' large drawings and diagrams and a pivotal work, a large model of a circular utopia, *Villa Adriana, Circular Utopia* (1980), echoed the eighteenth-century architects' imaginary projects.[4] Their works fell into four categories, and images of miniaturization and gigantism predominated within each: close-cropped photos; dioramas of ruins and utopian monuments; sculptural or architectural-sized fragments or paper casts of classical architecture and statuary, sometimes either corroded by pollution or so damaged it might have been calcified; and, finally, the paper debris of official archaeological commentary.

Ostia Antica was assembled in small rectilinear units, as if it could accommodate further extensions, and lit in grim, dramatic chiaroscuro. The ruin is so impressive in its sweep and detail that its dubious status as an accurate archaeological reconstruction is pushed to the background and its generic veracity is assumed. The artistic significance of historical allusions was inverted because the past, and specifically the antique past, had become a cipher for death and transience instead of permanence and stability. Evoking historical memory, then, at the start of the 1970s may not have been an end in itself, although many critics recycled the words as if the mere mention of history was sufficient to justify a description in terms of memory. Underlying the cult of memory was a preference for the rhetorical and literary over and above an epistemological inquiry, familiar from U.S. conceptual and minimalist art, into the nature of perception.

The simulation of the intricate detail and evocative obscurity of archaeological documentation and reconstruction was, in fact, linked to a trans-Atlantic cult of archival and research methodologies, amounting to something of a minor art movement. Several artists on both sides of the Atlantic created fictional simulations of historical and archaeological records. The list includes the Poiriers, Ian Hamilton Finlay, Richard Long, Paul Thek (specifically his *Ark and Pyramid* [1972] exhibited at *Documenta 5*), Nancy Spero (her long text and drawing scrolls, including *Torture of Women* [1976] and *Notes in Time on Women, Part II* [1979]), Charles Simonds (a large series of clay model buildings, including *People Who Lived in a Circle [Picaresque Landscape]* [1976]), Will Insley (who was exhibiting plans for an immense future civilization, *Onecity* [1974]), and Robert Stackhouse (who made skeletal remains of generic Viking longships). Other artists invented contemporary versions of ancient mystical, religious, and social rituals, many of which were simply New Age ceremonies renamed "art." Charles Simonds invented rituals such as *Birth* (1970) and *Landscape/Body/Dwelling* (1971), which incorporated some of his clay models. Jack Burnham described many such projects in *Great Western Salt Works;* Lucy Lippard also sympathetically charted the phenomenon in several books, including *Overlay* and *Mixed Blessings.*[5] Much of this work has dated badly, and it was easily targeted as evidence of naive psychological primitivism.[6]

Robert Smithson's work was positioned at the edge of this discourse, but his concerns were always more mainstream, self-reflexive, skeptical, and melancholic. This sat uneasily with the celebratory nature of much ritual-based art, as did his links with the

Anne and Patrick Poirier, *Ostia Antica* (1972). Installation view. Terra-cotta; 472 inches × 236 inches. Collection Museum Moderner Kunst Stiftung Ludwig, Vienna.

more austere New York art-critical scene and his conceptualist artist friends. On the other hand, his continual curiosity about primal Jungian symbols and his toying with Atlantean references in *Spiral Jetty* (1970) accurately reflect the late 1960s and early 1970s sensibility described above, and these archetypal symbols were seized upon by writers such as Burnham. We have to remember that Smithson's work sat alongside Simonds's miniature cities in early 1970s exhibitions such as *Interventions in Landscape* (1974, MIT Hayden Gallery), and many curators saw Simonds's work as part of the same movement outside the studio as Smithson's (Simonds assembled his tiny clay models onsite in derelict or poor areas of New York and other cities).

In Europe, *Ostia Antica* presented the same double messages. On the one hand, it seems to be an excerpt from an encyclopedic reconstitution of ancient culture, much as Smithson's multiple presentations of *Spiral Jetty*—as film, as sculptural construction, as documentation—seem to be excerpts from a larger, all-encompassing, open-ended encyclopedia. On the other, *Ostia Antica* resembles Simonds's clay models more closely than any work by Smithson (the Poiriers were compared more than once with Simonds on account of their miniaturized archaeology), although it is, as might have been expected, more classically literate, less primitivist, and without doubt more atavistic than Simonds's work; the artists thus confirm national stereotypes. Both pieces are bounded by the consistent, imaginary spectacle of a diorama rather than by the fractured, unconventional display methods typical of Smithson. Simonds's terracotta models—weathered homes for his invented "Little People"—look like Native American versions of *Ostia Antica*, for both are ostensibly plausible archaeological reconstructions and both take advantage of the peculiar quality of miniaturization, even if the former is overshadowed by nature and the latter by culture.[7] In Edward Lucie-Smith's 1980 survey volume, *Art in the Seventies*, the writer linked the Poiriers to Simonds, while noting the ambivalent quasi-documentary status of their works:

> Anne and Patrick Poirier, for example, made elaborate reconstructions in model form of *Ostia Antica*, which were presented to the public as art-works. More recently at the Serpentine Gallery in London, they showed a piece called *A Circular Utopia*, an uncannily convincing reconstruction of a temple complex which existed only in the artists' own imaginations.[8]

The preference for the literary, and especially the reappearance of such classical motifs, presented critics with particular problems. Apart from the apparent contradiction of progressive artists reintroducing one outmoded cultural language when another—that of modernism—had only recently been thoroughly discredited, the use of classical forms looked sentimental, for the deployment of columns and temples seemed to indicate nothing more than a cult of picturesque ruins. A few years later, American critic David Frankel, for example, attempted to justify the Poiriers' use of an apparently regressive language by appealing to the idea of a common humanity: "It is wrong to believe that these myths and ancient geneses do not concern us anymore. The human soul is made of memory and forgetfulness; these constitute being."[9]

Anne and Patrick Poirier, *Ostia Antica* (detail) (1972). Installation view. Terra-cotta, 472 inches × 236 inches. Collection Museum Moderner Kunst Stiftung Ludwig, Vienna.

Anne and Patrick Poirier, *Ouranopolis* (1995). Installation view. Wood, acrylic paint, Plexiglas, steel, 72 inches × 172 inches; work suspended from ceiling. Courtesy Thaddeus Ropac Gallery, Paris.

Frankel described the Poiriers' invented city *Ouranopolis* (1995) but missed the Poiriers' interest in mnemonics and constructed viewpoints, so evident in the multiple viewpoints through elaborate portholes into the enormous, hovering spaceship "Ouranopolis," loosely translated from Latin, means "Heavenly City" and was also the name of a city of the classical period—which survives as a village to the present day—constructed at the gateway to the holy Mount Athos peninsula by one of Alexander the Great's heirs.[10]

Despite such apologias, the Poiriers' art was far more resistant than that of Kounellis or Paolini to incorporation into the narrative of avant-garde art, for it presented the same problems as other art based on classical motifs: The iconography overshadowed the art, leading viewers toward interpretations based on nostalgia, poetry, and, irresistibly, the same return to order as suspect classicisms (that is, those classicisms attacked by Benjamin Buchloh in his indictment of neoexpressionist painting, in which he equated neoexpressionism from the late 1970s onward with the neoclassical, crypto-fascist "Return to Order" of the 1920s.)[11] The Poiriers did not see themselves as neoclassical artists at all, nor, when neoexpressionism surfaced in Europe with the late-1970s arrival of trans-avant-garde artists such as Sandro Chia or the French painter Gérard Garouste, did they feel any affinity with these artists. They

were uninterested in the bombastic rhetoric of U.S. neoexpressionist artists or in classicizing postmodernists such as Carlo Maria Mariani. According to the Poiriers, their work was neither neoexpressionist nor neoclassical, and they had no desire to reestablish conservative modes of representation based on classical systems.

The presence of such elements in their works, even so, calls for explanation, for their interest in the representation of catastrophe was shared by artists and theorists with whom they seem ill-matched, including trans-avant-garde curator and theorist Achille Bonito Oliva.[12] The Poiriers did share two key concerns with German neoexpressionist painter Anselm Kiefer, whose massive, perspectival vistas postdate *Ostia Antica* by many years: First, their representations of history as architectural ruins are equally indecipherable, and this virtuosic indecipherability is equally central to their representation of memory. Second, they take as their primary motif the theme of loss, but with such indecipherable intentions that each artist's work *could* be an interrogation of their audience's relationship to that loss. Because they appropriated conservative forms, they were accused of endorsing conservative ideologies.[13] Both the Poiriers and Kiefer left the tension between image and signification extraordinarily and dangerously open-ended precisely because of their works' hyperdetermined significations.

The ambivalent connotations of contemporary neoclassicisms, along with the ethnic, nationalist subjectivity they seem to entail, have to be acknowledged. Per Luigi Tazzi explained the reasons why classical metaphors became unconvincing: Their "bombastic aggrandizement by genii" such as Picasso and their degradation by association with Italian and German fascism had deeply discredited classical metaphor.[14] Tazzi linked the Poiriers instead with an altogether different stream of classicism in contemporary art: *arte povera*'s fragmented quotation of classical iconography, which was, according to Tazzi, first sighted in the sculptures and installations of Jannis Kounellis and Guilio Paolini during the late 1960s.

The Poiriers were living in Italy during the late 1960s, and they remembered the excitement they felt when they saw the early *arte povera* exhibitions. Kounellis and Paolini drew on classical motifs in a deliberately piecemeal way, placing dislocated antique elements—whether fragments or whole statues—into galleries as elements in ready-mades. This is not the same thing at all as neoclassicism, for though these works are self-reflexive, ironic, and self-conscious, as neoclassical style has often been, identification with classical style is blocked—as it would be later in the Poiriers' works as well—by fragmentation and the bracketing attendant upon archival sorting and sifting, which is as prominent as the objects thus categorized. As Tazzi observed, fragmentation was a standard and almost mandatory trope of 1970s art, as it would also be during the 1980s, when at the hands of critics such as Owens (in "The Allegorical Impulse") it became almost omnipresent.[15] Tazzi implied that the Poiriers elegantly quoted the ruins of classical iconography rather than classical iconography itself, which left certain artistic procedures open—specifically the ordering, classification, and systematization of a foreign world—but excluded others. The Poiriers, though, were aware of the anachronism of classical metaphor, deploying metonymy to signify

an unrecoverable removal. They were certainly aware of the difference between icon-ography and iconology.[16] For the Poiriers, classical style did not signify homogeneity and stability; classical space was irrational and unbounded. The superficial homogen-eity of classical style masks chronological heterogeneity and therefore, for the Poiriers, classicism did not signify a specific place or period.

The Poiriers' archaeological fabrication, therefore, involved fragmentations, dis-tortions, and transformations, but the undeniable limitation of these methods was that this type of art became all too typical of the 1970s, and in retrospect it looks determined by a now-dated taste for the atavistic, the same criticism leveled at Kiefer. As a trope within postmodern style, the classical fragment remained categorically conservative even though the Poiriers saw their art as a method of conservation. The Poiriers were European and white, which explained the ease and assurance with which they positioned themselves as custodians of memory within the mainstream of Euro-pean art history. This tradition, however, had already become complicated and subtly marginal because of more powerful museological, art-historical, and critical narratives constructed after 1945 from New York.

The City as Text

When asked what they saw as the principal theme of their work, the Poiriers' answer was emphatic if cryptic: They repeatedly replied that memory was the central, unify-ing element. Like the Boyles, they spoke of trying to re-create moments of intense concentration within which would be housed a vast mental world consisting of swathes of information, pictures, sounds, and actions—all of which we would normally call the contents of memory. The aspiration recalls Marcel Proust, of course, and beyond him the French philosopher Henri Bergson, whose influence the Poiriers freely acknowledged.[17] Despite their protestations, therefore, an element of Tazzi's criticism was accurate: Their particular quasi-archaeological style was not linked in an indis-soluble way with its form, since an "archaeological" method was a way of classifying and ordering, rather than creating, forms. This was at the same time the crux of crit-icism and precisely what the Poiriers wished.

In *Ostia Antica*, for example, they presented an almost overwhelming quantity of information, enumerating countless numbers of almost indistinguishable miniature ruined houses, temples, and amphitheaters across a very large, horizontal installation. The minute difference between a ruined house and its neighbors is virtually illegible. The ruined city, Ostia Antica, is itself an unexplained, mysterious given, yet the artists supplied no clue to its fictional or factual status. Ostia Antica's formal structures are not the result of material process, unlike in conceptualist artworks of the period, so even comparisons with minimalism or conceptualism are not illuminating. Finally, Anne and Patrick Poirier consistently demonstrated a virtuosity in several techniques, whose results are, like the Boyles' casts, hard to formally evaluate since the criteria for judgment—for the aesthetic evaluation of archaeological reconstructions—are obscure.

The Poiriers' version of minimalist installation, in which model making and archaeological reconstruction replaced pure Platonic forms, implied that minimalist and conceptualist structures could be replicated through labor-intensive craft and reconstituted in apparently traditional idioms.

The organization of memory—of thoughts stored in the mind—into retrievable form was a real and pressing issue for early 1970s artists, as Burnham's essays, Smithson's encyclopedic projects, and Art & Language's index-card files had all attested. It was equally important to the Poiriers, as their constant references to memory demonstrated. At first sight, their classical forms appear to have been organized through allegorical frameworks. If this had been so, though, they would have been reading the classical past into the present through allegory, as neoexpressionists such as Kiefer were to later do. The risks were obvious, as their essayist Günter Metken observed in the catalog for their 1991 Vienna retrospective: "[M]emory is on everyone's lips. Is the cult of memory beset by inflation?"[18] But *Ostia Antica* blocks allegorical readings, and the way it does this needs to be reconsidered.

Ostia Antica takes as its general location the classical past, but it is not an allegorical image even though it is highly symbolic and allusive. It looks instead like a snapshot taken at a moment in some version of the past, as if something has been withdrawn to somewhere else, leaving the world in ruins. *Ostia Antica* creates the wonder of a great spectacle, for it grandly describes a slice of another world that has materialized without the agency of an artist's hand. It is a composition of images produced from a memory archive of architectural forms, and like Boyle Family's trompe l'oeil bas-reliefs, its auratic presence is linked to a chain of half-recognized, semilegible memories.[19]

For several years, from the late 1970s onward, the Poiriers constructed a series of models of the imaginary city of Mnemosyne, a city of memory.[20] In a late version of the city, *Mnemosyne* (1991), the miniature utopian city is laid out according to the cavities and divisions within a human cranium, following the designs of an imaginary architect, but it still is not a catalog of resemblances and references to other places, for to be a catalog it would have to articulate itself through indexical order. The identification of architecture with memory was made quite clear in the fictional journal accompanying *Ouranopolis:*

> Je note les étapes de ma lente progression, car je n'ai pas encore bien compris à quelle logique, ou à quelle anarchie, répond le plan de ce bâtiment.... Je suis arrivé hier dans une zone que j'ai nommée pour moi-même la "section des architectures de la mémoire."

> [I am noting the stages of my slow progression, for I do not yet fully understand what logic, or what anarchy, this building's plan follows.... I arrived yesterday at an area that I named, for my own reference, the "section of memory architecture."][21]

The journal was typical of the texts and photographs that had accompanied the Poiriers' projects from *Ostia Antica* on. The imaginary building it described was

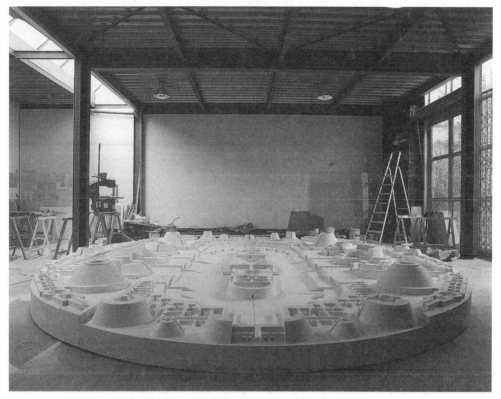

Anne and Patrick Poirier, *Mnemosyne* (1991). Installation view. Wood, tempera, 276 inches × 196 inches × 12 inches. Courtesy Thaddeus Ropac Gallery, Paris.

devoted to memory architecture of a type familiar from memory science. One wing, according to their text, was dominated by a long corridor from which doors issued; each door bore the name of one of the Poiriers' previous installations, including *Mnemosyne*. There was no trace of the inhabitants of this Lilliputian world. The Poiriers' fictional architect/archaeologist then described his unease, as he saw his own silhouette "qui s'enfuit au fond d'une galerie" [which fled to the back of a gallery].[22] The phantom archaeologist disappeared into the gloom, and so, too, did the individual artistic identities of the two members of the collaboration. The Poiriers constructed a fictional, framing metatext to navigate the near-infinite detail of their installations for the viewer, because the monuments of Mnemosyne differed from each other only marginally and were composed into meaningful patterns and forms that vaguely recalled other buildings and places.

Mnemosyne is the representation of the city as a body and a text: Words are incorporated in the artists' explanatory fiction, and images are visibly reproduced from other sources, though these remain only half-clear. Assembled out of these recognizable or hermetic architectural components, the model city coheres into the shape of a brain. At the center is an arena, near which are a Theatre of Memory, a Theatre of Oblivion, and rooms for the soul. Building fragments and pyramidal shapes are strewn

around the steps of the amphitheater; all of these look like architectural fragments composed according to classical orders. The city is based on the strange organization of Aby Warburg's Hamburg library, which later became the basis for the Warburg Institute (London). The famous art historian and inventor of iconology arranged his books according to shifting iconological divisions instead of alphabetical order or the Dewey system.[23] The Poiriers read books by Erwin Panofsky in translation during the late 1960s, and they were intimately aware of the science of iconology, as *Mnemosyne* demonstrates. Craig Owens insisted that in allegory, the reader's attention shuttles from text to text; it occurs whenever "one text is *read through* another."[24] He described postmodern works where allegory led, through fragmentation, to the collapse of signification. *Mnemosyne* is slightly different: It is a highly symbolic visual "text" that is nonetheless not primarily allegorical, for its poetic identifications give way neither to other texts nor to a collapse of signification. Its symbols point toward iconological, not iconographic, organization. This is not to suggest that the Poiriers' work is not symbolic—it is—but simply to note that it is so overloaded with metaphor that metaphoric order and relationships collapse, but not quite in the way outlined by Owens. The viewer's primary visual relationships are either with the work's spectacular whole or with its iconic details, a poetic contamination we saw earlier in the dilemmas faced by early conceptual artists. The point is this: The Poirier's works are indecipherable despite the legibility of their symbolic order, the coherence of their organization, and their arrangements that mimic meaningful propositions. The interpretation of memory and time as layered, spatial, and potentially indecipherable is completely familiar to archaeologists, and archaeology was the discipline the Poiriers simulated.

The question of how and to what end "memory" can be theorized and organized looms large, for all the elements in the complicated visual fields constituted by the Poiriers' ruined cities were connected with what the artists insisted was the important aspect of their work: memory. But memory would have to be something more than an imprecise evocation of mood, for, if this were not the case, memory would be nothing more than the nostalgia familiar from the neoexpressionist return to the past. The nature of the Poiriers' cities' organization was twofold: views of ruined cities, and fragments drawn from an archive (and excerpted from an infinite storehouse of images). Spread out across a horizontal plane, their cities appeared capable of infinite extension like the ruined archives they depicted. Their cities came to be modeled on ancient and medieval memory-retrieval systems. For example, the primary identifications of *Ostia Antica* are between memory and architecture. The cities are texts, and the buildings are to be read like hyperlinks. Accordingly, thoughts are identified with architectural forms, and both are seen as a sort of writing in the mind that when presented as images, appear both chaotic and ruinous.

Both Frances Yates and Mary Carruthers have established that these identifications are ancient, even though they have been marginalized from the birth of printing onward; as Carruthers observes, "memory as a written surface is so ancient and pervasive in all Western cultures that it must, I think, be seen as a governing model."[25]

Further, this memory writing could be organized to mnemonic effect by practitioners through constructed imaginary landscapes "imprinted" by memorization onto the surface of the mind, which was conceptualized by mnemonics experts as being malleable and soft, like wax. But why privilege the visual in the economy of memory? The answer, according to Carruthers, is that "[a]ccording to the early writers, retention and retrieval are stimulated best by visual means, and the visual forms of sense perception are what gives stability and permanence to memory storage."[26] From their encounters with both Frances Yates's and Mary Carruthers's books, the Poiriers consciously ordered their works according to the art of memory—systems invented by pre-Enlightenment philosophers to memorize vast quantities of information. At the same time, their works exploited the loss of these systems as the common heritage of literate, knowing subjects. In other words, their cities offer themselves as texts but pose the text as a seductive secret, as a representation that is self-consciously limited to the metonymic traces left by a withdrawal.

Carruthers's descriptions of "memory as a set of waxed tablets upon which material is inscribed, and memory as a storehouse or inventory" match many of the Poiriers' works, for they exactly resemble these mnemonic libraries. The cast-paper reliefs that accompanied the cities in suites corresponded to the imaginary figures and carved bodies that were linked by the memory system to each specific space. Paper casting provided an indexical register, capturing the "texture" of history as well. These casts resemble the imaginary sculptures that, according to Carruthers, were envisaged in front of regularly divided architectural spaces. The spaces' detail was to be visualized with great clarity, often in the obscurity of semidarkness—much, one gathers, in the manner of a bas-relief or the latter-day, flatbed space typical of Robert Rauschenberg's 1960s silk-screen prints. Memory, it emerges from Carruthers's and Yates's expositions of these theories, has rules: From Cicero's *De inventione* (86–82 B.C.) onward, mnemonic experts asserted that images are easier to remember than words, and the easiest images to remember are bizarre, violent, and fantastic. Images were to be meditated upon; their obscurity and partialness was deliberate, and there was a built-in indeterminacy that hampered both iconographic programming and the audience's iconographic but not proto-iconological interpretation. The "meaning" of the past, of which memories are traces, is not stable. It was no more available to the Poiriers' audiences than it had been to the viewers of Smithson's *Spiral Jetty*, and the latter's refusal to disclose itself as a meaningful proposition is comparable to the Poiriers' (or, to make the point even clearer, Anselm Kiefer's) works' prolific, easily deciphered iconographical references that do not really explain anything about the art. In this way, the very degeneracy of classical motifs and the collapse of tradition that might have seemed to invalidate the Poiriers' fragmented classicism was precisely their point.

The Poiriers' miniature cities exhibit, then, a certain semantic impenetrability that has nothing to do with artistic limitations; rather, it is highly deliberate, reflecting the artists' early awareness of *arte povera* and minimalism. Their model cities are imaginary but plausible reconstructions, and so they hover in a zone between historical

responsibility and fiction. The Poiriers responded to the evacuation of signification by reinvesting the work of art with an exaggerated aura connected with the framing discourses with which they surrounded their works. This produced both significations and contamination. Poetry and aura are linked terms, and both, as early conceptualists were aware, are the outcomes of ruination. If the Poiriers stressed the term memory, they linked it to a specific chain of significations:

> Our activity about war and the fragility of culture, which is in reality the major *axe* [axis] of our research, with the actual "DESEQUILIBRE" in the world and this end of the century, and also the fact of getting older makes our work more specific in that direction. Also, the CRUELTY.[27]

In the years after 1945, modern Europe seemed to have been turned into a ruin by war. Both artists were brought up among the reconstruction of what seemed to them like the wreckage of a great ship, and they were intensely aware of their childhood memories of those ruins while they were working on *Ostia Antica* and its companion cities, returning to the same photographs of ruins—photographs from their extensive travels in Cambodia, Turkey, and the Mediterranean Basin—interspersed with images of Europe in ruins just after 1945, correlating different times and places through the organizing theme of violence.[28] It is not clear whether the Poiriers were embodying an antiocular impulse or whether they were alluding to and citing such an impulse: Belief in the ability of images to preserve memory was at apparent odds with their equal belief in the collapse and catastrophic ruin of the city of memory. There is a special category of images that escapes this contradiction, of course: the conjunction of ruins and words, which has its own name—epigraphy—and a long tradition. Its appearance in art was both personally and artistically significant for the artists. According to Patrick Poirier, he met Anne in front of Nicolas Poussin's *Et in Arcadia ego* (1638–39) at the Louvre.[29]

Even if untrue, the anecdote is telling, for the Poiriers, like Poussin, both depicted and constructed epigraphic inscriptions. Poussin's Arcadian shepherds discover, upon deciphering an inscription that they find half-hidden at a ruin, that death and historical memory intersect in the art of architectural epigraphy. We have to understand the ambivalence that underlay the attraction of such an image in the later 1960s, in the first years after the first waves of minimalist and conceptualist art: Scottish artist Ian Hamilton Finlay's constructed garden at Stonypath provides an illuminating comparison.[30] Finlay, like the Poiriers, did not so much reconcile these trajectories as insist on their constant, fragile coexistence. The Poiriers and Finlay were both intensely aware of the catastrophe embodied as modern history. They both appropriated classical iconographies of cults of death as preserved in funerary statuary and ruins, for the idea of death has always been as culturally constructed as the idea of a knowing subject: Memorials and monuments, for example, are erected in order to express achievements and to teach history; these icons, as much as representations of the dead, have been the means of creating memory.[31]

Self-consciously memorial art such as the Poiriers' also implies a didactic message, as well as an understanding that memorials define and delimit traumatic memory. The Poiriers' version of antiquity relies on our acceptance of the commemorative connotations carried by the classical past. This is a second-order dialectic, like that of Anselm Kiefer's paintings of ruined fascist architecture, dependent upon a knowledgeable subject's appreciation of the disjunction of word and image, and its obstinate obscurity explains the Poiriers' overdetermination of their antiocular significations. The identification of antiquity with memory also relies on our acquiescence in Warburg's theories of iconology—and in particular in his belief, underlying the *Mnemosyne Atlas* project (1929), his unfinished archival assemblages of reproductions of art and images from mass culture, that certain artistic images are charged with a special affective aura connected with their nature as the composite of a chain of previous images—or in Siegfried Kracauer's notion of the "*monogram*," an unforgettable image that would condense an individual's biography into a single, meaningful ornamental figure.[32]

The Author as Traveling Subject

Ostia Antica is an excerpt from an overarching project. The Poiriers formulated this encompassing "work" at the start of their career and spent the next decades elaborating it with single-minded diligence:

> Bit by bit, in stages and through successive accumulations, we form and construct the different rooms of an immense Museum-Library of which we are, simultaneously, both the archaeologists and the architects. . . . For more than 20 years, at the risk of losing ourselves, we have nevertheless persevered in this mental and physical rambling, pushed by an immense curiosity, not for the past, as most people believed, but rather for that essential faculty of which we are constituted, i.e., Memory, and which Sigmund Freud, who also loved archaeological metaphors, compared to ancient Rome.[33]

With these words and images in mind, it is additionally clear that the ruined cities are representations of mental cataclysm, for the brain is an obvious metonym for memory. The shattered glass shards of the later work, *Ouranopolis*, are the putative result of earthquakes and were totally consistent with this aim. The contents of the human head are represented as ruins and buildings but also as apparently endless containers subject to cataclysm. The spectacular horizontal extension of the Poiriers' ruins is a model of the way memory proliferates, even when subject to sickness and convulsion. This mental spatiality is a crucial concept both for an understanding of the Poiriers' works and also for an architectural and predominantly visual conception of memory. Their project incorporated earlier work into its schema after the event, altering the emphasis and even, retrospectively, the meaning of previous installations, rendering iconographical programs and chronological history completely relative, so that they appeared as discrete parts of an infinitely extending, expanding whole, like a vast,

blank dream (or memory) screen. They were retrospectively rewriting their oeuvre. The double nature of this horizontality was apparent to reviewers, even hostile ones, as a deliberate artistic restriction to external rather than internal signification (an eclectic relation to style) and as a precursor of a nascent postmodern relationship to historical eclecticism.

This was the inevitable constraint of a working mode based on a critical attitude to avant-garde history, as was that of Gilbert & George: The Poiriers' constraints and eclecticism were easily mistaken as conservatism, amounting, as they did, to a self-conscious disavowal of personal subjectivity. Like Gilbert & George, then, the Poiriers could be categorized as purveyors of morbid nostalgia and melancholy, but this nostalgia—the final, lowest point of sentiment in an involution from memory, according to Bergson—was the object of both artist teams' critique. Their collaborations—and the alternate identities these implied to the viewer—were different aspects of a related critique of artistic identity as anything other than textual. And in the Poiriers' collaboration, individual artistic identity was subsumed. They insisted that a quite different author was constituted by their collaboration, not the combination of two subjectivities but "a new, invented author."[34] "His" works were elaborated over time as excerpts from a much larger phantom project:

> Et de même que je porte en moi un immense paysage, une ville sans fin formé de tous les lieux et de tous les temps de ma vie, j'imagine la Mémoire, cette MNEMOSYNE primordiale dont parlent les théogonies oubliées, comme une architecture immense.

> [And just as I carry within myself an immense landscape, an unending city comprising all the places and all the times of my life, I imagine memory, this primordial MNEMOSYNE that forgotten theogonies speak of, as an immense structure.][35]

The device of a fictional identity allowed the Poiriers to imagine themselves traveling in their own works as their "third hand," an architect-archaeologist. They had constructed a relatively passive and therefore quite matter-of-fact "subject-who-remembers," to borrow Mary Carruthers's description of the medieval subject in memory discourse.[36] The Poiriers' written narratives and stories were fictional equivalents of explanatory catalog essays or research papers through which the artists expanded the titular, framing function usually reserved by critics and curators into a full-blown, artist-generated, quasi-critical commentary, replete with elaborate critical apparatus. Other French artists, most obviously Jean le Gac, were generating narrative texts as art at the same time. Fictional construction disrupted the stable orderly flow of museum time. The audience saw a documentary image "without a future," to paraphrase Roland Barthes, who divided the history of the world into two phases, predating and postdating the history of photography.[37] The almost exclusively documentary existence of *Mnemosyne* froze it in a quasi-documentary zone of hybrid aesthetic status that disrupted the perceived flow of time, for the snapshots offered by its documentation and incarnation as several installations did not swim onward,

changing over time with a subject according to the normal flow of history and memory. If, after the invention of the photograph, the past became as certain as the present but immutable, then works of art that mimicked documentation (especially photographic documentation or quasi-scientific reconstructions that indexed a nonexistent referent) were a special case of this hybridity, especially in the sense that, as Barthes noted, photography (and memorialization) produced "neither subject or object but a subject who feels he is becoming an object."[38]

We shall return to this distinction in relation to the intersection of text and image. Here, though, the process of fictionalization did not result in the artists' total identification with their work, as it did with the artists of chapters 6 to 9. The Poiriers preserved the distinction between their invented single identity and their own lives, often working separately for long periods in their Paris studio on collaborative projects. Even though they frequently gathered resources and documentation on site individually, they found that they always ended with the same responses and inspirations. Their fictionalization was considerably more complex than the simple creation of an artistic research team based on the complementary talents of its members. They created a fragmented subject and a fragmented spectator, who was a reader and a viewer, but one who was kept ignorant of the systems encompassing and explaining the work.

There is a similar oeuvre that illuminates the correlations between the city as a text and as a memory storage navigated by a modified artistic identity: the conceptual art and landscape architecture of Arakawa and Madeline Gins from the 1970s onward. Arakawa's and Gins's artistic collaboration was directly related to their quasi-scientific, philosophical research into mental extension and memory. Their later projects were architectural in scale, relating parts of the brain to buildings and garden architecture of their own design. *Site of Reversible Destiny* (1996), at Yoro Park, Gifu, Japan, looks like a map of the brain. Different segments of the site are divided into discrete areas designated as the places to perform different mental functions and are clearly signposted. Areas include a Trajectory Membrane Gate, a Landing Site, a Person Region, the Body Enclave, and the Person as World Suffusion Zone. The artists' elimination of a stable, monocultural self was also a refutation of the associated construction of time. Their gardens are images of a globally interdependent self. According to this quasi-phenomenological view, movement and time occur across physical space but time represents the organization of the experience of space.

In the same way, the cities of *Mnemosyne* and *Domus Aurea* existed in a conversation in time and space with their companion installations. The whole work materializes across individual installations as the Poiriers' unitary corpus. Their "third hand"— the invented archaeologist—is an investigator, whose systematic finds construct an image of knowledge that is highly anthropomorphic and that contains subterranean images and stratified layers that are connected, gradually comprising a bigger, holistic image that exists only in memory but is an image of the subject's own body. In other words, the total work—the city of Ouranopolis—could never be concretely shown,

Anne and Patrick Poirier, *Domus Aurea,* Construction #IV (1976–77). Installation view. Water, wood, charcoal, coal, paint, 590 inches × 315 inches. Collection FRAC, Bretagne.

not least because the body can never be seen whole by its owner (a point to which we will return) except in memory. The experience of contemplating the two works, and the Poiriers' installations in general (even when they include sections of legible text that superficially suggest straightforward allegorical decoding), is spatial and stratified in the extreme. Arakawa's and Gins's architectural theories resemble this, for the type of memory that is necessary to find one's way around the Site of Reversible Destiny, as well as across Ostia Antica and Mnemosyne, was based on repetition and repro- duction according to corporeal experience. Subjects can incorporate but can also ex- pel experience, and intention can be mobilized like a bodily movement in space.[39] According to Arakawa and Gins, memory constructs time; it is crucial to find one's way in space (and therefore in time).

In an earlier text, *Pour ne pas mourir* (To Not Die) (1979), Arakawa and Gins had described the fiction of space, place, and the creation of space in typically pedantic prose: "To observe (experience) through a 'fiction of place' the inevitability of blank in the land of configured energies out of which space (desire/perception/will) is form- ing."[40] They later referred to existence as a series of interconnected moments of self- consciousness and reflexivity that they called "landing sites," places where the subject registers where he or she is. They divided these sites into three eccentrically named categories: "perceptual landing sites," which describe moments of tactility and corpo- real sensation; "imaging landing sites," which describe the activity that fills in the gaps between such moments and allows the subject to create a map; and finally, "architec- tural landing sites," which described the experience of perceptual and phenomenolog- ical location.[41] Both teams' systems are obscure and hermetic; both developed a quasi- architectural phenomenology from tautological conceptualism and minimalism—in the Poiriers' case, as architectural fragments, and for Arakawa and Gins, as proposi- tions on canvas or, later, as gardens. Both teams created works that proliferate in potentially endless sequences and series, elaborating memory as layered and spatial.

The Heap of Stones and Words

Anne and Patrick Poirier's cities resemble anarchic collections of obsoletely coded wreckage; in terms of memory conceived as lacking defined contours, this is totally appropriate. Conceptual art had focused on the same issues of memory and classifi- cation, for its activities were no longer necessarily bound by an object but by the need to hold large amounts of information in the head. Inevitably, artists rediscovered her- metic systems of memory organization and systems of archival representation. Arturo Schwarz's and Jack Burnham's fantastic (and now somewhat unfashionable) symbolic readings of Duchamp's oeuvre were revisionist symptoms of such a process.[42] Many artists had come to expect, as Jack Burnham observed, that "[p]resently it will be accepted that art is an archaic information processing system, characteristically Byzan- tine rather than inefficient."[43] Burnham proposed that the advanced artist's role was to prepare new codes and analyze data when making works of art. If "the art object is,

in effect, an information 'trigger' for mobilizing the information cycle," then Burnham was allotting art a role outside an allegorical economy: a role connected instead to memory and its determined retrieval of a preexisting storehouse of images or, alternately, to its ability to represent and reorganize—to morph—the mutable contents of this storehouse.[44] This difference is highly significant, but it also begs the question of the status of both archaic memory systems and, equally, the primitive state of information retrieval using computers in the 1960s, along with the romantic rhetoric associated with their arrival.

From this summary, it might be guessed that a successful systems aesthetic concerned with a rigorous relation to cultural memory would need to base itself on images rather than text. The reason is, as Carruthers observed, that "a true memory image is a mental creation, and it has the elaboration and flexibility, the ability to store and sort large amounts of information, that no pictured diagram can possibly approximate."[45] A systems-based art could, as an obvious corollary, also perhaps embody a comprehension and critique of iconology. This was the irony of the Poiriers' use of Warburg's library plan—their appropriation of iconology's founder's "memory" while simultaneously turning iconic forms to a different use: to creating a ruinous, uncontrollable relationship between signifier and signified, even though antique systems supposedly assumed a stable relation. When the artists of chapters 3, 4, and 5 talked about the recovery or the preservation of memory, they were speaking as much about memory as a capacity as about the preservation of memory's contents. Most of all, they were seeking to be precise, not nostalgically diffuse.

The Poiriers' cities reprivileged the visual, not through rhetorical appeals to tradition but through the fastidious organization of multiple descriptions—which resembled Burnham's "list structures" in their enumeration of every possible, quasi-conceptual facet of a project or an idea—and through the tropes of the gigantic and the miniature. Though few of their conceptualist peers made the same connection with memory structures, there were notable exceptions, most obviously Alighiero e Boetti, who also worked in collaborations. Repetition, obscurity, and stratification reflected identifiable historical, but also contemporary, conceptions of memory in which its objects were not limited by defining contours and in which both subject/object boundaries (as in Barthes's descriptions of photographic memory) and signifier/signified relations were actively blurred. Collaborative and fictionalized authorship emphasized this blurring. At the same time, the "memory" described by the Poiriers, in both their works and their statements, was prompted or organized by iconic images or, more exactly, images of memory systems based on iconic forms that had indistinct but oracular significations, like memories' indistinct contours. But the Poiriers also welcomed untrammeled interpretation, as conceptual artists had not. Their obsession with magnification, miniaturization and the grotesque was absolutely congruent with such a logic of reading and deliberate openness, even indeterminacy, in relation to critical interpretation. Their ruins sit strangely beside the works of their *arte povera* peers or Robert Smithson's spirals because of their virtuosic exaggeration of craft

and delirious inflation of the rhetoric surrounding memory. On the other hand, their deserted, *Marie Celeste*-like installations are uncanny, and this (along with their awareness of memory systems) was symptomatic of a more widely felt, though almost always more myopic, attempt to reintroduce metaphoric and narrative systems into conceptualism that, in Europe, led to many conceptualists' "return" to conventional media and conventional art objects. Both Boyle Family and Anne and Patrick Poirier preserved recognizable definitions of studio-based "art," even if this work was arrived at through unconventional identities and systems and by work far outside the studio. But the Poiriers revisualization of viewing went further: They articulated their ruined fragments and cities so thoroughly, as both microcosms and macrocosms of modernity's crises, that the viewer reread their cities and museums—and therefore memory itself—as spatial texts deliberately and systematically withholding a secret place of origin.

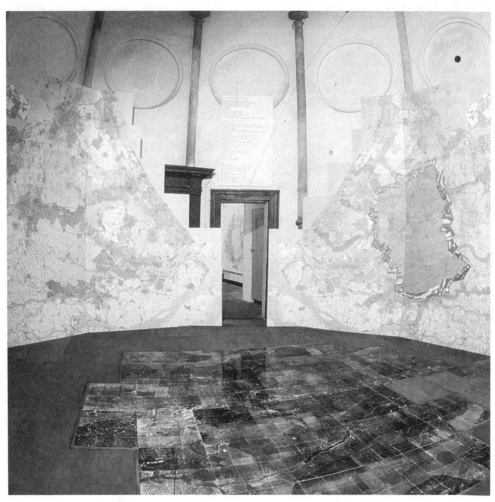

Helen Mayer Harrison and Newton Harrison, *Green Heart Vision* (1995). Overall installation view of proposal prepared for the Cultural Council of Southern Holland and the Province of South Holland, proposing an ecological corridor, 1–2 kilometers wide, separating urban from agricultural areas in the Randstad.

5. Memory and Ethics:
Helen Mayer Harrison and Newton Harrison

The Client Is the Environment

Memory can be contained within images, and chapters 1–4 have revolved around descriptions of how artists emerging from the context of a highly antivisual conceptualism grappled with images, not words, in order to construct memory systems while at the same time admitting the ruinous relationship of intention to unconstrained textuality. Intention, signification, and memory had clearly become problematic concepts. To be sure, memory's significations in art were often vague and even willfully obscure, as critics noted even in the early 1970s. My discussion, however, is not a critique of theories of memory as such. It is a description of the way memory in art was constructed—or, more accurately, of the way artists made attempts to organize memory substitutes according to more precise systems and intentions than simply those of nostalgia. Iconology and mnemonic systems were but two possible, though almost certainly inadequate, models for the representation, structuring, and regulation of memory in visual texts.[1] For all this, the question remains: Does such unexpected precision, framed by new types of artistic identity, simply offer the same old meanings? That is the underlying question in this chapter's analysis of Helen Mayer Harrison and Newton Harrison's environmental art.

According to memory theorist Mary Carruthers, pre-Renaissance readers valued memory much more highly than its opposite, imagination; the reverse has by and large been the case since the nineteenth century. The working method of collaboration has convenient if superficial affinities with memory, for the fact of artistic collaboration implies an ideological downplaying of the role of imagination as it is usually conceived: as the expression of individual subjectivity. Memory, on the other hand, makes things relative: It gives perspective and has therefore sometimes been considered ethical in itself because it relativizes the individual, self-centered subjectivity that is a poor guide

to how to act. According to medieval theologians, the commemorative process transpiring from the act of reading is ethical because reading a book is a process resembling a meeting of minds, a way of making others present, and therefore reaches beyond the confines of an egoistic "I."[2] It is not mechanical or transparent. By default, the artistic collaborations discussed in chapters 3–5 tended to reprioritize both critical memory and historical memory. By no coincidence, all of these artists saw their collaborations and their art in highly ethical terms. They felt that memory needed to be preserved precisely because in a society in need of ethics, in need of a guide to how to act in the world—especially with regard to the fragile environment—memory would be ethical. An ethical art, however, would have to be constructed without descending into anachronistic romanticism (as the Boyles so accurately understood) and without forgetting the lessons of conceptual art. The theatrical and historicist language of Boyle Family and Anne and Patrick Poirier was interwoven with a desire for an ethical postconceptualist art, and this was also true for Helen Mayer Harrison and Newton Harrison.

For the Harrisons, conceptual art consisted of a "conversation between artist and audience, using different signs."[3] They had been always concerned with ethical, environmental, and moral issues, and conceptual art seemed to them to privilege nothing except art: They found its cerebral, disinterested mental abstraction completely insufficient. The Harrisons' installations, books, and sites represent the uncanny surfacing of something repressed but present in minimal and conceptual art: ethics. Ethics had been potential but not manifest in earlier minimalism. They were implied in the framing discourses of Donald Judd's highly moralistic art criticism and later in the austere rigors of his site-specific self-curating at Marfa, Texas, and they were equally clear in Carl Andre's participation in the antiwar and Art Workers' Coalition movements.[4] Minimalist artists, however, did not wish to bluntly spell out in their work their awareness that art is not disinterested; the Harrisons did. They understood that art is implicated in the movements of power, and the texts in their works reflect on their place in this exchange. According to the Harrisons, their client was not a museum, corporation, or public authority. Instead, Helen Mayer Harrison observed, "The client is the environment." Their own relation to money was that they made "art in the public interest" in a situation where "the metaphors and values once given to ecology are now given to the marketplace." They charged fees for their commissions: "Ethics mean we have to get paid." Their fees were negotiated according to each project, and they strictly avoided all speculative investments, even though their projects sometimes had considerable impact on real estate values. For example, their proposal for massive land rezoning affected land values in the region bordering on their Dutch *Green Heart Vision* project (1995).

A Single Decision Generates a Life's Work

Helen Mayer Harrison and Newton Harrison began their artistic collaboration in 1971. They intended this as a lifetime artistic decision, but it was not an abrupt decision, for

Helen Mayer Harrison had assisted Newton Harrison with his previous, systems-based installations, and according to Newton Harrison, they had been cooperating on projects for several years. Both were heavily involved in the peace movement, and they subsequently worked together at the Peace Center in Greenwich Village, and at David Dellinger's Living Center in New Jersey. Helen Harrison also worked as the New York coordinator of the Women's Strike for Peace in the early 1960s. Newton Harrison recalled that in 1969 they jointly constructed a world map of endangered species. At that point, although they continually consulted each other about Newton's works and about contemporary art in general, they maintained separate careers, Newton as an artist, Helen as a sociologist.

For all their previous cooperation, they were both aware that the decision to collaborate artistically was a "frame" separating the new work from their previous activities and that the distinguishing force of the frame was based on a conceptual decision or act: "Part of the discourse of that period was the idea that a single decision could generate a life's work. So we asked ourselves, 'What would be a nontrivial single decision?'"[5] Their decision to abandon separate careers was prompted when Helen Harrison was fast-tracked for a prospective vice-chancellorship at the University of California. She felt she could work toward the radical social change she wished for more readily by collaborating with Newton as an artist than through the slow, incremental bureaucracy of the University of California system, where they had both been faculty members since 1967. So, according to Newton Harrison, "In a sense, Helen became an artist and I became a researcher, in the process of teaching each other to be the other party."[6] They recall that the reaction from other artists, including those involved in performance, installation, and conceptual art, was extraordinarily negative. Most assumed that Helen Harrison would disappear, subsumed by male ego (an assumption that we also saw surface in connection with Boyle Family): "Eleanor Antin said 'How can you let Newton take you over?' People got used to it. By 1976, no one was worried."

From the start, Helen Mayer Harrison and Newton Harrison worked on an epic scale. Employing fieldwork techniques from sociology, such as interviews and community consultations, they gathered vast amounts of information about environmentally threatened sites. From this research, they made large series of collages, photomurals, and books, combining enlargements of aerial photographs, maps, and illustrative drawings with evocative texts, captions, and detailed descriptions of ecological strategies that were designed to heal degraded or damaged regions. The effect was poetic but unambiguously practical, for they were suggesting concrete, socially viable environmental strategies. They complicated this straightforward and increasingly pedagogical aim in two ways. Both require that we take account of artistic collaboration.

First, the Harrisons were effectively engaged in the creation of a surrogate body composed of combinations of texts, poetry, manifestos, and installations. All this was framed by the fact of the Harrisons' artistic collaboration in which, as well as working

with each other, they subcontracted tasks to short-term and long-term team members, rather like the directors of a small, highly specialized, and highly respected consultancy business. Their letterhead read: "The Harrison Studio, Helen Mayer Harrison, Newton Harrison & Associates." At different times their children worked with them, just as Sebastian and Georgia Boyle worked with their parents. The Harrisons employed the same core team of researchers over several projects: Vera Westergaad and Gabriel Harrison.

In effect, they constructed a collaborative entity composed of many people, and they used media like photocopiers, computers, drafting machines, and even, in early works such as *Portable Fish Farm: Survival Piece #3* (1971), living animals such as catfish, brine shrimp, and lobsters instead of paint and paper. In their projects, the Harrisons constructed complex feasibility studies, sending out "vision statements" and poetic manifestos through project submissions, environmental impact statements, press releases, and the mail. In other words, the Harrisons' artistic identity was constructed through the traces of projects—which often did not exist at all except through letterheaded correspondence, exhibition documentation, artists' books, architectural plans, and mappings of projected futures. They were effectively working as environmental consultants, although they still exhibited in art galleries and museums, for they were involved in real projects to effect environmental change. They worked, in their own words, in a zone between art, landscape design, and architecture. Other artists of their generation moved toward this area for similar reasons: From the 1980s onward, for example, Vito Acconci—previously known for his confrontational solo actions—

Helen Mayer Harrison and Newton Harrison, *Portable Fish Farm: Survival Piece #3* (1971). Installation view, six rubber-lined tanks, 96 inches × 240 inches × 36 inches, containing catfish, brine shrimp, and lobster ecosystem. Catfish electrocuted at exhibition opening for ritual feast, exhibited in *Eleven Los Angeles Artists,* Hayward Gallery, London (1971).

worked with his own team of landscape architects. The Harrisons' studio statement and artists' book for a later project, *Green Heart Vision* (1995), emphasized the importance they attached to imagining and defining their iconic concepts through teamwork, so both the issues they addressed and their own speaking positions (physical, geographic, and ethical) were constantly described, monitored, and acknowledged:

> Finally
> the Green Heart
> cannot continue to be itself
> until
> and unless
> its borders
> are defined.[7]

The same artists' book contains a description of their working process: The initial phase of collaboration was completely private—just the artists and their core team—permitting a free allocation of working roles and generation of ideas; after a period of intensive research, mental overload, and information gathering, they produced a "conceptual vision," and only then did they commission external participation.[8] At this point they contacted professionals and planners to assist in the execution of the conceptual design. Maarten van Wesemael mentions several working concepts that the Harrisons associated with the process of artistic collaboration, including "conversation" and "drift." (These terms will be clarified later in this chapter.)

The process of diffused authorship, here necessarily accompanied by conferences, media events, and intense discussion with ever-expanding circles of people, was also accompanied by a movement beyond the studio—toward research carried out on site in locations as diverse as the Sacramento River delta, California; Kassel, Germany; Pasadena, California; and Ljubljana, Slovenia. Such fieldwork lay beyond the psychically lonely location within which artistic authenticity had traditionally been framed and certified: the artist's studio. Caroline Jones has analyzed the use of industrial models of production and location by postwar American artists, and her conclusion tallies with the evidence of this book so far: that the changing nature of the "machine in the studio" (her phrase) was accompanied by shifts in authorial identities, away from the individual, studio-based artist toward art made outside any conventional studio or configuration of artistic workers, noting in the process the phenomenon of collaborative teams such as Anne and Patrick Poirier, Komar and Melamid, or Gilbert & George.[9] As she observes, such teams directly embodied a critique of the certifying, original hand of the artist, for their works made it clear that more than one artist was making the art. The Harrisons' encyclopedic compilation of separate environmental studies and futurological predictions, *The Lagoon Cycle* (1974–84), demonstrates this fragmentation and specialization: They commissioned scientists, technicians, and model fabricators wherever they needed to assemble information and materials beyond their individual expertise.

There was a second way by which they complicated their pedagogical aim: The Harrisons' ability to persuade the audience of the importance of what they were saying depended on their communicating a relationship to history based on unusually long-term perspectives and hence on the invocation of memory. This immediately recalls the Poiriers, and, as it happens, both teams were at least distantly aware and positively respectful of each other's work. During the early 1970s, one way of invoking this perspective seemed to be to provide overwhelming detail. Another was to enfold historical evidence and autobiography alike in a laconic, matter-of-fact poetic style that was vague about precise metaphoric meaning: Donald Judd's criticism and Richard Long's or Hamish Fulton's lists and brief descriptions of land art walks were examples. Such lists were useful because, in Jack Burnham's words, they provided the "phenomenal qualities which would never have shown up in a fabricator's plans, but which proved necessary for the 'seeing' of the object."[10] But simply fabricating miniature ecosystems as fantasies without real-time framing texts would not have achieved what the Harrisons wanted, for they wished to move beyond minimalist ambiguity and suggestiveness into more direct advocacy. The problem was to do this without falling prey to the impoverishment of artistic language by either political overdetermination or the indecipherable, problematically ambiguous aesthetics of inchoately recalled (but auratically enhanced) memory chains.

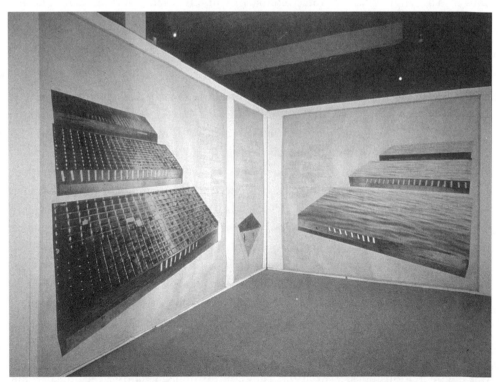

Helen Mayer Harrison and Newton Harrison, *Panel 4* and *Panel 6, The Third Lagoon*, from *The Lagoon Cycle* (1974–84). Installation view of two mural panels (*Panel 4*: 96 inches × 101 inches; *Panel 6*: 96 inches × 98 inches), detail from mural in more than fifty parts. Collection John Kluge, Metromedia.

The solution was to match overwhelming detail with an antiteleological relationship to artistic innovation. In other words, the Harrisons appropriated conceptual art without necessarily owing any commitment to its particular consciousness of art history. They freely admitted that they saw the language of conceptual art as available, like a ready-made. According to Newton Harrison, their art "was particularly related to other reductionist modes of that period." The Harrisons' complication of minimalist structures by the use of living organisms as elements was, within the strict terms of an inquiry into the nature of art, a gratuitous elaboration, but one that had precedents in conceptual art, with its declared separation of structure from meaning. On the other hand, their relation to recent art history was not simply one of style, in the sense that previous art could be merely mined for a series of surface effects, for their anthropology and sociology were practical, analytical, and ethnographic tools, as were Hans Haacke's installations of the same period, rather than decorative flourishes. Such work is now, of course, widely recognized as part of the "literary" recomplication of art suggested by Craig Owens in "Earthwords," where he outlined an artistic trajectory in which meaning surplus to the appropriate self-definition of a given artistic genre would be generated by metaphor.[11] The oscillation between the literary and the visual was common to much art, as we have seen, and this art's terms were clearly extra-artistic—social rather than aesthetic—when measured by strict formalist definitions.

The Harrisons were also just not very interested in exploring the problem of art's universality or its transcendence. Their installations embodied a vision of art as contingent upon place in space and upon location or circumstance in time. They were more concerned with the survival of natural systems than with the survival of art. They were disinterested in Kantian disinterest and therefore in Greenberg's formalism. It is clear, though, that the Harrisons depended on the "given" disinterest of art as a framing discourse within which they could manipulate and refine their otherwise functional terms. More concretely, works such as *The Lagoon Cycle* exemplified the ethnographic tendency within 1970s art that we have already noted, but they did so in a way that redefined artistic work beyond the studio as an active, participatory type of cultural anthropology. The Harrisons were more concerned with the fate of the planet than with the fate of the avant-garde, and they were even less interested in a competitive, Hegelian avant-garde relationship to history in which art-historical sources would be remobilized and modified.

Where did this distinction come from? Craig Adcock noted their "choice of ecology as a ready-made practice," linking this to their understanding of Duchamp.[12] The Harrisons specifically and pointedly acknowledged their special debt to Duchamp, but their intentions coincided with a view of avant-garde history characterized by interaction rather than rupture and by a positive disinterest in avant-garde maneuvers or a search for historical primacy. Robert Smithson was not specifically an influence upon their practice, but his textual Earth art would seem to have been an obvious model, as it was for other artists. The Harrisons said that they were conceptual artists

and that though they did not produce conventional paintings or sculptures, they did show in galleries and museums because such venues were "safe places" in which confrontations between competing discourses and groups could be enacted and resolved. Their benign installations would seem, then, to confirm Hal Foster's characterization of the avant-garde's second cyclical incarnation, as opposed to Peter Bürger's theorization of the avant-garde's failure. In Foster's account, modernist history was replayed after 1945 for the second time, and its catharsis was strategically important.[13]

There was another side to the Harrisons' relationship with avant-garde history. Their antimodernism ruled them out of possible inclusion in a canon such as Foster's post-1945 avant-garde. Even though, and perhaps because, their work displayed all the signs of a politically strategic, interdisciplinary ethnography, it refused to interest itself in art-historical arbitration or to conceptualize itself within an avant-garde framework focused on Kantian transcendence. Their attitude was instead profoundly countercultural. *The Lagoon Cycle*, for example, looked like a set of straightforward environmental and conservation investigations. Only its discursive and physical location—within the domain of contemporary art, installed in art museums—and its ambiguous poetics distinguished it from ethnographic display. The Harrisons' outsider status was comparable to that of the Boyles and Finlay: They all chose a position at the "periphery" from whence to critique the state of things rather than at the "center" to critique the state of art. This "periphery" was both metaphorical and literal. The Harrisons based themselves at Del Mar, California, near San Diego, from the 1970s on and worked seminomadically around the world as well. Del Mar is far enough away from New York—and even sufficiently distant from the nearest regional metropolis, Los Angeles—to qualify as peripheral, but the Harrisons were not interested in the idea of provincial or regional, California-based art either. Much of their working life was spent in Europe or in transit. Through a long-term ecological perspective, Sisyphean proposal preparation, and constant travel, they deliberately cultivated a global rather than a metropolitan perspective. This perspective meant that they did not necessarily conceptualize New York as the center of the world (nor the avant-garde as the locus of artistic value), and so they were able, in one early work, *San Diego as the Center of the World* (1974), to construct an azimuthal world projection with San Diego at its center.[14]

If the Harrisons, the Boyles, and the Poiriers all saw themselves as conservers of history and memory, so too did other teams define themselves in the same way. German photographers Bernd and Hilla Becher, who were often exhibited alongside minimalist artists, also saw memory as grammatical and ordered rather than as nostalgic in affect. They insisted that "[w]e do not intend to make reliquaries out of old industrial buildings. What we would like is to produce a more or less perfect chain of different forms and shapes."[15] Memory, for the Bechers, has rules and uses.

The Bechers worked together from 1959 onward and, according to former students, were almost inseparable, even sharing a teaching position (to the initial disapproval of the college administration) at the Düsseldorf Art Academy. Their long series

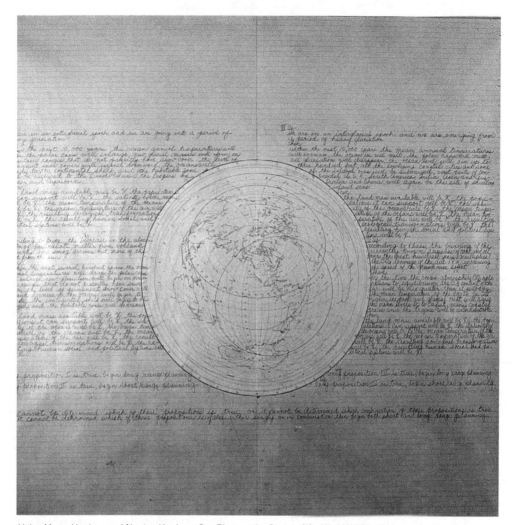

Helen Mayer Harrison and Newton Harrison, *San Diego as the Center of the World* (1974). Photomural, azimuthal equidistant projection map of the world with San Diego, California, at the center. Photographs, oils, and graphite, 96 inches × 96 inches. Collection Power Institute, University of Sydney, Sydney.

of documentary photographs of cooling towers, blast furnaces, mine heads, and industrial buildings were, according to the artists, a contribution to the archive of industrial archaeology. Their documentations of obsolete industrial plants were valued by cultural historians as well as celebrated by minimalist artists.[16] And they were categorized as minimalist or conceptualist artists because of their exhaustive enumeration of subject matter and their patient determination to record every possible variation of whatever type of industrial plant they chose, even though the differences were minute. The Bechers consistently insisted on the sociological and conservationist dimensions of their photographs: The artistic parameters of their activity—documenting obsolescent industrial cooling towers and furnaces made between 1860 and 1960 that were

disappearing from a postindustrial world—were determined by their desire to pre-serve and record but were organized according to morphological similarities of form as well as function.

The consistency of their methods accentuated these similarities: They almost always took their photographs at the same time of year (spring and autumn) and on overcast days (to take advantage of diffused, neutral light), from the same slightly ele-vated point of view, without any human figures, using very long exposures. They painstakingly shot photographs from the midpoint of each tower in order to study each object from the same position. As has often been noted, this consistency allowed a grammar of forms to emerge. It also, however, allowed their series to extend almost infinitely in the establishment of different industrial types, limited solely by the avail-ability of old factories. Like the Harrisons, the Boyles, and the Poiriers, the Bechers established an archive that was stratified and organized by repetition into types, or as they suggested, "families," in arrangements of up to nine similar towers organized on the same panel.[17] Again, archives are not encyclopedias: The Bechers' aims were not encyclopedic but, like the Poiriers', archaeological and archival. They enlarged their principles of organization with each large group of work so that previous typologies were found to be insufficient: "Our selections are obvious but it has taken us many years to realise they are obvious.... Within each group there are the same distinctions and more."[18] It must be noted that the Bechers did not specify anything other than the creation and organization of an archive as their starting point. The artistic method of anonymity that valued surface characteristics and the extension of an archive coin-cided with a personal decision to collaborate—a coincidence shared with the three other teams.

Artistic collaboration was consistent with this perspective on history, in which countercultural ideas and collective work could loom large: As we saw, Newton Har-rison linked the Harrisons' decision to work collaboratively with the quintessential 1960s countercultural penchant for basing a life's work on an arbitrary decision such as a throwing of dice or a divinatory exercise like the *I Ching*. Such countercultural perspectives were not uncommon among young artists in North America or Europe in the 1960s. The Harrisons admired Carl Gustav Jung's teachings enormously, and they recalled that alternative psychotherapist Fritz Perls (who was trained by Jung) had a big impact upon them both; Helen Mayer Harrison even worked under Perls and completed an internship with Carl Rogers. Even so, the Harrisons insisted that they had no interest at all in the culture of psychedelic drugs, nor did they have any interest in ecstatic mystical traditions. On the other hand, they had certainly been influenced by consciousness-raising psychotherapy that did not involve psychedelic substances, and they had a long-standing commitment to environmental action, hav-ing read Rachel Carson's landmark book on looming environmental disaster, *Silent Spring*, as early as 1962.

Ironically, then, Newton Harrison's last noncollaborative work embodied one of the most striking psychedelic tropes: the light show. The Los Angeles County Museum

of Art (LACMA) commissioned a light work, *The Encapsulated Aurora* (1970), for Osaka's Expo 70; it was later exhibited in LACMA's giant 1971 *Art and Technology* exhibition, curated by Maurice Tuchman.[19] The artist, who was teamed with the Jet Propulsion Laboratories, produced long, cylindrical plexiglass tubes filled with gas that glowed in darkness, as if color had been made to hang in the air—a high-technology vision of color liberated from its support.[20] *The Encapsulated Aurora*'s disembodied ethereality could equally, of course, have been seen as a three-dimensional equivalent of Jules Olitski's paintings, which show the latent but disavowed mysticism inherent in late-formalist painting, despite formalist critics' temperamental distaste for popular culture and the highly theatrical counterculture.

The Harrisons' first installations were the *Survival Series* (1971–73). These large, laboriously constructed simulacra of small, simple ecosystems reflect the development of a trajectory—one that aimed to leave the lightest and most invisible of footprints in the environment—different and separate from the Earth art characterized by Robert Smithson or Michael Heizer.[21] Their first fish farm, the fulsomely titled *Notations on the Ecosystem of the Western Salt Works with the Inclusion of Brine Shrimp: Survival Piece #2* (1971), reflects the zeitgeist of the U.S. domestic context at the beginning of the 1970s—increasing ecological consciousness, flourishing conservation movements, and the proliferation of communes—incorporating the inevitable biosphere, a modern Noah's ark, and New Age ritual.[22] The work (also exhibited at LACMA's *Art and Technology*) may have constituted the first discrete ecosystem to be used as both subject matter and materials in art. Its ritual associations were lost neither on contemporary viewers nor on the Harrisons, who invented elaborate and somewhat contrived rituals ("Harvesting and Feasting" actions) for *Notations on the Ecosystem of the Western Salt Works with the Inclusion of Brine Shrimp: Survival Piece #2*. When *Portable Fish Farm: Survival Piece #3* (1971) was installed in London for the exhibition *Eleven Los Angeles Artists,* the Harrisons built six large rubber-lined tanks containing catfish, brine shrimp, and lobsters. They harvested and cooked the fish as the marine animals grew, but their attempts to serve the cooked fish to the audience provoked complaints from English animal liberationists. The artists had initially felt that each of these works was a minimalist "field" and that, at a certain level, a shift in scale was the only structural difference between their fish farms and Sol LeWitt's wall drawings or Carl Andre's floor pieces. However, Newton Harrison observed that when the works were realized, "the outcome turned out to be something other than a minimalist or conceptualist work of art."[23]

Up to this point, the Harrisons were dividing their labor according to gender-defined roles: nurturing, washing, and cooking were allocated to Helen; Newton built and maintained the tank and ecosystem. According to the artists, 1970–71 was a period of research in which they established the methods and routines possible with collaboration, and between 1971–73 they experimented with gender-coded, highly determined performances and rituals, whose gender divisions they were later to firmly reject.

Helen Mayer Harrison and Newton Harrison, *Notations on the Ecosystem of the Western Salt Works with the Inclusion of Brine Shrimp: Survival Piece #2* (1971). Installation view, wooden box, 120 inches × 480 inches × 10 inches, with four compartments, containing *Dunaliella* algae and *Artemia* brine shrimp ecosystem, up to one ton per acre harvest rate. Exhibited in *Art and Technology,* Los Angeles County Museum, Los Angeles (1971).

It is important to remember the different connotations and disjunctions of technology and ecology from the late 1960s on. Jack Burnham observed in 1974 that the notion of ecological art, as distinct from art about machines, was well advanced long before Tuchman's gigantic *Art and Technology* project in 1971.[24] Global survival in the face of supposedly impending worldwide ecological catastrophe, according to many contemporary observers, prompted a crystallization of this distinction. Artists' fascination with technology had therefore been ambivalent rather than affirmative for some time, and nouveau réaliste artist Jean Tinguely's self-destructive machines, for example, were only one such manifestation of this. Pontus Hulten had curated *The Machine at the End of the Mechanical Age* at the Museum of Modern Art (New York) in 1968, and this exhibition foregrounded technology's phantasmagoric aspect as much as its wonder and power. At the start of the 1970s, however, the gap between Earth artists such as Smithson or Heizer on the one hand and the Harrisons or Haacke on the other definitely widened as conservation groups mobilized against technological despoliation of the environment. The Harrisons observed, "They [Smithson and Heizer] used earth as material; we feel that our works were amongst the first to deal

with ecology in the full sense of the term. The key test for ecological art is the concept of the niche."[25] It seems that collaboration shifted Newton Harrison toward a less technologically oriented art and toward a more social practice, for Helen Mayer Harrison was temperamentally opposed to using capital-intensive machines in art. Helen Mayer Harrison may have directed the key decisions through which the two artists moved their joint works toward a more text-based, consultative art and away from labor- and capital-intensive virtual ecosystems.[26]

Both artists certainly felt that Earth art was ethically deficient. They based this perception on works such as Heizer's great geometric notch cut into the side of a valley, *Double Negative* (1969–70); Smithson's spiral of bulldozed rubble edging out into Utah's Great Salt Lake, *Spiral Jetty* (1970); and the most notorious, Smithson's aborted 1970 project to cover an island near Vancouver, British Columbia, with broken glass. Earth artists damaged or destroyed the immediate environment without serious regard for its plants and animals. The Harrisons, like other people who encountered Smithson competitively, found him touchy and easily offended. After *Spiral Jetty* was finished, they asked him if they could work with algae and brine shrimp at the site in order to return the water around the spiral ramp to its natural color. They explained to Smithson why the water at the edge of the spiral had turned red (the algae turned red in response to increased salinity). He refused their proposal outright. The Harrisons published their disagreement, but further discussions were aborted because, immediately afterward, Smithson died in a light-aircraft accident. The Harrisons felt a far greater affinity with Walter de Maria, observing that his concept determined a work's form "in transaction with the natural," but despite their admiration for de Maria, a gulf separates works such as his *Lightning Field* (1977) from *The Lagoon Cycle*. De Maria's poles were imposed on their Rocky Mountains environment, marking out the harsh, messy plateau vegetation with spooky, science-fiction precision. The Harrisons' work, on the other hand, existed as descriptions and simulacra. When their models of parallel, environmentally benign possibilities were realized on a large scale outside the museum, they represented an apparent return to environmentally sustainable states in which very little artistic intervention was obvious at all. The difference between the Harrisons and Earth artists would seem to lie in attitudes toward real-time intervention and its consequences and therefore in the Harrisons' interest in actions planned according to an enlarged ethical perspective.

According to Newton Harrison, there was a transition in their work from systems (which they equated with the conceptual) into narration during the 1970s, recalling the transition in the Poiriers' projects during the same period. *Lagoon—Simulating Monsoon* (1973) was an 8′ × 10′ × 3′ fish tank in which the Harrisons simulated an estuarial system near the equator. They established a healthy colony of edible Sri Lankan crabs in the tank to prove a point about environmental change and natural forces, but the work had another, equally benign, but almost theistic connotation: According to Jack Burnham, "Harrison feels that when he is taking care of the crabs on their

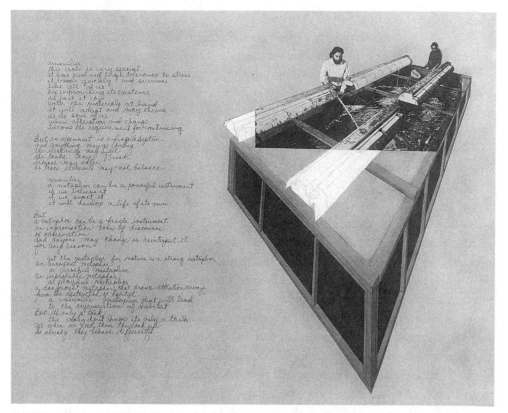

Helen Mayer Harrison and Newton Harrison, *Panel 2, The Second Lagoon*, from *The Lagoon Cycle* (1974–84). Mural panel, detail from mural, 96 inches × 90 inches, in more than fifty parts. Collection John Kluge, Metromedia. This work is based on a photograph of *Lagoon—Simulating Monsoon* (1973), a fish tank, 96 inches × 120 inches × 36 inches, simulating an equatorial estuarial system at Del Mar, California, part of the *Sea Grant* (1974) project.

terms, he is substituting for nature."[27] The example of conceptual art had opened the Harrisons' eyes to the "total freedom to work with complexity," but they had no desire to leave unforeseen, damaging loose ends arising from their art. *The Meditations on the Sacramento River, the Delta, and the Bays at San Francisco* (1976–77), for example, was a reasoned, researched critique of the green revolution and industrialized agrobusiness; it was presented as billboards, a performance, and posters. *The Meditations on the Sacramento River* used "art" as a discursive site within which they could situate real-time demonstrations and futures modeling. Fiction was to play a considerable role in these demonstrations, specifically fictional projections of new geopolitical divisions: In a work centered on the Great Lakes of the same year, they reinvented North America's political boundaries, proposing that the citizens of the Great Lakes region secede from both the United States and Canada to form a new, ecologically conscious nation. The extra-artistic character of these projects is not insignificant, for the artists' domination of critical discourse surrounding their work occurred not simply because they imposed their will upon critics but because their learning didactically directed the audience's responses away from art.

Dialogue, Conversational Drift, and Forgetting

The phrase "expanding conversations" recurs in the Harrisons' commentaries. It characterizes a work of utterly exhausting scale and complexity that they commenced in the mid-1970s: an enormous, 360-foot-long text-and-photomural whose installation was not completed until the mid-1980s. *The Lagoon Cycle* included photographs, maps, and two small artificial ponds in which the artists simulated the effects of monsoons upon estuary creatures. They also presented long semifictional, semiautobiographical performance-dialogues between two characters, "The Lagoonmaker" and "The Witness," and these dialogues were transcribed into the exhibition catalog. As Newton Harrison noted, "[T]hey read as inspired propaganda in poetic form, and the art aspect is not discussed."[28] In later projects, they organized their research and reflections into similar fictional discussions. These odd, heavily scripted conversations resembled joint poetry readings about the new perspectives gained during their collaborative work and about their own implied place in the dialogues. They worked better as performances than as text: In performance, the dialogues had something of the laconic quality of Laurie Anderson's cryptic soliloquies (of, say, *Americans on the Move* [1979]) but as printed texts, like Anderson's bleak parables, they were portentous and somewhat wooden. In the opening passage of the Harrisons' dialogue for *Atempause für den Save Fluss* (Breathing Space for the Sava River) (1988–90), they discussed the uncertainty and the motives behind designating public discourse as art. Their dialogue rehearsed the way that their collaboration was a metaphor for a wider cooperative work, that of creating the sense of responsibility that they saw as being directly linked to memory. This memory was necessary to save the Sava River, which flows through Slovenia, Croatia, and Serbia:

> How do I know we will say anything worth
> listening to
> will it be remembered for more than a
> moment
> You said
> Remembering and forgetting are in
> totality
> the sum of human understanding.[29]

Their dialogues were clearly a way of turning aside from the adversarial confrontation that seemed to be inherent in ecological activism. It is, after all, hard to argue with poetry. In a 1991 artists' statement for the *Team Spirit* catalog, they wrote: "[A]n aesthetic exists always in interaction with, and in commentary on, a larger social context . . . to isolate an aesthetic and attempt to make it unrelated to other things is impossible."[30] The Harrisons insisted on embedding visual art within textual discourse, whether simply within the framework of an installation that combined text with images or within the wider context of "conversations" started outside the art museum.

Principally, however, they located their work within the museum's walls because of the advantages of its ecological niche within capitalist society: The art museum is almost uniquely nonthreatening, no matter what artists think.

What, though, was the point of such elliptical, ambiguous discourse? Susan Fillin-Yei wrote:

> Elsewhere, questions which restate conventional conversational gambits suggest new ways of thinking, for example, "thinking/about a new history," a phrase which, seemingly, moves us into the future looking back at past decisions. Invoking hindsight, a vision of change as already having occurred, perhaps makes it easier to think about those new decisions we will need to make.[31]

Their formal conversations attempted to persuade the listener of the possibility of what the Harrisons frequently referred to as "parallel vision," for they believed that fixed beliefs about the future and the present are costly and should be accompanied by imagined alternatives, both feasible and less likely: according to the Harrisons, alternative histories of a particular fictive type.

The genealogy of such proposals is Nietzschean, mediated through countercultural influences that included the German philosopher among its own sources. Elizabeth Grosz explains the German philosopher's identification of self and memory thus:

> Nietzsche wants to locate the primordial or mythical origins of culture in the ability to make promises, the ability to keep one's word, to propel into the future an avowal made in the past or present. This ability to make promises is dependent on the constitution of an interiority, a moral sense, a will. The will to remember, which Nietzsche characterized in this case as an active desire, a desire not to rid oneself, "a desire for the continuance of something desired once, a real memory of the will" . . . The ability to make promises involves renouncing forgetfulness, at least in part, and, in spite of intervening events, being able to put intention or commitment into action.[32]

Certainly the rationale behind generating scenarios, proposals, and possibilities, which is what the Harrisons systematically made from *The Lagoon Cycle* onward, would seem to lie in this Nietzschean reidentification of self—at least as Grosz exhaustively describes it in this long excerpt—and with the idea of the self as constituted by the ability to make promises in the context of an active "counterforgetfulness." All action, therefore, first requires forgetting. Richard Terdiman recasts this activity (via Walter Benjamin) through the prism of modernity's memory crisis rather than through Antonio Gramsci's more familiar term "hegemony":

> [Nietzsche] conceptualizes how the investment of the present by the past . . . colonizes the mind and restricts the creative potentiality of human beings. It does so in a vast structure of routinized social and cultural practices that no one consciously elects and everyone inevitably experiences. The control exercised by these structures is

uncannily spectral, and all the more threatening for its invisibility. Authentic origi-nality, decisive action, thus require enforcing a rupture with the past.[33]

The Harrisons identified their artistic self with the projection of will through con-structive fantasy and positive commitments rather than through the perpetuation of inherited cultural patterns or personal expressive subjectivities. These sentiments were at the same time the basis of much countercultural political action, familiar to later generations through concepts such as "playpower."[34] But the Harrisons' cultivation of impersonal voices, proliferation of information, reconstruction of pristine ecosystems, and invention of multiple futures were intimately connected with the capacity to remember and to constructively replace one type of memory with another (to coun-terforget) rather than to retreat into oblivion. Theirs was a recognition of visual mem-ory as contingent and not as a hyperabstraction. Above all, it was a recognition of the often malign weight and sheer mediating force of memory.

We must note something else, given the sheer complexity of the Harrisons' works: The texts were not even lucid, although they were clearly written and assembled with considerable lucidity and intellectual coherence. The effect of such an overload of information, and of the dramatization of so much information, was delirium. Look-ing at their installations did not establish order. Rather, it opened a door onto the experience of a labyrinth.

Collaboration facilitated this reorientation and disorientation of self. The Har-risons spoke in the third person, and they downplayed traditional signs of visual cre-ativity such as handwriting or expressive self-illustration in favor of typewritten text and photography: "Much of our work ... has no signature.... In fact, the larger the idea, the greater the anonymity."[35] As proof, there was also a shift in their collabora-tive method. Beginning in the early 1970s, they began to move away from the stereo-typical binary roles of female and male, in which women were linked to nurturing roles and men to hunting and which they had celebrated in their early performances. They also began to depart from the collaborative divisions of labor hypothesized by many critics, so that Helen Harrison was no longer the "researcher" and Newton Har-rison the "maker." The creation of new genderless identities—The Witness and The Lagoonmaker—reflected a conscious desire to move away from binary cultural oppo-sites such as male/female, nature/culture, work/leisure, and good/bad. They were defin-ing the niche comprising "eco-artist" against the categories of land art or Earth art, and they did this by eliminating the signs of their identifiable, individual personalities in favor of many roles and voices.

Such interdisciplinary art also further collapsed or ignored the boundaries of artistic categories—the boundaries between painting, sculpture, and theater—and the boundary between art and nonart that had been so important to formalist critics. *The Serpentine Lattice* (1993) is a slide installation describing the disappearing North American Pacific Coast temperate rain forest. The Harrisons proposed that the remain-ing areas of rain forest be seen as a lattice—a patchwork of forest and cleared land—

and their insight was that the resulting lattice could be seen, in multiple views through overlays and the reversal of figure and ground, as an iconic form. They produced a conceptual design and a planning document in which several different perspectives were emphasized. At the heart of *The Serpentine Lattice* project is a large, semitransparent parchment map of the great vanished forest laid over a recent Geological Survey map of the same region. In the gallery space, the parchment, hanging in darkness, resembled a brain set inside a skull, and inside this, the shape of the enormous original forest was a long serpentine.[36] We can compare *The Serpentine Lattice* to Anne and Patrick Poirier's *Mnemosyne* (1991): *Mnemosyne* is a representation of a city that coheres into the shape of a brain, whereas *The Serpentine Lattice* is the representation of an ecological process that cohered into an iconic, serpentine shape inside a skull. The Harrisons developed and repeated this image through the rest of their installation, using the iconic form as a mnemonic device that would refer viewers to plans for the forests' regeneration.

The mnemonic power they ascribed to icons was immense. According to the Harrisons, these icons exist in real time as evolving forms—emblems abstracted from the shapes of "green" corridors or zones—and in *Green Heart Vision*'s media release, the Harrisons wrote: "The Green Heart Vision put forward by the Harrisons is a single form that encodes a complex array of functions, processes and concerns. The form itself is a ring around the Green Heart, approximately 140 kilometres long and one to two kilometres wide, that we call the Ring of Biodiversity."[37] Another artists' book, *A Brown Coal Park for Sudraum Leipzig* (1996), contains a diagram of park boundaries transformed into a logo resembling a snowflake. This image was to be commemorated and celebrated. It was to be at the heart of Sudraum Leipzig's new, invented identity, much as New Age ritual performances had been at the heart of the Harrisons' early installations. They captioned the *Brown Coal Park* diagrams with a short statement:

> Where the shape of turned earth
> in Sudraum Leipzig
> can be seen
> at its smallest scale as a logo
> and at its largest scale as a new icon
> in the cultural landscape.[38]

The great importance of icons was that they were a conceptual tool mediating between information and action. Reducing ecological proposals to iconic logos was a simple visual method of grasping a complex abstraction—the ecology of a particular environment—without being overwhelmed by it. Most important, icons can be memorized. Just as Elizabeth Grosz characterizes Nietzsche as arguing that "a counterforgetfulness needs to be instituted," so icons were aids to this counterforgetfulness. The concept is akin to Joseph Beuys's idea of "social sculpture" or Robert Smithson's late projects, such as his proposal for the Dallas–Fort Worth Regional Airport (1969).[39]

Helen Mayer Harrison and Newton Harrison, *Green Heart Vision* (1995). Installation view of proposal prepared for the Cultural Council of Southern Holland and the Province of South Holland, proposing an ecological corridor, 1–2 kilometers wide, separating urban from agricultural areas in the Randstad.

The imaginary status of the Harrisons' plans or visions has to be emphasized: The artists described their working process as the creation of possible worlds, worlds that were, strictly speaking, semifictional. *The Lagoon Cycle* and *The Serpentine Lattice* were combinations of photographic installations, books, wall texts, and maps. Some of this information was factual (the collation of scientific and sociological fieldwork), and another part was analytical (critiques and assessments), but a large amount— dispersed throughout the works—consisted of the visualization of the consequences of constructive change. These texts, diagrams, and maps purported to be documentary, historical, and sociological records of the same status as the rest of the works, but essentially they were fictions. This type of "forgery"—we can call it that for the moment—has precedents. It was common for authors of medieval religious texts, for example, to claim that they had discovered manuscripts written in earlier periods; such works are called pseudoepigraphic (we encountered the same term in the discussion

of the Poiriers), seeking the authority that comes from authorship by an ancient, respected source. Pseudoepigraphic media have changed, of course: Photography has now become the most authoritative form of visual text, representing the empirical world for most inhabitants of industrialized societies. For the Harrisons, culture and ideology could be reconstructed from the fiction of projected documentary futures set among photographs and maps of environmental despoliation. The genealogy of these fictions is also quite old—war narratives and chronicles—and the Harrisons' maps, as Michel de Certeau observed in his essay for *The Lagoon Cycle*'s exhibition catalog, were like maps of battlegrounds or disaster zones.[40] Once again, as for the Poiriers and for Art & Language, seeing was equated—this time through scientific studies of the future—with war.

The extreme demands that such composite works made on the viewer's patience and time could possibly be compensated for by the production of an almost cinematic spectacle, as in the liminal installation of *The Serpentine Lattice*. On the other hand, the impatient viewer's boredom could be, as it had been in conceptual art and especially in Joseph Kosuth's later *Investigations,* incorporated into the work both as a gatekeeping deterrent and as a simulacrum of the artists' own creative process. The Harrisons, like Kosuth, allowed incomprehension, coincidence, and inadvertent encounters (encounters with art as small paid advertisements in newspapers, for example) to order the overload of information with which they dealt. The Harrisons' projects, installed in a gallery, are excerpts from an archive, not an encyclopedia, of organized factual and fictional material, and archival organization permits many entrance points into the works' narratives.

How was the artists' own creative process linked to the Nietzschean "ability to make promises" and "counterforgetfulness"? The Harrisons absolutely insisted that they worked only where they were invited, according to a precept of conversational drift. They would pursue a project where they were welcomed, even if that was in the most uncomprehending way, but they would walk away from projects where their proposals met indifference, just as they would put partly completed projects on hold wherever and whenever they met resistance, in order to work on the myriad other proposals and exhibitions that they were simultaneously developing. If they pushed, they believed, they would be pushed out. A proposal for a work about Tibet that they began in the early 1990s, *Tibet Is the High Ground* (1995), met this fate.[41] They presented a project to create an "analog" forest to replace that of vast deforested areas in Tibet, and this, they hoped, would stimulate beneficial changes in weather patterns. The artists' book detailing the prospectus outlined a typical combination of activities to be organized by the Harrisons: symposia, plans, documentation, and correspondence for a project to turn Tibet into a "Peace Park," according to the Dalai Lama's already-existing and widely publicized proposal. After an initial burst of enthusiasm from the Dalai Lama and his staff, everything went wrong. The concept encountered extreme hostility from the Chinese, which forced friends, curators, and museums with whom the artists were working—and who wished to be able to work with the

Republic of China—to take sides. The Harrisons put the work into indefinite suspension. The same process was illustrated by their project to regenerate the Sava River, which was halted by the disintegration of Yugoslavia and the fighting that followed. The conversation, they observed, "drifted away."

The Harrisons were relatively indifferent to the particular critique of museums mounted by the neo-avant-garde during the 1970s and 1980s. Their desire to "make a difference" could only occur in the wider world, not in a reformulation of the art museum, which they saw as simply presenting otherwise unavailable opportunities, as did Hans Haacke: It would be a safe house but was not a necessary given. On the other hand, the artistic identities chosen by the Harrisons were performative, self-consciously discursive, and located within a wide field of social interaction. The role of artist was a negotiating tool rather than a given, even though they were both extraordinarily charismatic and impressive in person. In this sense, their collaborative persona has to be understood as different, despite other affinities, from that of Arakawa and Madeline Gins, and even more from that of Robert Smithson. They had no time for the enumeration of tautologies with which other artists were busy, for they were too busy outside the studio, cleaning up the environmental mess.

Conservation and Art

The artists of chapters 3, 4, and 5 took artistic form as a ready-made. Their works were nascently postmodern, but in a particularly troubling way, for various tropes taken to be axiomatic in postmodern art—irony, double coding, allegorical fragmentation—were more or less absent in favor of an unusual and tenacious belief in memory as an ethical prompt. We are now habituated to second-degree and third-degree visual strategies, but these artists seemed indifferent to the distinction between a quotation of the past and absorption in the past. Their relation to conservation blurred into a conservationism that marginalized their work. Each team saw its work occurring in relative isolation, separate from the great avant-garde narratives embodied by what they saw as more fashionable, mainstream art—the art featured on the pages of *Artforum* and theorized in *October* (strangely enough, all three teams received a fairly flattering quantity of attention from such journals over the decades). Instead, the Poiriers, the Harrisons, and the Boyles consciously chose positions at the physical or mental peripheries of the art world: in San Diego, in scattered remote wilderness areas, and in a far-off imaginary classical world.

Such positions were all the better to preserve and cultivate the role of ethical outsiders within the world of contemporary art, because these artists believed that images should be read as texts, linking visuality to ethics and memory.[47] Unlike conceptual artists and many Earth artists, who saw ecological and social debates as the raw materials upon which to create the framing discourses that constituted their art, the Boyles, the Poiriers, and the Harrisons saw the content inside the artwork's frame as crucial rather than arbitrary: Artistic content was not a hall of mirrors; rather,

TIBET IS THE
HIGH GROUND

NEWTON HARRISON
AND
HELEN MAYER HARRISON

Helen Mayer Harrison and Newton Harrison, cover of *Tibet Is the High Ground*, artists' book (Del Mar, Calif.: Harrison Studio, 1995).

Tibet is the High Ground

Helen Mayer Harrison and Newton Harrison, page 9 of *Tibet Is the High Ground*, artists' book (Del Mar, Calif.: Harrison Studio, 1995).

collaboration was the part of the "frame" of the work of art that destabilized its bound-aries. The type of memory that the three teams were interested in and, as we have seen, that both the Poiriers and the Harrisons clearly articulated in written statements, was creative, active, and connected with their understanding of archives. But it was also iconic, symbolic, and purposefully both indecipherable and overdetermined. Their impressive access to interdisciplinary information was based on an understanding that archives were a means of access to nonartistic specialist fields for artists who were able to read and sift information selectively and unsystematically. Neither team saw memory as a passive repository of information, as the information in a mental computer upon which a subject might draw, even though they borrowed extensively from writers who did. Their notion of memory was more active. They saw it as more than a faculty, as a part of the subject's basic identity: The self is remembered and remembering is representation, for retrieval ultimately fails. The Poiriers' temples and libraries were models of a mental life composed of modules, not unlike the architec-tural model of the mind proposed by British archaeologist Steven Mithen and others. The great library that they elaborated over decades was a thinly veiled metaphor for the reading rooms, chapels, and vast spaces of their own joint collaborative "mind."

This constructed self—one composed of chosen memories—sits apparently at odds with the attempts of the artists in chapters 1 and 2 to test, through collabora-tions, their perception that the self was essentially empty and void and that artistic identity was in essence meaningless except as strategic decisions in a game of chess. Both conceptions, however, refused more traditional ideas of the artistic self as essen-tially separate from its objects: One notion tended toward the denial of the subject's real existence; the other to a refusal of its autonomy. Both constituted an anticipation of what would become postmodern orthodoxy over the following decade, but they had an unexpectedly ethical emphasis that resurfaced in many younger artists' ethno-graphic and archivist works during the later 1990s. Collaboration, which suppressed the evidence of an artist's hand, reinforced the iconic textuality of their works. The avoidance of the hand in place of thought stressed the iconic at the expense of the indexical and iconology at the expense of iconography and allegory. It thus ran counter to much better known trajectories bridging late modernism and the postmodern, and it clearly recontextualizes the emergence of postmodern art as a prolongation of the modern, at least because its crisis of representation was haunted by modernity's memory crisis.

Finally, the family structure of these collaborations inflected their production in a particular way, and their works obviously declared their multiple authorship, for they were either demonstrably heterogeneous or else determinedly anonymous in style. This was in contrast to the artists of chapters 6–9, for whom collaboration involved the identification of artists with their art and with each other. According to that very different model of artistic collaboration, art could be the embodiment of personal union. This was to be an obsessive, dangerous, and potentially unstable working method. The long-term stability of the collaborations between the artists in the last

three chapters was equally predictable. Their collaborations continue into the new century, and their works can increasingly be seen as subtly different from those of their peers with whom they were compared during earlier decades. The collaborations of Boyle Family, Anne and Patrick Poirier, and Helen Mayer Harrison and Newton Harrison were protective identities, behind which diverse and fluid production methods and discursive specializations could occur without policing by traditional gender divisions of labor, hierarchy, and prestige.

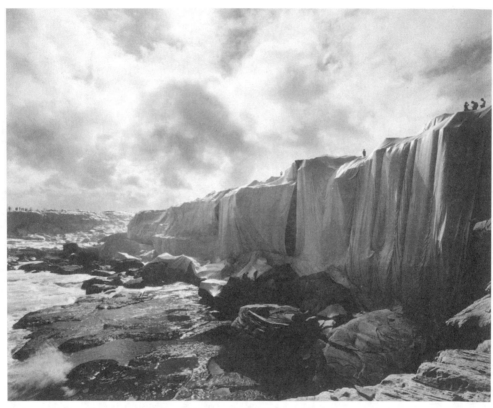

Christo and Jeanne-Claude, *Wrapped Coast, Little Bay, One Million Square Feet, Sydney, Australia* (1969). Temporary work of art, Little Bay, Sydney; view looking south to La Perouse and grave sites. Photograph Harry Shunk, collection John Kaldor archive, Sydney. Copyright Christo 1969.

6. Negotiated Identity:
Christo and Jeanne-Claude

Disappearing Act

Christo and Jeanne-Claude's wrappings after 1969, Gilbert & George's living sculptures commencing at the same time, and Marina Abramović and Ulay's actions after 1976 represent progressively more extreme modes of collaboration that blur and double the "normal" figure of the artist as an individual identity. The journey from conventional artistic identities to this extreme involved, first, a disappearing act and, second, the literal processes of travel and constant movement. Empathy with the actors or subjects was conceived—and the figure of the artists was coded—in an emphatically elusive, deliberately evasive manner. The terms of absorption and theatricality are the unlikely key to this code of misplacement. Michael Fried's analysis of these terms, deliberately misapplied to the works of these artistic collaborations, reclaims them from the avant-garde categories of antiart and theater with which performance and installation has been often associated, not least by Fried himself.

The earlier chapters of this book established the relativity of conceptions of the artist. Collaboration was adopted as method in conceptual art during the late 1960s and early 1970s. By and large, such artists worked with bureaucratic and corporate models of identity. Slightly later, others developed models of collaboration based on family alliances and ethnographic methodologies. This chapter and chapters 7, 8, and 9 look at another distinct type of constructed identity—the third hand—and what it entailed. First, I describe the artistic collaboration between Christo and Jeanne-Claude, which represents a transition from traditional artistic identity to the identification of the collaboration itself as an artwork. Chapter 7 maps the terms of absorption and theatricality onto Gilbert & George's living sculptures, which represent a far more complex, troubling example of collaborative self-effacement. Next, in Marina Abramović

and Ulay's actions, I examine in chapter 8 the basis—the ground, in the artists' words—of artistic language. Chapter 9 defines the third identity that resulted from these collaborations. Did this third identity resemble a third hand, a doppelgänger (an apparition associated with death, sometimes experienced historically as a shadow or as the double of a living person), or was it a phantom extension of the artists' joint will, rather like a phantom limb? The nature of this modified figure is important, for it represents the artists' strategy to convince their audience of a different understanding of artistic identity. These 1970s works now seem prescient with respect to art in the late 1990s, when so many artists absent themselves from the position of either author or maker.

The Artists' Name: Christo and Jeanne-Claude

The temporary works of art of Christo and Jeanne-Claude survive, but only just.[1] This is no accident, for their disappearance after a fixed period of time was just as crucial as their best-known method of manufacture, wrapping. They do survive, but in documentary form as photographs, films, and books. The couple's photo-documentations exist at the intersection of photography and the art that followed early conceptualism. They are inscribed with a shifting idea of artistic work and a new figure of the artist and are just as indexical of 1970s concerns as are better-known but more conventional

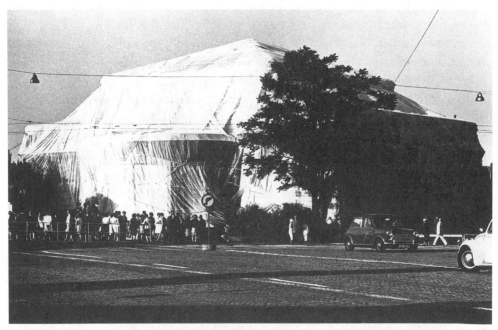

Christo and Jeanne-Claude, *Wrapped Kunsthalle, Bern, Switzerland* (1968). Three thousand square meters (33,333 square feet) of synthetic fabric and 3,666 meters (12,097 feet) of rope. Photograph Thomas Cugini. Copyright Christo 1968.

bodies of 1970s photography. Photography is the medium through which we now approach transitory art forms such as those of Christo and Jeanne-Claude, and in particular their important first large wrapped environmental installations, which they call temporary works of art.

The first of these to take over an entire landscape was in Sydney (the couple had wrapped the Bern Kunsthalle in 1968 and Chicago's Museum of Contemporary Art in 1969). In 1969, art collector and patron John Kaldor invited Christo and Jeanne-Claude to give a series of lectures in Australia. Instead, Christo and Jeanne-Claude completed an influential and spectacular work, *Wrapped Coast, Little Bay, One Million Square Feet, Sydney, Australia* (1969).[2] The piece attracted enormous local media coverage and considerable international attention. The London art magazine *Studio International* ran the following description:

> Christo's latest package, 1,000,000 sq. ft. of the Australian coastline at Little Bay, near Sydney covering a frontage of approximately one mile, was realized for the period 1 to 28 November. Using a poly-propylene fabric, 35 miles of rope, two-way radios

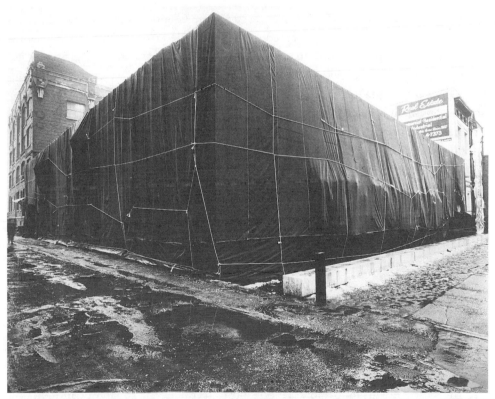

Christo and Jeanne-Claude, *Wrapped Museum of Contemporary Art, Chicago* (1969). Nine hundred square meters (10,000 square feet) of tarpaulin and 1,100 meters (3,600 feet) of rope. Photograph Harry Shunk. Copyright Christo 1969.

and an estimated 17,000 man-hours, and despite southerly gales and pyromaniac hooligans, Christo wrapped up rocks to a height of 84 feet. Sponsors were the Aspen Centre of Contemporary Art, Colorado, and Christo himself.[3]

These bare facts hide several stories that typify Christo and Jeanne-Claude's works of art over the next two decades, all of which reflect their nomadic, mobile artistic identity and the extensive negotiations that accompanied each work. *Wrapped Coast, Little Bay, One Million Square Feet, Sydney, Australia* was the couple's first major environmental sculpture. It had been intended for a site in California, but negotiations foundered. Kaldor originally wanted Christo to give lectures about his work. However, the artist did not wish to travel without completing a work, and he suggested that if Kaldor found a site, he would create an environmental wrapped work. Even though Christo alone was credited for the work at the time, he and Jeanne-Claude worked as a team on the piece, sharing responsibility for its completion. Jeanne-Claude was responsible for all correspondence and project administration.

Since the early 1990s, Christo and Jeanne-Claude have sternly insisted on joint reattribution of all works from the late 1960s onward, including *Wrapped Coast, Little Bay, One Million Square Feet, Sydney, Australia*, even though Christo's interviews from earlier periods carried little reference to Jeanne-Claude's role in the works. This absence seems surprising, given the couple's present determined insistence on joint attribution of "Christo's" works in negotiations with magazines and researchers for exhibition participation, copyright clearance, or caption checking.[4] Christo and Jeanne-Claude, I think, gradually altered their attitudes and opinions about the public acknowledgment of their collaboration but did not wish this shift to be solidly pinned down. In a joint interview with Christo, Jeanne-Claude said: "I'm not only an administrator of Christo's beautiful ideas. For instance, *The Surrounded Islands* was my idea. Most of the people don't know that."[5]

In a 1989 interview, Christo seemed to deny this. He said: "It [the work] is the idea of one man. I make the point in discussion of my art that I do not do commissions; I decide my projects and how to do them. The projects continually translate this great individualism, this creative freedom."[6] In 1990, he was quoted as saying: "The work is a huge, individualistic gesture that is entirely decided by me."[7] *Wrapped Coast, Little Bay, One Million Square Feet, Sydney, Australia* and its successors were recognized as signs of intense individuality in critical commentary and newspaper cartoons.[8] The wrapped works gained a level of brand-name recognition achieved by very few other artists (Jackson Pollock's drips, Joseph Beuys's hat, and Andy Warhol's *Campbell's Soup Cans* are the other obvious examples in late-twentieth century art). But the work was the product of two artists, even though the media and much art commentary continued to credit Christo alone. How is it possible to reconcile the apparent contradiction between the couple's reattribution of their work as jointly made and Christo's just-quoted statements? When and why did Jeanne-Claude "become" an author, especially since the authorship of Christo's works had been shared, though covertly, for so long

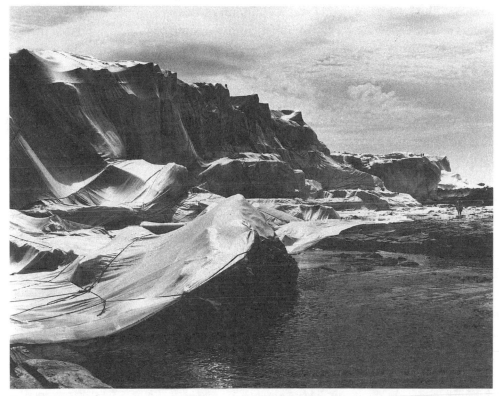

Christo and Jeanne-Claude, *Wrapped Coast, Little Bay, One Million Square Feet, Sydney, Australia* (1969). Temporary work of art, Little Bay, Sydney; view looking north to Malabar. Photograph Harry Shunk, collection John Kaldor archive, Sydney. Copyright Christo 1969.

before 1994, when, according to the artists, the cost of cooperating in the mythologization of a single, patriarchal artist figure became too great? Then, as Jeanne-Claude recalled, the two heeded the advice of their son and "came out," as had many other husband-and-wife teams of the 1960s and 1970s, including Ilya and Emilia Kabakov, Nancy and Ed Kienholz, and Claes Oldenburg and Coosje Van Bruggen.[9]

The answer lies in the identity that the artists had created in the process of their collaboration. Up to the renaming of their collaboration, Christo was almost certainly distinguishing between his authorial name—the name "Christo" for which he had become famous—and the names of the two artists behind that brand name. Although his emphasis on "individuality" seemed to contradict his collaborative working method, by the 1980s the name "Christo" had come, I think, to denote a corporation, a trademark idea, and copyright ownership as well as a single man or even the collaboration between Christo and Jeanne-Claude itself. Even their insistence on financing each work themselves was an artistic decision consistent with this identity as well as a pragmatic choice. It was part of their creation of a corporate and transnational artistic identity. It seems clear that individuality was instrumental and iconic rather than subjective and genuinely reflective of sole artistic authorship. Eliminating his surname,

Javacheff, in favor of "Christo" was a symptom of the same process. Christo's statements and interviews took on a complete consistency if it was understood that his use of the pronoun "I" was equivalent to an inversion of the royal "we": By "I" he meant "Christo" the artist, not Christo Javacheff the person; he was allowing himself to be subsumed by his doppelgänger, the Christo corporation.

Equally, the performative characteristic of the temporary works of art, from *Wrapped Coast, Little Bay, One Million Square Feet, Sydney, Australia* on, was the transformation of labor and raw materials of considerable monetary value into an aesthetic gesture able to be exchanged for nothing, for they were spectacularly unsalable, resistant to commodification, and above all, impermanent. Christo and Jeanne-Claude paid for these expensive gestures partly by the sale of drawings and assemblages.[10] Such salable objects were, however, strangely detached from the temporary works of art themselves. They were representations rather than working visualizations—scaled-down versions made before the event. Even then, it was Christo and Jeanne-Claude's own corporation—their own doppelgänger—that financed their work, employing the old-fashioned graphic design and drafting skills of its employee Christo and the marketing skills of its director Jeanne-Claude to pay the corporation's bills. In 1990, Christo observed: "My wife, Jeanne-Claude, who is the manager of all the projects,

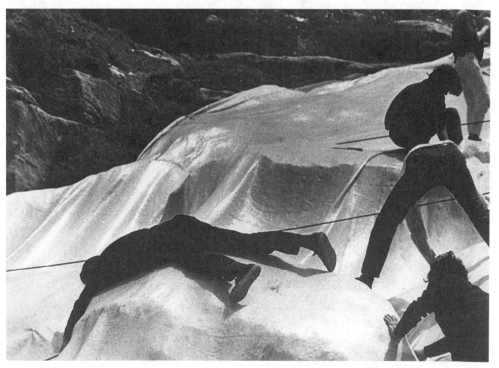

Christo and Jeanne-Claude, *Wrapped Coast, Little Bay, One Million Square Feet, Sydney, Australia* (1969). Temporary work of art, Little Bay, Sydney; students and assistants at work. Photograph Harry Shunk, collection John Kaldor archive, Sydney. Copyright Christo 1969.

is the president and treasurer of the corporation."[11] Christo and Jeanne-Claude's corporate doppelgänger could have been seen figuratively as the collaboration's corporate "business arm." Their constructed corporate identity mimicked the inverted relationship between financial and cultural capital: Great emotional, psychic, and financial investment resulted in the loss of financial capital but the creation of considerable cultural capital. Christo and Jeanne-Claude freely emphasized, then, the capitalist underpinning of their calculations, insisting that exaggerating the libertarian aspect of free enterprise gave them artistic freedom: "This is simply a capitalistic venture."[12]

Because they were creating ephemeral, highly speculative projects, this enterprise depended on a leap of faith. As the *Wall Street Journal* once reported, the frame of reference that Christo and Jeanne-Claude presented to the public, to anxious, worried assistants, and to bankers was one of almost messianic belief in their own importance and the self-sustaining momentum of their doppelgänger. This belief communicated itself to their associates with an assurance that created a similar assurance among their associates.[13] A letter dated 21 June 1969 from Christo to John Kaldor reads: "From your telephone call this morning, I understand that you are afraid. Do not be! Everything will go all right. It will not be easy—of course—but it will be OK."[14]

It should be noted that Christo and Jeanne-Claude so often reiterated their refusal of corporate sponsorship that this refusal must be looked at as integral to their perception of how their art was to be seen. Given the couple's claim to exclusive credit and financial responsibility for *Wrapped Coast, Little Bay, One Million Square Feet, Sydney, Australia,* the first of their trademark temporary works of art, how did the patron who facilitated negotiations and assisted with its realization benefit from this, his first designated "Art Project," and its successors? John Kaldor did not benefit in any direct way; he was a genuinely enthusiastic, generous sponsor. Further questions immediately arise, though: To what extent were Christo's works complicit in the oppressive workings of capital, and to what conscious extent did association with such a project lubricate capital's other workings? To a certain degree, the businesslike nature of this collaboration had affinities with corporate modes of organization, but there is no evidence that Christo (nor other artists sponsored by Kaldor, including Gilbert & George) was nudged in any corporatist direction by involvement with any sponsor: Christo and Jeanne-Claude retained the executive structure of their collaborative partnership, and authority and decision making was not diffused even though labor was delegated. Neither then nor now do they credit their large work teams as "artists" instead of engineers, fabric technicians, environmental consultants, lawyers, and so on.[15] And even at the top of this corporate structure, the division of management was supposedly gendered and divided. But this was fictional. The artists now insist that both have always worked on all aspects of the temporary works of art.[16]

It seems that Christo and Jeanne-Claude, like Boyle Family and other artistic teams, felt immense but decreasing curatorial and critical pressure (commercial market

pressures were peripheral, for both artistic teams' relationship to the market was relatively unimportant compared with their relationships to museums and curators) to present conventionally patriarchal authors to the public. Clearly, within the countercultural and university milieu of southern California, there was greater social permission for Helen Mayer Harrison to take the same authorial credit as Newton Harrison, but even so, as Helen Mayer Harrison recalled, there had been considerable disapproval from her feminist colleagues. One index of the considerable (even though incomplete) amelioration of sexual inequality in the art world since the 1970s is the decreasing usefulness of patriarchal fictions to artist teams and their deployment of other hybrid identities.

If this patriarchal fiction bears out the intimate relationship—a relationship resembling camouflage—of authorship to social context, then what was the relationship of traveling teams' works to the local or peripheral histories they encountered? Was it one of straightforward orientalism, a fetishization of the exotic? Christo and Jeanne-Claude also made a lesser-known work during their Australian visit: the *Wool Works* (1969) at the National Gallery of Victoria in Melbourne. By coincidence, Joseph Kosuth's *Joseph Kosuth: Fifteen Locations 1969/70 (Art as Idea as Idea 1966–70)*, discussed in chapter 1, appeared, unnoticed, exactly the same week in newspapers across Australia. In the gallery's penitential, gray, rain-soaked Murdoch Court, workers and museum staff wrapped two semitrailer loads of wool bales in dark tarpaulins. Indoors, visible from the courtyard in the silver-foil-walled temporary exhibitions area, they arranged seventy-five partly opened wool bales separated by steel barriers in two long rows across the floor.[17] The monolithic dark forms of the wrapped bales outdoors were an ominous backdrop to the overflowing wool bales inside, which looked as though an obscure, quasi-industrial process of being emptied onto the floor had been interrupted. The result was unexpectedly uncanny, as Ross Lansell observed in his review for *Nation*:

> Christo, that Buster Keaton–like figure in an absurd world of his own making, is upon us.... Although Christo denies he is an environmental artist, one of the [Allan] Kaprow species, the bluntness, the primality, the rudeness of this particular "Wool Works," dominates its setting, primarily because of its very strangeness, and shows up the fine artiness of the building.[18]

Christo and Jeanne-Claude had chosen to wrap a product of immense economic importance to Australia and in particular to the state of Victoria, which was historically the wool industry's national center. Wool traditionally represented financial power for the city of Melbourne, and the contrast of opened and wrapped bales connoted transactions—the transference and conservation—of both kinetic and economic energy. Capital is resistant to visual representation, for although it can be visually symbolized it has no fixed shape. The energy transfers mapped in these temporary works of art were unseen; the sense of sight was an inadequate mechanism to trace the implied transfer of capital indicated by bales of wool. Once again, the intersection of visuality and memory was a site of potentiality *and* inaccessibility, and this is a

conjunction we find repeated in the remainder of this book. But inside the museum's enclosing walls as an art object more or less indistinguishable from any other minimal-ist installation, *Wool Works* was a relatively simple allegorization of capital, fairly un-problematic in its relation to the transformation of artistic labor into art. Furthermore, its documentation exists in an absolutely straightforward manner as the documenta-tion of a transient work of art. Outside the museum walls, however, the significations of the temporary works of art were more diffuse, and the allegorization of the Sisyph-ean labor and maintenance work carried out by the artists' team of assistants was more indeterminate. Further, the documentary record was also more problematic because it blurred the boundary between landscape photography and artistic document. Inside the museum, the temporary work of art was a straightforward if overdetermined alle-gory; outside, the work was a memory blockage producing a double vision born of the work's imminent disappearance, transforming the present into a pressure—a more accurate model of the relation of memory to modernity.

Obstacles, Divisions, and Difficulties: Photographic Documentation and Art

Christo and Jeanne-Claude covered their found objects in opaque or semiopaque material so that the objects' features were obscured and blurred. The artists almost always, in one way or another, created obstacles and divisions between the viewing subject and the veiled or partly obscured object. Christo said: "Au départ, nous em-pruntons l'espace et subitement nous essayons de créer des obstacles, des divisions, des difficultés" [At the outset, we borrow a space and all of a sudden we try to create obsta-cles, divisions, and difficulties].[19] Christo and Jeanne-Claude always veiled or at least partially covered their subjects. In his early solo work, *Wrapped Woman* (1963), which was made before the collaboration with Jeanne-Claude commenced, Christo wrapped a living, naked woman. In 1970, a reporter wrote:

> In Germany, in 1963, he wrapped his first girl, a well-rounded nude blonde with a demure page-boy hair-style. In a well-rehearsed "strip-tease in reverse," he swathed her in hundreds of feet of transparent polyethylene and then tied her into a package with rope. (The girl lived, of course, because arrangements had been made for her to go on breathing outside air. The "sculpture" lived because the entire wrapping was recorded on film.)[20]

Later, Christo and Jeanne-Claude wrapped or covered things and places, their works actively flaunting the ubiquitous artifice, patterning, and disguise of elaborate drapery. Retrospectively, *Wrapped Woman* seems gratuitously oblivious to its sexual-political implications, much as did Yves Klein's performatively painted *Anthropomé-tries* (1960). Like the work of the nouveaux réalistes, Christo's early work depended on the audience's acceptance of a repeated, emphatically masculine signature gesture. From the environmental wrapped works onward, however, Christo and Jeanne-Claude may have wished to avoid this overtly mannered theatricality. In a 1977 interview,

Christo vigorously rejected any link with theater in his art: "Some people say I make theater art, but [it] is not theater, because there is not one element of make-believe anywhere."[21] Attention was displaced from both wrapped object and drapery alike into a performative drama, onto a sense of hidden potential tragedy around which the curtains were definitively closed. This tragedy was not always potential: Christo and Jeanne-Claude did not know that the seaside cliffs at Little Bay, near Sydney, were the places to which dying Aboriginal people were driven during the early-nineteenth-century settler-introduced plagues.

Christo and Jeanne-Claude made veils rather than wrappings, and their veils were metaphors for divisions, between the material world, its descriptions, and the action of erotic and violent desire. In a sense, the artists' industrial-strength veils both obscured and revealed the chosen site. This had been presaged in Christo's *Store Fronts* (1963–65), and especially *Four Storefronts Corner* (1964–65). They were sculptural installations with simulated curtained, closed-up shopwindows—and therefore also dramatic distancing devices that recapitulated something of the effect of photography: The wrappings resembled a photographic print's chemical membrane. This character is obvious in the photographs of the Sydney work: If the wrapping is perfectly and unexpectedly complemented by nature—by spectacular stormy skies and ocean waves

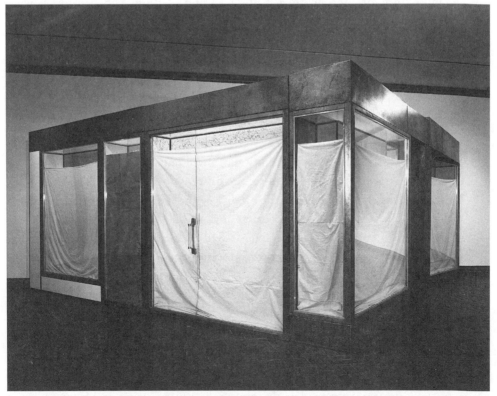

Christo, *Four Storefronts Corner* (1964–65). Galvanized metal, clear and colored Plexiglas, masonite, fabric, and electric light, 97.5 inches × 224 inches × 24 inches. Photograph Eeva-Inkeri. Copyright Christo 1965.

in these photographs—then this conjunction of skeletally artificial and fulsome, over-blown atmospheric nature looks like stages in the photographic development of an image in a chemical tank.

The doubleness of this membrane—its materiality and its illusionist transparency—was the subject of much conceptual photography at this time, in work as diverse as Ed Ruscha's *Twenty-Six Gasoline Stations* (1963) and Jeff Wall's *Landscape Manual* (1970). Christo and Jeanne-Claude were perceived as part of the wider, heterogeneous conceptual art movement that included such work: Udo Kulterman's book *Art and Life* (1971) featured Christo and Jeanne-Claude's Sydney work.[22] *Wrapped Coast, Little Bay, One Million Square Feet, Sydney, Australia* was, according to the artist, his "first project not concerned with one single object."[23] It was also the first of their projects that required and even encouraged the viewer's physical movement across and into the no-longer-monolithic sculpture. As they observed, it incorporated the dimension of time: Christo said that "people would take time to walk from one side of the project to the other. For me, that element of time is the most significant and influential part of the project."[24] The wrapped temporary work of art—if it was environmental—could not be seen as a discrete object in its totality; rather, it could only be seen from a number of different perspectives.

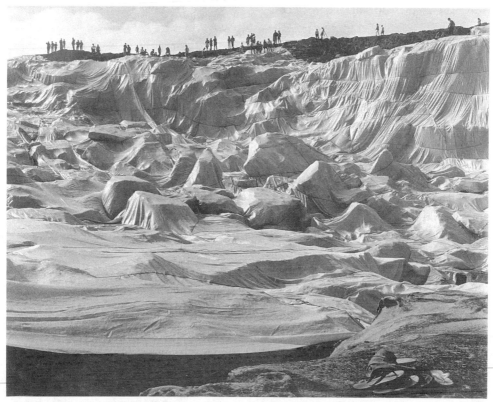

Christo and Jeanne-Claude, *Wrapped Coast, Little Bay, One Million Square Feet, Sydney, Australia* (1969). Temporary work of art, Little Bay, Sydney. Photograph Harry Shunk, collection John Kaldor archive, Sydney. Copyright Christo 1969.

Because it was temporary, most audiences viewed the temporary work within the terms of the indexical traces of the artists' careful and exhaustive photographic documentation. As with all their subsequent projects, Christo and Jeanne-Claude made a point of photography's transparency—of photography's putative ability to communicate a neutral, documentary truth—by commissioning and assembling an overwhelming quantity of beautiful photographs, especially those by Harry Shunk. However, these were no more than compensation for the projects' transience. Christo and Jeanne-Claude actively stressed the fact that the temporary works of art were no longer available—certainly not through recollections prompted by photographs—and that their life as memories was fragile and unstable.[25] Photographic documentation did not constitute a proper memory. Why not? And why did Christo and Jeanne-Claude not consider this documentation to be a trace of their disappearing temporary works of art, especially since their intention was not to make fine-art photographs? Their refusal to assume that the works could be preserved in memory was by default a position on what memory might mean and whether it could still be an active faculty, specifically in a visual economy flooded by photographic representations.[26] This, though, raises other questions: Would photographs, if arranged as archives, create or constitute a memory discourse, even if the artists wished to deny this effect? The question remains—it was implicit in minimal/conceptual photography generally from Ed Ruscha to Jeff Wall: Can memory could be activated by a collection of photographs, and is what is activated merely nostalgia?

For Christo and Jeanne-Claude the answer was clear. Their works had literally disappeared from the face of the earth, for they were dismantled almost as soon as they were erected.[27] According to Christo: "There is a kind of simplicity in these projects— they are temporary, almost nomadic. This impermanence translates into an awareness of the vulnerability of things, of their passing away."[28]

Collaborative authorship was more than personal idiosyncrasy, as was Christo and Jeanne-Claude's insistence on impermanence. It was one solution to a disbelief in traditional ideas of what art might be. And the context was the widespread questioning of what visual form a conceptualist experience might take, if any. The ways of approaching this question revolved around the problem of what would convince. In the late 1960s and early 1970s, artists gradually reassessed the properties of photographs, identifying the most crucial property of photography as its anthropological capacity rather than its ability to be the source of quasi-surrealist wonder. Vancouver, British Columbia, artist Jeff Wall wrote that the crisis of painting was a microcosmic view of the crisis of representation.[29] According to Wall, photography, an indexical form whose proper aesthetic domain of competence (in the Greenbergian sense) was its transparency, remained capable of retaining its representational capacity. The important property of photography was its transparency—its lack of opacity.[30] Where photography becomes opaque, in the sense of adapting painterly connections or signs of manufacture (as in art photography), it moves away from its strength, which according to Wall's later gloss of Greenberg's theory, is its indexical relationship to

its referent, even when this referent is itself culturally and artistically mediated. The strength of photography—its illusion of transparency—was crucial in the activity of legitimizing new forms of art, for it was the chief means by which performance and installation artists memorialized transient events. Nevertheless, Christo and Jeanne-Claude, while *creating* a body of photographic documentation, refused to authorize it as art in itself, *denying* photography's capacity to reproduce the contents of memory, in the process effectively contradicting Wall's notion of transparency.

Christo and Jeanne-Claude's viewer was a constrained but active participant in a modern pastoral drama, and this is a role that I will explore in chapters 7, 8, and 9. The work of art was a part of real life—an obstacle and a tourist attraction—rather than an art-gallery experience. Even though the wrapping was synthetic, the installation had left the gallery frame behind. Just as important, impermanence was not only a property of the works but was an element of identity, existing side by side with the intense subjectivity of "Christo's" wrapped "gestures." The artists constantly reminded the public that they were without commercial gallery representation, for they wished to present themselves as artists who had left the stable world of galleries and museums and who were in effect homeless. As Christo noted: "My works have to do with this displaced dimension. They borrow many elements. I am not German, or French, or American—my projects address this idea of rootlessness."[31] This homelessness implied a transient art object. Despite other theorists' claims for photography and the implied, often triumphalist claims of memory discourse adapted to art criticism, such an art object would disappear and be effaced at the same time as the artists carefully constructed a particularly heroic figure of the "artist" through their enormous archive of self-curated and self-published photo-documentation. Christo said: "With us, Gilbert & George, Charlotte Moorman and Nam June Paik, the important thing was not that there would be some permanent object, but that there was another dimension that needed to be experienced."[32]

Christo and Jeanne-Claude represented themselves in a particular way: They repeatedly said that they were not bound by tradition and, more significantly, that they were attempting to make art beyond the physical and mental boundaries of the art world. Their movement beyond traditional authorship was more complicated, for their constitution of a singular, almost megalomaniac corporate identity (replete with trademark artistic signature) coexisted with its apparent opposite, a highly cooperative collaborative working method.

Gilbert & George, *The Singing Sculpture* (1973). Art Gallery of New South Wales, Sydney. Living sculptures standing back to back in front of drawings. Photograph courtesy John Kaldor archive, Sydney.

7. Eliminating Personality:
Gilbert & George

Self-Absorbed Artists

In their early works, as living sculptures, Gilbert & George appear as a collaboration of a particular type: as three-dimensional sculptural objects that are also apparitions of a higher reality. They chose a radical strategy of self-effacement, emphasizing a discontinuity that was both physical and mental between themselves and their beholders. Their personal, individual selves were missing in action, gone almost without trace. This chapter analyzes that discontinuity, arguing that their noncommunication went hand in hand with the fact of their collaboration as a couple, that couples are not necessarily families, and that procreation is not necessarily central or even peripheral to that sexual and social contract. Though these artists are a (same-sex) couple, their collaboration was not that of a family but rather, like the collaboration of Marina Abramović and Ulay, that of lovers whose identities might (in a recognizably romantic and familiar formulation) merge or blur as a function of intensity and communion.

By the early 1970s, the tropes of the first wave of conceptual art—rigorous, tautological structures and bureaucracy—had become devalued. This was in part because the idea of artistic work as inherently valuable was no longer uncontested. Artistic work was not a sufficient raison d'être in itself, as disagreements among conceptual artists themselves had revealed. To establish the importance of what they were doing and seeing, various artists rejected both the theatrical rhetoric of the first phase of Happenings and the impersonal office games of conceptual art.

The idea of art that encodes personal absence and misplaced identity—of going away and leaving markers or traces of that departure—is far from new and has at least one clear artistic precedent from a much earlier period: the Enlightenment. The

believability of Gilbert & George's work *The Singing Sculpture* (1969–73) was as dependent on their manipulation of absorption and theatricality as were the eighteenth-century paintings analyzed by Michael Fried in his influential study of Denis Diderot's bourgeois milieu in eighteenth-century Paris.[1] Fried developed the opposition between theater and visual art in his early essays attacking minimalist art. He later elaborated the subtle dichotomy between absorption and theatricality in *Absorption and Theatricality: Painting and Beholder in the Age of Diderot*. Personal absence and misplaced identity in art had been theorized, as well, in the same context, that of Denis Diderot's long 1767 essays on landscape painter Claude-Joseph Vernet.[2] In the celebrated "Salon of 1767," Diderot imagined himself stepping into and taking country walks in Vernet's landscapes.

To recapitulate Michael Fried's elaboration of Diderot's theories: This imagining was prompted by Diderot's proposal that the spectator of a painting must be free and active, not just a passive consumer, and conversely that the painting itself should seem to be an impassive object in nature and not appear to be *asking* to be looked at. Diderot was arguing for two ideas: The beholder has an active role in the work of art, and the work of art can be a place in which the artist or the viewer could "go for a walk," mentally moving around within the picture space. Fried also observed that "the fundamental question addressed by Diderot in his *Salons* and related texts concerned the conditions that had to be fulfilled in order for the art of painting successfully to persuade its audience of the truthfulness of its representations."[3] The resulting artistic preference for the painter's self-effacement and depersonalization represented a departure from previous rococo ideas of theatrical self-presentation and the spectator's appreciation of such theatricality. Mental travel was part of the process of dissociation in a special case of absorption—the pastoral—in which the disembodied spectator became a visually active phantom participant in the work itself. According to Fried, the risk of the overtly theatrical was the failure to convince the beholder of the reality of the illusion presented on the pictorial surface.[4] The artist, though, could systematically negate the element of theater through the representation of profound self-absorption, as in Jean Chardin's paintings of boys intently building houses of cards or blowing bubbles. Fried's reading of Diderot provides a conceptual model for understanding artistic self-representation where the attributes of a declamatory, assertive artistic self are apparently absent.

It is obvious that French art of the eighteenth century is as profoundly different from the performance art of the early 1970s as it is from late-formalist painting; this difference, however, does not prevent the application of Fried's theory of manipulated spectatorship to the art of different periods, even though he remains deeply antipathetic to all forms of installation and performance art, which he saw in 1967 as theatrical to an extreme degree, arguing that this quality was detrimental to visual art.[5] According to Fried in his later writing—which, he insisted, was to be read as discontinuous with earlier essays such as "Art and Objecthood" (1967)—in mannerism,

artifice, and the overtly theatrical (as opposed to a more desirable quality, the dramatic) one ran the risk of making patently insincere advances to the beholder. The theatrical work of art would not be able to project a convincing image of the world because it became "a theater, *un théâtre*, an artificial construction whose too-obvious designs on its audience made it repugnant to persons of taste."[6] In 1967, he may have been correct in describing the first generation of installations and performances—for example, Robert Morris's famous *Site* (1964), which resembled an enactment of the process of looking at Édouard Manet's *Olympia* (1863)—as "theater." Contemporary critics, such as Jack Burnham, agreed that this new art resembled theater but disputed Fried's next logical steps. According to Burnham:

> The post-formalist sensibility naturally responds to stimuli both within and outside the proposed art format. To this extent some of it does begin to resemble "theater," as imputed by Michael Fried. More likely though, the label of "theatricality" is a red herring disguising the real nature of the shift in priorities.[7]

Fried's negative valuation of installation and performance—which he thought inherently incapable of embodying drama and fatally flawed by theater (theater and drama were, in Fried's view, completely different genres)—was, however, completely premature. Fried later observed that none of the critics of "Art and Objecthood" contended that what he called literalist art was not theatrical, and that they simply tried to reverse his negative assessment of theatricality itself.[8] My contention is that though both Gilbert & George's and Marina Abramović and Ulay's collaborative actions are frequently spectacular, they are not theatrical in the sense that Fried came to use the term in his later writing. I make this assertion because it enables a productive (and accurate, if troubling) rereading of the 1970s and not because I naively assume a continuity between the antitheatrical tradition in French eighteenth- and nineteenth-century painting and formalist critics' and painters' struggle against theater in art in the 1960s. So, this chapter and chapter 8 are deeply and perversely indebted to Fried's later writing, but they also find that a given artistic strategy is not embodied in its expected form. Art critics—even art historians—have to expect that they may sometimes reluctantly find quality in unexpected places.

On the contrary, the element of theater as Fried defined it could be systematically negated, in the very art forms in which he assumed it would be present, through the means of a presentation of profound self-absorption. Some artists, in particular Gilbert & George and Marina Abramović and Ulay, did just this, even though conventional wisdom—and the unquestioning assumption that Fried's later exposition of theatricality and absorption as contingent in artists' strategies and audiences' expectations would be congruent with his earlier analysis of theater as the antithesis of art—seems to suggest that their works are theatrical.[9] These actions require an account outside the parameters of performance art and antiart narratives, even though this is normally thought to be their proper home.

The Singing Sculpture

In the same year (1969) that Christo and Jean-Claude erected *Wrapped Coast, Little Bay, One Million Square Feet, Sydney, Australia,* British artists Gilbert & George immersed themselves in convention and etiquette—replacing the geometric rules governing the steel plates and plywood playground obstacles of American minimalism with ritualized enactments of English good manners—in order to become "living sculptures." Their collaborative method, according to Carter Ratcliff, was to "treat life in the spirit of art."[10] As Ratcliff observed, this method also placed them outside the boundaries of transgressive, ironic avant-garde art, for an interest in nineteenth-century Victorian aesthetics was an inversion of avant-gardism's straightforward trajectory away from premodern philosophies of art. For reasons that now seem laughable, in view of the relatively gentle blurring of the social and the artistic that they presented, Gilbert & George momentarily seemed threatening enough to be cast outside contemporary aesthetic frameworks: "'I think that these two young men are too radical for us at present', said Michael Kustow, Director of the Institute of Contemporary Arts [ICA], referring to an offer by 'Gilbert & George' to present one of their 'living sculptures' at an exhibition at Nash House in the Mall last summer."[11] *The Singing Sculpture* was the decisive public event through which Gilbert & George's systematic transformation of their lives into "living sculptures" came to general public notice. Gilbert & George had proposed that the ICA host its first incarnation. The work was to be performed to the accompaniment of a silly, sentimental music hall tune—Bud Flanagan's anthem, "Underneath the Arches."[12] Alternatively, they were to exhibit themselves "just standing, statue-like, on six-foot high pedestals, 'speaking about beauty and feeling' into a tape recorder."[13] The two artists had cast themselves as both homeless aesthetes and as a hybrid work of art composed, in equal portions, of music hall tramp and Walter Pater. Both identities proposed interminable journeying: As tramps, the artists were doomed to life outdoors on the road or "underneath the arches," while Pater's melancholic aesthetics suggested a long mental quest for quality.

In August 1969, Gilbert & George sent an ornate manifesto to leading art figures, declaring that they were "walking along a new road. They left their little studio with all the tools and brushes, taking with them only some music, gentle smiles on their faces and the most serious intentions in the world."[14] In the May 1970 issue of *Studio International,* critic Michael Moynihan noted this detachment from normal routines, observing that

> [t]hey appear to be living on private means and Mrs Passmore's [George's wife and mother of his then-sixteen-month-old-daughter] earnings as a kindergarten teacher. "Whatever else they are, they are emphatically not phoneys," observed Mr Kustow.[15]

Along with homelessness goes a move away from the family and familial models toward a radically new life and identity, as I have already noted: At this point, George's

Gilbert & George, *The Singing Sculpture* (1973). Art Gallery of New South Wales, Sydney. Living sculptures staring left, cane raised. Photograph courtesy John Kaldor archive, Sydney.

THE RITZ WE NEVER SIGH FOR, THE CARLTON THEY CAN KEEP, THERES ONLY ONE PLACE THAT WE KNOW AND THAT IS WHERE WE SLEEP. UNDERNEATH THE ARCHES WE DREAM OUR DREAMS AWAY, UNDERNEATH THE ARCHES ON COBBLESTONES WE LAY. EVERY NIGHT YOULL FIND US TIRED OUT AND WORN, HAPPY WHEN THE DAY-BREAK COMES CREEPING HERALDING THE DAWN. SLEEPING WHEN ITS RAINING AND SLEEPING WHEN ITS FINE, WE HEAR TRAINS RATTLING BY ABOVE. PAVEMENT IS OUR PILLOW NO MATTER WHERE WE STRAY, UNDERNEATH THE ARCHES WE DREAM OUR DREAMS AWAY.

Best Wishes from
"ART FOR ALL"
12 FOURNIER STREET, LONDON E1, ENGLAND, TEL. 01-247 0161

Gilbert & George, *A "magazine sculpture" by Gilbert & George* (1970). "Art for All," page of artists' project for *Studio International* 179, no. 922 (May 1970): 218–21.

wife is almost invisible (much like the members of Boyle Family or Jeanne-Claude early in their careers); she henceforth drops out of the picture altogether. Gilbert & George did find temporary homes for *The Singing Sculpture* at the Royal College of Art (as *Our New Sculpture* [1969]) and, shortly afterward, at St. Martin's School of Art under its present title. The two "sculptors" stood on a small table in drab suits, their faces and hands covered in bronze paint, and sang "Underneath the Arches" to a long-playing record or, later, taped accompaniment. Each time the record finished, one of the artists climbed down from the table, restarted the music, took a walking stick, and handed a glove to the other. Behind the artists at many installments, massive drawings ran like stage sets around and behind both audience and artists; these landscapes were drawn in a monochromatic London kitchen sink school version of impressionism, recalling English painter Edward Middleditch's 1950s paintings. Although the monumental drawings blurred the distinction between art and life (casting Gilbert & George and gallery visitors as tacit participants in a precarious drama in front of pastoral stage sets), they did not at all lessen the gap between artists and audience. The events were long and arduous: five seven-hour days in London in 1970; ten five-hour days in New York in 1971. Over the next four years, until August 1973, Gilbert & George re-presented *The Singing Sculpture* approximately two dozen times; its last exhibitions were at the Art Gallery of New South Wales and, a week later, at the National Gallery of Victoria. After that, Gilbert & George retired the work (apart from a brief resuscitation at Sonnabend Gallery, New York, in 1991) because, as Gilbert later noted, they found the work "too limiting."[16]

After this point in their career, images of violence and abjection outweighed pastoral and comic ones. Studied impassivity gave way to staccato movement and in their photographic suites, to fragmentation, disrupted viewpoints, and grimy urban landscapes. After 1973, Gilbert & George exaggerated the element of drunken, dissipated melancholy in their work—like overburdened, world-weary Pierrots—and they spent much of the period in a state of highly disciplined intoxication. One of the very few works by Gilbert & George that bore a close resemblance to *The Singing Sculpture* (other than the latter's brief, uncanny 1991 resurrection) was *The Red Sculpture* (1975), in which the red-painted artists froze in poses suggested by tape-recorded commands, including "Cherry Blossom" and "Dark Shadow."[17] *The Red Sculpture* unlike *The Singing Sculpture*, was a savage work in which humor was replaced by punishment and scruffy gentility by the nihilism of dedicated dandies. Gilbert & George's statements still insisted on the importance of ethics in art, even though their self-consciously parodic public displays of dissipation and drunkenness resembled the defeatist nihilism they insisted they abhorred.

Good Manners

Gilbert & George's interpolation of etiquette and class into conceptual art was, from the point of view of rigorous avant-garde practitioners and the mildly scandalized

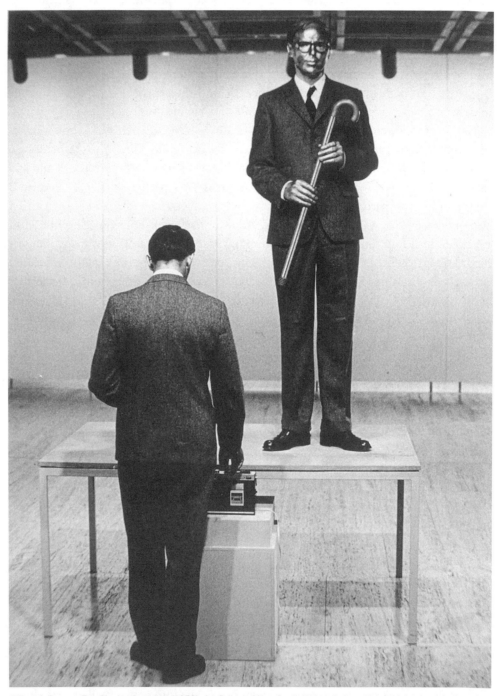

Gilbert & George, *The Singing Sculpture* (1973). Art Gallery of New South Wales, Sydney. Living sculpture restarting recording. Photograph courtesy John Kaldor archive, Sydney.

general public alike, both impure and improper. For example, although Joseph Kosuth demonstrated an insider's knowledge of London art in "Art after Philosophy," part 2, he omitted Gilbert & George's names, even though the two artists had exhibited in well-known venues, including the Robert Fraser Gallery, over sufficient time to have warranted inclusion in this "Who's Who" of international conceptual art.[18] Artists to whom they might have been compared and with whom they worked—Bruce McLean, for instance—were, however, described by Kosuth as making a "'conceptual' sort of work." The English members of Art & Language were completely disapproving. According to Mel Ramsden, "In the 70's most of those involved in A & L regarded the work of those two as ... opposed to the domain of epistemological adequacy that we saw ourselves constructing—however madly."[19] Continental audiences and curators were less disapproving, finding a stylistic home for the pair with members of the *arte povera* group: Harald Szeemann included the pair in the 1972 *Documenta 5*.[20]

On a broader scale, the homelessness of these "living sculptures" was a literal enactment of the consequences of avant-garde stylistic exhaustion, marking their distance from both late-modernist formalism and conceptual art alike. Their early works—like charades—signified the catastrophe of avant-garde reduction. Like the singing sculptures themselves, representation was homeless because publicly shared artistic language had become nonsensical nostalgia (like the music hall tune) or pillaged fragments akin to the deliberately overrhetorical and therefore carefully unconvincing landscapes that Gilbert & George hung behind their singing sculptures. Though they occupied the same physical space as the audience, they behaved as if they lived on an elevated mental plane. This strategy was not shared by most performance artists of the period, who wished to bridge the gap between artist and audience. Gilbert & George had no such desire and even wished to distance themselves from the genre of performance itself. According to Gilbert: "We never did performance, ever. We never called it performance, ever. We didn't like it. For many, many years, we wouldn't even show in the standard group shows to do with performance, because we felt it was something completely different. Performance—that was a Fluxus movement."[21] In interviews and in correspondence, they absolutely insisted on this difference, distancing themselves from the interactive connotations of performance art made by charismatic personalities who emphasized bodily experience. Given this distaste and in order for their distance to be properly convincing, the artists had to eliminate all signs of private personality or individual interaction, preserving only a public persona. Working as a collaborative team was one means to this end; refusing to live outside art was another.

They protected their elaborately dignified double mental distance as living sculptures both on exhibition and in private. As many of their hosts and guides recalled, the two living sculptures behaved formally at all times, exaggerating genteel etiquette until it became a regal distance. Kaldor, for example, was astonished at their ability to maintain complete control of any situation, intoxication notwithstanding.[22] During *Living Sculpture* (1969), they remained frozen in one pose for five hours on the

Stedelijk Museum stairs. Carter Ratcliff observed: "[W]hen they posed on the stairs in Amsterdam, they couldn't be friendly in any of the usual ways. The form of the piece didn't permit it."[23] The requirements of detachment meant that they never established eye contact with audiences, nor did they allow time to stop for breaks or to chat. They were accosted by members of the crowd during 1969 rock concert performances at the London Lyceum and by bemused members of The Who at the Sussex Festival that same year, but they replied neither to provocations nor to friendly questions offstage. Their masklike metallized face paint both prohibited all interaction and irresistibly recalled the makeup of clowns and mimes. It was reported that they removed this substance from their faces with Ajax, a highly abrasive kitchen cleanser.[24]

It was therefore significant that Gilbert & George's deliberately quaint, carefully misspelled manifesto, "Laws of Sculptors," spelled out their disinterest and lack of rhetorical design upon the audience. "Laws of Sculptors" appeared, complete with misspellings, in *Studio International*'s May 1970 issue:

1. Allways be smartly dressed, well groomed relaxed friendly polite and in complete control.
2. Make the world to believe in you and to pay heavily for this priviledge.
3. Never worry assess discuss or critisize but remain quiet respectful and calm.
4. The lord chissels still, so dont leave your bench for long.[25]

The free spelling and odd, archaic syntax were no accident. It might, at first, have seemed simply cute—a quality then called camp. Instead, the "Laws of Sculptors" were uncanny, for this was a camp parody of a manifesto and, what is more important, a camp parody of artistic integrity. Integrity was here equated with tradition, manners, and etiquette in an obvious critique of—and carefully worded departure from—the logic of avant-garde transgression.

To recapitulate: Gilbert & George had commenced with an initially ironic, fictive, self-reflexive gesture—naming themselves "Living Sculptures." Utter seriousness (without irony) then followed.[26] This is crucial: An initial performative gesture by artists—calling themselves an artistic collaboration—created a new artistic identity. The act of signing and titling each work then became crucially important, not as authentication but as an unacknowledged and unverifiable parody of the verification of identity. Their pedantic, self-dramatizing titles and insistent signing were a fetish, and Gilbert & George even presented themselves as a logo.[27] They designed a "Gilbert & George" seal for envelopes and in 1969 presented themselves with the seal branded on their foreheads. These were not "antiart" gestures, and as proof it should be remembered that Gilbert & George had, straight-faced beyond irony, elevated art to the level of a pseudoreligious, quasi-Ruskinian quest.

The "Laws of Sculptors" were also a recipe for studied impassivity. The fourth item on the list was evidence of their awareness that the role of living sculpture

demanded the continual reenactment of dissociation. The result was extraordinarily charismatic and potent, so much so that the audience stood back, almost as if separated from the artists by plate glass. According to Gilbert & George's patron, John Kaldor, audiences were mesmerized: "You went along thinking you'd spend five minutes and would end up spending several hours."[28] Gilbert & George should be compared with other artists who manipulated this quality: Joseph Beuys and James Lee Byars. Byars and Beuys had also collaborated on joint staged "actions."[29] All made works that often denied language any power at all, and all consistently wore distinctive personal uniforms connoting specific occupational types: Beuys, his hunter's jacket, hat, and walking stick; Byars, a cape; Gilbert & George, their ill-fitting, increasingly old-fashioned, drab suits. Gilbert & George were aware of the importance of brand-name identification, for they wished their constructed identity to be at the center of the viewer's experience of their work. They kept their brand name foremost through the force of charismatic but mute public personalities that were not in the least dependent for effect on speech or on solo public appearance.

The significance of this refusal to speak can be assessed through a comparison with Vito Acconci's early actions, which also presented spectacles in which a hermetic, self-enclosed drama — unavailable to the audience except through direct, personal contact with the artist—was enacted. In a 1971 action, for example, Acconci was blindfolded at the edge of a pier at night in the company of a person whom he specified he "did not trust."[30] He started walking. Unless the person he did not trust stopped him, he would wander off the edge of the pier into the water below. In another 1971 work, Acconci advertised that he would be at an abandoned pier at night at a certain time. People could go to meet him there, and each viewer would be told something about the artist that he did not want known. The viewer was then able to choose whether to blackmail the artist or not. Acconci noted that this, like another 1970 work in which he and an assistant attempted to imitate each other's actions while blindfolded, was a situation involving the stimulation of "extrasensory perception." He complained, however, that "the viewer was always outside," and he therefore shifted his later works toward forms that, unlike *The Singing Sculpture*, were identifiably theatrical and actively solicited attention. His actions, then, often depended on either audience movement or active audience intimidation. On the other hand, Gilbert & George presented themselves in actions of extreme formality that excluded the audience. In 1970, their teachers at St. Martins recalled them as being uncommunicative and "given to long stretches of silence."[31] By contrast, the American Acconci was searching for ways to involve his viewers and to blur the division between work and audience, so that in the mid-1970s, he was giving his audience tasks to perform in an attempt to convince them that they had been taken into account.[32] Gilbert & George were not really engaged in performances, and so they refused the term "performances" in favor of the word "exhibition," whose effect was the exact opposite. They did not seek to lessen the gap between artists and audience at all.

Gilbert & George, *A "magazine sculpture" by Gilbert & George* (1970). "George the Cunt," page of artists' project for *Studio International* 179, no. 922 (May 1970): 218–21. The word "cunt" was blacked out for publication.

Gilbert & George, *A "magazine sculpture" by Gilbert & George* (1970). "Gilbert the Shit," page of artists' project for *Studio International* 179, no. 922 (May 1970): 218 21. The word "shit" was blacked out for publication.

Mimes, Puppets, and Automata

Gilbert & George's robotic self-control and evasion of personal contact was redolent of the utter self-absorption of mimes. Indeed, most gallery audiences of the late 1960s and early 1970s would have been aware of the then-famous French mime Marcel Marceau, with whose routines they might have associated *The Singing Sculpture*. Gilbert & George combined Marceau's inscrutability and heavy makeup with his Pierrot-like pathos and aura of vulnerable naiveté. But the link with mime was even more significant than this affinity might suggest, for with its refusal of communication, except as intoned accompaniment to recorded music, and immobility punctuated by jerky movement, the affective power of *The Singing Sculpture* was directly comparable to that of mime. Gilbert & George were completely deadpan, avoiding any theatrical gestures toward irony or humor, even though their "exhibition" was a completely artificial hybrid of performance genres, occupying an intermediate zone between karaoke, music hall entertainment, and austere ritual. But it was their consistent disinterest in the audience that enabled *The Singing Sculpture* to successfully sidestep charges of superficiality and hypermannerism.

In "The Autonomy of Affect," Brian Massumi eloquently locates mime's power in interruption and notes its decomposition of movement into a series of submovements punctuated by jerks.[33] At each jerk, according to Massumi (who draws in turn on Gilles Deleuze), continuity is suspended, allowing the signification of potential movements that are made present without being actualized. Each jerk is therefore a point at which an instant of virtuality appears. In 1970, Michael Moynihan referred to the artists' moving in jerks like robots on a small tabletop to the strains of "Underneath the Arches" and quoted George's comment that "you know when you're walking and you suddenly feel there's someone you know coming up behind you and your leg and arm and body muscles go stiff with nerves? That's how we walked, completely unrelaxed, a zombie-like walk, two circuits right round the audience."[34] In such a way, Gilbert & George brought their uncanny self-creations—and the double identity of the collaboration—to a semiautonomous, marionette-like "life."

The discipline of mime has certain characteristics of communicative emptiness and awkwardness, as Massumi observed and George confirmed; the marionette figure has others. According to Steve Tillis, a marionette inspires double vision in the spectator: The puppet figure is an object, but one onto which the viewer projects his or her own emotions.[35] Furthermore, the viewer is unable to resolve the conflict of seeing the puppet as an object *and* as a live, sentient subject. Tillis writes: "[T]he audience's acknowledgment of the puppet, through perception and imagination, sets up a conflict between the puppet as object and as life."[36]

Gilbert & George embodied a similar double doubleness—both literal and as marionettes—for they so objectified themselves that they appeared as a pair of emotionless puppets. The point here is not that the viewer is able to project a vast body of emotions onto such figures but rather that their nonexpressive, uncommunicative

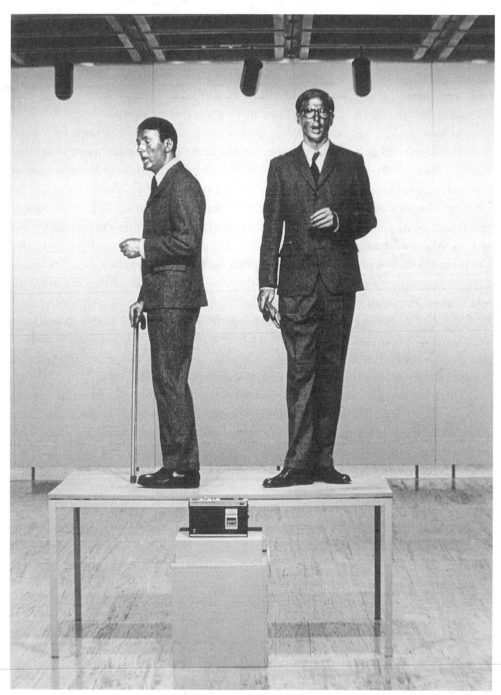

Gilbert & George, *The Singing Sculpture* (1973). Art Gallery of New South Wales, Sydney. Living sculptures singing.
Photograph courtesy John Kaldor archive, Sydney.

blankness was crucial to the communication of the complexity of the gap between artists and viewer. Gilbert & George's work depended on their being a canceled zero point as art—a point where the criteria of aesthetic discrimination were simultaneously completely uncertain but assertively projected (even as a cult).

If Gilbert & George's living sculptures can be linked to the impassive, etiquette-obsessed phenomenon of the British dandy and their method to the disciplines of mime and puppetry, then their strange, metallic appearance and movement through the broken rhythms of mime relates *The Singing Sculpture* to a late-1960s fascination with humanoids. There had already been considerable interest in automata and human simulacra during the late 1960s, in projects focusing on the intersection of art and science. The first primitive examples of computer graphics, drawn by experimental robots, had begun appearing in art magazine print supplements, including those of *Studio International*, in London. Billy Kluver's international Experiments in Art and Technology (EAT) project also attracted wide attention. At the Los Angeles County Museum of Art, curator Maurice Tuchman was pairing large numbers of artists, including James Lee Byars and Richard Serra, with enormous industrial corporations. Many of these projects attempted to incorporate artificial intelligence. Under the umbrella of this project, Christo's original designs for *Wrapped Coast, Little Bay, One Million Square Feet, Sydney, Australia* were made with a Californian site in mind, and curator Tuchman even reproduced Christo's proposal in the catalog for the final 1971 *Art and Technology* exhibition. Following the publication of Joseph Needham's monumental books tracing the history of Chinese science, the idea of complete alternative philosophies of science, along with details of fabulously exotic inventions, became widely popular in European and American intellectual circles.[37]

These offbeat scientific and technological interests found a place in art magazines and contemporary art spaces alongside conceptual and minimal art. Jack Burnham wrote many articles, including "Real Time Systems" for *Artforum* magazine, in which he compared the role of the artist to that of a software designer and computer programmer, describing several early artworks using systems found in "real time," artificial intelligence, and fictional artworks. He particularly recommended a collaborative group of artists and computer scientists, Pulsa, who were to provide a model for the next generation of art.[38] In the October 1969 issue of *Studio International*, Joseph Kosuth's seminal first installment of "Art after Philosophy" appeared alongside Victor Burgin's essay "Situational Aesthetics," the seventh essay in a long-running series of articles on technology and art, and Gustav Metzger's sprawling article on the history of automata, "Automata in History," part 2.[39]

Metzger's essay was a confusing visual mix of commentary, detailed captions, tiny illustrations, learned bibliographic references, and artistic speculation. It resembled a textual artwork itself, somewhat like Robert Smithson's 1968 *Artforum* article "A Sedimentation of the Mind: Earth Proposals," in which a similar mix of history, criticism, and speculation appeared. "Automata in History," part 2, also examined the sensual and the erotic aspects of automata, reproducing and describing several eccentric Indian

machines. Metzger juxtaposed these automata with a contemporary English robot on wheels, which had been designed to automatically detect and extinguish fires but which also closely resembled kinetic art's self-conscious mechanical doubling of the human body, specifically one of nouveau réaliste artist Jean Tinguely's deliberately useless "metamechanical" machines, such as his self-destructing *Homage to New York* (1960).

Without a doubt, there was something monstrous about *The Singing Sculpture*; this was a clear and deliberate denial of the ability of the viewer to experience the humanness, expressiveness, and bodily finitude that Fried saw as negative attributes of literalist art (art that did not so much acknowledge the objecthood of the art object as simply and literally exist as a dumb object, such as, in Fried's opinion, the works of minimalists Donald Judd or Larry Bell). As living sculptures (as opposed to performance artists), Gilbert & George cultivated this same literalist dumbness; their work was thus monstrous in its denial of conventionalized artistic identities.

Gilbert & George had re-created in a double performative gesture—calling themselves an artistic collaboration and calling themselves works of art. This created an auratic and fictive presence: the "persona" of the collaborative team. The artists' diminished real bodies had effectively become distant, spectralized apparitions, whose appearance was marked by, first, a profound self-absorption in which all appeal to the audience was avoided and, second, the rhythmically disjointed movements and stillness of marionettes and mimes.

The identification of the artists with their works of art, as well as with labor, was deliberate: If the artists were uncommunicative, so would be the works. Chapters 8 and 9 describe the performances of Marina Abramović and Ulay and then isolate the features that link their actions to the living sculptures: A third, phantom identity, created by team effort, obscured the identities of the individual artists, presenting the artists as depersonalized objects in nature.

Marina Abramović and Ulay, *Tango* (1981). Action, Latrobe University, Melbourne. Photograph John Lethbridge.

8. Missing in Action:
Marina Abramović and Ulay

The Relation Works

From their actions of 1976 onward—in the *Relation Works* (1976–80) and then the *Nightsea Crossing* series (1981–86)—Marina Abramović and Ulay (F. Uwe Layseipen) strained against the limits of representation. Like Gilbert & George, this artist team re-created itself as a third identity, but Abramović and Ulay extended the themes of ascetic, ritualized homelessness and displacement in a far more extreme manner than Gilbert & George; their collaborative teamwork was part of a radical redefinition of the edges of the self. This self would be available to the artists only through a process, once again, of disappearance and seductive inaccessibility; as Abramović recalled, "When you are focused on the here and now, people get the impression that you are absent."[1]

The *Relation Works*, created in the first years of the collaboration, involved stylized forms of obliviousness. During 1979, though, Abramović and Ulay began systematically refining these dramatic actions into scenarios of immobility and completely frozen withdrawal. Ironically, Michael Fried's opposition of absorption to theatricality again assists in deciphering an art to which he would have been completely unsympathetic—endurance-based performance and installation during the 1970s in which human action was fundamental—but which was also defiantly and unexpectedly antitheatrical, on account of the paramount discontinuity between artist and audience. During the late twentieth century, artists could, again by contrast to eighteenth-century painters, set their own bodies tasks that were so difficult or painful that they—as protagonists within the work—were to all appearances oblivious to everything else. The reasoning that led these artists to absorption and self-effacement—and to the elimination of all signs of personal identity except its final, involuntary traces—also

157

posited, as we shall see, the presentation of a space that permitted, even demanded, mental travel but insisted on the subject's inaccessibility. I propose that this inaccessibility, which in turn rests both upon the two artists' conception of a self regulated by forces beyond the limits of an individual subjectivity and also on a conception of identity as basically void, positions their work both in intention and in its operation partly within but even more beyond a psychoanalytically constructed perspective on trauma, gender, masochism, and identity formation. Their withdrawal into totally private but shared absorption first confirms but ultimately obliterates the supposed plenitude of the romantically self-sufficient couple.[2] Their collaborative actions, including the later *Nightsea Crossings*, insist on both dimensions, as did the two artists in their many statements. Their status—only evident as surprisingly late as the early 1990s—as precursors of a deconstructive body art, predicting works by younger artists of the later 1990s such as Pipilotti Rist or Jane and Louise Wilson, lies precisely in their momentary escapes from (but complex, conflicted, and riven acknowledgments of) the gendered boundaries of individual subjectivity.

To bring out the sheer difference of this perspective from that normally ascribed to their works, it is worth once more recapitulating a subtle point in Fried's argument. He observed that at a certain point in eighteenth-century French painting, an artist's immediate task was to extinguish or forestall the viewer's consciousness that the artist was aware of being beheld. His case studies had done this "by entirely engrossing or, as I chiefly say, absorbing his *dramatis personae* in their actions and states of mind. A personage so absorbed appeared unconscious or oblivious of everything but the object of his or her absorption, as if to all intents and purposes there were nothing and no one else in the world."[3] Performance artists certainly did not have the particular painterly skills of Fried's eighteenth-century French painter at their disposal, but the comparison between the two periods' representation of absorption is not completely gratuitous, for the irrational underside of Enlightenment thought was a shared undertone.

The analogy breaks down, of course, and the chief difference between eighteenth-century painting and the 1970s performance art I am discussing is obvious but nevertheless in itself highly instructive: The work of art became, quite literally, the artist himself and herself; the result, given that the artists were not foregrounding social or sexual codings but rather withdrawing the self from view, was an almost unprecedented breakdown of the borders of self and thus (again deliberately taking Fried's terminology) of the borders between the inside and outside of the work of art.[4] It might be objected that the difficulty of establishing the nature of the author, let alone the boundaries of the work, could lead to the experience of the artists as nothing more than objects (the exact same gamble at stake in abstract painters' identification of shape as form) as opposed to art. The tension this doubt produced in the viewer was compounded by both the spectacular, even sensational character of the actions and the eccentricity of the artists, insomuch as an audience was aware of their unorthodox philosophical trajectory. It seems clear to me that these objections and doubts

were anticipated and even welcomed, for the policing and maintenance of discursive boundaries among media were less important to Abramović and Ulay (let alone the other artists of this book, especially Gilbert & George) than the need to strain against and surpass the conceptual limits of both art and personal identity and yet still distinguish themselves (as other artists' actions and performances did not) from other kinds of objects in the world. Furthermore, the collaboration itself became the artists' subject matter, a permutation of artistic teamwork that is the real subject of this chapter.

Marina Abramović's early actions before her collaboration with Ulay constituted a theater of self-imposed cruelty. They were predicated on the interaction or the intervention of the audience. Where audience participation was solicited, the results were morally ambivalent—or they were short-circuited by the artist's inability to escape a theatrical artificiality that many members of the public found repugnant. In *Rhythm o* (1974), Abramović invited a randomly chosen audience from the streets of Naples to choose from:

> 72 objects on the table
> that one can use on me as desired.
> I am the object.
> During this period I take full responsibility.[5]

The objects included flowers, lipstick, a gun, bullets, knives, a whip, soap, and honey. The work lasted for six hours, from 8 P.M. to 2 A.M. The result was aggressive and violent: Abramović was stripped, cut with a razor blade, punched, a gun muzzle was thrust into her mouth, and a fight broke out among the audience, clearing the hall. *Rhythm o*'s interaction apparently took the form of violence, scandal, and near-rape. Even though the artist presented herself as absolutely impassive, the audience obviously responded as if she was sexually and physically available. Both men and women, as photographs of the action clearly show, were gleefully active in her humiliation and abjection. The performance documentation is extraordinarily bleak and melancholy. In one particularly grueling sequence of photographs, a middle-aged man addresses the young artist, kisses her, and fondles her breasts. Despite her remarkable fearlessness, Abramović's face carried a look of profound, contained desolation. Her audience had responded to contrived self-objectification with devastating predictability. What differentiated *Rhythm o*, however, from the later, more interesting resolution of the *Relation Works* was not its relation to sexual violence but the actor/artist's relationship to language. In the earlier work, the artist preserved a conventional distance from the work's other actors (who also happened to be the audience), for they were "used" as well as "using." In another, equally memorable work the following year, *Role Exchange* (1975), she swapped places with an Amsterdam prostitute for several hours during her exhibition opening at De Appel Gallery. Abramović's ungainly behavior canceled the piece, for although she attracted several customers, her awkwardness then scared them off. Her manner was unconvincing and artificial.

Abramović and Ulay's collaboration commenced with performance actions in

Marina Abramović, *Rhythm 0* (1974). Action, six hours duration, Galleria Studio Mora, Naples. Photograph Giovanna dal Magro.

the mid- to late-1970s that involved feats of physical endurance, pain, and mental self-control. In these *Relation Works*, the mode of address was more complex than in Abramović's solo actions, for it was double. The collaborating artists were together involved in a completely absorbing personal action, as opposed to acting or representing absorption for the audience. They smashed their bodies repeatedly into a wall-sized partition (1977), drove their small van around and around in a circle (1977), slapped each other's faces as hard as they could (1977), and moved heavy stones backward and forward (1978). They also performed feats of immobility and suspended action, sitting back to back tied together by their hair (1977) or standing stock-still with a stretched bow held by Marina and an arrow held by Ulay pointing straight at her heart (1980). For several years they moved from performance to performance and from host gallery to host gallery, living as guests in curators' homes or outdoors. Their nomadic existence resembled the complex, perambulatory penances of Indian sadhus, who renounced material comforts and the stability of a fixed home. They gradually moved toward the creation of completely static tableaux in which they experimented with different modes of physical and mental self-absorption.

Contrary to the general impression that the genres of performances and actions sought to lessen the difference between art and life and between artist and audience, the austerity of Abramović's collaboration with Ulay, commencing with the *Relation Works,* was dependent upon withdrawal from the audience and absorption in the gaze of the other performer. In other words, it involved the creation of a self-enclosed world in which it was difficult for members of the audience to see or gauge anything. Despite their rejection of traditional or contemporary theatrical rhetoric, the artists were drawn to violent actions and compulsive formats. Seen as ritual, Abramović and Ulay's ordeals were profoundly narcissistic, but seen as acknowledgments of the limits of representation, their noncommunication makes total sense. These ordeals were convincing, unlike *Rhythm 0* and *Role Exchange*, precisely because of the actors' disinterest in the audience. The actions were structured so that they could not be easily looked at, even though, like all works of art, they were. It was collaboration that enabled the artists to escape the audience's gaze, for what was presented was art about, and theoretically available to, something beyond communication: nonmaterial, nonverbal, prerational perception. And this putatively primal ground was definitely not the expression of an individual artist's sensibility.

Abramović and Ulay presented *The Brink* (1979) at the 1979 Sydney Biennale.[6] Ulay paced along a wall above the Art Gallery of New South Wales's sculpture courtyard; underneath, Marina patrolled the gradually moving edge of the wall's shadow. A couple of weeks later, at the National Gallery of Victoria in Melbourne, they performed *Go ... Stop ... Back ... Stop* (1979). Ulay moved around the museum's Murdoch Court to taped commands while Marina counted out swans' feathers.[7] *Go ... Stop ... Back ... Stop* can be compared to Gilbert & George's *The Singing Sculpture*, for both were regulated by commands and carried out in stylized, almost robotic movements. Each member of both teams moved in connected but periodically interrupted

Marina Abramović and Ulay, *The Brink* (1979). Action, duration four and one-half hours, Art Gallery of New South Wales, Sydney. Photograph Mike Parr.

orbits: Marina stopped walking every time a cloud passed overhead and blurred the wall's shadow. In a 1980 statement, Abramović and Ulay emphasized the mental self-distantiation and the physical nomadism required by such actions:

> ART VITAL
> no fixed living-place
> permanent movement
> direct contact
> local relation
> self-selection
> passing limitations
> taking risks
> mobile energy[8]

The curator who assisted the artists during their Melbourne actions observed their careful manipulation of performance environments. They stage-managed the performance venue, responding to the contingencies of sunlight, shadows, and architectural dimensions, focusing their audience's attention on transfers of energy rather than upon each artist's individual body. They also distinguished between "chosen" (found by the artists) and "given" (found and regulated by the host institution) venues for their actions: These museums were "given" spaces.[9] Abramović and Ulay presented themselves frozen in midaction or radically slowed down. As time progressed and their

energy levels fell, the audiences' tension levels rose. The artists often marked the performance environments with indexical signs generated by imitations of "real" work (Abramović described *Go . . . Stop . . . Back . . . Stop* as a deliberately "useless action"): In other performances, they used feathers, tire marks, or a shifted wall-partition.[10] This interest in the index almost certainly reflected the influence of Joseph Beuys, whose performance sculptures such as *The Chief* (1964) were allegories in which the physical conservation of heat by felt or honey (in *The Chief*, Beuys was wrapped in felt) became a metaphor for the storage of psychic energy.[11] Therefore, in *The Brink*, Abramović's stops marked the shifts in light and shadow whenever a passing cloud obscured the edge of the shadow along which she walked. The increasing quantity of swans' feathers scattered across the museum courtyard in *Go . . . Stop . . . Back . . . Stop* was also a measure of the two artists' increasing exhaustion over the duration of the performance. When the rules of their performance interrupted either artist's action, their movements went out of synchronization: They were passive agents, even automata, governed by the strict rules of external agencies and natural forces.

The "direct contact" of their work at this point was through senses other than sight. Abramović's later *Biography* (1994) paraphrases their earlier statement, describing

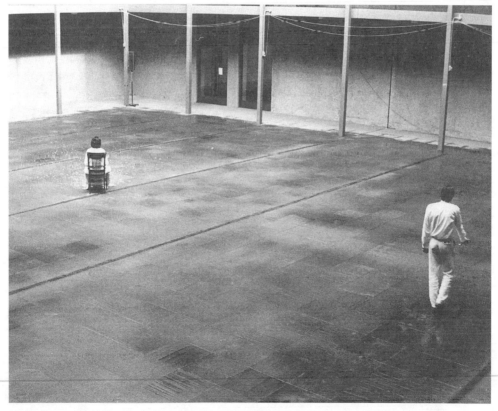

Marina Abramović and Ulay, *Go . . . Stop . . . Back . . . Stop* (1979). Action, duration one and one-half hours, National Gallery of Victoria, Melbourne. Photograph Bert Flugelman.

one of their early *Relation Works, Breathing In—Breathing Out* (1977), in a litany of nonvisual sensory experience. The final three lines of their statement alluded to working without preparation or previsualization—a method aptly described by the vernacular phrase "working blind":

1976 NO FIXED LIVING PLACE
DIRECT CONTACT
BREATHING IN—BREATHING OUT
WE ARE KNEELING FACE TO FACE
PRESSING OUR MOUTHS TOGETHER
OUR NOSES ARE BLOCKED WITH
FILTER TIPS
ONE BREATH CIRCULATES BETWEEN
THE TWO OF US
TIME: 19 MINUTES[12]

Marina Abramović and Ulay's emphasis on pain and endurance was in effect a contemporary attempt, such as those encountered in mystical and religious literature, to walk a path. Their actual practice of such a path—one based on painful penances and tests of endurance—differentiated them from most other similarly inclined artists of the period, who represented or depicted spiritual states but did not actively and systematically seek to embody them. Abramović and Ulay rejected the visual and

Marina Abramović and Ulay, *Breathing In—Breathing Out* (1977). Action, duration nineteen minutes, Student Cultural Center, Belgrade. Photograph Rudi Monster.

language as a source of knowledge in favor of physical inscriptions on the body—on a "body memory"—in an implicit critique of empirical visual understanding.[13]

There was a contemporary context for this rejection. Gilbert & George had been equally aware of the tyranny of visual knowledge, for they had exaggerated it to absurdity; Abramović and Ulay were aware of Gilbert & George, and Abramović was to include video clips of Gilbert & George's performances in a later solo performance (which included extensive quotations from other artists' performances), *Performing Body* (1998). As Carter Ratcliff observed, the gaze of the audience was necessary for the "living sculptures" to be constituted; Gilbert & George responded to the tyranny of this gaze by emphasizing the distance between themselves and the audience and by remaining hyperalert but personally evasive at all times.[14] Many curators and hosts, as we have noted, testified to Gilbert & George's simultaneous personal inaccessibility, poise, and sharp business acuity.

American artist Vito Acconci represented a superficially similar, endurance-based, performance practice. By contrast, however, Acconci's performances involved audience interaction, and overt manipulation of the audience was central to his work. For example, in the Atlantic City, New Jersey, action, *Broad Jump* (1971), he offered members of the audience a chance to exceed his jump and thus to win an hour with either of his two girlfriends. The artist retrospectively observed that he "was persuading the viewer to become actively involved in a sexual fantasy."[15] Acconci's intentions were, on the evidence of his statements, somewhat contradictory: They oscillated between manipulation and dialogue, but it is clear that he positively solicited the most theatrical interactions possible. Interaction with the audience, rather than self-absorption, was the essential, scripted component of his works.

In contrast, Abramović and Ulay's *Interruption in Space* (1977), Düsseldorf Art Academy, combined the same minimalist aesthetic and a similarly melodramatic leap, but to a completely different end. This action comprised a series of headlong dashes toward each other that were stopped dead by a partition, which was gradually pushed out of position. They repeated the action to the point of total exhaustion: Through this process, their naked bodies became bruised objects. According to another artist: "[I]f this had been a real-life drama, the audience could have stopped it or the police could have humanized the situation by beating someone up, but art is sacrosanct."[16] And many performances of the period did in fact incorporate or provoke audience intervention or were interrupted by the audience: Abramović's own early solo works—especially *Rhythm 5* (1974) and *Rhythm 0*—exemplify this trope and its artistic failure.[17] Abramović and Ulay's performances, however, actively ruled out audience intervention. The audience was clearly separated from the artists, and the artists ignored the audience. Unlike Fluxus artists such as Nam June Paik and Charlotte Moorman, Abramović and Ulay carefully avoided giving interviews or participating in debates after their performances.

In the works mentioned above, the artists' engagement in a specifically painful, spatial activity resembling work (walking, enduring something agonizing) was a way of

making process visible. This, in effect, suggests a certain process of self-representation defined by Fried's observation—made in the context not of performance art but of Gustave Courbet's painting—that self-representation is not necessarily determined by mimetic resemblance.[18] Instead, self-representation can be generated by an indexical trace, just as a thrown stone leaves traces—its ripples—on a still pool of water. The effacement of the very conditions of visual resemblance, according to Fried, is akin to breaking the pool's mirror surface. This same effacement was also integral to the activities of self-inscription and self-mutilation in much performance art. In a subtle extension of this discussion, Fried describes a mental activity—a sort of astonishment and a "marveling"—that can be induced by the presentation of the self as both present everywhere and visible nowhere. This not only recalls many historical periodizations of wonder but immediately brings Gilbert & George's *The Singing Sculpture* and Abramović and Ulay's action to mind.[19] Presentations of the figure of the artist himself and herself became representations of robotic or mannequin figures emptied of subjectivity. Such impassive actions amplified the normal processes of subjective identification.

BE QUIET STILL AND SOLITARY: Abramović and Ulay in the Desert

Artists forestalled the consciousness that they were aware of being beheld by removing themselves from the audience—literally absenting themselves to distant, isolated places where the only evidence of their actions after the event would be photographic or documentary traces of solitude and self-absorption in a desert, wilderness, or darkness. Marina Abramović and Ulay incorporated an extreme type of this artistic "tourism" into their work. Their search for an expanded sense of self, one that they were sure was possessed by Aboriginal people living in the Central Australian desert, might be seen as touristic—as yet another chapter in modern art's narrative of cultural primitivism. But if their romanticism was necessarily an orientalism, then such charges should probably be leveled at anyone who ever leaves home or empathizes with someone else.[20] In any case, as Abramović later observed, "Australia changed my life dramatically."[21]

Marina Abramović and Ulay were already shifting the focus of their work from violent actions to passive immobility (even though both types of work involved audience obliviousness) during 1979, when they had performed *The Brink* and *Go . . . Stop . . . Back . . . Stop*. They returned to Australia in 1980, traveling between October 1980 and March 1981 across Central Australia. Their slightly mad, Bruce Chatwin–like epic of crushing heat (they were visiting the center during its searing-hot summer), loneliness, disappointment, and delayed epiphany took them, like the English traveler and novelist, to Papunya (near Alice Springs), where, coincidentally, major Aboriginal artists had been producing acrylic paintings on canvas since 1971—and then through the Gibson Desert to Leonora, Willuna, and Mount Newman. Abramović and Ulay spent considerable time alone in the desert. Much of their journey was spent

Marina Abramović and Ulay, *Two Performances and Detour* (1979) Cover of artists' book showing photograph of desert landscape (Adelaide, Australia: Experimental Art Foundation, 1979).

struggling with sheer physical discomfort while camping alone for extended periods at remote desert water holes, but they were at the same time refining and extending their experiences of immobility and self-absorption. According to Abramović: "But, also, it is quite logical that we went to the desert because of our kind of background, and the work we do. We minimalize … and we try to realize with pure body and energy."[22] They were using the opportunity presented by their solitary existence to develop a heightened sensitivity and, they hoped, the ability to communicate through means other than speech or physical sight—in other words, through telepathy and clairvoyance. Abramović's biographical entry for that year read:

> 1981 EXPERIMENTS WITHOUT EATING AND
> TALKING FOR LONG PERIODS OF TIME
> MEETING TIBETANS
> NIGHTSEA CROSSING PERFORMANCE
> BE QUIET STILL AND SOLITARY
> THE WORLD WILL ROLL IN ECSTASY
> AT YOUR FEET
> EATING HONEY ANTS, GRASS HOPPERS
> ANIMA MUNDI
> WOUNDED SNAKE MEN
> MISSING BOOMERANG
> SLOW MOTION[23]

In the brief interview, published shortly after they had returned from the desert, Abramović and Ulay recorded their frustration with the apparently inaccessible primitive Other. Abramović said, "I must say for myself I expect very much from the contact with Aborigines, and I got very disappointed," adding, "I found there was something like a wall between them and me."[24] Nevertheless, Abramović and Ulay were eager to draw parallels between the nomadic heritage of desert Aborigines and their artistic practice. She observed: "We move all the time; they move all the time."[25] She noted the impermanence of both her performance actions and Aboriginal ceremonies. She then attached a particular connotation to the idea of disappearance and impermanence, one that was then still unclear to most critics and historians of Aboriginal art, though it had been associated with artistic actions by a few artists, specifically Dutch conceptualist Bas van Ader. She and Ulay emphasized that withdrawal from public view was a way of gathering psychic power. Having disappeared, "because of the incredible bonds of nature, you just function as a receiver, and as a sender, of certain energies and actually it's the most important experience, we felt."[26]

Abramović had seen an Aboriginal acrylic painting—a pattern of three concentric circles—at Papunya and had been mesmerized: "The energy you put in certain things can radiate; you can paint on cardboard or anything, it doesn't matter."[27] Whether Abramović realized it or not, a history of withdrawal and concealment was important to these paintings as well, for sacred powers had been preserved by hiding their traditional signs. As anthropologist Richard Kimber observed, there was a "fantastic amount of secrecy" involved in the continuous initiatory religious activity of Western Desert communities, and casual visitors were excluded from vast sectors of experience.[28] Abramović and Ulay expected Aboriginal artists to create paintings as close as possible to traditional culture, but Aboriginal artists desired to hide those truths.[29] Contrary to the European artists' desires, Aboriginal artists enacted the same refusal to represent or instruct as contemporary artists such as Abramović and Ulay. The European artists, however, were oblivious to the cultural ironies attendant upon what was a largely vicarious, albeit completely sincere, romanticism. Abramović recalled that the Aborigines they met were completely indifferent to them: "The Aborigines were not impressed at all."[30] Abramović's and Ulay's literally fantastic expectations of what they would find in their meetings with Aboriginal tribal elders in the desert were—at least initially—ludicrous and predictably disappointing. Later, however, they forged powerful and rewarding relationships with Central Desert Aborigines, which culminated in Aboriginal participation in one Amsterdam version of *Nightsea Crossing* (1983).

Abramović's and Ulay's melodramatic expectations were the result of their powerful desires for the supernatural, which they projected onto Aboriginal actors in their spiritual "desert quest"; the result was primitivism. But the refusal to write-the-self enacted in Aboriginal painting—in other words, the artists' double refusal to image an individual's subjectivity and insistence on silence, on the unknowability of their symbolic referent (along with the simultaneous international market reception of the

art precisely as an authentic writing of that innermost, spiritual self)—does help us to understand the sheer difference of Abramović and Ulay's project in comparison with those of their peers such as Chris Burden or Vito Acconci, whose works, as Kathy O'Dell suggests, should be understood through structures of masochism that provoke "viewers into examining the *structure of contract* so that certain of its aspects might be appreciated and mined, especially the *value of negotiation*."[31] Abramović and Ulay, on the other hand, proposed a different understanding of the structure of self. They did *not* negotiate, nor did they enter into any contract with their viewers at all. The silence and inaccessibility of their works was, more significantly (and this is additionally consistent with the artists' stated intentions) iconic: Pain pointed somewhere else. This enabled the production of a quasi-formalist ineffability, but when embodied in a transient form for which the artist was also the work of art, it also forced a reconsideration of the limits of representation and identity *beyond* interpersonal contact or structure.

The two artists were attempting to cultivate an indifference toward the travails associated with disappearance, pain, and even life itself during their desert journey.[32] This indifference, in turn, was connected with a denial of physical death: The two artists spoke about reincarnation and saw the body as a "boat" housing the spirit.[33] Both were familiar concepts within mysticism. Though I do not wish to criticize or caricature the validity of their enterprise, the result of their prioritization of pain and extrasensory perception was a continual identification of the supernatural with everyday things and an exceptionally romanticized—putting it bluntly, flaky—self-absorption in which both physical feelings and other people were reduced to phantoms and actors in a nonstop, real-life work of art.

This was the downside of being a "living sculpture." The absolute identification of self-absorbed artist with absorption, without an audience, attracted considerable personal penalty. From the earliest Happenings onward, artists had performed without audiences. The libretto for one of Allan Kaprow's famous Happenings, *Household* (1964), read: "There were no spectators at this event, which was to be performed regardless of weather."[34] Kaprow himself was intensely aware of the links between deliberately modified artistic authorship, quasi-monastic self-transformation, and the attempted elimination of the artistic self:

> At this point the "artist" as such is no longer a real entity. He has eliminated himself (and for one who has genuinely concerned himself with self-renunciation, the decision to do so must be respected). But its great poignancy is that it can never be a total act, for others must be made aware of the artist's disavowal of authorship if its meaning is not to be lost.[35]

As Kaprow noted, actions, performances, and installations were frequently closed, self-sufficient structures, performed or perceived in more than one time and place, often sealed off from audiences. Abramović and Ulay's lonely journey in remote Central Australia provided the groundwork for their later performances. Their mental preparation was envisaged as an overarching, private work of art that aimed to

transform their senses and bodies by meditation, isolation, and retreat.[36] Marina Abramović observed that they were "developing or working on certain intuitions or instinct for an almost telepathic way of communication, but then by coming to the city this just had to stop."[37] The project resembled Gilbert & George's self-made reincarnation as living sculptures. Neither collaborative team offered audiences the interactive contract usually but trustingly attributed to actions and Happenings. Abramović and Ulay's actions did not, any more than the living sculptures, bridge the gap between audience and artist.

Immobility, Withdrawal, and Work: *Nightsea Crossing*

After 1980, Marina Abramović and Ulay increasingly eliminated any sense of drama from their actions, presenting themselves through static *tableaux vivants* of exceptional impassivity that they explained by simultaneously corporeal and mystical metaphors: They characterized this period as "NO MOVEMENT/MENTAL TRANSFORMATION."[38] These actions consisted of long periods of complete immobility and, to all appearances, complete mental withdrawal from any engagement with the audience. They resembled joint meditation sessions staged in public with table settings of great but clichéd simplicity. The artists referred to these performances—and the preceding desert preparation—as the activity of "saints," just as the earlier tests of endurance had been the activity of "warriors."[39]

Tango (1981) was the first work made by the artists upon their return from the desert. Although the title was progressively altered by the artists (it was originally called *Similar Illusion*, then *No Tango,* and finally *Tango* or *Anima Mundi: Tango*), the piece, performed during the First Australian Sculpture Triennial at Melbourne's Latrobe University, was painfully static. Abramović wore a black dress; Ulay was dressed in a red suit. They played a few bars from a tango on a tape loop, moved together and apart a few times, then stopped frozen—suspended—in a tango embrace at the center of the room. The tango is a particularly melancholy dance form. Its movements are passionate and highly sexual, but the interaction between participants is choreographed to suggest the impossibility of human contact except through violence. The artists were surrounded by an audience sitting at tables, as if waiting for a meal: These viewers were immobile and separated from the artists both by physical obstacles (the linen-covered tables) and by their seated positions so that, as Abramović observed, "the public became a frame."[40] The tension among the comfortably seated viewers increased as the artists visibly tired and their outstretched arms dropped. The work was supposed to last for ninety minutes, but to the evident relief of the audience, it was interrupted by the Sculpture Triennial organizers.[41]

During *Gold Found by the Artists* (1981), the two artists fasted. They allowed themselves to take a drink of water only after each daily seven-hour performance had ended, the audience had departed, and they had been immediately driven to their temporary lodgings. They remained totally silent for sixteen days, alienated from the audience

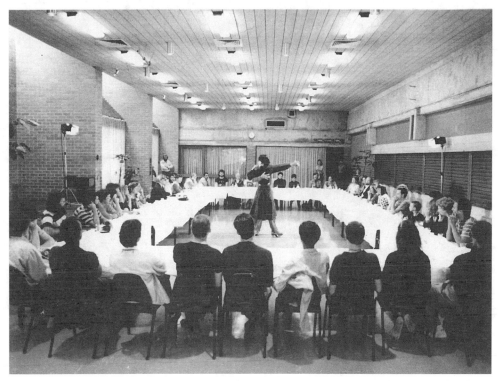

Marina Abramović and Ulay, *Tango* (1981). Action, duration ninety-six minutes, Latrobe University, Melbourne. Also titled *Anima Mundi: Tango*.

rather like Joseph Beuys in his performance *Coyote: "I Like America and America Likes Me"* (1974). Dressed in contrasting red and black outfits, Abramović and Ulay were completely still, staring at each other for each seven-hour installment across a long table upon which rested gold nuggets, a gold boomerang, and a live diamond python. The python in *Gold Found by the Artists* symbolized the current of psychic energy running down every person's spinal column; it is traditionally represented, in mystical literature, by a coiled snake. This mystical "snake" would be, in turn, metaphorically awakened by spiritual exercises, from which Abramović and Ulay's focused silences and mental withdrawal were clearly borrowed. The alchemical props on the tabletop somewhat unsubtly prompted the audience to recognize Abramović and Ulay's otherwise completely inaccessible, sealed-off process as a *tableau vivant* in which a process of hermetic mental transformation was taking place. Presumably, the live snake's mobility also indexed their psychic awakening; in Abramović's later solo performances, the opposite seemed to occur. In *Dragon Heads* (1990), she was wrapped in five live pythons and boas. Her safety from strangulation was dependent upon complete calm and relaxation, and the snakes' movements bore, in literal fact, an indexical but inversely proportional relation to her own serenity.

Gold Found by the Artists was performed in different cities for a total of ninety nonconsecutive days and was later retitled as part of one all-inclusive series, *Nightsea*

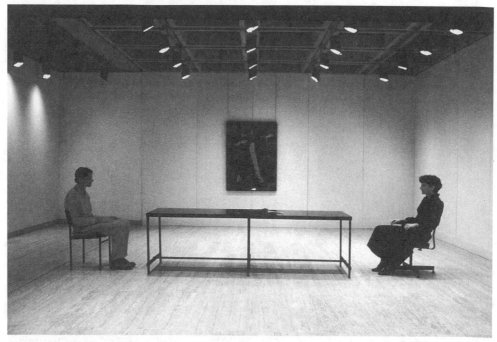

Marina Abramović and Ulay, *Gold Found by the Artists/Nightsea Crossing* (1981). Action, duration sixteen days, Art Gallery of New South Wales, Sydney. Photograph in the collection of the Art Gallery of New South Wales.

Crossing (1981–86). Some later versions dispensed with the props, leaving an empty table between the artists. If their earlier actions resembled work, this work resembled trance. Abramović and Ulay hoped this hard labor would liberate them from the encumbrance of the limits of language. The rules governing their labor were strict; in most of their works, neither spoke. In *Nightsea Crossing*, whose title refers to the soul's spiritual journey, speech was unthinkable. The popular left-liberal image of work within a capitalist economy superficially describes the appearance of Gilbert & George's tramp's work and Marina Abramović and Ulay's ordeals: Their work consisted of repetitive, alienated, inherently meaningless short tasks. The *Relation Works* incorporated literal effort and Sisyphean productivity that was heroic in scale, rather like Hamish Fulton's walks or Richard Long's marathon hikes across deserted moors at arbitrary, breakneck speed. For Abramović and Ulay, sitting in a state of complete, meditative self-absorption in *Nightsea Crossing* was also a form of work. It was a process of active self-purification, and it had several stages during which language was stripped away. In a version of *Nightsea Crossing* at the Amsterdam Round Lutheran Church, *Conjunction* (1983), the artists sat for four hours over four days with an Australian Aborigine and a Tibetan monk. In *Positive Zero* (1983), Abramović and Ulay sat for similar periods with six Tibetan lamas and two Australian Aborigines. The presence of Tibetans and Aborigines, who were members of actively religious, mystically oriented traditional communities, connoted active mystical work.

Both *Gold Found by the Artists* and *Tango* presented uncommunicative actors involved in inaccessible, trancelike work processes that were sealed off from the audience. At the same time, the works involved transfers of energy of two types. The first was hermetic: Abramović and Ulay were re-creating and enacting the state of non-verbal communication that their desert journey had inaugurated. This was signaled to the audience by alchemical symbols and experienced by the artists in quite spectacular visions.[42] This type of experience was not necessarily nonvisual even if it was incommunicable. In fact, from these works onward, visualization with the mind's eye (and the experience of paranormal, meditational phenomena over time with the mind's eye, not the physical eyes) became a definite aspect of the artists'—and particularly Abramović's—works. The other type of energy transfer—the artists' falling levels of strength producing increasing levels of audience tension—established an empathy between audience and artists without any rhetorical contract at all.

Abramović and Ulay's collaborative works emphasized, therefore, a particularly obvious relationship to their audience. The audience was ignored by the artists, who were profoundly and almost completely absorbed in their double self. The trope of "absorption" was overtly deployed but was, most important, quite dependent on collaboration. The mystical investigations offered by Marina Abramović and Ulay and the camp aestheticism of Gilbert & George were made believable by teamwork. They were saved by the complication of collaboration from straightforwardly idealistic eccentricity—or from hippie flakiness. Their contribution to the ongoing narrative of avant-garde art was as hard to evaluate as their sincerity precisely because—and this is the same point I made about works by other collaborations—the mechanism for adjudicating the importance of such collaboratively produced work is additionally complex. This was exacerbated by the artists' (particularly Gilbert & George's) ambivalent attitudes toward modernist and then postmodern avant-garde art. The manipulative simulation of an individual artistic identity by collaboration—and we have seen such simulation in many of this book's collaborations—reduced the history of modernism to conventions, and yet the only criteria suitable in the face of such a relativization of biography and politics turn out to be, ironically, those of formalist discourse—a discourse that locates meaning within the work, not within biography.

Not all artists wished to avoid theatricality and cultivate self-absorption. Most performance artists had temperamentally rejected Fried's formalism, not least because of his enthusiasm for post-painterly abstraction made by middle-aged white males. The transgressive rhetoric of conceptual art—and particularly the adversarial artistic claims made in the texts of works by Joseph Kosuth or by Mel Ramsden and Ian Burn—was itself often extremely theatrical, consisting of rhetorical chatter about action and utility interspersed with disingenuous appeals to common sense and left-liberal political community. On the other hand, Gilbert & George and Marina Abramović and Ulay made works that emphatically rejected theater and identifiable political programs altogether, even though they were a part of the generational drift

away from conservative formalist painting and sculpture. The two teams did, however, perversely reintroduce formalist structures into an antiformalist avant-garde, and this was itself further complicated by teamwork, for the representation of solitude was rendered yet more intricate because the artists were not alone and had virtually constructed the career of a third "artist" through teamwork.

Emptiness and the Death of the Author

The self-absorption and inaccessibility of the artists in the last two chapters were a self-representation that courts the charge of naive narcissism. The identification of artists with their works, as well as with labor itself, was crucial and deliberate. The equation of identity between artist and artwork resulted in a new type of collaboration involving physical and mental dysfunctions so apparently extreme and pathological that they must be examined closely.

There was evidently no painless link between collaborative art and the dissolution of identity, and yet, as we have seen, pain was not the point. It would be literal minded to imagine that the artists actually believed in a "death of the author," but they seem to have aspired to something quite similar, which implies not that such processes were not at work in earlier art but only that they were not as explicit. The many heterogeneous forms of installation, conceptual, and performance art had often emphasized their own textuality. The structuralist and poststructuralist relativization of identity (and especially Barthes's famous, endlessly reified, eventually totally recuperated "death of the author"), along with cultural theorists' and some art historians' relativizations of meaning as socially contingent on place and time, had considerable impact upon artistic practice during the 1970s and early 1980s. Structuralist theories influenced visual artists, including Robert Smithson, from the early 1970s onward, initially through articles in *Artforum*, through writers such as Jack Burnham and Lucy Lippard, and through the very wide popularization of Claude Lévi-Strauss's structuralist anthropology. Such theories often resulted in the adoption of a set of visual tropes in which stable authorial signature styles were demoted in favor of more heterodox stylistic allegiances. It is doubtful whether there was any causal relationship between collaborative art and a structuralist-inspired dissolution of the originary author in art, for the author is not the text. Blurring the two requires confusing the difference between reading and creating a visual text, and this deliberate misreading is precisely, though not naively, what happened in certain artistic collaborations.

As if to conspiratorially hide this "death of the author" from view, the particularly striking identity of collaborative artists/actors was a key element in their style: Biography and the work of art began to be interchangeable. Marina Abramović and Ulay's and Gilbert & George's performances were deliberately fragmentary. The artists had no "life" separate from their works. Abramović later remembered that "I see myself as a bridge."[43] Their desire to withdraw from contact with their audience, as well as their elimination of such traditionally recognized signs of authorship as stylistic

mannerisms, was not based on any opposition to art. Nor was it similar to the antiart sentiments held by activist artists such as the Guerilla Action Group during the same period. Their negation of self was really not oppositional, just as Ulay's early solo action, *Stealing the Painting* (1971)—for which he stole a much-loved painting from the National Gallery (Berlin) while being video-recorded during the theft and his escape—was only in part an anti-institutional gesture. Indeed, the combination of artistic collaboration and self-absorption went with an idealization of art's transformational capacity so extreme as to look like utopian modernism.

Nightsea Crossing had an intellectual pedigree that problematizes straightforward categorization. It was a process of active self-purification—a process common to both East and West—in which language was stripped back to and then putatively beyond its iconological bones. It was a conscientious and pedantically spectacular negation of both art and self—an emptying out of identities and structures. These works possessed a magnetism and charisma directly attributable to the trope of a vacuum, a motif traceable to Yves Klein, to John Cage, and back, of course, to Marcel Duchamp.[44] The state of being that Abramović and Ulay were unlocking during their stay in the desert was located, they thought, within their own minds rather than in an orientalized Other. The process of performance work as "living sculpture" was redefined by them as liberation from the encumbrance of language, but certainly not as the enactment of some catharsis. Indeed, Marina Abramović and Ulay saw their artistic "work" as more sweeping in scope than mere psychotherapy. According to Abramović's friend, Bojana Pejic, "For Abramović this body/boat is one that, during all the many physical or spiritual departures and detours, needs to be liberated from language, from 'the Symbolic.'"[45]

In retrospect, a state of being liberated from language or individual subjectivity sounds like an essentialist countercultural cliché. Stephen Bann, assessing the impact of Buddhism upon Japanese conceptualists, insisted that the Buddhist idea of the Void could not be equated, other than in a naive way, with the "vacuum" that lay behind the magnetic charisma of Duchamp's conceptual operations.[46] Yet I nevertheless think that the identification of Void with vacuum and with conceptualist negation is effectively made in Abramović's and Ulay's works, without the artists' necessary participation in the Buddhist faith, but with the sense that voidness was the common property of artistic experience. Furthermore, Abramović and Ulay had chanced upon a philosophy that actively and repeatedly emphasizes that there is no simple escape from metaphysics and no way of simply standing "outside" or "beyond" mental activity and language. In any case, the success of this identification depended upon the artists' ability to project the quality of absorption. Gilbert & George made the same identification of personal negation with affective power. If the artist was also the work of art, then nontheatrical, enacted absorption would be the embodiment of a state of being liberated from language and individual subjectivity, because this state is deemed available, at least in theory, through massive stress, rapid movement, silence, or meditative immobility. Abramović and Ulay attempted this in a variety of harrowing physical and

mental exercises that eclectically resembled Buddhist Vipashyana practices or Zen Buddhist *za-zen* movements. Ulay said, "I think our desert trip was part of tuning yourself more, training yourself."[47] The two artists were aware of the significant psychological connotations of emptiness as the stratum underlying phenomenological existence, reprinting an interview with the Dalai Lama on this precise subject in their 1985 exhibition catalog *Modus Vivendi*.[48] According to Abramović, the intense visions experienced during *Gold Found by the Artists* compelled them to seek a way of organizing or controlling the flood of disruptive, powerful sensations that Abramović designated as prelogical and that were certainly manifest as a powerful bodily fact and body memory: "I gained a kind of knowledge which was not logical. It was pre-logical. I think that when you have an experience which is outside the normal world, we have it because we create a certain gap in consciousness."[49] They accordingly visited the large Tibetan Buddhist community where the Dalai Lama resides at Dharamsala, in northern India, and undertook structured Mahayana Buddhist meditation sessions.

In a different but related (and in terms of art discourse, more recognizable) exposition of the concept of emptiness, Pejic defended Abramović against charges that her self-absorbed silence embodied an unreflective acceptance of herself as a speechless subject. According to Pejic, Abramović rejected language, and thus direct communication with the audience, in order to posit herself outside the "Law of the Father."[50] By contrast, artists such as Vito Acconci, in the works described in the last chapter, exposed the workings of masculinity in language through cooperation with the audience. However, Abramović and Ulay were not demystifying anything, though it is possible but incorrect to see their performances as reifications of gender roles. (Works in which Abramović is passive and Ulay active are the exception rather than the rule; usually, they did exactly the same thing, or else roles were not divided according to gender divisions.) They were digging through the strata of culturally constructed gender roles to the bedrock beneath, creating a new, hermaphroditic body outside the binary iteration of male and female or nature and culture. Even in 1979, Ulay had stated that it was "not important that we are man and woman. We talk of ourselves as bodies."[51] Moreover, from the beginning of the collaboration, they spoke of themselves as parts of a two-headed body. That the two parts of this new body were not simply united as one is clear: When Abramović observed that in "[t]he two bodies doing the same thing, but within, there is a separation," she was acknowledging the ambivalent oscillation between harmony and schizoid loneliness in the *Relation Works* and in the often troubled relationship between the two artists.[52] Their often abusive actions were the manifestation of the latent violence between two partners, a dynamic that they addressed through sublimation in the later *Nightsea Crossing* series.

It is immediately apparent that interpreting this art as symptom is of limited use, for Abramović and Ulay's idea of "Rest Energy" had to be distinguished from the agency of therapeutic catharsis, even if the ideas overlapped to some degree.[53] Describing such performances as enactments of trauma or ego formation added an unnecessary descriptive layer to their work, for nothing much was explained, nor had the

artists seen their performances in those terms in the first place. Even though it initially seemed an unlikely tool, the subtle formalist dichotomy of theatricality and absorption clearly describes these performances and installations far more accurately. Other interpretations—that Marina Abramović and Ulay's works or Gilbert & George's *Singing Sculpture* were primarily masochistic or traumatic in orientation, or that they were motivated by the desire to transgress taboos—are by themselves a dramatic oversimplification and misrepresentation of the artists' intentions. Such readings also ignore the evidence of the works themselves. Abramović and Ulay both stressed that they were moving from the personal to the completely impersonal: "from form to formlessness, from instrumental to mental, from time to timelessness."[54] Abramović emphasized that the endurance or expiation of pain was irrelevant to her conception of the works' meanings: "Pain is not there in the performance."[55] Both artists saw pain as an obstacle, like the fear of dying, rather than as a motif in itself. Collaboration was a resource, but it was not regulated by trauma or pain. Their repressions were neither uncovered nor resolved by collaborative catharsis. They were sublimated through a ritualistic, meditative system of repetition, distance, and self-absorption. But the question remains: What was the identity constituted by the triple conjunction of artists and their work? This is the subject of chapter 9.

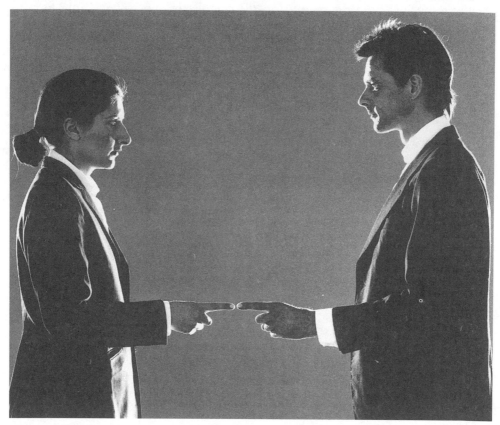

Marina Abramović and Ulay, *Point of Contact* (1981). Action, duration one hour, De Appel Gallery, Amsterdam. Photograph Rudi Monster.

9. Doubles, Doppelgängers, and the Third Hand

Collaboration as the Realm of the Uncanny

Another entity emerges in artistic collaboration by couples: a third artistic identity superimposed over and exceeding the individual artists. This identity, I observed before, is not necessarily that of the family, nor simply that of the merged identity of romantic lovers. Abramović and Ulay named this a third force, "Rest Energy," and insisted that a hermaphroditic identity, independent of them, was created by collaboration.[1] Other collaborations were equally aware of the creation of an authorial character exceeding the identity of two collaborating artists. According to Komar and Melamid, who had collaboratively evolved a hybrid type of history painting from a combination of socialist realist and modernism during the 1970s: "We invented that third person, the third artist, but we never specifically named that third artist."[2] Abramović and Ulay at first sight exactly matched the popular expectation and desire that collaborative artists who are also a heterosexual couple would image themselves either as lovers absorbed in their narcissistic plenitude, suppressing themselves as individuals, or as opponents locked in conflict. They chose actions that appear to confirm every one of these stereotypes through withdrawal or hyperactivity: a massively prolonged kiss; an arrow held at the heart of the lover; each staring into the other's eyes; slapping each other until totally exhausted. But all this actually evacuates the cliché of the romantic couple, leaving behind their uncanny simulacra—doubles, phantoms, spectralized bodies.

Freud's concept of the double illuminates the elusive extra identity created in such collaborative works. He locates the phenomenon of the "double" in the realm of the uncanny:

These themes are all concerned with the phenomenon of the "double," which appears in every shape and in every degree of development. Thus we have characters who are to be considered identical because they look alike. This relation is accentuated by mental processes leaping from one of these characters to another—by what we should call telepathy—, so that the one possesses knowledge, feeling and experience in common with the other. Or it is marked by the fact that the subject identifies himself with someone else, so that he is in doubt as to which his self is, or substitutes the extraneous self for his own. In other words, there is a doubling, dividing and interchanging of the self.[3]

This phenomenon of the double precisely describes the artists' self-representation. They folded themselves into an elusive extra identity: the double body of the collaboratively created third artist. Gilbert & George dressed alike, and with metallic face paint on, they looked alike. Abramović's and Ulay's bodies changed quite dramatically during their collaboration, and according to many observers, they became remarkably similar in appearance, even though they made a work highlighting the differences between their physiques, *Communist Body—Capitalist Body* (1979). They looked and behaved almost like twins: Both were tall, muscular, athletic, and long-haired, and they dressed in similar clothes. In addition, their birth dates were the same, and they first met in 1975 on their mutual birthday, as Abramović's *Biography* had emphasized:

1975
MEETING ULAY
STRONG ATTRACTION
30 NOVEMBER 30 NOVEMBER
BORN ON THE SAME DAY[4]

Ulay had frequently cross-dressed before the collaboration. According to Pejic and Thomas McEvilley, he had actively explored transvestism and cultivated associations with the transvestite community. The *Relation Works* and *Nightsea Crossing* were definitely not conceived as reinscriptions of binary male and female structures, as Helen Mayer Harrison and Newton Harrison's early ritual actions clearly were. Both artists were active or both were passive; they avoided enacting binary dichotomies. From the beginning of their collaboration, the two spoke of themselves as one hermaphroditic identity and as a "two-headed body."[5] According to Abramović's *Biography*:

1978
MALE AND FEMALE ENERGY UNITED
TO PRODUCE HERMAPHRODITIC
STATE OF BEING[6]

This body was not simply the sum of two parts: Abramović noted that "[w]hen you [Abramović and Ulay] entered the space of performance, you are a super-Self. Anything is possible. We work from the point of view of that higher Self."[7] In

conversation, Abramović and Ulay often spoke about the synthesis of male and female principles in their collaboration. Their ideas were not unusual: The concept of complementary male and female, "yang" and "yin," sexual energies was widely current in countercultural circles during the 1960s and 1970s, even if the idea of voluntarily obliterating sexual difference is now unfashionable. The energy "exchange" during their performances created, both artists thought, a third, independent existence that by 1980 they were designating as "Self."[8] In *Point of Contact* (1981), under hypnosis, they presented this energy in action: Looking into each other's eyes, they watched their hands drawn inexorably closer and closer. Abramović and Ulay were moving beyond recognizable gender-based markers of identity at the same time as they were also attempting to develop faculties such as telepathy through the processes of sensitization described in chapter 8. In public lectures after their collaboration had ended, they described the collaboration as symbiotic. They emphasized the absolute trust that had been necessary to make their works, even though they quarreled much like any other couple.

The process of working together in performance obviously represented a massive investment of experience and effort in a common goal, as well as a total sublimation of all their artistic efforts into a shared practice that annihilated the boundaries (psychic, mental, social) between the artists. Eliminating boundaries is not the same as eliminating difference: It implies travel and translation, not loss. Collaborative practice, and the specific demands and implications of performances that resembled ordeals, meant that there was considerable ambiguity around the edge of the personal and the possible. Abramović's and Ulay's paranormal experiences and exhausted bodies, for example, pushed past normally defined limits of behavior and sensitivity. When Abramović and Ulay insisted that their actions created a third hermaphroditic energy, the limits of their double "body" were clearly going to be different from the limits of individual physical bodies.[9] The collaborative work implied a phantom body—a third entity created by the two artists—and the nature of this body, either in the "safe house" of the art gallery or the world outside, was quite uncanny, for the distinction between the real and the phantasmic was blurred. Although Ian Burn and Mel Ramsden had prefigured this subversion in their words for *Soft-Tape* several years before, the cheerily positivist, rational tenor of their works did not presage Abramović's and Ulay's taste for the bizarre and magically uncanny.

One aspect of uncanniness—so discussed and then so conventionalized as a trope in art since the later 1980s—must be emphasized: the unexpectedness of the uncanny. The sensation of the uncanny occurs when "dark and buried," repressed images and beliefs come to light, bringing with them emotions of dread and creeping horror. According to historian Terry Castle, the uncanny has been a powerful set of artistic and literary tropes, extensively deployed since the Enlightenment. As she explains in a gloss of Freud's "The 'Uncanny,'" this quality is made active when apparitions cease to be an active part of a belief system and come into conflict with rational expectations—when primitive beliefs and repressions that have been "surmounted" seem, like the cartoon character the Phantom, to walk again.[10]

Many of the performances and installations of these chapters were uncanny. Christo and Jeanne-Claude's *Wrapped Coast, Little Bay, One Million Square Feet, Sydney, Australia* was a stretched veil: its unbroken, overlapping, bound folds hid rock but revealed more mysterious phantom forms, highlighting the surreal immanence of dreaming in the daytime world as an inadvertent and at the time unnoticed symbolic shroud, memorializing Aboriginal genocide. Like Christo's earlier wrapped women, the gargantuan wrapped Sydney coastline was also highly erotic: The fabric reminded several viewers of a false skin or a body stocking. Gilbert & George's masked, bronze-painted faces and unrelenting impersonality were similarly uncanny. Abramović and Ulay's *Relation Works* resembled children's games, but the self-inflicted damage and abjection was real and uncanny. Art galleries and museums are habitually thought of as places of beauty and reflection; artworks are not supposed to hurt themselves.

All these works were convincing because of their paradoxical inaccessibility and obscurity. But another factor was also at play: This was a zone between life and art, much like conceptual artists' office games and the Poiriers' ruins. The uncanny emerges from situations (children's play, for example) that carry familiar, reassuring associations. The uncanny is, as Freud noted, something terrible that reemerges into consciousness. The eruption of apparitions may be powerful and impressive but is also unexpected and therefore uncanny. As Castle observed, an apparently pedestrian work may suddenly turn uncanny, for its conventional narrative has lulled readers into the suspension of their disbelief and then, when the fantastic suddenly appears, betrays them. One problem faces artists manipulating the vocabulary of the uncanny: Its hidden elements are too easily recovered through repetition and turned into clichés. Because painting—the prime modernist signifier of expressive artistic identity—had come to be contained, confined, and exhausted by the economy of its framed boundaries, it could now embody the uncanny only with great difficulty. On the other hand, in the 1970s, installations and actions were still not governed by easily deduced criteria, nor were they as thoroughly recuperated. Installations and performances remained—at least to this point—enigmatic: Where the work of art began and where it ended was ambiguous. Art forms in which the boundaries between art and life were blurred could be sites for eruptions of the uncanny.

Gilbert & George made ordinary social rituals uncanny by staging them as art. They did so in a restrained, tasteful way that had almost nothing to do with the pyrotechnical fireworks of dada performance. They preserved the factual status of their actions, elevating personal ritual to art form. They carried out quotidian actions as living sculptures much in the manner of a well-run small business. As living sculptures, however, their behavior was distant and uncannily mechanical, like automata. For *The Meal* (1969), they sent invitations to 1,000 people in the London art world, inviting them to pay to attend a seven-course dinner with the artists and their guest, pop artist David Hockney, in a hired music room at a beautiful Arts Council property, Ripley. The cook was a professional chef; Lord Snowdon's butler was the waiter. Thirty guests attended, and they were to various degrees all overcome by the sheer

strangeness of the occasion. One man was so disconcerted that he went to a piano and played it very loudly, in a fruitless attempt to join in and convert the occasion from something uncanny into humor. Hockney himself, as a participant and the straight man in the drama, was relatively at ease, merely noting afterwards that the conversation was a bit banal. Quite correctly, he thought that Gilbert & George were "marvellous surrealists," even though the conventionally correct, snobbish butler had refused to serve him tea instead of coffee after port.[11] Gilbert & George's often stated belief in art as socially redeeming—a self-consciously camp nod toward both Ruskinian aesthetics and Russian revolutionary art of the 1920s—was rendered grotesque and uncanny when collective teamwork was translated into an absurd action like *The Singing Sculpture* or *The Meal*.[12] Both works involved audiences—art critics and general public alike—in tests of judgment as to whether something was real or imaginary.

The uncanny nature of these works should be contrasted with Fluxus performances which were for the most part intensely theatrical. Fluxus artists (with the ambivalent exception of Joseph Beuys, whose performances alternated between episodes of intense self-absorption and audience involvement) had no consistent desire to withdraw from their audiences, as Gilbert & George or Abramović and Ulay had done. Fluxus artist Nam June Paik and cellist Charlotte Moorman's performances demonstrate this difference. Paik's *TV Bra for Living Sculpture* (1969–76) attracted considerable media attention wherever it was installed.[13] Charlotte Moorman strapped an intricate, heavy construction, including two tiny television monitors covering her

Gilbert & George, *The Meal* (1969). Dinner served for David Hockney and guests at Ripley House, Kent, 14 May 1969.

breasts, onto her naked body. She played abstract phrases on her cello while Paik replayed images of the cellist, her cello, and the bystanders on the breast-sized monitors.

TV Bra for Living Sculpture converted Moorman into a living sculpture, but the work had little in common with Gilbert & George's *The Singing Sculpture* or Marina Abramović and Ulay's *Relation Works* other than affinities of form and production: Collaboration alone does not ensure an interest in absorption. Paik's and Moorman's work was both theatrical and antiart: Everyone could be an artist able to participate in the work. On the other hand, Gilbert & George and Marina Abramović and Ulay made, with only one or two exceptions, art out of their distance and detachment from the audience. Both Moorman and Paik were available after performances for questions and conversation, whereas Abramović and Ulay removed themselves afterwards. Gilbert & George's intense distaste for Fluxus and its communal activities has already been noted. Moorman did, though, perform works by Jim McWilliams with affinities to those of Gilbert & George and Abramović and Ulay: for example, *Ice Music for Sydney* (1972–76) and *The Ultimate Chocolate Experience* (1976). In the latter piece, Moorman sat holding her cello on a chair for thirty minutes, completely covered in dripping chocolate. Even though both works seemed to occupy the same zone of participatory theater as *TV Bra for Living Sculpture*, the superimposition of a spectacular covering—chocolate—over the performer and the gradual modification of her form immersed the static performer in a natural process that excluded the viewer. Other Fluxus performances also involved naked female bodies covered in edible material, but by contrast, these involved gratuitous, vicarious audience participation: Sedately clothed male viewers lasciviously licked cream off naked female flesh. The quotidian theatricality of Fluxus should generally be differentiated from Gilbert & George's and Marina Abramović and Ulay's self-absorbed dissociation.[14]

The Singing Sculpture and Abramović and Ulay's *Relation Works* comfortably confirmed commonsense expectations about advanced art (that it would be deskilled and scandalous) but betrayed these expectations with something stranger (music hall foolishness and real, not simulated, pain). These actions also betrayed the purity of conceptual art, highlighting and appropriating its tropes of endless, pathological enumeration and obsessive documentation, adding gratuitous layers of romantic narrative in place of generic Wittgensteinian dialogue. The actions of Gilbert & George and Abramović and Ulay embody a shopping list of the uncanny: doubles, dancing dolls, automata, alter egos and "mirror" selves, spectral emanations, omens, and clairvoyant precognition. The artists' relationship, like a wraith, became the subject of their works. In 1979, an artist-friend of Abramović and Ulay perceptively analyzed the implications and probable costs of this identification:

> Their relationship is now the pre-existent drama of their work implying at the ideal level, hermaphroditic fusion, sexual bliss, at the other, schizoid division, the archetype of either/or. Each performance recapitulates this drama of ideal fusion or catastrophic split, with varying degrees of intensity and specificity.[15]

The very fact of a collaboration, especially one in which the artists were also the actors in dramas of real communion and real pain, suggested to many viewers an almost unbearable closeness, even though the poles of schizoid division and fusion were not, as I next show, the only result of artistic collaboration, for the artists were not mistaking the uncanny itself, or its constraining forms, for psychic liberation. On the contrary, the drive toward near-death experience (the point at which the double emerges) was also a drive toward a hermaphroditic state characterized by relationality and mobility—in other words, by continual transaction.

Body Doubles and Doppelgängers

But what kind of unexpected double identity had the artists created? The answers overlap, as we might expect, but the first is also the most obvious: a double of a particular kind, a doppelgänger. It is worth remembering here that doppelgängers are popularly associated with the annihilation of personal identity, and this is what had happened. Just as Abramović and Ulay, through extreme self-absorption, spectralized their bodies, so the collaborative body became their real body, for the artists' corporeal bodies had been stripped of normal significance, like shadows. Their collaborative work implied a phantom body—an apparitional third entity created by the two artists—and the nature of this entity, either in the "safe house" of the art gallery or the world outside, was uncanny, for the distinction between the real and the phantasmic was blurred. The individual identities of Abramović, Ulay, Gilbert and George were marginalized or spectralized or became progressively and deliberately less accessible. Asked why they made a point of not distinguishing their separate contributions to the collaboration, George replied, "Well, it's not based on that. It is 'us' doing it together."[16] Marina Abramović and Ulay were well aware that they were creating a doppelgänger: In *Relation in Time* (1977) and *Breathing In—Breathing Out* they presented themselves as joined halves of a double being, like Siamese twins. Many of the *Relation Works* presented the two in symmetrically organized tableaux. Their other works also manipulated the idea of doubleness: Marina Abramović walked along the edge of a shadow during *The Brink;* in *Nightsea Crossing*, Abramović and Ulay looked like mirror images of each other. Shadows, like mirror reflections, are indexical doubles, for they do not exist without the original presence of a body or object. As a trope in art, shadows share many of the connotations of mirrors, and mirrors had also been the material of many conceptual works of art as well.

It is necessary to distinguish between these doubles and yet another type of phantom, that described by Nicolas Abraham, which "works like a ventriloquist, like a stranger within the subject's own mental topography" because it represents a secret repressed in another's (in Abraham's cases, the father's) unconscious.[17] Nevertheless, Abraham's observation that "the work of the phantom coincides in every respect with Freud's description of the death instinct" echoes collaborative artists' simultaneous correlation of collective work with extreme vicissitudes of experience and with the

emptiness and dissociation usually linked to death.[18] Analogies definitely have their limits, but as with the uncanny affinity between Enlightenment conceptions of the pastoral and 1970s performance art, the places where similarities break down reveal the temporal and physical contingencies of each: Two types of artistic collaboration—the family and the collaborative couple—could obviously be viewed through the lens of compensatory mechanisms, especially when a third identity appears alongside the artists.[19] Contemporary theories of the body have examined how compensations appear as phantoms, doubles, and doppelgängers. Elizabeth Grosz, for example, discusses the externalized image of the body as an ideal Other, quoting Jacques Lacan to the effect that the imaginary anatomy experienced by hysterics or people with delusions about imaginary limbs varies according to cultural ideas about the body and not according to empirical physiology.[20] The body image, therefore, has an existence independent of physical reality and the body.

The linked but slightly different possibility, therefore, is that the double identity created in artistic collaboration could be described as a phantom extension of the artists' joint will, rather like a phantom limb. In *Volatile Bodies*, Grosz explains the phenomenon of this phantom extension of the will:

> The phantom limb is a libidinally invested part of the body phantom, the image or *Doppelgänger* of the body the subject must develop if it is to be able to conceive of itself as an object and a body, and if it is to take on voluntary action in conceiving of itself as subject.[21]

Grosz suggests a way of theorizing the collaborative artist formed by the teamwork of two or more artists—the artists' phantom appendage or third hand. Although this is a familiar proposition about collaboration and teamwork, it is more than a poetic metaphor. In this context, artistic collaboration was an aesthetic gesture born of free choice, a way of acting freely rather than capitulating to circumstance, training, or expectations. Perhaps it was also, for these artist teams, a way of seeing the artistic self clearly. In the case of artists who were also actors in their works, it was definitely a way of having the artistic self made available for self-scrutiny. Grosz observes that human subjects are never able to see their own bodies completely. Though hands and legs may be visible, for example, the small of the back cannot be seen. No unified image of the body is possible; it is only available in fragments. The out-of-body, synchronistic visions of psychics—who say they see their bodies in trance from above and from several sides at once—enable a point of view of the whole body. Artistic collaborations, in effect, create another synthesized subject/bodily extension with the implicit expectation that the impossible idea of a unified body image may be almost magically attainable by the conjunction of complementary parts: Abramović reported that during the extended silences of *Nightsea Crossing*, she had the sensation of seeing in every direction around her, as if every pore of her body could see, and of developing a spectacularly magnified, all-encompassing sense of smell.[22] The artists' extreme subordination of their individual will by an imaginary entity resembles—even if in a benign

form—Grosz's description of autoscopy: "The subject's ego is no longer centered in its own body, and the body feels as if it has been taken over or controlled by outside forces."[23] Abramović's and Ulay's experiences cannot be reduced to pathology, however, because their relationship to the idea of what was "real" and what was "void" was too complex, as their citations from Mahayana Buddhism's negative theology show, and because, more important, it was linked to their freely chosen deconstruction of artistic identity by teamwork.

The idea that artists worked collaboratively in order to see themselves more clearly is obviously an excessively literal-minded solution to an ontological problem. Even so, in her discussion of phantom limbs, Grosz notes Lacan's suggestion that the cultural fascination with the human form may be explained by the desire for a stable identity.[24] If collaborative artists created a third hand, then this hand had affinities with phantom limbs, which have definite characteristics: They feel strangely different and more formal than real limbs; they resemble the limbs of automata and puppets.

An Excess of Authors: Collaboration as a Decision

Influential 1960s countercultural celebrities, including R. D. Laing, Richard Alpert, and Timothy Leary (who had all been variously influenced by Tibetan Buddhist psychology, Islamic Sufi dance, Christian mystics such as Nicholas of Cusa, and proto-countercultural theorists including Aldous Huxley), had romanticized alienation, doubling, and depersonalization.[25] Artists and writers of the period emphasized the possibilities of active, nonpathological body-image disintegration and reorganization and the re-formation of self. Joseph Beuys, for example, actively proselytized a concept of the artist as a paradigmatic example of actively chosen personal freedom. Gilbert & George specifically identified their collaboration as an active process of will, self-consciously constructed and requiring continual maintenance. They remembered:

> GEORGE: We are quite separate from everyday things.... we never cook ...
> GILBERT: Or wash ...
> GEORGE: We are not involved in ordinary things.... Not at all ...
> [Q:] Why do you shun everyday chores?
> GEORGE: To give us time and space to feel our way to our purpose. Every day we have to be sure that the purpose is set in the right direction. It needs redefining every day, every second.[26]

Whatever the motive, artists saw collaboration as a way of re-creating themselves as nonalienated subjects and as a free action by individuals who wished to step outside the boundaries of personal expectations and conditioning.[27] It is evident that not all third hands were doppelgängers, but neither did the concept of psychological compensation account for the formal and philosophical emptiness and disappearance at the heart of such finely nuanced spectralizations and phantasmic projections.

An alteration or loss of identity can, of course, be achieved in a number of ways,

both pathological or intentional, as the works of chapters 7 and 8 demonstrate. Self-mortification, self-alienation, phenomenal detachment, and the loss of personal ego were far more than a simple reflection of a crisis of self in a period of artistic flux: They were attempts to simultaneously surpass binary characterizations of identity and the means, contradictory though this may seem, to eliminate theatricality from actions.

The limits of representation are also the limits of language, and what lay beyond these limits was an important and complex question for these collaborations. It was the same question that had haunted conceptualist art of an earlier period. Gilbert & George's refusal to take time out to be anything other than living sculptures and Marina Abramović and Ulay's third hand were strategic means of shedding the traditional signs of unwanted artistic personality—the conventional studio-based artistic identity increasingly under question in the 1970s. Such extensions of conceptual art, a movement that became so retrospectively important in the 1990s, were predicated on the disintegration of authorial stability but also, even more important, on something else: the limited horizon of the concept of identity itself as posited either by Freud or within modernist criticism. This bracketing of "natural" artistic authorship identified itself, in Abramović and Ulay's complex perspective on language, for instance, with an emptiness and blankness outside and not inside the horizon of representation. Their flight outside the prison house of language—if it can be judged to have succeeded—was possible precisely because of both teams' escape as individual "artists" from their personal bodies into the uncanny but mobile realm of phantoms.

Conclusion:
The Value Added Landscape

Reformation of the Self

I have described three broad types of collaborative authorship, within which shared authorship was a strategy to convince the audience of new understandings of art and identity. I traced the transition from a conception of artistic identity and work in which artists were the creators of autonomous art objects to a conception of the "artist" as a figure emerging from different production methods, not as the creator of art objects unified by signature style. This figure was a tool, and neither a truth nor a presence encoded at the core of the artists' works.

This final chapter recapitulates the principal questions encountered in the course of my book and maps out the answers that the works of art suggest. Before this, though, I am going to return to the work of Ian Burn, the conceptual artist and member of Art & Language, because Burn's late paintings begin to answer these questions. What links the art I have described to art made now? Are the 1970s discontinuous with contemporary art? How and why did these artists arrive at such a different conception of self and identity from their postmodern colleagues of the 1980s, even though the art we have examined evolves away from insistent intentionality toward unconstrained reading?[1] Although the artists in this book were involved in a complex relativization and reformation of the self, necessitating a process of negation, they did not simply set meaning adrift. All, in different ways, appealed to a ground beneath cultural signification that was not based on an appeal to the fetish of personal artistic subjectivity. In other words, I have traced an alternate genealogy for the familiar themes that informed postmodern art as it emerged as a style in the 1980s. But I have definitely not found, unlike recent revisionist histories of conceptual art such as the exhibition catalog *Global Conceptualism: Point of Origin* (1999) or Tony Godfrey's

189

Conceptual Art (1998) any explanatory value in emphasizing any orderly transition from 1970s conceptualisms into postmodern art at all. But the same motifs, identities, and working methods that I describe reemerge in the mid- to late-1990s among younger artists as different as Scottish video-artist Douglas Gordon, Japanese high-technology avatar Mariko Mori, Jane and Louise Wilson, Group Irwin, the Danish ecological activist group Superflex, and many others. The list is immense, and the movement outside discursive boundaries, beyond stable artist/artwork divisions, into new forms of nonpolemical action should register, by the end of this book, as immediately familiar.

The Artist as a Value Added Landscape

Ian Burn returned to a particular type of artistic collaboration at the end of his life: the incorporation of other artists' works. This method of "collaboration" has many affinities with the appropriative methods of 1980s postmodernism, and Burn was aware that his late work constituted a critique of earlier conceptual art. He had insisted that artists not abandon a critical role to critics, asserting that artworks could and should incorporate many levels of discussion and that the role specializations of the "art industry" should not squeeze the artist out of art criticism: Conspiratorial interventions; his multiple lives as art theorist, artist, and occasional curator; and artistic collaborations had been part of that venture. Burn's flexibility implied much more than a strategy in a war over artistic turf. It was evidence that the complicated demands—on art, on audiences—of conceptual art had produced a self-imposed crisis among artists. Burn's very late work represented a final, elegiac postscript to that crisis, which had necessitated the migration from genre to genre and from identity to identity. His collaborations with Mel Ramsden and Art & Language had suggested the intertwining of altered authorship, postcolonial revisionism, and an artistic mainstream, and this intertwining remained the principal subject of his later paintings, which explicitly and implicitly suggested that the presence of an autonomous subject had been abandoned in favor of a more heterogeneous conception of the author and a more diffuse notion of truth in which fact and fiction were interwoven. Art, it seemed, had become more and more the memory or record of innovations and actions carried out by artists rather than their autonomous works. It is fair to say that all his work, including that with trade unions during the later 1970s and 1980s, was marked by his own deliberate refusal to finally decide on which side of the fence he stood with regard to the elimination of the subjective figure of the artist. For Burn, as for Kosuth, the question of whether or not painting was dead was the cipher signifying the figure of the subjective artist.

After his return to Australia from New York in 1977 and during his work with trade union–based arts organizations thereafter, Burn's personal artistic practice became almost invisible, except for the occasional exhibition of early conceptual works in international surveys.[2] From his background within conceptual art and its associated

critique of art institutions and the art market, he had emphasized the "contribution" of conceptual art and its successors, but he also understood the inevitable problematics of bringing art to the "people." For not only were the "people" already coming to art as consumers in a more turnstile-driven museum system, but political art itself had, Burn reluctantly saw, become an intellectual and aesthetic backwater. In 1991, he distanced himself from the community-based art on the grounds that it was becoming simply rhetorical. Burn saw the contradiction—for sentimental reasons otherwise largely elided by the Left—between a "politically correct" avant-garde and socially committed collectives.

During the last two years of his life, until his tragic death by drowning in 1993, Burn began to exhibit new work that embodied his double practice as both writer and artist. He purchased amateur paintings from secondhand shops and junk markets, framed them within wide white moldings, and added an overlaid text of elegantly printed words on Perspex, suspended in front of the paintings. These works, the *"Value Added" Landscapes* (1992–93), combine ready-made amateur landscapes with short essays describing the appropriated paintings. The texts are structuralist meditations on the activity of looking and reading; they enact the accretion of critical interpretation. Because of the transparency of the printed Perspex, it is impossible to concentrate exclusively on either text or picture, and so the landscape reappears like a ghostly afterimage as text was read, producing a constant slippage back and forth between image and writing. Other works, such as *This Is Not a Landscape* (1992), present a text in two versions. Sentences are repeated—with corrections and scrawled editing in gray lettering—on an overlaid transparent Perspex sheet. The underlying, unedited words read like old Art & Language tracts and *The Grammarian*.

The method of appropriation represented by these landscapes cannot be completely separated from the appropriation so characteristic of the 1980s, but Burn insisted on the works' status as "collaborations," emphasizing in the texts that his contribution was the discursive framing of another artist's work. He emphatically titled the exhibition itself *Collaborations*.[3] The works definitely incorporate other artists' productions without permission, as opposed to "cover versions" of borrowed images. The authors of Burn's discarded landscapes are unwilling collaborators, and although he acknowledged the name of the unwitting landscape painter wherever possible, the relationship is one of considered exploitation. As far as moral rights are concerned, the *"Value Added" Landscapes* clearly gloss over their obliteration of many amateur artists' intentions.

The incorporation of another person's "art" ("art" that would be critically assessed as "craft") can, however, be compared with *arte povera* artist Alighiero e Boetti's employment of Afghani embroiderers and the construction of his artistic identity through assistants for works such as *Ordine e Disordine* (Order and Disorder) (1973).[4] Boetti, however, paid the craftspeople whose work he incorporated; they had agreed to his commission, just as Kosuth's agents and newspapers around the world had agreed to display his *Fifteen Locations*. Boetti and Burn wished to avoid the attribution of the

This is a landscape. The absence of landscape, positions viewers, where impossibility declaims the necessity of landscape. Text becomes spectacle editing itself, which describes itself, is a landscape. A form haunted by content it can't allegorise, more or less foretold, pictorial meaning between texts defying painterly purpose. Not discrete entities, not a syntax of harmony, alluding to its own redescription: a guilt collaboration, each displacing another's self-importance, differently. Self-narration tells of elisions of sky and plain, rhetorics of tree and horizons. Abrasions of landscape revealed by textual drag, contrive pictorial drag; reading disfiguring surfaces, the practice of a painter.

Ian Burn, *This Is Not a Landscape* (1992). Oil, ink, wood, Perspex; 33 inches × 33 inches × 6 inches. Collection Monash University Gallery, Melbourne.

signs of conventional authorship (brush work, distinctive composition) to themselves; they wished to preserve a "critical" relationship to their images. The extent to which this self-distantiation was necessary to Burn is emphasized by the possibility, based on the similarities between many of the landscapes and his own early student landscapes, that he could have painted the "found" pictures if he had wished. The montage of amateur landscape painting with Burn's highly professional critical writing was, for Burn, an opportunity to reflect on cultural hierarchies and was certainly the occasion to revisit landscape genres of personal sentimental significance, for his own career had commenced as an amateur landscapist. Burn was a translator/artist attempting to mediate between different kingdoms: between image or text, and also between amateur art and expert art criticism.

As a sneaky insurance against almost inevitable misinterpretation, he also represented mediation in action in his prose as if he could somehow be detached from his

Against translucent light, a pictorial geography which is everywhere and nowhere, traces dismissed in memory. Complacent vision invokes prescriptions of landscape seeing organised in cliche: barn, fields, road, fences, emulating a community of received pictures. Landscape-ness fixed in perception, in cultural form. The fictive space of naturalism, of mauve, yellow, green tints becoming an allegory for a nice day. Salvaging meaning in replication, in pictorial obsessions of self-narrative, the how-to competence seeks an imagined redemption in the culture of nature.

Ian Burn, *"Value Added" Landscape #3* (1992). Oil, ink, wood, Perspex; 17 inches × 21 inches × 6 inches. Courtesy Avril Burn, Sydney.

art. The texts for Burn's *"Value Added" Landscapes* were self-consciously evocative, and thus they construct another purple layer of poetics for the viewer, in turn describing the pictures or anticipating the response. They simulate a viewer's reading: In each text, a description is followed by an often critical assessment. The painting underneath *"Value Added" Landscape #3* (1992), for example, is "an imagined redemption in the culture of nature." Spelling out the conditions and outcomes of viewing had been a constant in Burn's work. The *Mirror Pieces* had been accompanied by diagrammatic instructions.

Both the *"Value Added" Landscapes* and *This Is Not a Landscape* were constructed within a consciously disingenuous employment of both conceptual art's and minimalism's cosmopolitan—and by now global—syntax, but Burn also retrieved and mourned an untainted view of nature. In *"Value Added" Landscape #3* (1992), his text gently mocks the painting's "how-to competence," but in other pieces he evokes the mirage of a culturally and historically aware experience of nature, writing that "the joy of recognition produces the landscape controlled. Vigilant informality, a horizon of words lit by the streaky sky." In the *"Value Added" Landscape No. 11* (1993), Burn's texts did not exactly match their referents. They added a postcolonial but quixotic dimension to the usually transparent structure of conceptual artists' use of language. The re-presentation of objects from amateur culture, and their unexpectedly unequivocal recertification as art, paralleled Burn's earlier use of geography as a metaphorical vantage point from which to map imperial relationships—the center and the autonomous subject.

Burn's critical writing did not really serve as a guide to these "collaborations." Instead, the landscapes testified to the artist's intense nostalgia for the autonomous art object itself—the terrible nostalgia that had marked conceptual art's second phase in the early 1970s. This crisis and its accompanying nostalgia shaped artists' attempts to recuperate or surpass the autonomous artistic object. Whereas Boyle Family attempted the former, Gilbert & George were monuments to the latter. Mel Ramsden had observed that Burn's photocopied diagrams for his early *Mirror Pieces* were part of an ironic strategy made all the more ambiguous by the works' usual unfinished state.[5] *Soft-Tape* was never shown, and *Mirror Piece* (1967) was exhibited in an incomplete version in 1968; equally, the late landscapes are alternately hidden and foregrounded by their texts. The word "poetry" was found repeatedly (even if often pejoratively) in conceptual artists' statements, but the fictionalization of art through notes and art criticism and eventually in the delusory rhetoric of collective political action altogether represented something quite specific rather than vague. Artists like Burn were manipulating authorship by collective work or anonymity. Either way, it was an emancipation from the artist. Even the laborious office work of early conceptualism was an escape forward. However, this poetry, or, more precisely, this use of metaphor and discursive contexts, led toward an art that could neither preserve its aura of impersonal linguistic purity nor evolve into a politically or socially effective critique of authority, as the next generation was to find to its cost.

Conceptual artists wanted to turn the cultural authority of metropolitan discourse against itself through the mimicry of cultural authority, but this mimicry almost immediately came to be seen as the adoption of authority itself. The contradiction haunted Ian Burn's union work less than it haunted other artists' renunciations of art, but even so it remained like a phantom, which probably explains why Burn's final landscapes have such an uncanny quality, as if something—a poetic figure of the artist—that had been thought dead had come back to life. Burn could not quite bring himself to straightforwardly present his later works as an intermediate imaginative zone of reflexive critique like *The Grammarian*. Instead, he sought the support of appropriated, semianonymous landscapes so he could reinvest his text overlays of transparent Perspex with the signs of art.

The distinction between landscape tropes and the textual critique in Burn's typically ingenuous appropriation of amateur art is confusing, at least if it is simply assumed that Burn was reevaluating the differences between amateur and professional artist, a subject that these works do not address at all except as a decoy. His work with ordinary unionists and his history as a member of an elite New York art gang, as Michael Corris describes Art & Language, had itself become the material of his art.[6] The "political artist" as such was no longer a real entity, having lost almost every last trace of critical potential except that of sentiment, as Burn painstakingly analyzed in his 1993 essay "Art: Critical, Political."[7]

In 1970, attempting to police the borders between poetry and information, Burn had insisted that conceptual texts were "not to be considered literature or aesthetics or

criticism or any of the standard categories that one gets in the support or surrounds of the art environment."[8] Text, he then suggested, was simply a medium for the expression of thought. In 1993, by contrast, he noted that the ability to read pictures is a critical faculty but that to rely too much on this faculty would be to treat the work of art as nothing but a rhetorical surface. For Burn, whereas "looking" was a relatively passive action, then "seeing" signified finding and extracting sense and meaning in an act equivalent to recovering the artist's intentions and activity; here, the familiar model of memory as registration surfaces. His personal history as one of the first conceptual artists emerged once more, for he was presuming, as he and Ramsden had in *The Grammarian,* that a work of art would somehow be conceptually self-sufficient. As Andrew McNamara sympathetically but acutely points out, Burn was trying to save "seeing" from "reading" on the grounds that "reading is the failure to recognize any limit, it engages in untrammelled analysis that does violence to the integrity of the artwork."[9] For Burn, as for Kosuth, the artist's intentions remained communicable and privileged. His stress on "seeing images," McNamara observes, produces clarity, whereas for the artists in chapters 4–9 of this book, this untrammeled reading was not only far less damaging and more intertwined with seeing than Burn could admit but positively enmeshed with self-distantiation. The categories were blurred because intentionality always fails. The self-distantiation of perspective was, for these artistic collaborations, a far more important objective than immanence and correctly preserved intention. But despite his abiding attachment to the idea that language was transparent, Burn's late works clearly moved toward a more comprehensive understanding of reading and an ironic if reluctant acceptance of unconstrained interpretation. He was now literalizing the ostensible transparency of language and, with typical caution, staging the figure of an artist composed of two nonartists (an amateur and a critic), each of whom threatened to cancel the other and each of whose "real" status was uncertain. This was a literary conception—a strangely extravagant, original, paradoxical conception—of the artist as a "value added" landscape, and we have found our way once more to an ethical conception of reading.

The Intersection of Self and History

In chapters 1 and 2, I described the early conceptual art of Joseph Kosuth, Ian Burn, and Mel Ramsden. I wanted to find out whether an involvement in artistic collaboration was integral to their work, and how collaboration was inscribed in their art. Underneath this, I wondered if an interrogation of the inscribed figure of the artist would alter our sense of that conceptual art's significance. Distantiation of self, it emerges, was a constant. It was indicated by the artists' denigration of the qualities of poetry and painting, which were signs of the individual subjective personality that they rejected both in their writing and in their collective work. The use of others to realize his works was critical in Kosuth's transition from tautological propositions to discursive juxtapositions of text in extra-artistic contexts. The discursive "permeability"

of extra-artistic situations, in the form of employees' and agents' decisions on his behalf and later in his appropriated authors' considerable authority and iconic status, enabled Kosuth to "defeat" painting and thus the constraints of individual signature and expressivity. The gulf between his late-1960s *Investigations* and the mid-1970s networks of text, though, is immense and profoundly connected with his early works' opacity—that is, its resistance to the reader's identification. His text-based architectural installations, from the *Text/Context* series on, are metonymic in relation to their archives but not primarily indexical, for though we never see the texts in his work as being by "Kosuth," even if they are "Kosuth's," we *read* the texts, even his canceled texts, and inevitably then submit to narrative identification. In his early works, Kosuth wished to create an antivisual art of propositions but found, I think, that the result was insufficiently capable of producing mental visualization or memorization. The stripping back of art to an indexical function had eliminated the very tools the mind uses to retain memories: iconic and metonymic forms. In a sense, he was forced to take advantage of the retinal, in the form of real architectural spaces, to allow the fuller operational potential of reading, even though the artist in his own essays both admits and elides the considerable difference between his earlier and later work.

Burn and Ramsden wrote "works" that sought to occupy a zone between art and theory. The extra-artistic framework of these works—conspiracy, factional maneuvering, and collective authorship—was far from insignificant, for it enabled the displacement of a simple idea of the "self." Their bureaucratic methods were not just dysfunctional by-products of the artists' personalities or their historical hyperawareness. Corporate impersonality created the aura of expert critical authority and modernity fitting to artists whose relation to conventional studio practice was increasingly attenuated and who found that this persona was a highly effective tool in the policing of the artists' massive investments in intentionality. Without a fixed model of production and often with the figure of the individual artist ambiguously cloaked in conspiratorial, efficient, intimidatingly literate collective identities, conceptual art offered a critical mobility within which the terms of identity—whether geographical or authorial—changed from work to work according to context and carefully plotted opportunity. In Kosuth's later works, words were subsumed by their location in a chain of architectural forms and regional languages, as opposed to their position in a tautology. Architectural forms were redefined according to chains of text like a pictorial composition. This was also to be the dynamic of Burn's later landscapes.

The focus in Part II was collaborations based on families or couples who worked like anthropological or archaeological research teams, with an emphatically articulated, even rhetorical sense of historical perspective and memory but behind a cloak of stylistic semianonymity. Memory can be distinguished from mental illumination; this is the difference that Kosuth, and later the Boyles, Poiriers, and Harrisons, encountered in a movement from syllogisms toward landscapes of memory—away from the indexical and away from individuated, certifiable indexical marks, toward art without signature style. These teams presaged the postmodern rejection of modernism's frequent

rupture from tradition and history. They were obsessed with the subject's identification with history and memory, and they reconstituted a fictional figure of the artist. Boyle Family firmly rejected the tag of romanticism, insisting on their precision and their disbelief in the utility of individualist, traditionally expressive artistic identities. Anne and Patrick Poirier saw memory not as an allegorical stage—as might have been expected, given that their vast model cities were of antique provenance—but as a symbolic landscape of icons arranged for mnemonic effect but withholding the disclosure that archaeological retrieval offers. The Harrisons, in particular, did not see the contemporary subject's memory as necessarily fragmented: The activity of reading, as they saw it, is fragmented but also ethical. Collaborative and collective work was also ethical. Reading, therefore, is like artistic collaboration, because putting yourself into another's shoes implies taking a long-term, ethical perspective.

Part III looked at a later phase in conceptualist art, a phase in which the figure of the artist (and, again, an interwoven set of exaggerated, highly stressed, binary relationships between the visual and antivisual and between imagination and memory) was further deconstructed. Christo and Jeanne-Claude evolved a transitional artistic identity, in which a corporate "name" or trademark subsumed their own individual selves in an almost parodic exaggeration of artistic freedom. Gilbert & George linked their living sculpture's believability to their total self-absorption, creating a meta-identity that encompassed both artists, relegating them to the status of automata or puppets. Marina Abramović and Ulay referred to "body memory" and the "third force" that they created in their interaction with each other, stoically enduring extraordinary self-abuse in their experiments with the paranormal in order to create a new hermaphroditic being. This was not a naive attempt to experience an unmediated state of perception through the creation of a new body, and the recourse made by Abramović's friend and essayist Bojana Pejic to a concept of prelinguistic existence obscures the deconstructive nature of Abramović's collaboration with Ulay. Abramović herself also hindered this understanding in her autobiographical presentations of an eclectic collage of geomancy, Tibetan Buddhism, and shamanism. The bedrock she unambiguously referred to, though, was absence—the absence as ground familiar from well-known postwar philosophy but also specifically that of the later Mahayana Buddhism that denies the ultimate reality of all essences. Abramović and Ulay were acknowledging a sophisticated, non-Western, quasi-deconstructive precedent in Mahayana Buddhism.

In the collaborations discussed in this book, was conventional authorship reconstituted? The answer depends on the manner of the artists' inscriptions of themselves into their works—in other words, on the nature of the figure of the artist manifest in the work and, most of all, on the relation between the figure of the altered artists and the nature of their artistic "work." First, members of artistic collaborations seemed to shuttle back and forth between the opposite terms inside discursive and gendered identities without the need to identify exclusively with either, especially since a wall of ambiguity usually shielded each artist. A crude paraphrase of Freud divides the

mind in an equine pairing: The ego is the rider, steering and restraining the unruly id. In collaboration, the opportunity to move securely outside the reification of this economy is apparently offered by an act of symbiotic identification. The artist leaves the burden of the ego or the responsibility for the id to another, secure in the knowledge that the ego or id is safe. The artists in the third section of this book, and in particular Gilbert & George and Marina Abramović and Ulay, were interacting with each other in a specific way, moving outside the boundaries of sadistic or masochistic interaction precisely as those signifiers were set in motion. The artists enacted difference without its threatening the stability of their artistic ego. This implies not that the so-called Other is literally made actual in collaborating partners but more pragmatically that artists are freed to reidentify themselves as id or egos. This was a familiar liberating tactic in surrealism, along with the desire to free or unlock the unconscious, the site of the magical. But was this ever possible, or was the desire merely sentimental? And what was the function of such a literal folding of textuality onto the figure of the artist and the purpose of complicated, excessive artistic authorship in general?

To answer this question, we have to ignore for a moment the apparent extravagance of the artists' self-fashionings and return to the determined anonymity of their handiwork and to their self-absorption, their refusal to communicate. They were quite obviously inscrutable or self-sufficient, qualities that they also contrived or manipulated (as did Mark Boyle) in order to present collaboration as a boundary against the audience and against overdetermined readings. The desire to get "behind" the artists' identities—and to reify older subjectivities as if they lay behind the new—remained a constant. American critic Peter Schjeldahl, for example, noted that Swiss artists Peter Fischli and David Weiss had gained a "Tinkerbellish status," occupying an identity somewhere between "shamans and mascots."[10] According to Schjeldahl, the members of such artistic collaborations "project an emotional repletion, from being apparently sufficient to each other, that no individual (except the certifiably bonkers outsider artist) could command."[11] Schjeldahl's idea of repletion was connected with a deliberately gratuitous authorial excess. Artistic collaboration, he wrote, inevitably suggested an almost utopian level of interpersonal communication and commitment unusual in everyday life; this was a common expectation. The collaborating artists presented in this book were quite exotic; their extreme identities absolutely invited personal curiosity.

Elizabeth Grosz and Rosalind Krauss have noted Roger Caillois's studies of animal mimicry and his thesis that the doubling of camouflage is a function neither of need nor of adaptation.[12] In his famous 1935 paper, "Mimétisme et psychasthénie légendaire" (Mimicry and Legendary Psychasthenia), Caillois observed that animal mimicry—the patterns on moth's wings or animal fur, for example—was not really protective coloration, for predators used other senses than sight (smell, for instance) or hunted at night.[13] Camouflage did not, he thought, serve a practical use, and mimicry was not adaptive behavior. It was, as Krauss notes, "a failure to maintain the boundaries between inside and outside, between, that is, figure and ground."[14] Caillois suggested

that this is not a failure but a doubling, a mimicry, of the space around the body in order to allow for its possession by the surrounding environment. In Elizabeth Grosz's separate gloss of the same essay, she concludes: "Mimicry is a consequence not of space but of the representation of and captivation by space."[15] The same doublings, the same carefully gratuitous disguises and screens of secrecy, are found in the artistic collaborations of this book. Collaboration, like camouflage, is strictly speaking a surplus. Collaboration complicates the textuality already inherent in artistic statements.

There is another way of thinking—one that is more historical—about the same operations of secrecy, camouflage, and anonymity in relation to artistic collaboration, and this is through relationality and mobility. The influence of Marcel Duchamp was almost crucial for artists to arrive at their mutable notions of identity. The tropes of camouflage, conspiracy, and mimicry, all familiar from Duchamp's life and work, were in evidence or openly acknowledged by a large number of the collaborations surveyed in this book.[16] According to David Joselit, Duchamp saw chess as a process by which two players alternately redefine the conditions of each other's mobility, and "each alternately becomes the projection or embodiment of the other's unconscious."[17] Joselit suggests that an intersubjective model of the unconscious is implied in Duchamp's proposed marriage of chess and roulette. This, he says (drawing on Hubert Damisch's work), produces a discursive unconscious very different from that proposed by Freud. I think that the figure of John Cage is equally relevant, for Cage was interested not only in the process of negation (and the negation of self) but also in the genealogy of the emptiness thus uncovered. Cage, it turns out, was an artist of whom the teams in this book were very much aware.[18]

The drive to rethink artistic authorship is not the property of any one period, even one as productively unstable as the late 1960s and 1970s, but the trajectory of artistic collaboration in this period was part of an important sea change in art. From the late 1960s onward, artists moved away from modernist definitions of art and artistic work. At the same time, artistic collaborations moved toward identities that could be constructed, fictional, disguised, or absent. The trajectory that I have described throughout this book was simultaneously one of disclosure and withholding of the self. It reemerges in the mid- to late-1990s, not just in the art of Ian Burn but across the far wider field of younger, postconceptual artists. Art literally shapes artists.

Notes

Introduction

1. See, for instance, Yael Even, *Artistic Collaboration in Florentine Workshops* (Ann Arbor, Mich.: University Microfilms International, 1984); Svetlana Alpers, *Rembrandt's Enterprise: The Studio and the Market* (Chicago: University of Chicago Press, 1988).

2. See Thomas Crow, *Emulation: Making Artists for Revolutionary France* (New Haven, Conn.: Yale University Press, 1995).

3. In the late 1980s and early 1990s, perhaps in response to magazine editors' searches for new artistic novelties, there was a small spate of survey articles on alternative modes of artistic work. These include Eleanor Heartney, "Combined Operations," *Art in America* 77, no. 6 (June 1989): 140–47; Glenn Zorpette, "Dynamic Duos: Artists Are Teaming Up in Growing Numbers," *Art News* 93, no. 6 (summer 1994): 164–69. Heartney surveys collaborations by couples in U.S. and European contemporary art, including Kristin Jones and Andrew Ginzel, TODT, the Starn Twins, McDermott & McGough, and Clegg & Guttman, concluding that there are two types of artistic duos: those who work with research and high technology, combining forces in order to deal with large tasks and an excess of information, and those who work politically, producing implicit or explicit critiques of the art system. Zorpette's article is surprisingly thorough, citing "Artistic Collaboration in the Twentieth Century" essayist Robert Hobbs on the death of originality and interviewing the Harrisons, Poiriers, Bechers, Starns, Kienholzes and Komar and Melamid. As might have been expected from the list, Zorpette's focus is on couples who work as teams. He hypothesizes about gender roles in collaborations, asserting that female partners tend to be managers. Although considerable critical attention was lavished on new British collaborations in the mid-1990s, they were rarely considered in terms of artistic collaboration. One exception was the Southampton City Art Gallery's exhibition *Co-Operators;* see Godfrey Worsdale, curator, *Co-Operators,* exhibition catalog (Southampton, England: Southampton City Art Gallery, 1996); for a review of this exhibition, see David Barrett, "Co-Operators," *Frieze,* no. 28 (May 1996): 64.

4. Whitney Chadwick and Isabelle de Courtivron, eds., *Significant Others: Creativity and Intimate Partnership* (London: Thames and Hudson, 1993).

201

5. See Debra Bricker Balken, "Editor's Statement," *Interactions between Artists and Writers,* special issue, *Art Journal* 52, no. 4 (winter 1993): 16–17; Bricker Balken mentions a model of collaborative authorship developed in this book: the third hand, or the "third mind," writing that "William Burroughs and Bryon Gysin have argued that through the process of collaboration an anonymous and disembodied voice is created" (Bricker Balken, "Editor's Statement," 16).

6. Cynthia Jaffee McCabe, "Artistic Collaboration in the Twentieth Century: The Period between Two Wars," in Cynthia Jaffee McCabe, curator and ed., *Artistic Collaboration in the Twentieth Century,* exhibition catalog (Washington, D.C.: Smithsonian Institution, 1984), 15–44, 15.

7. Irit Rogoff, "Production Lines," in Susan Sollins and Nina Castelli Sundell, curators and eds., *Team Spirit,* exhibition catalog (New York: Independent Curators Incorporated, 1990), 33–39.

8. Ibid., 33.

9. Jack Stillinger, *Multiple Authorship and the Myth of Solitary Genius* (Oxford: Oxford University Press, 1991).

10. Michael Wood, *The Magician's Doubts: Nabokov and the Risks of Fiction* (Princeton, N.J.: Princeton University Press, 1995); for a discussion of this book, see John Banville, "Nabokov's Dark Treasures," *New York Review of Books* 42, no. 15 (5 October 1995): 4–6.

11. Leo Bersani and Ulysse Dutoit, *Caravaggio's Secrets* (Cambridge: MIT Press, 1998), 39.

12. For this study, particularly see Rosalind Krauss, *The Originality of the Avant-Garde and Other Modernist Myths* (Cambridge: MIT Press, 1985); Rosalind Krauss, *The Optical Unconscious* (Cambridge: MIT Press, 1993); Hal Foster, ed., *The Anti-Aesthetic: Essays on Postmodern Culture* (Port Townsend, Wash.: Bay Press, 1983); Hal Foster, *The Return of the Real* (Cambridge: MIT Press, 1996).

13. Jessica Prinz, *Art Discourse/Discourse in Art* (New Brunswick, N.J.: Rutgers University Press, 1991); Caroline A. Jones, *Machine in the Studio: Constructing the Postwar American Artist* (Chicago: University of Chicago Press, 1996). Jones addresses two stereotypical constructions: Documentary films and interviews reflect the status of the studio as a crucial locus of artistic identity; and art was the product of lone, male individuals, solely responsible for their work, who were divorced from the constraints of the world outside their studios.

14. See Charles Harrison, "The Conditions of Problems," in his *Essays on Art & Language* (Oxford: Basil Blackwell, 1991), 82–128. For a historicization of the avant-garde, see Raymond Williams, "Metropolitan Perceptions and the Emergence of Modernism" (1985), reprinted in his *The Politics of Modernism: Against the New Conformists,* ed. Tony Pinkney (London: Verso, 1989), 37–48.

15. See Edward Said, *Culture and Imperialism* (London: Chatto and Windus, 1993), 400.

16. See Gayatri Chakravorty Spivak, *The Post-Colonial Critic,* ed. Sarah Harasym (New York: Routledge, 1990); Homi K. Bhabha, "The Other Question: Discrimination and the Discourse of Colonialism," in Marcia Tucker, ed., *Out There: Marginalization and Contemporary Cultures* (Cambridge: MIT Press, 1990), 71–87; Geeta Kapur, "When Was Modernism in Indian Art?" *Journal of Arts and Ideas,* nos. 27–28 (March 1995): 105–26.

17. Said, *Culture and Imperialism,* 400.

18. Harald Szeemann, curator and ed., *When Attitudes Become Form: Works—Concepts—Processes—Situations—Information: Live in Your Head,* exhibition catalog (Bern: Kunsthalle, 1969), unpaginated.

19. Charles Harrison, "Against Precedents," *Studio International* 178, no. 914 (September 1969): 90; the essay does not appear in the earlier Bern catalog.

1. Art by Long Distance

1. I defer analysis of Art & Language as a collaborative enterprise to chapter 2, limiting myself here to a case study of one of Kosuth's series, because I do not see that his manipulation of artistic identity through collaborative corporatism, as opposed to the forms of bureaucracy, was as crucial to him, nor as nuanced, as the collaborations of his colleagues Ian Burn or Mel Ramsden.

2. Michel Foucault, *The Archaeology of Knowledge and the Discourse on Language* (1969), trans. A. M. Sheridan Smith (New York: Pantheon, 1972), 28. For a discussion of archives without museums and critique of André Malraux's famous metaphor of the museum without walls, see Hal Foster, "The Archive without Museums," *October*, no. 77 (summer 1996): 97–119.

3. Anthropology therefore joins the counterculture as a crucial but underacknowledged influence upon postmodernism in visual art.

4. See Ingrid Schaffner and Matthias Winzen, eds., *Deep Storage: Collecting, Storing, and Archiving in Art*, exhibition catalog (Munich and New York: Prestel, 1998).

5. See John C. Welchman, *Modernism Relocated: Towards a Cultural Studies of Visual Modernity* (Sydney: Allen and Unwin, 1995); particularly note Welchman's chapter on Kosuth, Freud, and translation: "Translation/(Procession)/Transference: Freud, Kosuth, and Writing," 115–45. For a historical overview of conceptual art, see Tony Godfrey, *Conceptual Art* (London: Phaidon, 1998).

6. Joseph Kosuth, public lecture (Artists' Week, Adelaide Festival, Adelaide, Australia, 10 March 1998, author's notes). Kosuth emphasized that the task of the artist at this point in time was to make his work "believable," a demand, and a diagnosis of late-1960s crisis, that I discuss more fully in later chapters. See Gabriele Guercio, "Formed in Resistance: Barry, Huebler, Kosuth, and Weiner vs. the American Press," in Claude Gurtz, ed., *L'art conceptuel: Une perspective,* exhibition catalog (Paris: Musée d'Art Moderne de la Ville de Paris, 1989), 74–81. I want to emphasize that though the notion of artistic crisis and a "great divide" has been extensively theorized through notions of visuality and also through the operations of capital, this crisis is also the memory crisis of late modernity, analyzed for early modernity in Richard Terdiman, *Present Past: Modernity and the Memory Crisis* (Ithaca, N.Y.: Cornell University Press, 1993).

7. Harald Szeemann, "Zur Ausstelung," in Harald Szeemann, curator and ed., *When Attitudes Become Form: Works—Concepts—Processes—Situations—Information: Live in Your Head,* exhibition catalog (Bern: Kunsthalle, 1969), unpaginated (my rough translation).

8. Max Kozloff, "The Trouble with Art-as-Idea," *Artforum* 11, no. 1 (September 1972): 35.

9. Joseph Kosuth, interview (1969), reprinted in Gurtz, *L'art conceptuel,* 83.

10. Kosuth sent Pinacotheca director Bruce Pollard a flier for the events, which read "15 locations 1969/70 / Joseph Kosuth / Art as Idea as Idea 1966–70" in different languages. The second paragraph noted that exhibitions (consisting of the typewritten texts that had been placed as advertisements) would be held at the Pasadena Art Museum (25 January to 1 March), the Douglas Gallery, Vancouver (4 October to 4 November), and so on, including "Pinacotheca, Australia" (31 October to 14 November).

11. Joseph Kosuth, "Artist's Statement," in Seth Siegelaub, curator and ed., *January 5–31, 1969* (New York: Seth Siegelaub, 1969), unpaginated. This catalog was bound by a ring binder, looking like a corporate office presentation. Kosuth's statement was accompanied by a photograph of newspapers containing the information for *1. Space (Art as Idea as Idea),* 1968, which had been printed in London newspapers. In his section of Szeemann's catalog, *When Attitudes*

Become Form, Kosuth listed the following articles: Gregory Battcock, "Painting Is Obsolete," *New York Free Press,* 23 January 1969, 7; John Perreault, "Art Disturbance," *Village Voice,* 23 January 1969, 18.

12. Bruce Pollard, interviewed by the author, Melbourne, 30 November 1997. For Kosuth's description of his working process, see Kosuth, "Artist's Statement," quoted in Gurtz, *L'art conceptuel,* 83; Kosuth's statement is virtually a reprint of his 1969 *Arts Magazine* interview, reprinted in Gurtz, *L'art conceptuel,* 82–83.

13. See Lucy R. Lippard, *Groups, Studio International* 179, no. 920 (March 1970): 93–99.

14. Ibid., 93.

15. Ibid.

16. Scott Burton, "Notes on the New," in Szeemann, *When Attitudes Become Form.*

17. Boetti, as is well known, frequently used assistants: They made the drawings for *Eight Contemporary Artists* (Museum of Modern Art, New York, October 1974–January 1975). *Ordine e Disordine* (Order and Disorder, 1973), was made by Afghani women embroiderers. It consisted of one hundred embroidered squares: Each 7″ × 7″ panel was divided into squares of four letters so that in each section there were sixteen letters. The women chose the colors, sometimes using the same color for a given letter, sometimes not. Boetti (like Kosuth) preferred to work through agents so that he did not have to negotiate directly with the actual fabrication.

18. Dan Cameron, "Against Collaboration," *Arts Magazine* 58, no. 7 (March 1984): 83–87, 83.

19. See Thomas Crow, *Emulation: Making Artists for Revolutionary France* (New Haven, Conn.: Yale University Press, 1995), especially chapter 4, "The School of Athens." Crow elaborates a radically extended idea of the assistant process in which work is dispersed but paradoxically creates an individual style. Boetti can be compared in many respects with Kosuth because both artists take credit for others' labor and creativity; both are open to charges of exploitation, because both can be seen as creating art that once again reifies center/periphery inequalities, complacent in its assumptions about historical diffusion.

20. Joseph Kosuth, "Comments on the Second Frame" (1977), in his *Art after Philosophy and After: Collected Writings 1966–1990,* ed. Gabriele Guercio (Cambridge: MIT Press, 1991), 169–73, 170. For an invaluable study of Kosuth and "framing," see John C. Welchman, *Invisible Colors: A Visual History of Titles* (New Haven, Conn.: Yale University Press, 1998). For an elaboration of framing discourses, see Paul Duro, ed., *The Rhetoric of the Frame: Essays on the Boundary of the Artwork* (Cambridge: Cambridge University Press, 1996).

21. Arthur R. Rose [Joseph Kosuth], "Four Interviews with Barry, Huebler, Kosuth, Weiner" (February 1969), reprinted in *Arts Magazine* 63, no. 6 (February 1989): 44–45. For a discussion, see Robert C. Morgan, "The Situation of Conceptual Art," *Arts Magazine* 63, no. 6 (February 1989): 40–43. The "interviews" followed Seth Siegelaub's "exhibition," of the four artists' work, *January 5–31, 1969* (1969).

22. See Jessica Prinz, *Art Discourse/Discourse in Art* (New Brunswick, N.J.: Rutgers University Press, 1991); her second chapter, "Text and Context: Reading Kosuth's Art," examines Kosuth's *Second Investigation,* focusing also on the Australian advertisements. *Art as Idea as Idea* (1968) was also published in the *London Times,* the *Daily Telegraph,* the *Financial Times,* the *Daily Express,* the *Observer,* in each case in the 27 December 1968 issues; also see Kosuth's artist project in Siegelaub's *January 5–31, 1969;* for Terry Smith's description of Kosuth as tourist, see Jelena Stojanovic, "Conceptual Art Then and Since," interviewed by Terry Smith, *Agenda* (Melbourne), nos. 26/27 (January–February 1993): 19–34, 24.

23. Joseph Kosuth, conversation with the author, Adelaide, 9 March 1998.

24. Ibid.

25. See Joseph Kosuth, "Art after Philosophy," parts 1–3," *Studio International* 178, no. 915 (October 1969): 134–37; 178, no. 916 (November 1969): 160–61; 178, no. 917 (December 1969): 212–13. The second part was accompanied, in the magazine's Letters to the Editor column, by an angry painter's reply to Kosuth.

26. See Benjamin H. D. Buchloh, "Conceptual Art, 1962–69: From the Aesthetic of Administration to the Critique of Institutions," *October,* no. 55 (winter 1990): 105–43. This is a version of his extremely controversial catalog essay in Gurtz, *L'art conceptuel.* For Kosuth's and Siegelaub's replies and Buchloh's counterreply, see Joseph Kosuth and Seth Siegelaub, "Reply to Benjamin Buchloh on Conceptual Art," *October,* no. 57 (summer 1991): 153–57; Benjamin H. D. Buchloh, "Benjamin Buchloh Replies to Joseph Kosuth and Seth Siegelaub," *October,* no. 57 (summer 1991): 158–61.

27. Douglas Huebler, quoted in Charles Harrison, "On Exhibitions and the World at Large: Seth Siegelaub in Conversation with Charles Harrison," *Studio International* 178, no. 917 (December 1969): 202–3, 203.

28. Quoted in Harrison, "On Exhibitions and the World at Large," 202.

29. For a younger, 1980s generation of readers, Walter Benjamin's thinking was usually mediated through art criticism rather than encountered as primary text, especially through Craig Owens's influential essay "The Allegorical Impulse." This slanted the readings of Benjamin's texts, of course. See Craig Owens, "The Allegorical Impulse: Towards a Theory of Postmodernism," Parts 1 and 2 (1980), reprinted in Brian Wallis, ed., *Art after Modernism: Rethinking Representation* (New York: New Museum of Contemporary Art, 1984), 202–35, 207. See also Benjamin H. D. Buchloh, "Allegorical Procedures: Appropriation and Montage in Contemporary Art," *Artforum* 21, no. 1 (September 1982): 43–56.

30. Again, Benjamin was read in the art world, as opposed to within his native discipline, and largely through secondary texts. Owens ("The Allegorical Impulse," 217) cites Benjamin (from *German Tragic Drama*) to the effect that "[t]he division between signifying written language and intoxicating spoken language opens up a gulf in the solid massif of verbal meaning and forces the gaze into the depths of language." Benjamin also spoke of "history as a petrified, primordial landscape" (Benjamin, *German Tragic Drama*, cited in Owens, "The Allegorical Impulse," 206.) Benjamin's theory of allegory was extensively cited by 1980s theorists. He became something of a cipher for the readers of postmodern texts, and my circuitous, second-hand citations of Benjamin throughout this book are deliberate demonstrations of this, for Benjamin was principally read second-hand.

31. Kosuth, "Art after Philosophy," part 2, 160–61.

32. Joseph Kosuth, public lecture (University of Melbourne, Melbourne, 13 March 1998, author's notes).

33. Kosuth, public lecture, University of Melbourne. Kosuth was included in Germano Celant's important exhibition *Conceptual Art/Land Art/Arte Povera,* held by the Galleria Civica d'Arte Moderna (Turin, Italy), January 1970.

34. Mary Douglas, quoted in Joseph Kosuth, "(Notes) On an 'Anthropologized' Art," in Kosuth, *Art after Philosophy and After,* 95–102, 95.

35. Joseph Kosuth and Robert Hunter, conversations with the author, 13 March 1998, Melbourne.

36. Jack Burnham, *Great Western Salt Works: Essays on the Meaning of Post-Formalist Art* (New York: George Braziller, 1974); Lucy R. Lippard, *Six Years: The Dematerialisation of the Art Object from 1966 to 1972* (New York: Praeger, 1973).

37. Gabriele Guercio, introduction to Kosuth, *Art after Philosophy and After,* xxi–xxxviii.

38. See Joseph Kosuth, *Joseph Kosuth: (Eine Grammatische Bemerkung)/(A Grammatical Remark),* artist's book (Stuttgart: Württembergischer Kunstverein and Edition Cantz, 1993);

Joseph Kosuth, *"The (Ethical) Space of Cabinets 7 and 9," Voltaire Room, Taylor Institution, Oxford University, Two Oxford Reading Rooms = Say: I Do Not Know/Joseph Kosuth, artist's book* (London: Book Works, 1994).

39. See Kosuth, public lecture, Artists' Week.

40. Buchloh, "Conceptual Art, 1962–69," 123.

41. Ibid., 122,

42. Joseph Kosuth, "Joseph Kosuth" (1996) (responses to questions sent by *Artpress* editors), in Catherine Millet, ed., *69/96: Avant-gardes et fin de siècle*, special issue, *Artpress*, no. 17 (1996): 76–78, 78.

43. Joseph Kosuth, "No Exit" (1988) in his *Art after Philosophy and After*, 227–34, 230. The phrase is a self-quotation from his earlier text "The Artist as Anthropologist."

44. Donald Kuspit, "Kosuth's Iconoclasm," *Artnet*, August 1996. [Online]. Available: http://www.artnet.com. Not archived; author's notes.

45. Welchman, *Modernism Relocated*, 144.

46. Terdiman, *Present Past*, 183.

47. Mary Carruthers, *The Book of Memory: A Study of Memory in Medieval Culture* (Cambridge: Cambridge University Press, 1990), 33. Carruthers also notes that Dante, at the start of *The Divine Comedy*, employs a particular phrase "in the book of my memory." She continues, "What I want to emphasize here is that Dante, in composing, sees the work in visual form, written in his memory as pages with text, rubrics and paragraphs" (224).

2. Conceptual Bureaucracy

1. Germano Celant, "The European Concert and the Festival of the Arts," in Art Gallery of Ontario, *The European Iceberg: Creativity in Germany and Italy Today*, exhibition catalog (Toronto: Art Gallery of Ontario, 1985), 13–22, 19. For discussions of this crisis, also see Charles Harrison, "Conceptual Art and the Suppression of the Beholder," in his *Essays on Art & Language* (Oxford: Basil Blackwell, 1991), 29–62, 19; Jelena Stojanovic, "Conceptual Art Then and Since," interviewed by Terry Smith, *Agenda* (Melbourne), nos. 26/27 (January–February 1993), 19–34.

2. Bruce Pollard, interviewed by the author, 15 March 1994, Melbourne.

3. Bazon Brock, "Cultural and Artistic Development in West Germany from the Sixties to the Eighties," in Art Gallery of Ontario, *The European Iceberg*, 248.

4. See Ann Goldstein and Anne Rorimer, curators and eds., *Reconsidering the Object of Art, 1965–75*, exhibition catalog (Los Angeles: Museum of Contemporary Art, 1995); see a discussion of this exhibition in James Meyer, "Reconsidering the Object of Art," *Artforum* 34, no. 6 (February 1996), 78–79 and 109; Queens Museum of Art, *Global Conceptualism: Points of Origin, 1950s–1980s*, exhibition catalog (New York: Queens Museum of Art, 1999).

5. Many curators and artists moved from project to project in a highly nomadic, globe-trotting fashion. Harald Szeemann, for example, visited Australia in 1971, curating *I Wish to Leave a Well-Made Child Here*; see *John Kaldor Art Project 2: Harald Szeemann in Australia 14–27/4/72*, exhibition catalog (Sydney: John Kaldor, 1971).

6. The frustration with such a blinkered view is, of course, far from original. Charles Harrison's annoyance at Hal Foster's New York–centrism is evident in his review of Hal Foster's *The Return of the Real* (Cambridge: MIT Press, 1996); see Charles Harrison, "Bürger-Helper," *Bookforum*, winter 1996–spring 1997 (November 1996): 30–31 and 34. For a European perspective, compiled in France, on the rise of conceptual art and a perspective very different from that in the United States, see the French magazine *Artpress*'s 1996 special edition on the fate of avant-garde art since 1969: Catherine Millet, ed., *69/96: Avant-gardes et fin de siècle*, special issue, *Artpress*, no. 17 (1996).

7. See Lucy Lippard, *Six Years: The Dematerialization of the Art Object from 1966 to 1972* (New York: Praeger, 1972).

8. Ian Burn, "Conceptual Art as Art," *Art and Australia* 8, no. 2 (September 1970), 167–70, 167.

9. Bill Indman, letter to the editor, *Art and Australia* 8, no. 2 (September 1970), 120.

10. Ibid.

11. Patrick McCaughey, letter to the editor, *Art and Australia* 8, no. 2 (September 1970), 120–21, 121. For a fuller exposition by McCaughey of formalist painting's importance in Australia, see Patrick McCaughey, "The Significance of the Field," *Art and Australia* 6, no. 3 (December 1968), 235–42.

12. McCaughey refers to Michael Fried's catalog essay "Three American Painters: Kenneth Noland, Jules Olitski, Frank Stella" (1965), which is reprinted in Michael Fried, *Art and Objecthood: Essays and Reviews* (Chicago: University of Chicago Press, 1998), 213–65.

13. McCaughey, letter to the editor, 121.

14. Ian Burn and Nigel Lendon, "Purity, Style, Amnesia," in Mandie Palmer, ed., *The Field Now*, exhibition catalog (Melbourne: Heide Park and Art Gallery, 1984), 19–22, 20.

15. Nigel Lendon, telephone interview by the author, 24 March 1998.

16. Burn's article employed the same logic, marginalizing even his erstwhile friends' art. Roger Cutforth, who collaborated with Burn and Ramsden in the late 1960s, objected to being periodized by Burn as a "process" artist and wrote an unpublished angry letter to the editors of *Art and Australia* objecting to what he saw as a one-sided account of new art (Roger Cutforth, unpublished letter to Robert Rooney, London, 24 May 1971).

17. For a sophisticated periodization of Indian modernism and postmodernism that powerfully makes precisely these points, see Geeta Kapur, "When Was Modernism in Indian Art?" *Journal of Arts and Ideas,* nos. 27–28 (March 1995): 105–26.

18. Burn, "Conceptual Art as Art," 167.

19. Ibid.

20. See also the large quantity of criticism and writing by many minimalist artists, including Robert Morris, Dan Flavin, and Donald Judd, and, even more important, Robert Smithson's many essays.

21. Also see Jack Burnham, curator and ed., *Software: Information Technology. Its Meaning for Art* (New York: Jewish Museum, 1970); for reviews, see Dore Ashton, "New York Commentary," *Studio International* 80, no. 927 (November 1970): 200–2; Kenneth Baker, "New York," *Artforum* 9, no. 4 (December 1970): 79–81.

22. Ian Burn, "Art Market, Affluence, and Degradation" (1975), reprinted in Amy Baker Sandback, ed., *Looking Critically: Twenty-one Years of Artforum* (Ann Arbor, Mich.: University Microfilms International, 1984), 173–77, 175.

23. For *Six Negatives,* the two artists worked with an appropriated text and *Roget's Thesaurus,* superimposing the processes of negation and photographic reproduction onto the alternate type of modified authorship mentioned above: the co-option of the work of a third, unwilling (but acknowledged and still evident) author. Burn later added the elaborate self-reflexive commentary.

24. Art & Language (Mel Ramsden, annotated by Michael Baldwin), "Making Art from a Different Place," catalog essay, in Art Gallery of Western Australia, *Ian Burn: Minimal-Conceptual Work, 1965–1970,* exhibition catalog (Perth: Art Gallery of Western Australia, 1992), 7–16.

25. Burn, "Conceptual Art as Art," 170.

26. Ian Burn, interview by Hazel de Berg, 30 April 1970, New York, tape recording and transcript, National Library of Australia, Canberra, unpublished transcript, 5801.

27. Art & Language (Ramsden), "Making Art from a Different Place," 11.

28. Ian Burn, *Dialogue: Writings in Art History* (Sydney: Allen and Unwin, 1991), 226; also see Art & Language (Ramsden), "Making Art from a Different Place," 11; Burn cites Allan Kaprow's essay "Impurity," *Art News* 61, no. 1 (January 1963): 30–33, in which Kaprow asserts that viewers are the "figures" and environment the "ground" in a figure-ground relationship.

29. Art & Language (Baldwin), "Making Art from a Different Place," 12.

30. Ibid. For a sophisticated discussion of *Soft-Tape*, see Michiel Dolk, "It's Only Art Conceptually: A Consideration of the Work of Ian Burn, 1965–70," in Art Gallery of Western Australia, *Ian Burn: Minimal-Conceptual Work*, 17–44, 30.

31. Art & Language (Ramsden), "Making Art from a Different Place," 11.

32. Burn, quoted in ibid., 12. Burn also wrote: "Communication, we argued, isn't just a semantic or conceptual problem of translation (deducing the 'right' correspondences and so on) but is also, importantly, a spatial problem" (Burn, *Dialogue*, 193).

33. Ian Burn and Mel Ramsden, part of the notes to *Soft-Tape*, reproduced in Ian Burn and Mel Ramsden, *Collected Works* (1971), artists book, unpaginated.

34. Mel Ramsden, letter to the author, 28 February 1997.

35. Ibid.

36. Robert Smithson, "Entropy and the New Monuments" (1966), in his *The Writings of Robert Smithson*, ed. Nancy Holt (New York: New York University Press, 1979), 9; see also Robert Smithson, "A Sedimentation of the Mind: Earth Proposals" (1968), in his *The Writings of Robert Smithson*, 82–91. Smithson used fictional voices in his autobiographical excursions into travelogues; in particular see Robert Smithson, "Incidents of Mirror-Travel in the Yucatan," *Artforum* 8, no. 1 (September 1969): 28–33.

37. Ian Burn, "Provincialism," *Art Dialogue*, no. 1 (October 1973): 3–11. Burn seems to have set many of the terms of this debate; Terry Smith's important and often-cited article "The Provincialism Problem," *Artforum* 13, no. 1 (September 1974): 54–59, is, however, much better known; see also Ian Burn, Nigel Lendon, Charles Merewether, and Ann Stephen, "The Provincialism Debates," in their *The Necessity of Australian Art* (Sydney: Power Institute, University of Sydney, 1988), 104–26.

38. Burn, "Provincialism," 4.

39. Ibid., 9.

40. Ian Burn, "Notes for Mirror Reflexes," reproduced in Burn and Ramsden, *Collected Works*. According to Burn, "A simple way of tracing my own development would be to say that I was first involved with the object, then that there was a theory or framework contingent on the object, then the object became contingent on the theory, and finally in the current work there is the theory or framework by itself" (Ian Burn, "Ian Burn," interview by Joel Fisher, in Terry Smith and Tony McGillick, curators and eds., *The Situation Now: Object or Post-Object Art?* exhibition catalog [Sydney: Contemporary Art Society, 1971], 39–41, 39).

41. Burn, interview by de Berg, 5802. The exhibition he refers to was *The Field* (National Gallery of Victoria, 1968).

42. Burn, "Conceptual Art as Art," 170.

43. Ian Burn, "Looking at Seeing and Reading," in *Looking at Seeing and Reading*, exhibition catalog (Sydney: Ivan Dougherty Gallery, 1993); Ian Burn, "The Role of Language" (1968), in his *Dialogue*, 120–24.

44. Burn, "Looking at Seeing and Reading," 2.

45. See Nelly Richard, "Interview with Nelly Richard," interview by Juan Davila, *Art and Text*, no. 8 (summer 1982/83): 57–59, 57. Richard observed: "Our problem then consists in demanding a gaze accustomed to disqualify all secondary or minor forms of art under the 'déjà vu' label."

46. *July 1969*, artist's book (New York: Art Press, 1969), 5; this work contains Burn's *Xerox Piece* (1969) (2–3) and his text work *Dialogue* (1969) (5).

47. Burn, interview by de Berg, 5804.

48. Bruce Pollard, unpublished letter to Ian Burn, Mel Ramsden, and Roger Cutforth, 28 August 1969. Surprisingly, landscape painter Fred Williams—a famous Australian artist working in a painterly, semifigurative landscape idiom inflected by post-painterly abstraction—bought one copy of a *Xerox Book* for himself and reserved another for his Sydney art dealer Rudy Komon. Williams was the hero of Australian formalist critics but remained, unlike many participants in that art scene, comparatively open-minded and interested in the works of younger artists. In addition, Komon had exhibited Burn's earlier minimalist paintings at his Sydney gallery in 1966 as part of a group exhibition, *Young Melbourne Painters*.

49. Art & Language (Ramsden), "Making Art from a Different Place," 13.

50. Ibid., 12.

51. Allan Kaprow, *Assemblage, Environments, and Happenings* (New York: Harry N. Abrams, 1966), 180.

52. See Richard Kostelanetz, *Breakthrough Fictioneers* (New York: Something Else Press, 1973).

53. Roger Cutforth, unpublished letter to Robert Rooney, London, 30 August 1971.

54. Michael Baldwin, in Michael Baldwin and Mel Ramsden, "On Art & Language," interview by Juan Vicente Aliaga and José Miguel Cortés, *Art and Text*, no. 35 (summer 1990): 23–37, 26–27; the 1972 *Documenta 5* catalog includes Bainbridge, Hurrell, Burn, Ramsden, Kosuth, and Baldwin as Art & Language members. There is such a large quantity of literature on Art & Language that any further recapitulation here of the group's history and factionalization would be redundant. For further information, see Charles Harrison, *Essays on Art & Language*; for an overview of the group's post–1970s activities, see *Art & Language,* exhibition catalog (Paris: Galerie Nationale du Jeu de Paume, 1993).

55. Mel Ramsden, in Baldwin and Ramsden, "On Art & Language," 27.

56. Charles Harrison, "The Conditions of Problems," in his *Essays on Art & Language* (Oxford: Basil Blackwell, 1991), 98.

57. Cutforth, letter to Rooney, 30 August 1971.

58. Ibid.; Benjamin H. D. Buchloh's "Conceptual Art 1962–69: From the Aesthetic of Administration to the Critique of Institutions," *October*, no. 55 (winter 1990): 105–43, suggests that the chronology of Kosuth's works may be similarly unreliable; Ian Burn later acknowledged this intense competitiveness in "Crisis and Aftermath" (1981), in his *Dialogue*, 120–24, here noting: "More than any other style during the 1960s, Conceptual Art constituted itself upon social criteria. While the work was often disguised within apparently formalist objectives, its character still contained a social dimension of a kind incompatible with the ethos of other styles associated with the avant-garde tradition of the period" (123).

59. Harrison, "The Conditions of Problems," 91. Art & Language's fluid, heterogeneous self-characterization resembled that of more recent collaborations such as the Slovenian collective Group Irwin or the Japanese group Dumb Type.

60. Terry Smith, "Art Criticism in Australia: The Mid-1970s Moment," in Robyn McKenzie, ed., *The Present and Recent Past of Australian Art and Criticism,* special supplement, *Agenda,* no. 2 (August 1988): 12–13, 12.

61. Burn, "Conceptual Art as Art," 168.

62. Burn, interview by de Berg, 5805.

63. Ibid.

64. Arthur R. Rose [Joseph Kosuth], "Four Interviews with Barry, Huebler, Kosuth, Weiner" (February 1969), reprinted in *Arts Magazine* 63, no. 6 (February 1989): 44–45,

reprinted in Claude Gurtz, ed., *L'art conceptuel: Une perspective,* exhibition catalog (Paris: Musée d'Art Moderne de la Ville de Paris, 1989), 82–83, 82.

65. Ian Burn, *Dialogue* (1969), in his *July 1969,* 5. In *Dialogue,* Burn returns to the idea of fiction and poetry in conceptual art: "3. Language reduces the role of perception and brings into use new material, areas for ideas and processes beyond previous perceiving." *July 1969* also contains Burn's *Xerox Piece* (1969) (2–3), and a conceptual work by American artist Adrian Piper abutting *Dialogue;* Piper's work, *Untitled* (1969) consists of eight blank pages.

66. Burn, *Dialogue,* 5.

67. Burn, "Conceptual Art as Art," 168.

68. Ian Burn and Mel Ramsden, *The Grammarian* (1970, New York), artists' book, unpaginated, section 12.

69. Burn and Ramsden, *The Grammarian,* section 8. This is reproduced whole in Burn and Ramsden's *Collected Works,* which was a thick artists' book bound by heavy, brutal rivets. It resembled a tradesman's training manual, consisting of photocopies of all the artists' works, articles, and diagrams from the period 1965 to 1971. Signed limited editions were available for collectors for $150. An unlimited edition could be acquired by art institutions for $55, by universities and libraries for $45, and by individuals for $35. The gallery where the work was exhibited was empty except for a table, several cane chairs, and eight or so photocopied, stapled volumes that were the "works." It was obvious that the artists had selected their collected works carefully, for certain of their essays were absent.

70. *The Grammarian's* tenth proposition reads: "There is a philosophical distinction between the grammarian and the lexicographer which may be helpful here since it exemplifies contrasting spectator capacities. The concerns of the grammarian are dependent upon making sense of the notion of significant sequence, whereas the lexicographer's task is to make sense of the notion of synomymy (e.g. between forms within the same language)" (Burn and Ramsden, *The Grammarian,* section 10).

71. Ibid., section 12.

72. Bruce Pollard, interview by the author, Melbourne, 15 March 1994.

73. Michael Baldwin, Charles Harrison, and Mel Ramsden, "Memories of the Medicine Show," *Art-Language,* new series, no. 2 (June 1997): 32–39, 38; *The Fox* appeared for about twelve months after April 1975, published by Art & Language Foundation Inc.

74. Cutforth's works, unlike Burn's or Ramsden's, were overtly poetic. The author collected descriptions and organized them in arbitrary categories; see Cutforth's *The Empire State Building: A Reference Work* (1969). This book was arranged bilingually in French and English sections that included "How the Empire State Building Was Constructed," "The Men," "The Empire State Building at Night," "Hub of Midtown Manhattan," "The View from the Empire State Building," "The World's Most Distinguished Address," "The Eight Wonders of the World," and "A Visit to the Eighth Wonder of the World." Cutforth's later works included conceptual posters in the London Underground. His 1974 film installation at the John Gibson Gallery (New York) was reviewed in *Artforum;* this film loop and slide projector montage of a female figure in landscape was lush and poetic; see Roberta Smith, "Reviews," *Artforum* 8, no. 1 (September 1974): 71–75, 74.

75. Cutforth, letter to Rooney, 24 May 1971.

76. Cutforth, letter to Rooney, 30 August 1971.

77. Ian Burn, "Glimpses on Peripheral Vision" (1990), in his *Dialogue,* 193.

78. See the chapter on Smithson in Jessica Prinz, *Art Discourse/Discourse in Art* (New Brunswick, N.J.: Rutgers University Press, 1991), 79–123; for Smithson's extensive discussions of entropy, see Smithson, "A Sedimentation of the Mind," and Gary Shapiro's beautifully

written book, *Earthwards: Robert Smithson and Art after Babel* (Berkeley and Los Angeles: University of California Press, 1995).

79. Mel Ramsden, letter to the author, 28 February 1997. Ramsden confirmed Wittgenstein's influence, widespread at the time, and also, as he put it, Ian Burn's "obsession" with Wilfred Sellars's writing.

80. Smithson, quoted in Prinz, *Art Discourse/Discourse in Art*, 100.

81. Kaprow, *Assemblage, Environments, and Happenings*, 180.

82. Burn, interview by de Berg, 5804.

83. Michael Baldwin (1980), quoted in Harrison, "Conceptual Art and the Suppression of the Beholder," 60.

84. Harrison, "The Conditions of Problems," 91.

85. Art & Language (Baldwin), "Making Art from a Different Place," 14.

86. Harrison, "Conceptual Art and the Suppression of the Beholder," 55.

87. Art & Language (Ramsden), "Making Art from a Different Place," 7.

88. Ibid., 14; Burn frequently emphasized the congruence of his handyman skills and self-taught artisan background with conceptual art (Burn, interview by de Berg, 5799).

3. Memory, Ruins, and Archives

1. The structure of these collaborations—based on marriage—distinguished them from others of this book. In legalistic terms, a marriage might be seen as a license to procreate, and these collaborations could be seen in such overliteral, sexualized terms.

2. Several scientific theorists of prehistory insist that similar metaphors are necessary to explain the development of human mental life from prehistory to the present; see Steven Mithen, *The Prehistory of the Mind: The Cognitive Origins of Art, Religion, and Science* (London: Thames and Hudson, 1996); Merlin Donald, *Origins of the Modern Mind: Three Stages in the Evolution of Culture and Cognition* (Cambridge, Mass.: Harvard University Press, 1991). Donald traces the crucial role of symbolic and notational systems in the preservation of memory through science and art. Mithen, working from archaeological and neuropsychological perspectives, proposes that the mind works through mental modular structures that can be likened to the multiple chapels and interlocking spaces of a cathedral.

3. Mark Boyle and Joan Hills, interview by the author, Greenwich, England, 21 December 1996; Anne and Patrick Poirier, interview by the author, Paris, 8 December 1996; Helen Mayer Harrison and Newton Harrison, interview by the author, Del Mar, California, 30 November 1996. For the remainder of this chapter, any quotes or citations attributed to a team but not accompanied by an endnote are from these interviews.

4. This book deliberately focuses on the first of these two themes—on memory rather than on ideas of nature—although the two are intimately connected, as will become clear in chapters 3, 4, and 5.

5. See Karl R. Popper, *Conjectures and Refutations: The Growth of Scientific Knowledge*, 2nd ed. (New York: Basic Books, 1965); Karl R. Popper, *The Logic of Scientific Discovery* (London: Hutchinson, 1972). The Harrisons and the Poiriers were invited to participate in several scientific conferences and colloquiums. Both teams were able to master scientific and anthropological languages sufficiently to negotiate with specialists; the Poiriers' 1995 residency at the Getty Institute coincided with several conferences on archaeology and conservation that the Getty invited them to attend.

6. For this, see their treatment in three ideologically quite different surveys: Brian Wallis, ed., *Art after Modernism: Rethinking Representation* (New York: New Museum of

Contemporary Art, 1984); Hal Foster, *The Return of the Real* (Cambridge: MIT Press, 1996); Charles Harrison and Paul Wood, eds., *Art in Theory, 1900–1990* (Oxford: Blackwell, 1992).

7. The effort to be expert led most writers to abandon their study of the artists. Helen Mayer Harrison spoke of one author who had attempted and abandoned a Derridean reading and of another who gave up his projected book on the Harrisons to retrain as an ecologist himself; the Harrisons insisted that mastering the languages of the specialists they were working with was unnecessary, for they themselves proceeded like amateurs. The Poiriers were expert in the area of archaeology and conservation techniques.

8. There are two connotations of the word "anthropology" to be noted here: The first refers to the artists' use of anthropological techniques and methods of museum display to create morphological resemblances between disparate objects as a trope (a *Wunderkammer*, or "curiosity cabinet," aesthetic); the second refers to art that inserts itself into a sociological, "real-time" dimension. Joseph Beuys, for example, was criticized for the first, and especially for his alleged obliviousness to the distinction between the two connotations, by critics such as Benjamin Buchloh. See Benjamin H. D. Buchloh, "Beuys: The Twilight of the Idol. Preliminary Notes for a Critique," *Artforum* 18, no. 5. (January 1980): 35–43. For the reverse view, see Donald Kuspit, "Joseph Beuys: The Body of the Artist," *Artforum* 29, no. 10 (summer 1991): 80–86; see Foster's critique of ethnography in *Return of the Real*, chapter 6, where he praises the sociological investigations of Hans Haacke and Mary Kelly; Foster's critique has considerable bite and some justice. He notes ethnographic style's three assumptions: first, that "the site of political transformation is the site of artistic transformation as well"; second, that this site is always elsewhere; third, that only if the artist is Other will he or she have access to transformative alterity (173). He disparagingly refers to the Poiriers in this connection (182). According to Foster, "Few principles of the ethnographic participant-observer are observed, let alone critiqued, and only limited engagement of the community is effected. Almost naturally the project strays from collaboration to self-fashioning, from a decentering of the artist as cultural authority to a remaking of the other in neo-primitivist guise" (196–97).

9. Boyle and Hills, interview; Tony Godfrey, "London Review," *Burlington Magazine* 129, no. 1006 (January 1987): 47.

10. Jack Burnham, "Systems Aesthetics," *Artforum* 7, no. 1 (September 1968): 30–35, 32.

11. Craig Owens, "The Allegorical Impulse," in Wallis, *Art after Modernism*, 213; Hal Foster, "Re: Post" (1982), in Wallis, *Art after Modernism*, 189–201, 196.

12. See David Thomson, "Object, Experience, Drama," *Studio International* 177, no. 912 (June 1969): 276–79, 276.

13. See Marie-Therese Suermann, "Frankfurt: The Boyle Family," *Contemporanea*, no. 20 (September 1990): 105; for a description of these displays, see Terry Castle, *The Female Thermometer: Eighteenth-Century Culture and the Invention of the Uncanny* (Oxford: Oxford University Press, 1995).

14. Boyle and Hills were highly enthusiastic at the mention of Freud's definition of the uncanny.

15. Mark Boyle, artist's statement, in Susan Sollins and Nina Castelli Sundell, curators and eds., *Team Spirit,* exhibition catalog (New York: Independent Curators Incorporated, 1990), 18.

16. See Amelia Jones's discussion of Abramović and Ulay in Amelia Jones, *Body Art/Performing the Subject* (Minneapolis: University of Minnesota Press, 1998), 140–41.

17. Boyle, "Beyond Image: Boyle Family," in Hayward Gallery, *Beyond Image* (London: Hayward Gallery and British Arts Council, 1986), 7–24, 8.

18. Ibid., 12.

19. Mark Boyle, letter to the author, 21 November 1996.

20. The Boyles' disdain was not completely reciprocated, as their representation of Britain at the 1978 Venice Biennale demonstrated. Their inclusion may have reflected a British celebration of the eccentric as a tolerable, interesting discursive identity. The Boyles' own impatience, though, almost certainly reflected their birthplace—Scotland—which has a long artistic tradition of independence from British influence.

21. Mark Boyle, cited in Thomson, "Object, Experience, Drama," 278.

22. J. L. Locher, *Mark Boyle's Journey to the Surface of the Earth* (Stuttgart: Edition Hansjörg Mayer, 1978), 17; see Bernard Smith, *European Vision and the South Pacific* (Oxford: Oxford University Press, 1960).

23. Walter Benjamin (*German Tragic Drama* [1928], cited in Owens, "The Allegorical Impulse," 216.

24. Locher, *Mark Boyle's Journey*, 21.

25. Godfrey, "London Review," 47.

26. Boyle, "Beyond Image," 18.

27. Borges's story became a favorite postmodern fable, reprinted in several canonical postmodern anthologies. But Borges was already well-known during the 1960s and 1970s before the story surfaced in young artists' reading lists; his early popularity is easily forgotten by theorists overeager to establish grandfather figures for 1980s appropriation practices; see Jorge Luis Borges, "Pierre Menard, Author of the Quixote" (1964), in Wallis, *Art after Modernism*, 3–12.

28. Burnham, "Systems Aesthetics," 32. He continues: "Similar attitudes were adopted by Judd for the purpose of critical examination. More than simply an art object's list structure, Judd included phenomenal qualities which would have never have shown up in a fabricator's plans, but which proved necessary for the 'seeing' of the object."

29. Caroline A. Jones, *Machine in the Studio: Constucting the Postwar American Artist* (Chicago: University of Chicago Press, 1996). She casts Jackson Pollock, Frank Stella, Andy Warhol, and Robert Smithson as stages on a trajectory that ends outside the generic studio. These artists, from Stella onward, adopted specific industrial models, from Stella's corporate delegation of decisions to assistants, through Andy Warhol's Factory (a reification of the Satanic mill of the Industrial Revolution); she finally describes Robert Smithson's postindustrial, poststudio, research-and-development corporatism.

30. *Pictures* was the now-famous 1978 exhibition at Artists Space (New York) which featured the works of Cindy Sherman, Jack Goldstein, and other soon-to-be-famous postmodern artists; Douglas Crimp wrote its widely influential, often cited catalog essay, reprinted as "Pictures," *October*, no. 8 (spring 1979): 75–88; see also Foster, "Re: Post," 196.

4. Memory Storage

1. Glenn Zorpette, "Dynamic Duos: Artists Are Teaming Up in Growing Numbers," *Art News* 93, no. 6 (summer 1994): 164–69, 166.

2. Anne and Patrick Poirier, interview by the author, Paris, 8 December 1996. For the remainder of this chapter, any quotes or citations attributed to this team but not accompanied by an endnote are from this interview.

3. See also one of the rare English-language discussions of their projects, a discussion of their large U.S. commission *Promenade classique* (1986), in Joan Marter, "Collaborations: Artists and Architects on Public Sites," *Art Journal* 48, no. 4 (winter 1989): 315–20, 318–19; for a general account and contextualization of the Poiriers' works, see the German-language publication, *Anne + Patrick Poirier, Kunstler: Kritisches Lexikon der Gegenartskunst* (Munich: Verlage Weltkunst und Bruckmann, 1996).

4. See Boullée's great visionary drawings of 1784, especially his designs for a cenotaph to Sir Isaac Newton, and Ledoux's intricate plans, drawn during the 1790s, for the town of Chaux, France.

5. See Lucy Lippard, *From the Center: Feminist Essays on Women's Art* (New York: Dutton, 1976); Lucy Lippard, *Overlay: Contemporary Art and the Art of Prehistory* (New York: Pantheon Books, 1983); Lucy Lippard, *Mixed Blessings: New Art in a Multicultural America* (New York: Pantheon Books, 1990). For Simonds, see Center Cultural de la Fundació "la Caixa," *Charles Simonds,* exhibition catalog (Barcelona: Center Cultural de la Fundació "la Caixa," 1994). For Smithson, see Jack Burnham, *Great Western Salt Works: Essays on the Meaning of Post-Formalist Art* (New York: George Braziller, 1974).

6. See Carter Ratcliff (1994), quoted in Center Cultural de la Fundació, *Charles Simonds,* 133. Also see Carter Ratcliff, "On Contemporary Primitivism," *Artforum* 14, no. 3 (November 1975): 57–65.

7. Susan Stewart, *On Longing: Narratives of the Miniature, the Gigantic, the Souvenir, the Collection* (Durham, N.C.: Duke University Press, 1993), xi–xiii. Stewart explains that the miniature is a metaphor for interior time and space, just as the gigantic, of course, stands for the authority of the collective and the state—all narratives of the self and the world reveal a longing for a place of origin. In this view, collections and exhibitions are places where narratives and nostalgias intersect as property and space. Both positive and negative receptions, not just of the Poiriers but also of Charles Simonds and all other artists—including Smithson—who worked with the stylistic forms of archival anthropology, were therefore an index of writers' ideological self-fashionings in relation to the dual themes of property and authority.

8. Edward Lucie-Smith, *Art in the Seventies* (London: Phaidon, 1980), 106.

9. David Frankel, "Anne and Patrick Poirier," *Artforum* 34, no. 5 (January 1996): 80.

10. For a description of the geography of Mount Athos, see Monk Andrew Agioritis, *Guide to Mount Athos* (Mount Athos: Holy Community of Mount Athos, undated).

11. See Benjamin H. D. Buchloh, "Figures of Authority, Ciphers of Regression: Notes on the Return of Representation in European Painting" (1981), in Brian Wallis, ed., *Art after Modernism: Rethinking Representation* (New York: New Museum of Contemporary Art, 1984), 107–35.

12. See the introductory sections of Achille Bonito Oliva, *The Italian Transavantgarde* (Milan: Giancarlo Politi Editore, 1980). These tropes were not, as we have seen, the exclusive possession of 1980s art; they had been at play all through the 1970s.

13. See the second-order reading outlined by Andreas Huyssen, "Anselm Kiefer: The Terror of History, the Temptation of Myth," *October,* no. 48 (spring 1989): 25–45: "Perhaps his project was precisely ... to counter the merely rational explanations of fascist terror by re-creating the aesthetic lure of fascism for the present and thus forcing us to confront the possibility that we ourselves are not immune to what we so rationally condemn and dismiss" (38–39). See Mark Rosenthal, ed., *Anselm Kiefer* (Philadelphia: Philadelphia Museum of Art, 1987), for a hyperallegorical, overdetermined reading of Kiefer.

14. Per Luigi Tazzi, "Anne and Patrick Poirier," *Artforum* 24, no. 4 (December 1985): 97–98.

15. Tazzi, "Anne and Patrick Poirier," 97. According to Tazzi, the Poiriers' ruins possessed neither the pared-down ritualism of Jannis Kounellis's works nor the philosophical clarity of Paolini's. Instead, he felt, their work elevated a "romanticism of archaeology"; also see Patricia Phillips, "Anne and Patrick Poirier: Storm King Art Center," *Artforum* 28, no. 3 (November 1989): 155–56.

16. See Erwin Panofsky, *Studies in Iconology: Humanistic Themes in the Art of the Renaissance* (1939; reprint New York: Icon Editions, 1972), especially the introduction (3–17). The

Poiriers read books by Panofsky, Aby Warburg, and E. H. Gombrich during the 1960s and 1970s.

17. The Poiriers stressed their debt to Bergson's elaboration of the durational quality of consciousness. Their awareness of Bergson (as well-read French intellectuals) explained their emphasis on the heuristic qualities of objects of consciousness, which could be "closed" (inert and resisting intuition) or "open" (thus activating sense-creating, meaningful thought).

18. Günter Metken," ... de la ville de Mnémosyne," in Museum Moderner Kunst Stiftung Ludwig, Vienna, *Anne et Patrick Poirier,* exhibition catalog (Milan: Electa, 1994), 27–35, 35.

19. See Stephen Greenblatt, "Resonance and Wonder," in I. Karp and S. Lavine, eds., *Exhibiting Cultures* (Washington, D.C.: Smithsonian Institution, 1990), 42–56; for an examination of the city view as text that has obvious relevance to this discussion, see M. Christine Boyer, *The City of Collective Memory: Its Historical Imagery and Architectural Entertainments* (Cambridge: MIT Press, 1994).

20. Mnemosyne, according to the *Theogony* of Hesiod, was the mother of the Muses. According to Roger Hinks, "This genealogy has an obvious meaning: without the faculty of memory it is impossible, before the invention of writing, not only to compose long poems, but also to preserve them and recite them. But there is a profounder significance in the primacy which Hesiod gives to Memory. ... without memory, civilized life is impossible, for memory is the prerequisite condition for that mental coherence which distinguishes human consciousness" (Roger Hinks, *Myth and Allegory in Ancient Art* [1939] [Nendeln, Liechtenstein: Kraus Reprint, 1968], 93).

21. Anne and Patrick Poirier, "Envoi de Anne et Patrick Poirier: Extrait du journal de l'architecte-archéologue," *Journal des expositions* (February 1996): 1.

22. Ibid.

23. According to Metken, "Warburg considérait cette Mnémosyne au nom imprononçable comme la sainte patronne de ses recherches" [Warburg considerd this mnemosyne with the unpronounceable name to be the patron saint of his research] (Metken, " ... de la ville de Mnemosyne," 31). For a detailed account of Warburg's library, see Fritz Saxl's chapter "The History of Warburg's Library," included in E. H. Gombrich, *Aby Warburg: An Intellectual Biography* (London: Warburg Institute, University of London, 1970), 325–38; in the same volume, see Gombrich's chapter "The Last Project: *MNEMOSYNE*" for a detailed account of Warburg's strange last project, *Mnemosyne* (1929), a visual "atlas" of iconology in photographs; for a related study of how shifting morphologies govern the organization of views, see Claude Gandelman, "Bodies, Maps, Texts," in his *Reading Pictures, Viewing Texts* (Bloomington: Indiana University Press, 1991), 81–93.

24. Craig Owens, "The Allegorical Impulse" (1980), in Wallis, *Art after Modernism,* 204.

25. Mary Carruthers, *The Book of Memory: A Study of Memory in Medieval Culture* (Cambridge: Cambridge University Press, 1990), 16; see Frances A. Yates, *The Art of Memory* (Chicago: University of Chicago Press, 1966). In her now-canonical, groundbreaking text, Yates presents a historical overview of memory systems, focusing on the memory systems of antiquity and then on the later esoteric memory systems of Ramon Llull, Giordano Bruno, Robert Fludd, and Roger Bacon.

26. Carruthers, *The Book of Memory,* 17.

27. Anne and Patrick Poirier, letter to the author, 17 November 1997; the emphases are the Poiriers'.

28. See Anne and Patrick Poirier, *Ruines sur Ruines: Regard* (Caen: Fonds Régional d'Art Contemporain de Basse-Normandie, 1994).

29. They mentioned the same meeting to Zorpette; see his "Dynamic Duos," 167.

30. Because of its many affinities with the Poiriers' ruined cities, it is worth describing Ian Hamilton Finlay's Stonypath garden. Since 1967, Ian Hamilton Finlay has elaborated an ornamental garden with artificial ponds, groves of trees, monuments, and commemorative plaques at Stonypath, in Lowlands Scotland (for an extensive description, see Yves Abrioux and Stephen Bann, *Ian Hamilton Finlay: A Visual Primer* [Edinburgh: Reaktion Books, 1985]). He worked with stone carvers, ceramicists, and carpenters, diffusing the notion of authorial control but retaining sole authorial ownership through complex collaborations with master craftsmen. Therefore, his work falls outside the criteria by which Stonypath could be called an artistic collaboration, but he was dependent on the skills and choices of masons and typographers, whom he credited. As Stephen Bann noted in 1969, at the start of Finlay's garden project: "In all cases Finlay is radically dependent on the co-operation of industrial firms and individuals, without whom his projects cannot be realized" ("Ian Hamilton Finlay: The Structure of a Poetic Universe," *Studio International* 177, no. 908 [February 1969]: 78–81, 81). Finlay, like the Harrisons, relied on subcontractors to fabricate his projects; this dispersal of activity meant the Harrisons and Finlay were auteurs rather than traditional artists. For his garden, Finlay drew on Arcadian and Enlightenment motifs: Claude Lorrain's landscape painting, Renaissance and Roman villas, Albrecht Dürer, Jean-Baptiste Corot, and the Marquis de Girardin's garden at Ermenonville, which was for a while the home of Jean-Jacques Rousseau and the place of his entombment. Finlay's garden was profoundly anomalous and therefore offensive to local government; this was his intention. He had asserted that "[c]ertain gardens are described as retreats when they are really attacks" (quoted in Stephen Bann, "Ian Hamilton Finlay: An Imaginary Portrait," in Serpentine Gallery, *Ian Hamilton Finlay*, exhibition catalog [London: Serpentine Gallery, 1977], 21). Such "attacks" resembled those mounted by the great Chinese amateur painters during the Sung and Yuan dynasties, when a retreat to garden hermitages was a rejection of secular values and a refusal to assent to the incorporation of art into the professional artistic class's bureaucracy. Finlay, like the Boyles, affected to despise both secular values and arts bureaucracy, identifying the latter with the fashionable avant-garde and disliking it as much for its superficiality as for its misdirection.

31. See Nigel Llewellyn, *The Art of Death: Visual Culture in the English Death Ritual* (London: Victoria and Albert Museum, 1991), 52.

32. See Siegfried Kracauer, "Photography" (1927), in his *The Mass Ornament: Weimar Essays*, ed. and trans. Thomas H. Levin (Cambridge, Mass.: Harvard University Press, 1995), 47–63, 60–61.

33. Anne and Patrick Poirier, "A Journey without Maps" artists' statement, in Susan Sollins and Nina Castelli Sundell, curators and eds., *Team Spirit*, exhibition catalog (New York: Independent Curators Incorporated, 1990), 70; also see Anne and Patrick Poirier, *Découvertes et rapports sur les diverses campagnes de fouilles entreprises durant les années 1988–1989–1990–1991* (Rome: Edizioni d'Arte Renografica, 1991), 143.

34. A literal translation of their term: "un nouveau auteur inventé"; Anne and Patrick Poirier, interview by the author.

35. Anne and Patrick Poirier, "Mnemosyne," in *Découverts et rapports*, 143.

36. Carruthers sees the subject constituted in the medieval discourse of memory and memorization thus: "So instead of the word 'self' or even 'individual' we might better speak of a 'subject-who-remembers,' and in remembering also feels and thinks and judges" (Carruthers, *The Book of Memory*, 182). As the Poiriers said: "J'erre depuis quelques temps à travers les salles qui me semblent innombrables de cet immense musée de l'Utopie que je suis en train de fouiller et de construire" [I wander for some time across what seem to me to be innumerable rooms of this immense utopian museum that I am busy excavating and building]. (Anne and Patrick Poirier, "Envoi," 1).

37. See Roland Barthes, *Camera Lucida* (1980), trans. Richard Howard (London: Flamingo, 1984), 90–91 and 96; also see Victor Burgin, "Re–Reading *Camera Lucida*," *Creative Camera*, November 1982, 730–734, and 744.

38. Barthes, *Camera Lucida*, 14.

39. The artists' floor text in the *Model No. 1 Critical Resemblances House* at Gins's and Arakawa's exhibition *Arakawa/Gins: Critical Resemblances* (Guggenheim [New York], June 1997) described this intertwined experience as follows: "Here is a home that consists primarily of entrances. The house throws bodily procedures underlying identity-formation off-kilter. No longer needing to have personalities, residents adopt instead a wait-and-see policy towards themselves."

40. Arakawa and Madeline Gins, *Pour ne pas mourir* (Paris: Littérature Editions de la Différance, 1979), 6. They continue: "[T]he world of 'fiction of place' is the sum of body given over to be felt as 'I'; they can be either visible or invisible. The building up of perceiving from little or nothing; making of fiction" (8). The book's endpaper suggests, in a manner as cryptic as it is helpful: "Blank is an event and a method. It is, unlike Emptiness, for example, not something to be believed in or not. It provides the tabula rasa with a fullness of its own."

41. Arakawa and Gins, artists' wall text in *Arakawa/Gins: Critical Resemblances*.

42. See the chapters on Duchamp in Burnham, *Great Western Salt Works;* see also Arturo Schwarz, *The Complete Works of Marcel Duchamp* (New York: Harry N. Abrams, 1969).

43. Burnham, "Real Time Systems," *Artforum* 8, no. 1 (September 1969): 49–55, 49.

44. Ibid., 50.

45. Carruthers, *The Book of Memory*, 256. She adds, "The rhetorical indeterminacy of a medieval diagram extends as well, I think, to all the elements that 'distinguish' a medieval page. Iconography, in art as well as literary criticism, treats images as direct signs of something, as having an inherent meaning that will be universal for all readers" (256–57).

5. Memory and Ethics

1. See Richard Terdiman's critique of mnemonics as a sufficient model of memory in *Present Past: Modernity and the Memory Crisis* (Ithaca, N.Y.: Cornell University Press, 1993), chapter 2: "What they memorized and performed were effectively lists" (57). He explains that such a model depends on Plato's familiar model of memory as registration and of stored experiences as impressions like that of a ring on a wax block. The problem with this model, of course, is twofold: First, its practitioners sought an unattainable fidelity; second, as Terdiman observes, in positing that memory could be accessed through a quasi-mechanical process and that the view onto its contents would be relatively transparent, the model was blind to the socially conditioned nature of representations, let alone the affective productivity of memory itself (Terdiman, *Present Past*, 58).

2. Mary Carruthers, *The Book of Memory: A Study of Memory in Medieval Culture* (Cambridge: Cambridge University Press, 1990), 17. Note, again, Terdiman's critique of this model of cultural memory, although Carruthers's argument about ethical memory complicates his straightforward reading of memory science as dependent upon the ideas of registration on the mental surface followed by retrieval.

3. Helen Mayer Harrison and Newton Harrison, interview with the author, Del Mar, California, 30 November 1996. For the remainder of this chapter, quotes or citations attributed to the team but not accompanied by an endnote are from this interview.

4. See Donald Judd, "Complaints: Part II" (1973), in *Complete Writings, 1959–1975* (Halifax: Nova Scotia College, 1975), 207–11.

5. Craig Adcock, "Conversational Drift: Helen Mayer Harrison and Newton Harrison,"

Art Journal 51, no. 2 (summer 1992): 35–45, 35. Their original decision was based on discursive framing: "Each body of work sought a larger or more comprehensive framing or understanding of what such a notion might mean and how we, as artists, might express it" (Helen Mayer Harrison and Newton Harrison, "Shifting Positions Toward the Earth: Art and Environmental Awareness," *Leonardo* 26, no. 5 [1993]: 371–77, 371).

6. Newton Harrison, cited in Glenn Zorpette, "Dynamic Duos: Artists Are Teaming Up in Growing Numbers," *Art News* 93, no. 6 (summer 1994): 164–69, 166.

7. Helen Mayer Harrison and Newton Harrison, *Green Heart Vision*, artists' book (Del Mar, Calif.: Harrison Studio, 1995), 16.

8. Maarten van Wesemael, "In the Studio," preface to Harrison and Harrison, *Green Heart Vision*, 29–30.

9. Caroline A. Jones, *Machine in the Studio: Constructing the Postwar American Artist* (Chicago: University of Chicago Press, 1996), 372.

10. Jack Burnham, "Systems Aesthetics," *Artforum* 7, no. 1 (September 1968): 30–35, 32.

11. Owens, "Earthwords," *October* 10 (Fall 1979): 121–30, 126.

12. Adcock, "Conversational Drift," 35–45.

13. For a theorization of the neo-avant-garde and catharsis, see Hal Foster, *The Return of the Real* (Cambridge: MIT Press, 1996); see also Peter Bürger, *Theory of the Avant-Garde*, trans. Michael Shaw (Minneapolis: University of Minnesota Press, 1984). Charles Harrison summarizes Foster's thesis thus: "For Foster, following Lacan, 'Repetition is not reproduction.' His counterclaim, then, is that the return of avant-gardism is not mere reenactment, but rather a traumatic form of critical enactment" (Charles Harrison, "Bürger Helper," *Bookforum,* winter 1996–spring 1997 [November 1996]: 30–31 and 34, 30). Foster wrote: "First, the shift to a horizontal way of working is consistent with the ethnographic turn in art and criticism: one selects a site, enters its culture and learns its language, conceives and presents a project, only to move to the next where the cycle is repeated" (Foster, *Return of the Real,* 202). The Harrisons fit Foster's description of the "horizontal" expansion of art; I would assert that the Harrisons were familiar "with the structure of each culture well enough to map it, but also with its history well enough to narrate it" (Foster, *Return of the Real,* 202). The Harrisons were able to do this, though Foster did not include them in his discussion except in the most peripheral manner, precisely because of the nature of artistic collaboration and its associated elements: teamwork, patient research over a long period, and a complete alertness to invitations or rejections of their offers ("conversational drift").

14. This piece, appropriately enough now in the collection of another museum at the "periphery," the Museum of Contemporary Art in Sydney, was also one of the first works of art to embody any awareness of the greenhouse effect. It is an 8′ × 8′ photomural. See Power Institute, *Acquisitions: 1974–76,* exhibition catalog (Sydney: Power Institute, University of Sydney, 1976), cover illustration.

15. Bernd and Hilla Becher, quoted in Enno Kaufmann, "The Mask of Opticality," *Aperture*, no. 123 (spring 1991): 56–69, 64.

16. See Carl Andre, "A Note on Bernhard and Hilla Becher," *Artforum* 11, no. 4 (December 1972): 59. The Bechers were included in *Documenta 5* (1972), as were other artists working with modified forms of authorship, including Gilbert & George, Art & Language, and Alighiero e Boetti.

17. The Bechers noted that "[b]y looking at the photographs simultaneously, you store the knowledge of an ideal type, which can be used the next time" (Bernd and Hilla Becher, cited in Lynda Morris, introduction to Arts Council of Great Britain, *Bernd and Hilla Becher* [London: Arts Council of Great Britain, 1974], unpaginated).

18. Ibid. The Bechers' exhibitions took industrial function as the initial organizing

principle, but within functional groups, their photographs are sometimes ordered according to size rather than chronology.

19. See Maurice Tuchman's lengthy curatorial rationale in Maurice Tuchman, curator, "An Introduction to *Art and Technology*," *Studio International* 181, no. 932 (April 1971): 173–80; see also *Artforum*'s special section titled "The *Art and Technology* Exhibition at the Los Angeles County Museum (Two Views)." The special section contains two essays: Jack Burnham, "Corporate Art," *Artforum* 10, no. 2 (October 1971): 66–71; Max Kozloff, "The Multimillion Dollar Art Boondoggle," *Artforum* 10, no. 2 (October 1971): 72–76.

20. According to Tuchman ("An Introduction to *Art and Technology*," 179), Expo 70's works had been commissioned for the *Art and Technology* exhibition and were subsequently made available to the Osaka Expo. Tuchman noted that the Jet Propulsion Laboratory had been a less-than-generous collaborator, perhaps because the company was in the process of shifting its corporate activities from space research to environmental design. If so, the firm's realignment was ironic, for Harrison was shortly to refocus toward the same broad environmental concerns.

21. See John Beardsley, *Earthworks and Beyond: Contemporary Art in the Land* (New York: Abbeville, 1984), for the characterization of the Harrisons and Smithson within overly neat categorizations of Earth art or land art.

22. The Harrisons wrote in their résumé that this work was commissioned by Tuchman for the *Art and Technology* exhibition and that it was a "10′ × 40′ × 10″ wooden box with four compartments of equal size but containing sea water of differing salinities, the algae *Dunaliella* and the brine shrimp *Artemia*. The first discrete ecosystem to be used as subject matter in art. The algae changed colors in response to different salinities. The brine shrimp harvest scaled up to one ton per acre" (Helen Mayer Harrison and Newton Harrison, *Joint Vitae* [Del Mar, Calif.: Harrison Studio, 1996], 5).

23. According to the Harrisons, "We were conceptual artists in the eco-category"; see also Adcock, "Conversational Drift," 35.

24. Jack Burnham, *Great Western Salt Works: Essays on the Meaning of Post-Formalist Art* (New York: George Braziller, 1974), 163.

25. Adcock, "Conversational Drift," 35; Newton Harrison observed in interview that "[w]e dissociated ourselves from Earth artists such as Michael Heizer." The Harrisons felt little sympathy with minimalist artists' architectural projects; for them, Donald Judd was an example of "the artist as a [real estate] developer." They approved of Christo's self-support structure, by which he financed his works himself, but they worried about the obtrusiveness of his enormous works and about the damage caused during their construction. The 1971 exhibition *Earth, Air, Fire, and Water* at the Boston Museum of Fine Arts was an early example of ecologically oriented art as opposed to Earth art. It included the Harrisons' *Hog Pasture: Survival Piece #1* (1971). For a review, see Kenneth Baker, "Boston," *Artforum* 9, no. 7 (March 1971): 72–74. Other artists in the exhibition included Hans Haacke and Alan Sonfist. Certain dysfunctional events were noted by Baker in his review—the abandonment of Robert Morris's huge construction after altercations and near-disasters with heavy machinery and the vandalism of David Lowry Burgess's massive ice piece by members of the public. Similar dysfunctions and vandalism were repeated on countless occasions during the 1970s.

26. The Harrisons asserted that they came to their collaboration with concerns that preoccupied one partner more than the other: Helen Mayer Harrison stressed the ethical dimensions when they were negotiating their first works; Newton Harrison was concerned by the topological and systems-based elements. This division of priorities changed; they stopped taking fixed research roles within the creation of the works. Instead, they pragmatically worked out "who would do what the best," and often this allocation did not coincide with their initial

ideas of who should or would perform which tasks. Helen Harrison observed that the *Survival Pieces* were energy expensive on the one hand and did not carry enough information on the other. She added photography to the work, and both artists then came to the conclusion, in 1973, that extended narratives would be crucial from that point on.

27. Burnham, *Great Western Salt Works*, 166; here, the patriarchal name substitutes for the team once again.

28. Adcock, "Conversational Drift," 39.

29. Helen Mayer Harrison and Newton Harrison, "Breathing Space for the Sava River," *IS Journal* 5, no. 2 (fall 1990): 42–58, 42. According to the Harrisons, in the Sava River work, they were proposing to create a new history instead of the apparently inevitable continuing story of a polluted river running through Slovenia and Serbia, subject to damming and the draining of valuable wetlands.

30. The editing is Newton Harrison's. Helen Mayer Harrison and Newton Harrison, "Artists' Statement," in Susan Sollins and Nina Castelli Sundell, curators and eds. *Team Spirit*, exhibition catalog (New York: Independent Curators Incorporated, 1990), 46.

31. Susan Fillin-Yei, "*The Serpentine Lattice:* Where You Said a Lattice and I Said a Serpentine and You Said Network the Watersheds and I Said a Game of Go," introduction to Helen Mayer Harrison and Newton Harrison, *The Serpentine Lattice* (Portland, Ore.: Reed College, 1993): 16–23, 22.

32. Elizabeth Grosz, *Volatile Bodies: Towards a Corporeal Feminism* (Sydney: Allen and Unwin, 1994), 131. For an account of Nietzsche's theorization of the body as an inscribed surface and the self as constituted by memory, also see *Volatile Bodies*, 125–37. About the malleability of time and mutability of being in relation to will, Nietzsche wrote: "Thus will your will have it. It must become smooth and subject to the mind as the mind's mirror and reflection" (Friedrich Nietzsche, *Thus Spoke Zarathustra*, trans. R. J. Hollingdale [Harmondsworth, England: Penguin Books, 1961], 136).

33. Terdiman, *Present Past*, 180.

34. See Richard Neville, *Playpower* (London: Cape, 1970).

35. Fillin-Yei, "*The Serpentine Lattice*," 21.

36. Ibid., 23.

37. Harrison and Harrison, *Green Heart Vision*, 20.

38. Helen Mayer Harrison and Newton Harrison, *A Brown Coal Park for Sudraum Leipzig*, artists' book (Del Mar, Calif.: The Harrison Studio, 1996), 16.

39. See Robert Smithson, "Aerial Art," *Studio International* 177, no. 910 (April 1969): 180–81.

40. Michel de Certeau, "Pay Attention: To Make Art," in Herbert F. Johnson Museum of Art, *The Lagoon Cycle*, exhibition catalog (Ithaca, N.Y.: Herbert F. Johnson Museum of Art, Cornell University, 1985), 17–18, 18.

41. See Helen Mayer Harrison and Newton Harrison, *Tibet Is the High Ground*, artists' book (Del Mar, Calif.: Harrison Studio, 1995).

42. It is clear that the sheer complexity of the Poiriers' and the Harrisons' works can be explained as an analysis of memory, but since Smithson's work had been interpreted through allegorical frameworks and valorized by critics as a precursor of 1980s postmodern allegorical forms, it appears at first that a conception of mutable but ethical causality—spelled out in the Harrisons' work—could perhaps be opposed to the calcified allegorical landscapes of ruin announced by Benjamin's influential texts and attributed by Owens to Smithson. This turns out, I think, to be a limited reading of memory as ground in Smithson's work. Gary Shapiro, in *Earthwards: Robert Smithson and Art after Babel* (Berkeley and Los Angeles: University of California Press, 1995), eloquently takes up Owens's essay, then distances Smithson's oeuvre

from those terms. To contextualize Smithson's rhetoric, see Richard Alpert, Ralph Metzner, and Timothy Leary, *The Psychedelic Experience* (1964; reprint, London: Academy Editions, 1972), especially 40–41, for a combination of splintered thought, Gothic fantasy, physics, and Jungian psychology eerily reminiscent of Smithson's commentary on *Spiral Jetty*: Anthony Haden-Guest, in his sometimes bizarre book *True Colors* (New York: Atlantic Monthly Press, 1996), asserts that LSD was Smithson's "drug of choice" (47), but unfortunately he does not elaborate on the artistic implications.

6. Negotiated Identity

1. "Temporary work of art" is the label that the artists insist is preferable to "sculpture," "installation," or "action." Their term is henceforth adopted in this chapter.

2. John Kaldor coordinated the project. For a full description of the work's genesis, see Nicholas Baume, "Critical Themes in Christo's Art, 1958–1970," in *Christo: John Kaldor Art Project 1990*, exhibition catalog (Sydney: Art Gallery of New South Wales, 1990), 33–42.

3. See untitled, unsigned paragraph in the editorial column, *Studio International* 178, no. 917 (December 1969): 206. In fact, the work existed for ten weeks, beginning 28 October 1969.

4. I cite my own experience preparing illustrations for my book *Peripheral Vision: Contemporary Australian Art, 1968–94* (Sydney: Craftsman House, 1995). The two artists checked several times that I had the caption details listing both artists absolutely correct. They were extremely concerned that I credit Jeanne-Claude as equal author.

5. Jeanne-Claude, in Christo and Jeanne-Claude, *Christo and Jeanne-Claude: Conversation with Anne-Françoise Penders*, ed. Anne-Françoise Penders (Gerpinnes, Belgium: Editions Tandem, 1994), 22.

6. Christo, quoted in Nicholas Baume, "Christo," *Art and Australia* 27, no. 1 (spring 1989): 81–91, 91.

7. Christo, quoted in Patricia C. Phillips, "Christo: Independence Is Most Important to Me. The Work of Art Is Like a Scream of Freedom," *Flash Art,* no. 151 (March–April 1990): 134–37, 135.

8. See Frank Benier's cartoon, with the caption "Well—that just about wraps it up Mr Christo," in Baume, "Critical Themes in Christo's Art," 41.

9. Jeanne-Claude, letter to the author, 10 December 1999.

10. Christo and Jeanne-Claude did not sell photographs, posters, books, or films. On the contrary, they heavily subsidized all their published material. The significance of gift economies to collaborative authorship will be explored in the rest of this book; see David Bourdon's sophisticated early discussion of gifts, packaging, and Christo in David Bourdon, *Christo* (New York: Harry Abrams, 1970), 9.

11. Christo, cited in Phillips, "Christo," 135.

12. Ibid.

13. For a thorough description of Christo and Jeanne-Claude's sophisticated, entrepreneurial financial organization, see "Prime Property: Beside Being an Artist, Christo Has Distinction of Being the Principal Asset of CVJ Corporation," *Wall Street Journal,* 12 July 1984, 1 and 18.

14. Christo and Jeanne-Claude, letter to John Kaldor, 21 June 1969, quoted in Baume, "Critical Themes in Christo's Art," 15.

15. Jeanne-Claude made this absolutely clear in a telephone conversation with the author (March 1995). Kaldor was not involved in any real estate activity or development associated with Christo and Jeanne-Claude's temporary work of art (the site has long since reverted to its original state and is not marked by any sign or plaque identifying its art-historical significance),

nor did he own the works the artists presented, although he did purchase works by the artists during and after their tours. He was not involved in commissioning art; he was facilitating its realization. Following the personal triumph of facilitating Christo and Jeanne-Claude's work, Kaldor said that he was inspired to create his own business corporation.

16. Jeanne-Claude, letter to the author, 10 December 1999.

17. For a hostile description of Christo's installation, see Alan Warren, "Not Wrapped in Christo," *Sun* (Melbourne) 5 November 1969, 36. Warren observed, "Scale and ambiguity were important ingredients of the action at Sydney's Little Bay. . . . But they were forgotten when Christo wrapped up some wool bales in the Keith Murdoch Court. The result can only be described as obvious, the type of job one would expect from any truck driver." This review appeared the same day that Joseph Kosuth's *Joseph Kosuth: Fifteen Locations 1969/70 (Art as Idea as Idea 1966–70)* was published in the same newspaper.

18. G. R. Lansell, "Baleful Christo," *Nation*, 15 November 1969, 15. Lansell was incorrect in his assertion that Christo had denied being an environmental artist.

19. Christo, in *Christo and Jeanne-Claude: Conversation with Anne-Françoise Penders*, 14.

20. Ian Ball, "Christo the Wrapper," *Daily Telegraph Magazine*, no. 284 (27 March 1970): 18–23, 20. Christo repeated this "action" several times, including in Philadelphia and London. See the superb photograph by Anthony Haden-Guest taken during filming in Charles Wilp's studio, London, which is reproduced in Baume, "Critical Themes in Christo's Art," 19.

21. Christo, quoted in Calvin Tomkins, "Onward and Upward with the Arts: Running Fence," *The New Yorker*, 27 March 1977, 43–81, 80; in the same article, Christo fastidiously distances himself from minimalism.

22. See Udo Kulterman, *Art and Life*, trans. John William Gabriel (New York: Praeger, 1971), 206–7.

23. Christo, quoted in Baume, "Christo," 85. Donald Brook also observed that *Wrapped Coast* was "more environment than object" ("Review," *Sydney Morning Herald*, 14 October 1969). Christo had in fact created an earlier outdoor temporary work of art *Le rideau de fer* (1962)—as opposed to an outdoor sculpture—several years earlier.

24. Quoted in Baume, "Critical Themes in Christo's Art," 39.

25. Jeanne-Claude, telephone conversation with the author, 19 August 1999.

26. See Siegfried Kracauer, "Photography" (1927), in his *The Mass Ornament: Weimar Essays*, ed. and trans. Thomas H. Levin (Cambridge, Mass.: Harvard University Press, 1995), 47–63, 60. For a discussion of Kracauer's thesis about the flood of photographic representations and memory, see Benjamin H. D. Buchloh, "Gerhard Richter's Atlas: The Anomic Archive," *October*, no. 88 (spring 1999): 117–45.

27. The most poignant and instantaneous case of this was Christo and Jeanne-Claude's *Running Fence* (1976). The epic narrative of *Running Fence*'s construction and immediate demolition—along with many attendant legal suits—is exhaustively described in Tomkins's "Onward and Upward with the Arts."

28. Christo, quoted in Baume, "Christo," 85.

29. Jeff Wall, "Unity and Fragmentation in Manet" (1984), in Thierry de Duve, Arielle Pelenc, and Boris Groys, eds., *Jeff Wall* (London: Phaidon, 1997), 78–89.

30. Jeff Wall, "Photography and Liquid Intelligence" (1989), in Duve, Pelenc, and Groys, *Jeff Wall*, 90–93. Also see Jeff Wall, "'Marks of Indifference': Aspects of Photography in, or as, Conceptual Art," in Ann Goldstein and Anne Rorimer, curators and eds., *Reconsidering the Object of Art, 1965–75*, exhibition catalog (Los Angeles: Museum of Contemporary Art, 1995), 247–67.

31. Quoted in Phillips, "Christo," 135.

32. Christo, letter, 26 August 1988, quoted in Nicholas Baume, "John Kaldor: Public

Patron/Private Collector," in *From Christo and Jeanne-Claude to Jeff Koons: John Kaldor Art Projects and Collection*, exhibition catalog (Sydney: Museum of Contemporary Art, 1995), 9–79, 25.

7. Eliminating Personality

1. See Michael Fried, *Absorption and Theatricality: Painting and Beholder in the Age of Diderot,* new ed. (Chicago: University of Chicago Press, 1988). I have extensively depended here upon Fried's concise summary of that book in the introductory chapter of his later book *Courbet's Realism* (Chicago: University of Chicago Press, 1990). The next paragraphs and all my rehearsals of absorption and theatricality borrow heavily from Fried's text. For a discussion and critical evaluation of Michael Fried's later writing, placing his dichotomy of absorption and theatricality into a critical, postmodern context, see Stephen Melville, "Compelling Acts, Haunting Connections," in his *Seams: Art as a Philosophical Context* (Amsterdam· Gordon ı Breach Arts, 1996), 187–98. Melville convincingly points out that Fried's binary construction is inadequate, though useful. In art, Melville says, the terms of theatricality and visuality overlap (191).

2. See Denis Diderot, *Diderot on Art: "The Salon of 1765" and "Notes on Painting,"* and *Diderot on Art: "The Salon of 1767,"* both volumes ed. and trans. John Goodman (New Haven, Conn.: Yale University Press, 1995); for a review of these translations, see N. Furbank, "Stylist at the Salon: The Impetuous Flood of Diderot's Art Criticism," *Times Literary Supplement*, no. 4832 (10 November 1995): 4–5.

3. Fried, *Courbet's Realism,* 6.

4. Ibid., 7.

5. For a rehearsal of the terms "theater" and "art," see Michael Fried, "Art and Objecthood" (1967), in Geoffrey Battcock, ed., *Minimal Art: A Critical Anthology* (New York: Dutton, 1969), 116–47. In his books on French painting (see note 1 above) written more than a decade later, Fried develops a different theory of art that concentrates on the issue of whether a work of art is "convincing" to its beholder; a work of art would be most convincing when it fastidiously appears to make no obvious pleas for special attention upon the viewer. Fried distinguishes between two axes of attention: One is the horizontal axis of action within the painting, along which the painting's actors occupy the space and appear to interact with each other and where an elaboration of the "content" takes place. The other axis extends between the beholder and the actors inside the picture's depicted space. Along this axis, the artist's rhetorical strategies unfold in a conversation with the beholder. For a critique of Fried's opposition to postobject art forms, see Henry M. Sayre, *The Object of Performance: The American Avant-Garde since 1970* (Chicago: University of Chicago Press, 1989), 6–7. Sayre notes Fried's exaggeration and misidentification of formalism with the avant-garde. It was precisely at this historical moment—the early 1970s—that the split between formalism and avant-garde modernism, nascent since Paul Cézanne's formalist recuperation of impressionist modernism, became widely apparent.

6. Fried, *Courbet's Realism,* 7.

7. Jack Burnham, "Systems Aesthetics," *Artforum* 7, no. 1 (September 1968): 30–35, 32. My misuse of Fried's arguments to describe art that he would have almost certainly detested is far from unprecedented. Jack Burnham observed that Fried's "continuous and perpetual present" was, if the great formalist critic had the eyes to see it, exactly the same quality experienced in the expanded field of postobject, ritual-based art. See Burnham's chapter, "Objects and Ritual: Towards a Working Ontology of Art," in his *Great Western Salt Works: Essays on the Meaning of Post-Formalist Art* (New York: George Braziller, 1974), 152.

8. Michael Fried, "An Introduction to My Art Criticism," in his *Art and Objecthood: Essays and Reviews* (Chicago: University of Chicago Press, 1998), 1–74, 52. Unfortunately, Fried abandoned art criticism after the mid-1970s; his short intellectual autobiography, "An Introduction to My Art Criticism," reiterates his continuing indifference to minimalist art (53), let alone the complete rethinking of art and artistic work that followed from conceptualism and minimalism.

9. In this chapter I willingly heed the artists' request (Gilbert & George, letter to the author, September 1999) and henceforth refer to *The Singing Sculpture* as a work of art on exhibition, not as a performance, even though in most strict definitional senses the work was "really" a performance. It is worthwhile noting that both Gilbert & George and Christo and Jeanne-Claude were attempting to shape discourse on their work (the latter by refusing the term "installation") by resisting its incorporation into a particular canon, which they felt would misrepresent the artistic identity that they were, equally self-consciously, shaping.

10. The motto, as Carter Ratcliff explained, was borrowed from the writings of nineteenth-century English aesthetician Walter Pater; Ratcliff was the author of a very considerable number of catalog essays on Gilbert & George; see Carter Ratcliff, "Gilbert & George and Modern Life," in Municipal Van Abbemuseum, *Gilbert & George, 1968 to 1980,* exhibition catalog (Eindhoven, Netherlands: Municipal Van Abbemuseum, 1980), 7–35, 14.

11. Quoted in Michael Moynihan, "Gilbert & George," *Studio International* 179, no. 922 (May 1970): 196–97, 196. This issue also contains Gilbert & George's artist project, *A "Magazine Sculpture" by Gilbert & George,* 218–21.

12. The famous Flanagan and Allen version was written in 1932. Gilbert & George preferred a more anodyne new version.

13. Moynihan, "Gilbert & George," 196.

14. See Gilbert & George, *A Message from the Sculptors, August 1969* (1969), postal sculpture. The text is quoted in Moynihan, "Gilbert & George," 196.

15. Moynihan, "Gilbert & George," 196.

16. Gilbert, in Gilbert & George, "Gilbert & George Interviewed," interview by Michelle Helmrich, *Eyeline* (Brisbane), no. 24 (autumn/winter 1994): 14–17, 16. For details, see Ratcliff, "Gilbert & George and Modern Life." *The Singing Sculpture* appeared in New York at Ileana Sonnabend Downtown, 25–27 September 1970.

17. See Carter Ratcliff, "Gilbert & George: The Fabric of Their Words," in Bruce Wolmer, ed., *Gilbert & George: The Singing Sculpture* (New York: Anthony McCall, 1993), 29–47, 35.

18. Joseph Kosuth, "Art after Philosophy," part 2, *Studio International* 178, no. 916 (November 1969): 160–61, 161.

19. Mel Ramsden, letter to the author, 28 February 1997.

20. Gilbert & George staged the performance at Galeries René Bloch, Forum Theater (Berlin), 20 February 1970. They appeared in Germano Celant's important exhibition *Conceptual Art/Land Art/Arte Povera,* held by the Galleria Civica d'Arte Moderna (Turin, Italy) January 1970, with European artists including Alighiero e Boetti, who was also experimenting with modified artistic identities.

21. Gilbert, in Gilbert & George, "Gilbert & George Interviewed," 16.

22. John Kaldor, cited in Nicholas Baume, "John Kaldor: Public Patron/Private Collector," in *From Christo and Jeanne-Claude to Jeff Koons: John Kaldor Art Projects and Collection,* exhibition catalog (Sydney: Museum of Contemporary Art, 1995), 9–79, 29.

23. Ratcliff, "Gilbert & George and Modern Life," 7.

24. Moynihan, "Gilbert & George," 196.

25. Gilbert & George, *A "Magazine Sculpture" by Gilbert & George,* 218.

26. Ratcliff, "Gilbert & George and Modern Life," 14. This, of course, is a central and important point in Ratcliff's interpretation of their work.

27. A photograph of the two artists is reproduced in the 1972 *Documenta 5* exhibition catalog. They are staring out across the Thames on the Embankment; the accompanying text reads "Lost Day, 14 March 1971, GILBERT & GEORGE, the Human Sculptors." Their "crest" is placed above the photograph; it reads "GILBERT & GEORGE/Art for All/12 Fournier St./London E1." (Harald Szeemann, curator and ed., *Documenta 5,* exhibition catalog [Kassel, 1972], 16, 107).

28. John Kaldor, quoted in Baume, "John Kaldor: Public Patron/Private Collector," 29.

29. Beuys had also, by this time, commenced a long series of collaborations with teams of students and assistants. On 22 June 1967 he had founded the German Student Party in his classroom at the Düsseldorf Kunstakademie, which earned him immediate dismissal.

30. Vito Acconci, "Vito Acconci sur lui-même," public lecture (Musée nationale d'art moderne, Centre Georges Pompidou, Paris, 19 February 1996, author's notes). Quotations from Acconci in this paragraph are from the same lecture, author's notes.

31. Moynihan, "Gilbert & George," 196.

32. Kathy O'Dell makes a similar point about complicity at greater length. She emphasizes the way Acconci establishes the viewer's complicity (as opposed to distance) in works such as *Trademarks* (1970) through choice of title (suggesting transaction) and abject, detailed close-ups (artist's suffering analogous to separation from the mother's breast). In this work, the artist bites deeply into his arms and legs in front of a camera. O'Dell argues that the viewer feels responsible for Acconci's masochism and at the same time recognizes the gap between audience and artist; see Kathy O'Dell, *Contract with the Skin: Masochism, Performance Art, and the 1970s* (Minneapolis: University of Minnesota Press, 1998), 18.

33. See Brian Massumi, "The Autonomy of Affect," *Cultural Critique,* no. 31 (fall 1995): 83–109, 102. Massumi continues to say that these jerks are empty but communicative and are held together, for example, in Ronald Reagan's speeches by the timbre of his voice. Reagan's gestural idiocy and verbal incoherence were doubled by his voice and received by the body politic like a mirror onto which the U.S. public projected and recognized its wishes. Reagan, therefore, "was many things to many people, but within a general framework of affective jingoism that in itself signified almost nothing" (103). The comparison of Reagan with Gilbert & George is irresistible, even if the affinity is limited to the economy of mime.

34. Moynihan, "Gilbert & George," 196.

35. Steve Tillis, *Towards an Aesthetics of the Puppet: Puppetry as a Theatrical Art,* Contributions in Drama and Theater Studies, monograph no. 47 (New York: Greenwood Press, 1992), 64–65.

36. Ibid., 64.

37. See Joseph Needham, *Science and Civilization in China* (Cambridge: Cambridge University Press, 1954); for the *Art and Technology* exhibition, see Maurice Tuchman, "An Introduction to *Art and Technology,"* *Studio International* 181, no. 932 (April 1971): 173–80; Jack Burnham, "Corporate Art," *Artforum* 10, no. 2 (October 1971): 66–71; Max Kozloff, "The Multimillion Dollar Art Boondoggle," *Artforum* 10, no. 2 (October 1971): 72–76.

38. Jack Burnham, "Real Time Systems," *Artforum* 8, no. 1 (September 1969): 49–55, 55.

39. See Gustav Metzger, "Automata in History," part 2, *Studio International* 178, no. 915 (October 1969): 109–17; Victor Burgin, "Situational Aesthetics," *Studio International* 178, no. 915 (October 1969): 118–21; Joseph Kosuth, "Art after Philosophy," part 1, *Studio International* 178, no. 915 (October 1969): 134–37. Metzger's part 1 had appeared in the March 1969 issue of *Studio International.*

8. Missing in Action

1. Marina Abramović, in Marina Abramović and Velimir Abramović, "Time-Space-Energy, or Talking about Asystemic Thinking," in Marina Abramović, *Artist Body: Performances, 1969–1998* (Milan: Charta, 1998), 400–417, 411. See Leo Bersani and Ulysse Dutoit, *Caravaggio's Secrets* (Cambridge: MIT Press, 1998), 40, for a much more sophisticated elaboration than I can summarize here of Caravaggio's depiction of an address that hides and its relation to an address to the beholder beyond masochism and narcissism.

2. See Kathy O'Dell, *Contract with the Skin: Masochism, Performance Art, and the 1970s* (Minneapolis: University of Minnesota Press, 1998); Amelia Jones, *Body Art/Performing the Subject* (Minneapolis: University of Minnesota Press, 1998). I respect the ability of both critics' Freudian methodology to generate consistent, integrated accounts of 1970s body art, but my interest is not the same as theirs in these admirable books, even though they deal with a related subject and in places with exactly the same art. I am arguing that the two books' hypotheses are not explanatory of the art, for I think that the psychoanalytic net they cast is too narrow in reach and that their catch, though interesting, is blind to the significance of the difference between artists such as Abramović and Ulay (or Gilbert & George) and more conventional individual artistic identities. A more sensitive reading of the works themselves is needed, for without this their similarities to and influence on more recent art remains inexplicable, as do the artists' often restated intentions that their work sought to exceed or surpass conventional models of identity. Jones (141) finds that the *Relation Works* reinscribe the power imbalances between male and female, in spite of the artists' statements to the contrary, veiling a privileged masculinity. As we will see, it is very difficult to sustain this reading if the works are closely examined, not least because establishing a utopian social balance between the sexes was not the artists' desire or concern. Masochism went hand in hand with disclosure; the conjunction of enacted hermaphrodism and enacted physical transcendence went hand in hand with absorption. Incidentally, if the link between disclosure and masochism was Vito Acconci's interest (as I will explain), it was also that of the female sexual partners he manipulated in early works such as *Broad Jump* (1971). Nancy Kitchel exhibited the documentation of her failed relationship with Acconci as a quasi-conceptual work at 112 Greene Street (New York) in 1974; see Alan Moore, "Review," *Artforum* 8, no. 1 (September 1974): 85.

3. Michael Fried, *Courbet's Realism* (Chicago: University of Chicago Press, 1990), 6–7.

4. Here and throughout this paragraph I am borrowing very closely from Fried's 1996 recapitulation and reassessment of his early essay "Shape as Form" (1966). See Michael Fried, "An Introduction to My Art Criticism," in his *Art and Objecthood: Essays and Reviews* (Chicago: University of Chicago Press, 1998), 27.

5. Marina Abramović, "Artist's Instructions," in Friedrich Meschede, ed., *Marina Abramović,* exhibition catalog (Berlin: National Gallery; Stuttgart: Edition Cantz, 1993), 68.

6. Jennifer Phipps, interview by the author, 17 January 1995, Melbourne. Biennale director Nick Waterlow hosted the artists in Sydney, introducing them to Western Desert Aboriginal artists at one dinner party; Phipps hosted the artists in Melbourne. For a contemporary review of their Sydney performance, see Mike Parr, "Parallel Fictions: The Third Biennale of Sydney, 1979," *Art and Australia* 17, no. 2 (December 1979): 172–83, 183; see also Jennifer Phipps, "Marina Abramović/Ulay/Ulay/Marina Abramović," *Art and Text*, no. 3 (spring 1981): 43–50.

7. The description is based on author's 1979 notes.

8. Abramović and Ulay, in Phipps, "Marina Abramović/Ulay," 43.

9. Marina Abramović, "Performing Body," performance/public lecture (Storey Hall Theatre, Melbourne, 15 April 1998, author's notes); hereafter cited simply as Abramović, "Performing Body."

10. Abramović, telephone conversation with the author, 22 March 1996.

11. Abramović and Beuys met in 1971 at the Edinburgh Festival. He saw her first performance outside Yugoslavia, *Rhythm 5*. Beuys was, of course, an extraordinarily influential and charismatic figure among younger European artists during the 1970s, but Abramović insisted that she was more influenced, at this stage of her career, by Yves Klein and Jannis Kounellis (Marina Abramović, telephone conversation with the author). She admired Beuys, though, and from 1974 on was in sporadic contact with him. Two chief resemblances link Abramović's performances to those of Klein: First, her actions also involved pain, feats of endurance, mystical symbolism, and the use of the artist's own body. Second, for both, art possessed the potential to give experiences beyond the prison house of language. Therefore, the concept of the "nothingness" underneath language consisted of something more than negation; they wanted their audiences to experience something similar. One report "estimated" that 40 percent of the visitors to Klein's April 1958 exhibition at the Iris Clert Gallery (Paris) claimed to have had an experience of the Void: "According to the press, 40% of those who got into the gallery reported that they had indeed experienced the palpable pictorial condition (*le dépassement*)" (Ronald Hunt, "Yves Klein," *Artforum* 7, no. 5 [January 1967]: 32–37, 34).

12. Marina Abramović, *Biography* (with Charles Atlas) (Ostfildern, Germany: Reihe Cantz, 1994), 25; *Biography* was a performance and a self-portrait; its text was Abramović's résumé, incorporating and recapitulating her collaboration with Ulay. She had gathered older, short statements and a catalog of her performances together for the 1993 National Gallery (Berlin) exhibition and now reused them.

13. For a description and theorization of possible modes of nonvisual and nonlinguistic memory, see Elizabeth Grosz, *Volatile Bodies: Towards a Corporeal Feminism* (Sydney: Allen and Unwin, 1994), 131–32; here, she analyzes Nietzsche's link between a "memory of the body" and pain. This insistence on corporeal sensation and dismissal of visual memory is directly relevant to Abramović and Ulay's actions and may be opposed to the attempts of artist teams in chapters 3, 4, and 5 to recuperate the power of images as a language. Grosz observes: "Nietzsche's insight is that pain is the key term in instituting memory. Civilization instills its basic requirements only by branding the law on bodies through a mnemonics of pain, a memory fashioned out of the suffering and pain of the body.... the degree of pain inflicted, Nietzsche suggests, is an index of poverty of memory: the worse memory is, the more cruel are the techniques for branding the body" (131–32).

14. Carter Ratcliff, "Gilbert & George and Modern Life," in Municipal Van Abbemuseum, *Gilbert & George, 1968 to 1980*, exhibition catalog (Eindhoven, Netherlands: Municipal Van Abbemuseum, 1980), 7–35, 10. Here Ratcliff compares their attitude to that of Wordsworth, citing Wordsworth's declaration that vision is "the most despotic of our senses."

15. Vito Acconci, "Vito Acconci sur lui-même," public lecture (Musée nationale d'art moderne, Centre Georges Pompidou, Paris, 19 February 1996, author's notes). There was another pseudocollaborative aspect to this work: He admitted that he also had to persuade his two women friends to participate in a sexual encounter with the "winner" as part of his work of art. Acconci's work, however sexist, therefore was not completely addressed to the viewer; it contained elements that correspond to the axis of self-absorption. None of these works, in fact, nor the paintings so valued by Fried, constituted themselves as either exclusively "theatrical" or exclusively "self-absorbed." In other words, all the works examined in this section of my book negotiate the strategies of absorption and theatricality. All incorporate tropes that potentially point to either strategy, even if one of the poles of absorption and theatricality does often dominate and, thus, convinces or fails to convince the viewer of the sincerity of the artists' attentions. It must be remembered that in Abramović and Ulay's actions, though not necessarily in those of Gilbert & George, the impression of sincerity and authenticity—in other words, of intention—was of paramount importance.

16. Parr, "Parallel Fictions," 183.

17. For an example of an artist's rhetorical attempt to act out his withdrawal from his audience and the audience's frustration at that withdrawal, the much earlier example of Arakawa's *Anti-Happening* (1960) should be cited. *Anti-Happening* was theatrical, though, because it elicited the audience's intervention directly by that very act of withdrawal. It consisted of the artist leading the audience up stepladders onto a balcony in a blacked-out gallery. Arakawa then removed the stepladders, leaving the audience trapped on a ledge in complete darkness. Eventually—and only after an hour of terror—the audience jumped down, found Arakawa lying silent on the floor, and assaulted him. The artist silently submitted to a severe beating (see Yoshiaki Tono, "Japan," *Artforum* 5, no. 5 [January 1967]: 53–55, 53).

18. In *Courbet's Realism* (Chicago: University of Chicago Press, 1990), Michael Fried observes that G. W. F. Hegel's aesthetics privilege action over seeing (276–77); the following paragraph is a crude paraphrase of Fried's arguments over these pages.

19. See Stephen Greenblatt, *Marvelous Possessions* (Chicago: University of Chicago Press, 1991). Greenblatt explains the operation of wonder, but he also periodizes the quality, within the specific historical context of the Spanish conquest of the Americas, as an aesthetic operation that naturalized the genocidal destruction of Native Americans; also see Lorraine Daston and Katherine Park, *Wonders and the Order of Nature, 1150–1750* (New York: Zone Books, 1998).

20. This was classic fieldwork technique carried out in a perfect and historically appropriate location: the Antipodes; see John Frow, "Tourism and the Semiotics of Nostalgia," *October*, no. 57 (summer 1991): 123–51.

21. Abramović, "Performing Body."

22. Abramović, in Phipps, "Marina Abramović/Ulay," 50.

23. Abramović, *Biography*, 41. Marina Abramović and Ulay observed: "M. The desert reduces yourself to yourself, that's all that happens. U. You are alone" (Phipps, "Marina Abramović/Ulay," 47).

24. Abramović, in Phipps, "Marina Abramović/Ulay," 46.

25. Ibid.

26. Ibid. 47. For another example of disappearance in art and for a search for art that would escape all institutional categorization, see the short career of Dutch conceptualist Bas van Ader, whose previously forgotten work was featured by Ann Goldstein and Anne Rorimer at the Los Angeles exhibition *Reconsidering the Object of Art, 1965–75* and in a documentary film by American filmmaker, artist, and theater director Erika Yeomans (*In Search of Bas Jan's Miraculous* [1997, 16 mm, 40 min.]—a forty-minute biopic on the artist. Van Ader's last work, *In Search of the Miraculous* (1975), consisted of the artist's solo voyage across the Atlantic, from Cape Cod to Ireland, in a small yacht. He disappeared in mid-Atlantic; the capsized boat was found months later off the Spanish coast, but his body was never found. The film biography emphasizes the mystery that inevitably accumulates around art that refuses its audience's gaze.

27. Abramović, in Phipps, "Marina Abramović/Ulay," 47.

28. Richard Kimber, quoted in Max Charlesworth, ed., *Ancestor Spirits* (Geelong, Australia: Deakin University Press, 1990), 40.

29. One result was the proliferation of infill dots and repetitive marks that dominated many paintings and separated precise motifs. Anthropologist Eric Michaels suggested that "current Aboriginal paintings be confronted directly as products of explicitly contemporary manufacture" (Eric Michaels, "Postmodernism, Appropriation, and Western Desert Acrylics," in *Postmodernism: A Consideration of the Appropriation of Aboriginal Imagery* [Brisbane, Australia: Institute of Modern Art, 1989], 32). This was exactly how they were intended: Acrylic painting did not exist in Aboriginal art before 1971. Traditional relationships, between Dreaming-owner and Dreaming-guardian, were indispensable to the correct censorship and transmission of

secret motifs, and these were now complicated by the production and proliferation of art. For an excellent elaboration of ritual significance and acrylic production methods in Aboriginal art, see Peter Sutton, ed., *Dreamings: The Art of Aboriginal Australia* (New York: Viking, 1989).

30. Abramović, telephone conversation with the author, 22 March 1997.

31. O'Dell, *Contract with the Skin*, 84.

32. According to Abramović, "*Nightsea Crossing* came out of this immobility, out of the heat that was an absolute wall around us. That kind of heat makes you motionless. We replayed our lives like a movie. Only after that, a non-visible world opened up" (Marina Abramović, telephone conversation with the author, 22 March 1997).

33. See Thomas McEvilley, "Ethics, Esthetics, and Relation in the work of Marina Abramović and Ulay," in Stedelijk van Abbemuseum, *Ulay and Marina Abramović: Modus Vivendi Works, 1980–1985*, exhibition catalog (Eindhoven, Netherlands: Stedelijk van Abbemuseum, 1985), 9–14, 10.

34. Allan Kaprow, *Some Recent Happenings* (New York: Something Else Press [A Great Bear Pamphlet], 1966), 3.

35. Allan Kaprow, *Assemblage, Environments, and Happenings* (New York: Harry N. Abrams, 1966), 180.

36. Abramović remembered in hindsight: "After three months, everything was in perfect harmony" (Abramović, telephone conversation with the author, 22 March 1997).

37. Abramović, in Phipps, "Marina Abramović/Ulay," 50.

38. Abramović, *Biography*, 35.

39. Thomas McEvilley, "Ethics, Esthetics, and Relation." McEvilley's essay is pertinent to my discussion; see also the same author's essay "Great Walk Talk," in Marina Abramović and Ulay, *The Lovers*, exhibition catalog (Amsterdam: Stedelijk Museum, 1989), 73–115.

40. Marina Abramović, telephone conversation with the author, 22 March 1997.

41. Jennifer Phipps, interview by the author; also see Phipps, "Marina Abramović/Ulay," 47. The National Gallery (Berlin) catalog retitles the work *Anima Mundi: Tango* (1981) and incorrectly places the performance at the National Gallery of Victoria instead of Latrobe University. It also incorrectly states that the action lasted three hours.

42. Abramović, telephone conversation with the author, 22 March 1997. She remembered the performances as extraordinarily intense experiences that followed a definite rhythm: "After one hour, the body hurts so much you think you will lose consciousness, so much pain. Then you don't care. You don't blink. It was like tripping [on LSD]. Ulay's response was different: He was in great pain."

43. Abramović, "Performing Body."

44. For an elaboration of Duchamp's negation of art, see Hans Richter, "In Memory of Marcel Duchamp," *Form*, no. 9 (April 1969): 4.

45. Bojana Pejic, "Being-in-the-Body: On the Spiritual in Marina Abramović's Art," in Meschede, *Marina Abramović*, 25–37, 26. The prevailing interpretation of the relationship embodied in Abramović and Ulay's collaborative works—not to mention most other body art—has been to see their construction of intense proximity and symbiosis as painful and traumatic rather than ecstatic and pleasurable. For an example of this, see the manner of their inclusion in the exhibition *femininmasculin* (Paris: Center Georges Pompidou, 1995). As I have indicated, artists and critics were interested in pain because, as Nietzsche suggested, pain can be an agency of memory, and memory, as I have argued in previous chapters, was an important issue for artists. Togetherness has thus been conceptualized as an ordeal rather than as work, as a fortress wall, or, even more rarely, as an ecstatic experience—thus the reluctant revaluation of Carolee Schneeman's unfashionably optimistic group performances such as *Meat Joy* (1964). The overemphasis is understandable, for pain was the currency of so many

performances, including many of Abramović's and Ulay's own works, as well as those of Gina Pane, Chris Burden, and Vito Acconci. Abramović and Ulay's collaborative work, though, is not simply body art: It is double-body art, and therefore quite different. Marina Abramović, incidentally, has a particularly high regard for the performances of Rebecca Horn and Chris Burden, planning performed simulations of her own and other artists' canonical performances in response to her sense that a new generation of younger artists had misunderstood these works (Marina Abramović, telephone conversation with the author, 22 March 1997).

46. Stephen Bann, introduction to *Global Conceptualism: Points of Origin, 1950s–1980s*, exhibition catalog (New York: Queens Museum of Art, 1999), 3–13, 13.

47. Ulay, in Phipps, "Marina Abramović/Ulay," 50. Buddhist philosophy stresses nonattachment to pleasure or pain; this is one of the virtues acquired through meditation on the Buddhist path to self-perfection. Translating *za-zen* as "indifference" is misleading because the reaction to outward stimulus from sense objects is controlled. The Japanese term "*za-zen*" means "Zen-sitting" and refers to the process of Zen meditation. The fame of Zen in the West from the 1950s on has meant that when art-critical comparisons and analogies are made with Buddhism, they are invariably made with Zen, which was only one of many schools within the vast heritage of Buddhist philosophy. Abramović and Ulay's performance works were unsystematic attempts to explore extreme states of consciousness that had already been systematically codified in Mahayana Buddhism, for example by the Six Topics (meditation techniques taught by Tilopa, also known as Tillipa, the great Buddhist mystic and teacher); see sGampopa, *The Jewel Ornament of Liberation*, trans. and annotated by Herbert Guenther (London: Rider, 1959), xiii. The Six Topics were: the development of the mystic "inner heat" through concentration; the experience of seeing one's own body as a phantom; the experience of the state of dreams; the experience of the Radiant Light; the experience of the state between birth and rebirth while living; and the practice of spiritual meditation to raise the consciousness to higher planes.

48. See "Emptiness: The Two Truths. Excerpts from 'An Interview with the Dalai Lama,'" in Ulay and Marina Abramović, *Modus Vivendi*, 75–77. The artists' connection at this time with Buddhist philosophy—and Abramović's ongoing link in particular—is acknowledged in this interview. To understand the concept of emptiness alluded to by the artists, it is necessary to refer to the Mahayana Buddhist understanding of the "bedrock" underlying individual psychological life and therefore to allude to the concept of Skandhas, explained in the famous Mahayana meditation manual written by the Tibetan teacher and monk, sGampopa (sGampopa, *The Jewel Ornament of Liberation*, 200). The Skandhas are the five constituents of individual psychological life (the Buddhist description of subjectivity): corporeality, feeling, discrimination, motivation, and consciousness. Mahayana Buddhism teaches that these constituents are together an accurate description of the mind but that they do not begin to describe anything that is ultimate. The mind is provisional, and so are the fruits of analysis. In the same way, the experiences of meditation (and, presumably, actions such as Abramović and Ulay's) that go beyond the wavering, confused nature of normal mental activity are nothing ultimate in themselves, though at the time they appear to be. Afterwards, the subject can mistake such memories for the real things themselves. By clinging to this type of nostalgia the subject turns rapture (or the artist's actions) into the worship of dead concepts. This has a dulling and retarding effect. Guenther quotes a Buddhist sutra to the effect that the activities of mind are regarded as not only constructed by language but also completely illusory, for there is only emptiness (Guenther, annotations to sGampopa, *The Jewel Ornament of Liberation*, 207). SGampopa continues: "Since it is not obtained by itself, from others or both / Nor by the three aspects of time [past, present or future] / The belief in a Self collapses" (sGampopa, *The Jewel Ornament of Liberation*, 207). Mortification of the body was a standard technique

among Christian, Buddhist, and Hindu mystics (and spiritual aspirants generally), but the demonstration of great physical endurance was not an end in itself; it was a means to the stripping away of layers of mental activity. As another important Buddhist sutra observes: "First open this heap of skin with your intellect / Then separate the flesh from the network of bones with the scalpel of discriminating awareness. / Having opened the bones also look into the marrow / And see for yourself / Whether there is anything solid" (Bodhicaryàvatara, quoted in Guenther, annotations in sGampopa, *The Jewel Ornament of Liberation*, 47). Marina Abramović and Ulay were carrying on this tradition without strict adherence to any organized mystical system. Many poststructuralist or Heideggerian commentators have noted that philosophical discussions of a ground characterized by emptiness, negation, and voidness are not necessarily to be categorized as utopian, Jungian, or philosophically naive. See Nathan Katz, "Prasanga and Deconstruction: Tibetan Hermeneutics and the *Yana* Controversy," *Philosophy East and West*. 34, no. 2 (April 1984): 185–203; see also Kevin Hart, *The Trespass of the Sign: Deconstruction, Theology, and Philosophy* (Cambridge: Cambridge University Press, 1989).

49. Abramović, telephone conversation with the author, 22 March 1997: Abramović and Abramović, "Time-Space-Energy, or Talking about Asystemic Thinking," 402.

50. Pejic, "Being-in-the-Body," 26.

51. Marina Abramović and Ulay, interview with Heidi Grundman, Vienna (1978), in Art Gallery of New South Wales, *European Dialogue: Biennale of Sydney, 1979* (Sydney: Art Gallery of New South Wales, 1979), 19. For the incorrect application of binary gender reifications in Abramović and Ulay's collaboration, see Katarzyna Michalak, "Performing Life, Living Art: Abramović/Ulay and KwieKulik," *Afterimage* 27, no. 3 (November/December 1999): 15–17.

52. Abramović, in Pejic, "Being-in-the-Body," 34.

53. Abramović, *Biography*, 35.

54. Abramović and Ulay, "Artists' Statement," in *Ulay and Marina Abramović: Modus Vivendi*, 31; also see Meschede, *Marina Abramović*, 179.

55. Abramović, "Performing Body." Abramović noted that she did not feel pain during their performances but did after they finished, and that she and Ulay had different pain thresholds (Abramović, telephone conversation with the author, 22 March 1997).

9. Doubles, Doppelgängers, and the Third Hand

1. Abramović asserted: "In every cell of our body we have energy that we never use. Survival situations give you the energy to use this energy. The same energy is used by Tibetans in Inner Heat exercises. We needed that excess energy when we made the work with the bow and arrow pointing at my heart" (Marina Abramović, telephone conversation with the author, 22 March 1996). She also observed in a later autobiographical performance, *Performing Body* (1998), that "[t]he performance is an exchange of energy" (Marina Abramović, "Performing Body," performance/public lecture [Storey Hall Theatre, Melbourne, 15 April 1998, author's notes]); hereafter cited as Abramović, "Performing Body."

2. Alex Melamid, taped interview with the author, New York, 4 December 1996; Melamid cited extensive Russian literary precedents for the renunciation of one's own voice in favor of an invented, fictitious identity, observing: "The artist's 'name' is important; it's a fictional device."

3. Sigmund Freud, "The 'Uncanny'" (1919), in *The Standard Edition of the Complete Psychological Works of Sigmund Freud*, vol. 17, ed. and trans. James Strachey (London: Hogarth Press, 1955), 234. Terry Castle links the themes of the double and the uncanny through this quote (Terry Castle, *The Female Thermometer: Eighteenth-Century Culture and the Invention of the Uncanny* [Oxford: Oxford University Press, 1995], 19); also see Claude Rawson's review of

Castle's book, "Taking the Temperature of the Times," *Times Literary Supplement,* no. 4837 (15 December 1995): 10–11. For a famous study of the double, see Otto Rank, *The Double: A Psychoanalytic Study,* trans. and ed. Harry Tucker Jr. (Chapel Hill: University of North Carolina Press, 1971).

4. Marina Abramović, *Biography* (with Charles Atlas) (Ostfildern: Reihe Cantz, 1994), 25.

5. Abramović and Ulay, quoted in Bojana Pejic, "Being-in-the-Body: On the Spiritual in Marina Abramović's Art," in Friedrich Meschede, ed., *Marina Abramović* (Berlin: National Gallery; Stuttgart: Edition Cantz, 1993), 34.

6. Abramović, *Biography,* 29.

7. Abramović, "*Performing Body.*"

8. Abramović and Ulay, in Jennifer Phipps, "Marina Abramović/Ulay/Ulay/Marina Abramović," *Art and Text,* no. 3 (spring 1981): 43–50, 43. Abramović observed: "In every cell of our body we have energy that we never use. Survival situations give you the energy to use this energy. The same energy is used by Tibetans in Inner Heat exercises. We needed that excess energy when we made the work with the bow and arrow pointing at my heart" (Marina Abramović, telephone conversation with the author, 22 March 1996; these Tibetan mental exercises were described in the endnotes to chapter 8). She also observed: "The performance is an exchange of energy" (Marina Abramović, "Performing Body").

9. Abramović, *Biography,* 29.

10. Castle, *The Female Thermometer,* 7.

11. Quoted in Michael Moynihan, "Gilbert & George," *Studio International* 179, no. 922 (May 1970): 196–97, 197.

12. *The Meal* fits into a catalog of meals as art that includes Daniel Spoerri's important "dinners" of the early 1960s—refigured and immortalized in his *An Anecdoted Topography of Chance (Re-Anecdoted Version),* trans. Emmett Williams (New York: Something Else Press, 1966)—Spanish sculptor Antoni Miralda's edible sculptures, Jim McWilliams's *The Ultimate Chocolate Experience* (1976), and, much later, the work of Thai/U.S. artist Rirkrit Tiravanija, who cleared out gallery spaces, put in chairs and tables, and served meals to gallery-goers in various performances during the early 1990s.

13. See Nam June Paik, *Video Time—Video Space,* ed. Toni Stooss and Thomas Kellein (New York: Abrams, 1993). Paik had begun working with video during the 1960s not because of its (then) congruence with television but because video, as a far less cumbersome and less costly medium than cinema, could appropriate and then present a double of almost anything; for a Fluxus artist, this was a very real quality, for video offered a performative experience—a sense of actual time—as opposed to a miniature substitute for cinema.

14. Younger neo-Fluxus artists in the 1990s—for example the U.S. artist Janine Antoni— did, strangely enough, demonstrate an interest in these tropes of the artist's withdrawal and inaccessibility: Antoni's *Slumber* (1994, re-created in 1996 at the Guggenheim Museum) featured the artist asleep on at least one occasion, oblivious to the gaze of the audience, and at other times—at night when the gallery was closed to the public—unavailable. She worked on a woven tapestry in her exhibition space by day, converting her nightdress into a bed sheet. At night, she slept in the gallery, covering herself with this newly woven drape. Antoni's *Butterfly Kisses* (1993) resembles Abramović and Ulay's *Relation Works*: She winked each eye 1,124 times; the mascara on her eyes marked the paper against which she had pressed her face, leaving a "drawing" that was an index of her action in the same way that the feathers of *Go . . . Stop . . . Back . . . Stop* had been an index of Abramović and Ulay's endurance and exhaustion.

15. Mike Parr, "Parallel Fictions," 178.

16. Gilbert, in Gilbert & George, "Gilbert & George Interviewed," interview by Michelle Helmrich, *Eyeline* (Brisbane), no. 24 (autumn/winter): 14–17, 17.

17. Nicolas Abraham, "Notes on the Phantom: A Complement to Freud's Metapsychology" (1975), reprinted in *Critical Inquiry,* no. 13 (winter 1987): 287–92, 290.

18. Ibid., 291.

19. Critic Peter Schjeldahl, for example, discusses and then rejects this view in "Child's Play," *Artforum* 34, no. 10 (summer 1996): 80 and 126, 126.

20. Elizabeth Grosz, *Volatile Bodies: Towards a Corporeal Feminism* (Sydney: Allen and Unwin, 1994), 39–46.

21. Ibid., 41–42.

22. Abramović, telephone conversation with the author, 22 March 1997.

23. Grosz, *Volatile Bodies,* 43.

24. Ibid.

25. See Timothy Leary, *The Politics of Ecstasy* (London: Paladin, 1970); Richard Neville, *Playpower* (London: Cape, 1970); Theodore Roszak, *The Making of a Counter Culture* (London: Faber, 1970).

26. Gilbert & George, quoted in Douglas McGill, "Two Artists Who Probe the Meaning of Life" (1985), reprinted in Susan Sollins and Nina Castelli Sundell, curators and eds., *Team Spirit,* exhibition catalog (New York: Independent Curators Incorporated, 1990), 44.

27. See Caroline Tisdall, *Joseph Beuys* (London: Thames and Hudson, 1979), 84–105.

Conclusion

1. Richard Terdiman, *Present Past: Modernity and Memory Crisis* (Ithaca, N.Y.: Cornell University Press, 1993), 68. Terdiman identifies the "fundamental suspicion concerning signification itself." He continues: "In this perspective, our contemporary suspicion about meaning, the familiar crisis of representation appears as theoretical reflexes of the same changes in the patterns of production and transmission of socially agreed sense that determined the memory crisis" (68).

2. This activity is exhaustively documented in *Ian Burn, Art: Critical, Political,* whose editor, Sandy Kirby, worked with Burn on a 1985 exhibition for the Art Gallery of New South Wales, *Working Art: A Survey of Art in the Australian Labor Movement in the 1980s.* See Ian Burn, *Ian Burn, Art: Critical, Political,* ed. Sandy Kirby (Sydney: University of Western Sydney Nepean, 1996).

3. Ian Burn, *Notes on "Value Added" Landscapes,* exhibition catalog (Melbourne: Sutton Gallery, 1993), unpaginated.

4. See Musée d'Art Moderne de la Communauté de Lille, Villeneuve d'Ascq, *Alighiero Boetti Rétrospective,* exhibition catalog (Lille, France: Musée d'Art Moderne de la Communauté de Lille, Villeneuve d'Ascq, 1996); see also Alain Cueff, "Alighiero e Boetti," *Parkett,* no. 13 (August 1987): 6–21.

5. Ramsden, in Art & Language (Mel Ramsden, annotated by Michael Baldwin), "Making Art from a Different Place," in *Ian Burn: Minimal Conceptual Work, 1965–1970,* exhibition catalog (Perth: Art Gallery of Western Australia, 1992), 7–16, 12.

6. Michael Corris, "Inside a New York Art Gang: Selected Documents of Art & Language, New York," in Ann Stephen, ed., *Artists Think: The Late Works of Ian Burn,* exhibition catalog (Sydney: Power Publications, 1996), 60–71.

7. Ian Burn, "Art: Critical, Political," *Art Monthly Australia,* no. 58 (April 1993): 19–22; reprinted in Burn, *Ian Burn, Art: Critical, Political,* 58–63.

8. Burn, interview by Hazel de Berg, 30 April 1970, New York, tape recording and transcript, National Library of Australia, Canberra, unpublished transcript, 5805.

9. Andrew McNamara, "The 'Mess' of Australian Art: The Necessity of Reading in Ian Burn's Historiography," in Stephen, *Artists Think,* 29–41, 36 and 38.

10. Peter Schjeldahl, "Child's Play," *Artforum* 34, no. 10 (summer 1996): 80 and 126, 126; see also Carter Ratcliff, "Masters of the Glum Eureka: Peter Fischli and David Weiss," *Art in America* 75, no. 1 (January 1987): 98–101.

11. Schjeldahl, "Child's Play," 126.

12. Elizabeth Grosz, *Volatile Bodies: Towards a Corporeal Feminism* (Sydney: Allen and Unwin, 1994), 46–47; and Rosalind Krauss, *The Optical Unconscious* (Cambridge: MIT Press, 1993), 155–56; also see Brian Massumi, "The Autonomy of Affect," *Cultural Critique*, no. 31 (fall 1995): 83–109.

13. Roger Caillois, "Mimétisme et psychasthénie légendaire," *Minotaure*, no. 7 (June 1935), cited in Martin Jay, *Downcast Eyes: The Denigration of Vision in Twentieth-Century French Thought* (Berkeley and Los Angeles: University of California Press, 1993), 342.

14. Krauss, *Optical Unconscious*, 155.

15. Grosz, *Volatile Bodies*, 46.

16. See Calvin Tomkins, *Marcel Duchamp: A Biography* (New York: Henry Holt and Company, 1996). Tomkins elaborates Duchamp's strategic manipulation of circumstance, like a chess game or even like the Harrisons' concept of "conversational drift."

17. For this distinction, as well as an explanation of Duchamp's presentation of the self as ready-made, see David Joselit, *Infinite Regress: Marcel Duchamp 1910–1941* (Cambridge: MIT Press, 1998), 177. Joselit's discussion is based on a close reading of Hubert Damisch's essay "The Duchamp Defense" (1979), trans. Rosalind Krauss, *October*, no. 10 (fall 1979): 5–28. The rest of this paragraph draws on Joselit's discussion and his summary of Damisch, as do the pages that follow.

18. See Marina Abramović and Velimir Abramović, "Time-Space-Energy, or Talking about Asystemic Thinking," in Marina Abramović, ed., *Artist Body: Performances, 1969–1998* (Milan: Charta, 1998), 400–417, 406.

Index

Charles Green, an artist, art critic, and art historian specializing in the history of international and Australian art after 1960, is a lecturer in art history and theory at the University of New South Wales. He is the Australian reviewer for *Artforum* and the author of *Peripheral Vision: Contemporary Australian Art, 1970–94*. Since 1989, he has been working collaboratively with Lyndell Brown. Their art is included in several major public and private collections, and they have received many awards and residencies, including the Asialink residency at Sanskriti Kendra in Delhi, India.